BERNINI

BERNINI

HIS LIFE AND HIS ROME

FRANCO MORMANDO

University of Chicago Press
Chicago and London

FRANCO MORMANDO is associate professor of Italian at Boston College. Among his publications are *The Preacher's Demons: Bernardino of Siena and the Social Underworld of Early Renaissance Italy* (University of Chicago Press, 1999), which won the Howard R. Marraro Prize for Distinguished Scholarship in Italian History; as editor and exhibition co-curator, *Saints and Sinners: Caravaggio and the Baroque Image* (McMullen Museum of Art, Boston College, 1999); as co-editor, *Piety and Plague: From Byzantium to the Baroque* (Sixteenth Century Essays and Studies, Truman State University Press, 2007); as co-editor and co-curator, *Hope and Healing: Painting in Italy in a Time of Plague, 1500–1800* (Worcester Art Museum, 2005); and *Domenico Bernini: The Life of Gian Lorenzo Bernini*, A Translation and Critical Edition with Introduction and Commentary (Penn State University Press, 2011).

In 2005 Professor Mormando was designated a Cavaliere (Knight) in the Ordine della Stella della solidarietà italiana by the president of the Republic of Italy, in recognition of his achievement in the promotion of Italian language and culture.

The University of Chicago Press, Chicago 60637
The University of Chicago Press, Ltd., London
© 2011 by The University of Chicago
All rights reserved. Published 2011.
Printed in the United States of America
20 19 18 17 16 15 14 13 12 11 1 2 3 4 5

ISBN-13: 978-0-226-53852-5 (cloth)
ISBN-10: 0-226-53852-4 (cloth)

Library of Congress Cataloging-in-Publication Data

Mormando, Franco.
 Bernini : his life and his Rome / Franco Mormando.
 p. cm.
 Includes bibliographical references and index.
 ISBN-13: 978-0-226-53852-5 (cloth : alk. paper)
 ISBN-10: 0-226-53852-4 (cloth : alk. paper) 1. Bernini, Gian Lorenzo, 1598–1680. 2. Sculptors—Italy—Biography. I. Title.
 NB623.B5M67 2011
 709.2—dc23
 [B]
 2011023774

♾ This paper meets the requirements of ANSI/NISO Z39.48–1992 (Permanence of Paper).

TO ✈ DANIEL JAMES MOUHOT

CONTENTS

The First English-Language Biography of Bernini

Thanks to his Fountain of the Four Rivers in Piazza Navona, his *Saint Teresa in Ecstasy* in Santa Maria della Vittoria, his grand Colonnade of St. Peter's Square, and many other captivating works of art and architecture, Gian Lorenzo Bernini is today second only to Caravaggio as the most popular celebrity-artist of Baroque Rome. Millions of tourists each year come to know and love Bernini's many works in Rome and elsewhere. No other artist has left so large, so enduring, and so delightful a mark on Rome as Bernini. In the history of Western art, moreover, Bernini easily counts as one of the most influential artists of all time, in fact, far more so than Caravaggio.

Yet, despite the influence and popularity of Bernini's works, few people come to know the man himself. Why? Because there is no place in the modern printed literature where "the man himself" can really be found. In all the vast bibliography on the artist, in any language, little attention is paid to Bernini's private life and personal interactions. Examine the current (and not-so-current) literature on Bernini and you will find that it focuses, predominantly if not exclusively, on his works of art and architecture, his public "performance," and the other impersonal facts of his curriculum vitae—as if that were the sum total of his life and identity, and as if that is all we needed to know to fully understand the phenomenon that was Bernini and his epoch-making works of art. It is not.

Even the popular books marketed as introductions to Bernini's life and career are still more or less technical discussions of his works, in

chronological order, with meager biographical data and social context inserted here and there. Some recent attempts at biography have been made in Italian and German, but they don't go far enough. Admittedly, the primary sources (including the authors of the first full-length "official" Italian biographies composed shortly before and after his death) make it extremely difficult for us to get to know the man himself. This is because they were either not interested in the topic, or, as in the case of the first official biographies, were instead intent on marketing a carefully constructed, idealized, and thus depersonalized image of Bernini. The first seventeenth-century biographies (upon which we are still much dependent for our information about the artist) attempt to sell the myth of "Bernini the genius" who, divinely inspired and larger-than-life, transcended the ordinary needs, drives, and desires that are an inescapable part of the human condition.

During his lifetime, moreover, the vigilantly self-protective Bernini himself played it extremely close to the vest and rarely volunteered his opinion except on the most uncontroversial of topics. He never put his thoughts down on paper, certainly never on matters regarding his personal life. Nonetheless, we can still sift out sufficient evidence from the official biographies and the mass of other primary sources (diaries, private letters, news bulletins, diplomatic dispatches), from which to build a truer picture of the recognizably human being. Of course, this means that at times, like detectives, we are obliged to read between the lines in order to deduce what we can from the archival pages.

This book makes the pursuit of "Bernini himself," the uncensored, flesh-and-blood human being, one of its primary objectives, as it also narrates the milestones of his public career and family history. Thus it can claim to be the first biography of Bernini to appear in English and one of very few to appear in any language since his death in 1680. To compensate for the silences within the primary sources about Bernini's private life, it also reconstructs from other primary sources what we know about the daily life and worldview ("mentality") of a man of his station in seventeenth-century Italy, looking at family structure, urban experience, economics, religion, and politics. Although an artist of unique, innovative vision, Bernini was, at the same time, a man of his specific time and place in history. For that reason, this biography also looks at those major events, issues, and personalities that had a significant impact on the lives of seventeenth-century Romans, including Bernini, if at times indirectly. Readers will

come to learn much about the daily life and politics of Baroque Rome, for Bernini's life was inextricably enmeshed in that of his beloved city. As Pope Urban VIII famously proclaimed: "Bernini was made for Rome, and Rome for Bernini." This biography is as much a portrait of seventeenth-century Rome as it is of Bernini.

My account, however, does not neglect Bernini's many wonderful works of sculpture, architecture, painting, and theater. As the direct inventions of his imagination, these, too, I believe, reveal the "man himself" and are essential to the picture we are constructing, in addition to being, of course, the most significant, enduring accomplishments of his professional life. Nonetheless, I have been cautious in drawing too many specific conclusions about Bernini the person from the evidence of his public works of art: this is simply too hazardous and too tentative an enterprise with any artistic figure. At the same time, I have limited my descriptions of these works as art objects and usually give only the most essential historical detail about their origin and execution. Thorough descriptions and detailed documentation about Bernini's artistic production can be found in previous works on the artist, cited in my notes and bibliography.

This biography presumes no intimate knowledge of art or European history on the reader's part and is narrated in a conversational, nonscholarly mode. Although notes are kept to a minimum, all historical data relating to Bernini's life and all quotations are documented. (Documentation for less known historical data of any type has been provided as well.) My account is the fruit of ten uninterrupted years of researching Bernini's life and many more years spent studying Baroque Rome. The first product of that research was my extensively annotated English translation and critical edition of the biography of Bernini written by his youngest son, Domenico, never before translated or republished since its original publication in 1713. In examining every facet and every year of Bernini's life, I constantly returned to the seventeenth-century primary sources themselves, rather than simply repeat what is found in the later secondary literature. Much of the information presented here has been newly extracted from little-known publications—old and new—of difficult access or mined from the maze of footnotes in large scholarly monographs and journals.

For this reason, even more specialized readers, I daresay, will find this biography of interest and profit. Not only does it address issues ignored in other Bernini studies, it presents for the first time—and in English—the

latest and not widely disseminated archival discoveries. It summarizes recent decades of intense scholarly research inspired, most especially, by the late twentieth-century anniversaries of Bernini's birth (1598) and death (1680), but which continues at full speed even in this new century. In summarizing the latest discoveries and updating the facts, this biography overturns a few long-held generalizations and oft-repeated legends about Bernini, while filling gaps in our knowledge about the unfolding of his life and career.

Finally, because Bernini has never been the subject of a full-length, probingly candid biography, much of the general public, I've discovered, assumes that the artist's private life was, in itself, dull and uneventful. Nothing could be further from the truth. I guarantee that in the pages that follow you will come to meet, or know better, a fascinating (if not always lovable) human being, one whose private life had its share of scandal, intrigue, and much of the type of interpersonal drama that we are accustomed to seeing on TV soap operas. Caravaggio was not the only Roman Baroque artist who had a wild, tempestuous personality and engaged in antisocial, even criminal behavior. Let the reader beware.

ACKNOWLEDGMENTS

The space allotted, unfortunately, does not permit me to adequately extend my thanks to all those who in some way assisted me in the making of this biography, but I would be seriously remiss if I did not at least mention with deepest gratitude Josephine von Henneberg, Eraldo Bellini, Deborah Contrada, Pamela Jones, Sheila Barker, Saul Engelbourg, the inimitable Tom Powers, and, above all, John W. O'Malley, who has been for many years both wise mentor and warm personal friend. Furthermore, this book would never have seen the light of day without the lively personal interest and expert professional guidance of Susan Bielstein of the University of Chicago Press. My sincere thanks also go to Carol Saller for her patient, expert editing of the manuscript and to Anthony Burton for the many services lent to the production of the book.

Finally, I would like to acknowledge the personal encouragement of Charles Scribner III, whose best-selling book, *Gianlorenzo Bernini* (New York: Harry N. Abrams, 1991), remains one of the most informative, most insightful, and best written introductory books on the art of Bernini. His scholarship on Bernini, Caravaggio, and Rubens has long been an inspiration to me, especially his 1991 article in *Proceedings of the American Philosophical Society*, "Transfigurations: Bernini's Last Works." Although Dr. Scribner may not necessarily share all the interpretations of Bernini and his work contained in this biography, I would not have arrived at my deepened understanding of Bernini without the assistance of his own scholarship.

WEBSITE INFORMATION

For further information and discussion of Bernini's life and works, readers are directed to the Bernini section of my personal website: https://share .bc.edu/12436/20993.

MONEY, WAGES, AND COST OF LIVING
IN BAROQUE ROME

Monetary values given in the Bernini sources are usually in terms of the silver papal *scudo* (literally, shield). The standard currency of Rome in the seventeenth century, the silver scudo was a coin weighing 31.788 grams. Unlike today, at that time the weight of a coin (i.e., its gold or silver content) determined its monetary value. The Roman scudo was divided into 100 *baiocchi* (pronounced "bye-OAK-kee"), singular, *baiocco*, a copper coin.

Even early in his career, the young Bernini was already commanding impressively high prices for his work. He was, for example, paid 1,000 scudi for his statue *Apollo and Daphne*, which he completed in 1625 at the age of twenty-seven. In order to have meaning for readers today, that sum and the others encountered in Bernini's biography must be put into the context of the cost of living and wages in seventeenth-century Rome, figures that did not change significantly over Bernini's lifetime.

Although we lack a thorough, systematic study of the economy of Baroque Rome, a sampling of available figures on wages and prices will give us a general picture of that economy. "A family of five in Rome around 1600 could live modestly on 90 *scudi* a year" (Spear, 312); therefore, such a family could have survived for ten years on what Bernini earned for his *Apollo and Daphne* alone. For a single person, the absolute minimum for a decent living was about 2 scudi per month, although that probably precluded much consumption of olive oil or wine, each of which cost in the mid-seventeenth-century 1 scudo per liter (Stumpo, 39). In the period

1606–7, "a field worker made . . . about 50 *scudi* a year; a skilled mason earned . . . about 85 *scudi* annually; in 1627, a tailor made half as much" (Spear, 312). In 1621, a Roman copyist, representing a form of manual but highly skilled labor, was earning 15 scudi per month reproducing documents and manuscripts (Storey, 148). At midcentury papal employees were well compensated: a simple papal soldier (including the Swiss Guards) received a yearly salary of 48 scudi, while a cavalry soldier (*cavalleggero*) earned double that amount, 96 scudi a year. A doctor in the papal navy was paid 216 scudi in the course of a year; yet even a simple musician in the papal court also received a handsome wage, 84 scudi per year (Stumpo, 40).

In the early part of the century, decent working-class apartment rents in Rome ranged from 12 to 40 scudi per month, though poorer folk could find some sort of housing for just 1 scudo per month. In the same period a dozen eggs cost 1 baiocco, and a pair of shoes 50 baiocchi, the latter roughly equivalent to what an average worker earned in two days (Spear, 312). In the seventeenth century, the *pagnotta*, the standardized loaf of bread (weighing an average of eight ounces) of the Roman lower classes was fixed by law at 1 baiocco. Therefore, a minimal yearly ration of bread for one person would cost close to 4 scudi (Reinhardt, 1997, 209).

Contrasting ordinary wages and prices against a more affluent standard, let us look at the biggest player in town, the papal court. In the first half of the seventeenth century, the annual revenue of the papal treasury averaged about 1.5 million scudi; in the second half, the average had risen remarkably to 2.5 million scudi. However, the total debt was always and perilously many times that amount: in 1657 it was 30.7 million scudi and nearly 40 million in 1678 (Carboni, 151–52, 171). The cost of the St. Peter's Colonnade project (begun 1657) is estimated at 1 million scudi, representing, therefore, just under half of the papacy's annual income. On that same project, the salaries of the ordinary worker ranged from 60 to 120 scudi per year, whereas a "poor" cardinal of the period enjoyed an annual income of at least 5,500 scudi (Rietbergen, 1983, 150–55). For 36,000 scudi, in 1624 a Roman prince, Michele Peretti (descendent of Pope Sixtus V), purchased from the papal treasury a handsome, medium-sized, historic mansion in the city center, today's Palazzo Fiano-Almagià, adjacent to the Church of San Lorenzo in Lucina (Spada, 131n68). For only 25,000 scudi, however, in 1662 Cardinal Flavio Chigi acquired from the Colonna family a property of similar category (plus a small adjacent building) but in much need

of renovation (Waddy, 302). We don't know, however, whether in either case the buyers paid full market price for their new homes.

It is extremely difficult to make estimates of currency equivalents—Baroque scudi versus American dollars—over so vast a span of time and cultures. There are numerous variables to factor into the equation with no fixed points of reference over the centuries. However, I would conjecture, conservatively, that in Baroque Rome 25,000 scudi most likely had the purchasing power of at least a million dollars in today's currency, based on my interpretation of the empirical economic evidence.[1]

Hence, in terms of the compensation Bernini commanded and the material cost of his works of art, our artist, by the age of twenty-five, was already a "luxury" afforded almost exclusively by the super-rich, namely, popes, kings, princes, "rich" cardinals, and bankers. By mid-life he himself was one of Rome's multimillionaires. Of this there is no doubt. At his death in 1680, the eighty-two-year-old Bernini left an estate which, according to the most conservative figure given by contemporary sources, was worth not less than 300,000 scudi, or roughly twelve million twenty-first-century American dollars.

ABBREVIATIONS

The following abbreviations are used in my notes (see Works Cited for complete data):

BALDINUCCI ⤞ Filippo Baldinucci, *Vita del cavaliere Gio. Lorenzo Bernino*, first published in 1682. Page numbers preceded by the letter *i* refer to the 1948 Italian edition (published under a slightly different title); those preceded by the letter *e* refer to the English translation, *The Life of Bernini*, 1966, reprinted 2006.

BALQ ⤞ Franco Borsi, et al., eds., *Gian Lorenzo Bernini: Il testamento, la casa, la raccolta dei beni*.

CHANTELOU ⤞ Paul Fréart de Chantelou, *Journal de voyage du Cavalier Bernin en France*; in English. Translated as *Diary of the Cavaliere Bernini's Visit to France*), cited by the entry date, with page numbers given for both the 2001 French (pagination preceded by *f.*) and the 1985 English edition (pagination preceded by *e.*). This diary is a record of Bernini's stay at King Louis XIV's court from June to October 1665.

DOMENICO ⤞ Domenico Bernini, *Vita del cavalier Gio. Lorenzo Bernino*, first published in 1713. English translation by Mormando, *Domenico Bernini: The Life of Gian Lorenzo Bernini*, 2011. All citations are to the original pagination, preserved in the 2011 edition.

REGISTA ⤞ *Gian Lorenzo Bernini: Regista del Barocco*, 1999.

ROSSI/AVVISI ⤞ Seventeenth-century Roman *avvisi* (handwritten and usually anonymous news bulletins prepared by private individuals) published by Ermete Rossi in the 1930s and 40s in the now defunct periodical *Roma* under the rubric "Roma Ignorata." Cited by journal volume, year, and page.

THE NEAPOLITAN METEOR

<div style="text-align: center">CHAPTER I</div>

A Twelve-Year-Old Pregnant Bride

Pedophilia is what we would call it today—a man of twenty-five marrying a twelve-year-old girl—but in premodern Europe, it was, if not common, nonetheless perfectly legal. It had been perfectly legal as far back as anyone could remember and was to remain so for generations to come in the eyes of both church and state. Once the two parties had reached puberty—twelve for girls, fourteen for boys—the law allowed the contracting of marriage, no matter how great the difference in years between husband and wife. And so, in a private, at-home ceremony in Naples, on January 17, 1587, Gian Lorenzo Bernini's father, Tuscan sculptor Pietro, born in 1562, was joined in matrimony with the Neapolitan maiden Angelica di Giovanni Galante. Angelica, according to their marriage registration, was "about twelve years old." Choosing for one's spouse a much younger girl, a child-bride with an impressionable mind and pliable will, was in those days considered by men to be practical and praiseworthy: all the easier to shape her into the

perfect wife—silent, submissive, patient. The chances were that her virtue was also intact—in other words, she would still be a virgin. Furthermore, her youth and vigor would guarantee years of successful childbearing and efficient housekeeping, especially given the frightfully low life expectancy for women back then. The church, too, seemed to actively encourage marriage between a young girl and a vastly older man. After all, did it not unceasingly offer as marital role models the "perfect" wedded couple, Saint Joseph and his bride Mary, mother of Jesus Christ? Today with the Christ Child, they can be seen depicted in ecclesiastical art in every corner of Catholic Europe as "The Holy Family," he an old man with white hair and wrinkled skin and, she hardly more than a blushing adolescent.

However, though legal in the eyes of the state and licit in the eyes of the church, marriage at twelve (or fourteen) years old was in fact not common at the time and would have raised some eyebrows, to be sure. So why did Pietro risk public ridicule by robbing the cradle to secure a bride? What was it about her charm, or perhaps, her dowry? The record is silent on the latter question, but a small detail in the surviving documentation suggests a compelling scenario: the obligatory banns announcing a future marriage between engaged persons are normally published on three separate occasions over a broad stretch of time. But here, in the case of Pietro and Angelica, these notices were hurriedly compressed by the parish priest into the brief span of just one week, right before the ceremony itself: January 4, 6, and 11. In this Catholic time and place, in the absence of imminent death or departure for war, this could only mean one thing: the bride was already pregnant and the marriage was one of face-saving reparation. This is never a happy way to begin a marriage. Yet, despite its hasty beginning, the union between Pietro and Angelica proved long-lasting and was, we presume, reasonably content; it ended only with death (his in 1629, hers in 1647), having produced thirteen children. How ironically fitting, nonetheless, that one of the first things we know about Gian Lorenzo Bernini's family history should be this fact of slightly disordered sexual conduct. The artist himself would play out a similar dynamic in his own adult life.[1]

Having been rushed perhaps unwillingly into marriage, poor Pietro was soon to learn that his first-born child was not a son who would proudly carry his name forward and hopefully marry into a rich family higher up on the social scale. Instead it was a daughter, a burden of a child, who would need to be married off at the price of an exorbitant dowry or else sent off,

kicking and screaming if necessary, to a nunnery—which even then meant paying out a dowry, albeit somewhat smaller. Pietro could not have been pleased. In any case, the infant girl was baptized Agnese and, like the early Christian martyr whose name she bore, was unfortunately to have a short life: she died in Rome in October 1609, as wife of a Tuscan painter of note, Agostino Ciampelli, future collaborator and foe of Gian Lorenzo's on major projects such as the Baldacchino in St. Peter's Basilica. Poor Pietro for not having gotten immediately his first-born son, but poorer even still Angelica, who had to keep producing children until the arrival of a male heir, and then some. After Agnese came an unbroken, anxiety-raising series of four more daughters (Emiliana, Dorotea, Eugenia, and Giuditta) and then, at long last, on December 7, 1598, the first boy, our Gian Lorenzo. He was followed by two more girls, Camilla and Beatrice, but the final issue was all male: Francesco, Vincenzo, Luigi, Ignazio, and Domenico. These last four children were born in Rome, where the family had moved in late 1606, Angelica giving birth to the last of her thirteen children, Domenico, in December 1616. Of all his siblings, Bernini would be closest to his younger brother Luigi (born 1610), at least professionally. The talented engineer-sculptor Luigi would serve as Gian Lorenzo's indispensable right-hand man throughout his career, despite the violent emotional storms that erupted in their relationship at a couple of junctures.[2]

Since Gian Lorenzo was born after a series of five daughters, Pietro, fearing he would get no further male heirs, gave his first son two names, that of his own grandfather and father, Giovanni (John) and Lorenzo (Lawrence). However, as an adult, our artist seems to have considered his real name simply Lorenzo. The most detailed contemporary biography of Bernini—compiled during the last years of his life by his youngest son, Domenico—tells us that one of the first, mature sculptures of Bernini's early artistic adulthood was executed (in 1617) as an "act of pious devotion" in honor of his patron saint, Saint Lawrence on the fiery grill. Saint Lawrence's feast, August 10, Bernini considered his "name day," as he was to later mention to his Parisian friend, the diarist Paul Fréart de Chantelou. Bernini's first name, Giovanni, in the surviving documentation, is usually reduced to the minuscule abbreviation, "Gio.," or, often enough, simply omitted. Eventually, sometime after his death, "Gio. (or Giovan) Lorenzo" gave way to the smoother "Gian Lorenzo," the form by which he is today most commonly known.

As for the family name, Bernini—or more often in contemporary sources, Bernino—derives from Barnini, which is how we find Pietro's last name spelled in his 1587 marriage documents. Barnini, in turn, comes from "del [or di] Barna," that is, "child of Barna," short for Barnabas. Barnabas was then a popular name in Tuscany, ever since Saint Barnabas the Apostle had, from heaven on high, miraculously helped secure for the Guelfs a decisive military victory over their Ghibelline enemies in 1289. Heavenly Providence Most High was also at work on December 7, 1598, declares the aforementioned Domenico in his *Life of the Cavalier Gian Lorenzo Bernini*, when it sent to Pietro and Angelica their first-born son. Marveling over his well-formed body, and especially the intensity of his observant gaze, the proud parents undoubtedly began weaving fanciful hopes of great expectations for the infant Gian Lorenzo. Little did they know that they had just become the parents of a rare prodigy who, as sculptor, architect, painter, playwright, and scenographer, was destined to take his place in history as the greatest artist of his age, worthy successor to the already legendary Leonardo, Raphael, and Michelangelo. He was also to be the last of the universal artistic prodigies produced by Italy in its glorious Renaissance and Baroque centuries. With his death in 1680, a four-hundred-year era of Italian cultural supremacy effectively came to an end.[3]

"Don't think Destiny's more than what's packed into childhood," wrote the poet Rainer Maria Rilke in the seventh of his *Duino Elegies*, and that sentiment has found much resonance in modern psychology, from Freud onward, as it has explored the mysteries of the human person. Unfortunately we know little about everyday details, public or private, of Bernini's first years, beginning with the figures of his parents. What kind of people were they? How did they relate to their children? Like many of the wives and mothers of important men in European history, Angelica Bernini is all but invisible to us today, despite so much recent research into our artist's life. Little is known about her beyond the few bare facts already given. At one point, probably in the 1620s, Bernini painted a portrait of his mother in oil, as we know from the family's household inventory, but that portrait is now lost, perhaps hanging in some private collection in Italy, its sitter's true identity unrecognized. Apart from her last will and testament, a single, undated letter by Angelica (but probably written down for her by someone more literate than she) is all that remains of her personal effects. But what a letter: written most likely in 1638, it is brief yet eloquent, opening up for us

a rare, honestly revelatory window onto the character of the young Bernini in his bachelor days. Bernini would be quite annoyed by the unlucky fact that of all the letters written by his mother and father, it would have to be this one that survived the thousand accidents of nearly four hundred years. Angelica's letter is a humble but desperate plea to papal nephew Cardinal Francesco Barberini, Bernini's employer at the Fabbrica (Office of the Works) of St. Peter's Basilica, begging his help in reigning in her wild son Gian Lorenzo. Gian Lorenzo, she says, simply thinks he is "padrone del mondo," master of the whole world, and is misbehaving in the most appalling, even criminal, manner. What that misbehavior was, and what else Angelica says of her son in that letter, we shall see in our next chapter.

As for father Pietro, though better known to posterity than Angelica, he too has long resided in the shadows of history, which has allowed only glimpses of his person and his activity in the world. In the past few decades, however, thanks to many new discoveries of both written documentation and sculptural works from his own hand, Pietro has emerged a bit more fully and more stably into the light, at least as a public persona. He was the son of peasant-cobbler Lorenzo and his wife, Camilla Boccapianola (who in 1609 was still alive and living with her son in Rome). Pietro was born and raised in Sesto Fiorentino, a small town just six miles northwest of Florence, where the simple stone house in which he was born still stands.

After an artistic apprenticeship in Florence, Pietro moved to Rome in 1580 where he remained for four years, only to move further south to Naples, his home for twenty years, except for a short interlude back in Florence in 1595. Initially Pietro, it seems, was a jack-of-all-trades as an artist, but eventually passion and talent made him focus on sculpture. To date, apart from collaborative pieces, some thirty sculptures in marble—Madonna-and-Childs, saints, angels, allegorical figures, small mythological scenes, decorative elements for fountains and gardens—have been identified as works from his hand. In terms of art historical categories, Pietro's work is usually labeled Late Mannerist, Mannerism being that diverse stylistic interval between High Renaissance and Baroque, whose precise definition art historians have never succeeded in establishing to the satisfaction of all. In any case, a "mediocre artist" who produced "monotonous, derivative works" is how Pietro was described and summarily dismissed by two prominent art historians in 1969; it was a judgment widely shared by their colleagues, Italian or otherwise, before and after, in the twentieth century.

For his contemporaries, however, Pietro was an artist "of no ordinary acclaim," as we are told by Filippo Baldinucci, noted Florentine art connoisseur and author of the first published (1682), book-length biography of Gian Lorenzo Bernini. Baldinucci's claim is confirmed by the fact that Pietro succeeded in securing prestigious commissions starting in the 1590s in Naples in both the city's cathedral and the magnificent Certosa di San Martino (the Carthusian monastery church), then under the patronage of the Spanish viceroy. These were followed later and even more significantly by work in the famous Pauline (or Borghese) Chapel in the Basilica of Santa Maria Maggiore, Rome, a commission from the pope himself. In his brief account of Pietro's life (1642), Roman friend and painter Giovanni Baglione (the same man who sued Caravaggio for libel in 1606) praises Pietro unqualifiedly when it comes to the self-confidence and sheer technical skill with which he carved marble, as he himself had witnessed: "Pietro handled marble with complete ease, having few peers in this skill." Another art biographer in Rome, Baglione's younger contemporary Giovanni Battista Passeri, also praises Pietro as an artist "of talent and good reputation," adding, too, that he was also a "good, decent gentleman." There were too few of the latter in the cutthroat competitive art world of Baroque Rome!

More recently Pietro's good reputation has begun to be restored to him—thanks to the rediscovery or reexamination of several of his works showing a more versatile, more original, more refined talent over a longer span of time than previously thought, as well as a more positive reevaluation of the long-disparaged Mannerist sculpture in general. So much so that, in the estimation of some art historians today, Pietro stands out as "one of the greatest exponents of Late Mannerist sculpture," with his greatest masterpieces, the two monumental reliefs for Santa Maria Maggiore, the *Assumption of the Virgin* and the *Coronation of Clement VIII*, having wondrously challenged "all expectations of what a historical relief should be," to the admiration of their original audiences, including his papal patron. Scholars may not be able to agree on an all-encompassing assessment of Mannerism, but that style as exemplified by Pietro at his best did accomplish bold, new things in sculpture in terms of movement, space, and compositional complexity: these qualities undoubtedly inspired the boy Gian Lorenzo, as he watched his father at work. These qualities were also to be at the center of the Baroque revolution that the mature Bernini was to bring about in his own sculpture.[4]

We Pause to Talk about Our Sources

To be sure, no matter what further discoveries are made about his art, Pietro will never make it to the "Top Ten List of Best Italian Sculptors." But we need to insist a bit on Pietro's above-ordinary talent and contemporary reputation. This insistence is necessary not only because of the long eclipse he has suffered in modern art history, but also to counteract the lukewarm impression of Pietro's vital contribution to the development of his son's artistic talent left by the earliest and most influential published sources of Bernini's life. These sources either ignore Pietro or vastly understate the role he played in Gian Lorenzo's formation. This impression of Pietro, moreover, has its origins in his own son Gian Lorenzo. Through the fanciful, self-mythologizing accounts of his earliest artistic training and production that he consistently dished out throughout his adult life to patrons, friends, and members of his family, Gian Lorenzo all but wrote his father effectively out of the picture.

One of those family members was Gian Lorenzo's youngest son and last child, Domenico. While Bernini was still alive, Domenico wove his father's autobiographical reminiscences—some fact, some fiction—into the long, anecdote-filled biography, *The Life of the Cavalier Gian Lorenzo Bernini*, which we have already cited and will be often citing in the pages that follow. In writing his narrative, Domenico made use of a short biographical sketch (which I call for convenience the *Vita Brevis*), composed by his eldest brother Monsignor Pietro Filippo, another invaluable source for Bernini scholars. Included among the hundreds of family documents sold by the Bernini heirs to the Bibliothèque nationale in Paris in the 1890s, it has finally been published in English translation.[5]

Composed during the last years of his father's life and circulating in manuscript form until published in 1713, Domenico's work in large part created the enduring "Bernini myth," which still finds ready, unquestioning acceptance from readers in many quarters, including art historians and other scholars. Thus, the obligatory task of any conscientious biographer today, the present writer included, is as much to identify what aspects of Domenico's text involve mythologizing untruths or exaggerations as it is to mine it cautiously for reliable data and insights at times available nowhere else. The wheat must be separated from the chaff: not everything in Domenico is to be believed. By the same token, not everything is to be

discarded as mere apologetic fantasy. Knowing the difference in the absence of external corroboration is not always easy and requires at times a subjective judgment call by the scholar. Obviously, the material from Domenico used in this biography represents what I consider the "wheat" of his narrative.

Domenico's successfully marketed "Bernini myth" is also disseminated by another early biography, the aforementioned 1682 *Life of Bernini* by Filippo Baldinucci, which derives from some earlier, prepublication version of Domenico's text. It is a matter of documented fact that in compiling the other entries in his famous series of artist biographies, the *Notizie dei professori del disegno da Cimabue in qua* (1681–1728), Baldinucci routinely copied, verbatim and without attribution, large blocks of text supplied to him by others close to the artists in question, as he did in the case of Domenico's work. There is no other way to explain the extensive, word-for-word textual overlap between Domenico and Baldinucci. It could not have come from some hypothetical common primary source, for none exists (Pietro Filippo's sketch is too brief and crude to have served in this capacity). Completely without anecdotal detail, Baldinucci's biography, however, is much shorter and much drier in its tone than Domenico's. Though a derivative text and written by a non–family member who never met Bernini, Baldinucci's book has until recently been treated as the premier biographical source inasmuch as it was long believed erroneously that Domenico simply plagiarized Baldinucci rather than vice versa, as we now know to have been the case.

To complete our survey of the Bernini primary biographical sources, we need to mention the third of the most important early book-length narratives, the extensive journal left by Frenchman Paul Fréart de Chantelou. Chantelou's *Diary of the Cavaliere Bernini's Visit to France* comprises some three hundred pages meticulously recording Bernini's conversations and activities, many of them "behind the scenes," during his four-month stay at the court of Louis XIV in Paris in 1665. Chantelou, the eyewitness, was the privileged royal courtier assigned by King Louis to serve as the artist's assistant, translator, tour guide, and overall friendly companion. Though not published until the late nineteenth century, the diary was known and consulted even while still in manuscript form: it is cited, for example, in the *Memoirs* of Charles Perrault (d. 1703), Bernini's nemesis at the French court, who served as Prime Minister Colbert's personal assistant for art and architecture, and is today best known as a writer of children's fairy tales.

Though highly respectful of the artist, Chantelou's *Diary* reveals many unflattering details about Bernini's character and behavior that the "Cavaliere" would have certainly preferred to keep under lock and key. At the same time, it nonetheless repeats (from Bernini's own mouth) some of the self-mythologizing exaggerations and untruths told by Bernini about his personal development and professional career that we find in Domenico and Baldinucci. There is a great mass of other contemporary sources—letters, diaries, diplomatic dispatches, anonymous news bulletins—that supply in piecemeal fashion more biographical data about Bernini. These will be cited as we make our way through the densely packed eighty-two years of the artist's life in the pages that follow.

To return now to the father, Pietro Bernini, one important component of the "Bernini myth" transmitted by all three principal sources (Domenico, Baldinucci, Chantelou) is that of the peerless child prodigy Gian Lorenzo "passing himself off to posterity like a new Minerva who emerged fully formed and fully armed from Jupiter's brain" (in the words of Italian art critic Federico Zeri). This Minerva-like birth and the subsequent realization of the young artist's potential took place, the Bernini myth would have us believe, with little or no active assistance from other human beings, all of whom would have been lesser mortals compared with Gian Lorenzo Bernini. Perpetrating this fantasy means denying Pietro any real role in the formation of his son's talent, technique, and style. It also means passing over in silence, for example, what were probably many collaborative works by father and son through which Gian Lorenzo, step by step, would have learned the intricacies of his trade and perhaps found the seeds of inspiration for his own future artistic innovations. In fact, as Domenico seems to want us to believe, in attempting to train the boy prodigy Gian Lorenzo in his profession, a dumbfounded Pietro soon "understood that the only worthy teacher of such a disciple was the boy's own genius . . . and he therefore gave his son the freedom to work as he wished." In other words, Pietro's principal contribution was simply knowing how to stay out of the way.

In Baldinucci, as in Domenico, little is said of Pietro's training his son, though the Florentine biographer does at least acknowledge the father's excellence as a sculptor. As for Chantelou's diary, the extroverted, long-winded Bernini talks on various occasions—with much name-dropping—about his youth, training, and early artistic influences, but his father Pietro merits only three brief mentions, and never as an active, significant

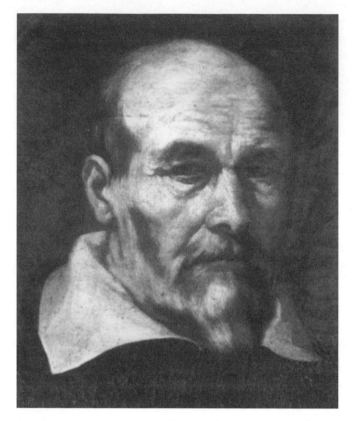

FIG. 1 ➤➤ Contemporary copy after G. L. Bernini, *Pietro Bernini*, 1629, Academia di San Luca, Rome.

participant in his formation. As Federico Zeri concludes somewhat acerbi-
cally, "Bernini's active maneuvering to eliminate his rivals (of which the
most illustrious victim was Francesco Borromini) began extremely early, not
sparing even his own father Pietro.... It is difficult being the son of a famous
father, but in Pietro's case, it is difficult being the father of a famous son."

Nonetheless, Pietro, as far as we know, never displayed the least bit
of jealousy or resentment toward the son, who by his early twenties was
to seize center stage not only from his father, but from nearly every other
sculptor then active in Rome. Pietro, the humble and loving father, seems
to have simply delighted in his son's genius and success. As Chantelou re-
cords in his diary, "One of the first things I remember his telling me was
how one day this pope [Urban VIII], then still Cardinal Barberini, came to

see his father. . . . He looked at something the Cavaliere [Gian Lorenzo], then only eight years old, had just finished, and, turning to the father, said with a smile, 'Take care, Signor Bernini, this child will soon surpass you and will certainly be greater than his master.' He says his father replied sharply, 'That doesn't worry me. Your Eminence knows that in this game the one who loses wins.'"

Pietro's career as independent sculptor was essentially over by 1617. Thereafter he seems to have serenely accepted a role as behind-the-scenes assistant to his son when Bernini's commissions steadily grew in number and complexity starting in the early 1620s, necessitating an ever-expanding workshop of collaborators. Gian Lorenzo's portrait in oil of his father survives today in a contemporary copy in the headquarters of the Roman artists' academy, the Accademia di San Luca: it shows a handsome man of dignity, intelligence, and authority, with fine, regular features and a dark-eyed, piercing glance like that of his son (fig. 1). The canvas bears the date 1629, the year in which on August 29, aged sixty-seven, Pietro, "sculptor to His Holiness Pope Urban VIII," died in Rome, "amidst many graces and much happiness." He left his eldest son, Gian Lorenzo, as the new head of the extensive, and soon to be extravagantly rich, Bernini clan. But we are getting ahead of our story.[6]

Childhood in a "Paradise Inhabited by Demons"

It was at the time, after Paris and London, the largest and most densely populated city in Europe, teeming with over three hundred thousand inhabitants. It boasted a history stretching back three thousand years. It sat within one of the most rhapsodically beautiful, most celebrated natural landscapes on the continent. It contained within its walls dizzying wealth in the form of fine art, manufactured goods, and gold and silver stored in patrician palaces as fine as those found anywhere else in Italy. But alas, it was also the nightmarish crucible of an appalling amount of desperate poverty, criminality, and all other forms of immorality and incivility, with chronic popular unrest ever ready to erupt into violent revolt and anarchy.

Welcome to Naples, Italy, circa 1600. Naples was then the cosmopolitan capital of the Spanish kingdom of Southern Italy and Gian Lorenzo's home for the first eight years of his life. Already by Bernini's birth, it was an old cliché to describe the city as "a paradise inhabited by demons."

The Naples of Bernini's childhood was an Eden offering the best of what nature can produce by way of climate, agriculture, and maritime delights. But it was reputedly also full of people who were "malignant, bad, and full of treasons" crammed into a walled urban environment of incessant noise, nasty odors, and horrendous hygiene. Its interior streets, we are told, were so "narrow, dark, and melancholy" that, looking up, one could scarcely see the sky. One grim statistic stands out in particular: throughout the seventeenth century the Hospital of the Annunziata alone—one of Naples's busiest—received five hundred abandoned babies each and every year. So much unloved and uncared-for humanity. Most of the city's enduring problems stemmed from its rapid population growth, aggravated by the unconquerable caprices of nature: drought, famine, flood, epidemic disease, earthquakes, and volcanic eruptions (Vesuvius!). "See Naples and then die," famously exclaimed an ecstatic Goethe, who visited a later but essentially unchanged Naples. The German poet meant his exclamation as positive praise; for many ill-prepared visitors, instead, it was a deadly prediction.

For Gian Lorenzo, an intelligent, impressionable child with keenly observant eyes and an especially active imagination, the first eight years of his life in Naples must have been a constant feast for the senses. So many rich, contrasting impressions storing up in the recesses of his psyche, only to spontaneously return at frequent intervals during the creative years of his adulthood in Rome. It is, of course, difficult to correlate specific details of the adult Bernini's character, life, and production with his Neapolitan childhood. Occasionally Bernini's contemporaries did so: Pierre Cureau de La Chambre, for instance, a French cleric who knew the elderly Bernini well and wrote one of the earliest surviving public eulogies of our artist, reports that Bernini colored and punctuated his speech with "certain extremely expressive gestures, which are natural to Neapolitans." In the primary biographical sources we find Bernini himself making only one explicit personal reference to Naples—his voracious love of fruit, he claimed, was a trait of those born in Naples. Nonetheless Bernini could not have helped but absorb from his childhood environment much of the colorful exuberance, theatrical flamboyance, and intense emotionalism that were (and are) defining qualities of the Neapolitan temperament. These were most especially evident in the frequent public spectacles of popular religion, which we know about from the diaries and letters of travelers to Naples. It is cer-

tainly no coincidence that Giambattista Marino, Bernini's older contemporary and father of the Baroque revolution in poetry, was likewise born and bred in Naples.[7]

Whatever positive qualities his Neapolitan heritage may have instilled in him, the adult Bernini played down the fact of his Southern Italian birth. As far as he was concerned and as he publicly declared till the end of his days, he was a Florentine—even though over the course of a lifetime he spent no more than a week in the Tuscan capital. Florentine he claimed to be not only because of his father, but also because of the subtle campaign he waged throughout his life to persuade his contemporaries that he was the new Michelangelo, that is, the supreme universal genius of his age. To pass as the new Michelangelo a Florentine pedigree was highly desirable, for Florence had been the cradle of Michelangelo's genius and of the very rebirth of Italian art in the Renaissance. Yet what might have been conveyed subtly on Bernini's part is explicit in his son Domenico's text: the theme of "Bernini as the Michelangelo of his century" comes up early in the narrative, shortly after the family arrives in Rome, at the time of his father's first, momentous encounter with Pope Paul V. It comes in the form of a solemn prediction from the pontiff himself: "The young Bernini finished the drawing [improvised at the pope's request] with such mastery that the pope stood there in admiration and was moved to simply exclaim to several cardinals who happened to be present on this occasion, 'This child will be the Michelangelo of his age.'"

Insist as he did on his Florentine identity, Bernini's contemporaries in Rome, especially his enemies, annoyingly, would not let him forget the truth of his beginnings. In his guidebook to Rome of 1661–63, the *Roma ornata dall'architettura, pittura e scultura*, Fioravante Martinelli (friend of Bernini's archrival Francesco Borromini) pointedly corrects the record about Bernini's birth: "Bernini was Florentine according to what Baglione writes, but the truth is that he was born in Naples." The already mentioned Giambattista Passeri in his collection of art biographies snidely remarks upon "Bernini the Neapolitan, or, as he would have it, Florentine," but even the friendly Filippo Baldinucci includes Bernini in one of his lists of famous Neapolitan artists. Similarly, the inscriptions of two well-known contemporary engravings—Ottavio Leoni's 1622 portrait of Bernini and Louis Rouhier's 1651 view of Bernini's Fountain of the Four Rivers in Piazza Navona—prominently label Gian Lorenzo as "Napoletano." Bernini would

have preferred that they had omitted that detail, especially since as of August 26, 1630, he was in fact *civis romanus*, an official "citizen" of Rome, having been granted the privilege by the Conservatori of the Eternal City.

Returning to Gian Lorenzo's boyhood in Naples, we should not be surprised to learn from son Domenico that the child prodigy was not at all interested in "the usual childish pastimes" and instead would "spend entire hours completely transfixed" in watching his father at work. Pietro was all too happy to initiate his young son into his profession, and the results, of course, were immediate and marvelous: "Following his father's example, at the age of eight, he carved a small marble head of a small boy to the great admiration of Pietro, who thereby realized that, in view of such beginnings, only great expectations could be conceived for his son's future." When Gian Lorenzo was not immersed in training as a sculptor, he, like most boys of middle-class families, was learning the three Rs—reading, writing and arithmetic. However, all we know about his formal education is contained in Domenico's one, brief line: "He was raised in the first rudiments of letters with good discipline by Pietro and Angelica." Angelica herself may not have been literate, since her childhood and therefore probably her formal education as well, ended, as we saw, at the age of twelve. In any case, with at least his father literate, Bernini, like most of his peers, was home-schooled. His parents probably had no resources to hire a private tutor nor saw the need for much book-learning in a future sculptor.[8]

Despite this scholastic deprivation, Bernini's native intelligence—Domenico and our other primary sources assure us—was phenomenal for its profundity and versatility. According to Domenico, the artist's contemporaries were constantly amazed to witness, as his friend and patron Pope Alexander VII would often exclaim, "how, by sheer force of his intellect alone, Bernini could arrive at the same depth of understanding in any discussion on any subject, where others had barely arrived after many years of study." What Domenico does not tell us, however, is that the same Pope Alexander tutored the middle-aged Bernini in some of the fundamentals of Latin and Italian grammar, as we know from the artist's exercise sheets (with explanations in the pope's handwriting) that survive in the archives. About Bernini's intellectual abilities, his admiring French friend Chantelou observes in his diary that "without having studied Bernini has nearly all the advantages with which learning can endow a man." But let us note the cautionary term, "nearly." It means that Bernini's lack of formal education

was still showing at the age of sixty-seven when Chantelou made his acquaintance. Domenico's claims about his father's intellectual prowess "on any subject" cannot be proven, because apart from scattered remarks about his profession (his art theory) and theology (or rather, popular spirituality), none of Bernini's supposedly brilliant insights have survived. As for his art theory, most of what Bernini preached was completely conventional for his time (though in practice he was often far from conventional) whereas his pronouncements on religion, when stripped of their showy Baroque rhetoric, are banal. As a result, one is tempted to think that Domenico exaggerates his father's stature as a public intellectual, as he does almost every other aspect of his life and personality.

Refusing to believe Domenico's hyperbole, at least one scholar has gone so far as to declare that Bernini was fundamentally, as the Italians say, "uomo senza lettere," a man without letters—that is, a person without any substantial academic training or deep interest in the world of books. Perhaps this is too extreme a judgment, but it is revealing that nowhere in the minutely detailed inventory of Bernini's possessions at the time of his death is there any reference to a library (we presume he had one, however small) or to individual books. It is probably safe to say that Bernini did not spend much time reading books. Whatever book learning he needed for the production of his art—for example, the relevant pages from Saint Teresa of Avila's *Autobiography* or the description of Emperor Constantine's physical appearance from Nicephorus's *Historia Ecclesiastica*—he likely had others find and read for him. And what learning—or rather appearance of learning he needed in order to shine forth in social gatherings of courtiers and *virtuosi*, he was able to absorb from the erudite company that was never in short supply in Rome. Nonetheless, while he may not have been what we call an "intellectual" and his grasp of academic subjects may have been that of a dilettante, Bernini surely possessed a fine, acute, native intelligence. Without that, he never could have survived, let alone succeeded as much as he did, in the competitive, culturally refined world of Baroque Rome.[9]

MOVING ON UP: TO ROME, 1606

Early in 1606 Pietro's dream came true. A summons to Rome. From the pope. To work on the soon-to-be sumptuous Pauline Chapel, then under

construction by the papal family, the Borghese, in one of the most vener-
able basilicas in all Christendom, Santa Maria Maggiore. For an artist in
early seventeenth-century Catholic Europe, a papal commission was the
highest honor imaginable, as well as the most promising ticket to wealth
and fame. Pietro was asked to create a large, multifigure relief, the *Assump-
tion of the Virgin*, to be prominently displayed on the facade of the chapel.
Though he still had business in Naples, Pietro lost little time in packing up
his big family and leaving by December of that year. He was eager to get
to Rome not only for himself but for the sake of his son, Gian Lorenzo:
"Pietro was keenly desirous of arriving in the papal capital for he wished
his son to encounter in the field of Rome that fortune which, accompanied
by merit, very often exalts her disciples in that great city of talent and does
so to a degree simply beyond all belief."

In the early seventeenth century, more so than in any other time since
the fall of the Roman Empire, it was true that all roads led to Rome. "For
the memory of having once been Mistress of the World and for those an-
cient relics of her past glories as well as for her modern marvels . . . , Rome
has become the emporium of the universe: from every direction, in every
season, and from all nations, people flock to Rome in order to gaze upon
her magnificence. She is homeland equally to foreigners as she is to her
own citizens." This is how the Venetian ambassador Pietro Contarini de-
scribed the city in the early seventeenth century. Jean-Baptiste Colbert,
chief minister of King Louis XIV, simply called Rome "the premier city
of the world." If not the largest, it was certainly the most cosmopolitan of
all European capitals, the destination of thousands of tourists and pilgrims
each year, no less so than of princes and other grandees from around the
globe, including in 1608 from the Congo and in 1615 from Japan. Foreign
spies, too, were everywhere, embedded even within the households of the
cardinals and sending home detailed reports of the latest political news and
local gossip. It was the unrivaled crossroads of the West.

Rome was also the destination of artists and artisans of all types—paint-
ers, sculptors, architects, engravers, stuccoists, goldsmiths, carpenters, ma-
sons, and stone carvers. Some came as temporary visitors to study the ex-
quisite monuments of ancient art and architecture (as well as the works of
modern masters—above all, Raphael and Michelangelo) that could be
found only in Rome. Others (most famously Frenchman Nicolas Poussin)
stayed as long-term residents, finding employment in the huge citywide

artistic workshop that Rome then represented. For artists there was much work to be had in Rome during most of the seventeenth century, for the popes were pouring vast sums of money into the rebuilding, modernization, and stupor-inspiring embellishment of the Eternal City. The ultimate aim of this feverish building, carving, painting, and gilding was to prove to the world through sheer material splendor—*magnificenza*, to use the buzz-word of the time—that not only was modern Rome the worthy successor to the ancient capital city, but also, and even more important, that the Roman Catholic Church was still the one, true legitimate religion, the sole authentic possessor of the full apostolic authority in direct descent from Saint Peter himself.

This campaign for the Renovatio Romae, the Restoration of the Glory of Rome, had been set in motion by the popes of the mid-fifteenth century when the Renaissance, born in Florence, truly hit Rome. The campaign began in earnest with Pope Nicholas V (d. 1455), whose so-called "Testament" explicitly spells out the message "We build to impress." In the sixteenth century, in the wake of the physically disastrous sack of the city (1527) by the frenzied troops of Emperor Charles V and the even more disastrous Protestant Reformation (symbolically begun in 1517 with the publication of Luther's *Ninety-Five Theses*), the Renovatio Romae became all the more urgent. Once the great reform Council of Trent concluded in 1563 and set in motion the Counter-Reformation to beat back Protestant gains, both spiritual and political, the rebuilding of Rome became an abiding papal priority, if not an obsession. In Rome, the boom in papal artistic patronage was to last uninterrupted until the early 1670s, when the money simply ran out. Pietro Bernini was one of its numerous beneficiaries. By the end of his life, his son Gian Lorenzo would beat every record to become the number-one beneficiary of all time.

In 1606, when the Bernini family arrived on the scene, Rome's population, according to the official census, stood at 105,724 souls. In terms of population, the papal capital then ranked fifth in Italy, after Naples, Milan, Venice, and Palermo. (Italy was then still a patchwork of independent states and Spanish colonies.) Rome's inhabitants were mostly clustered in the big triangular elbow of land created by the large bend of the Tiber River. This land unfortunately also served as the vulnerable flood plain of the Tiber. Like plague and the many other dread epidemic diseases that the Romans were powerless to prevent, flooding of the Tiber was a constant

threat and recurrent reality, often devastatingly so, as in December 1598, January 1606, February 1637, December 1647, and November 1660—and in Bernini's lifetime several more times, less disastrously. These unhappy events are the result, scientists tell us, of the "Little Ice Age" suffered by Europe from approximately 1500 to 1800 that brought with it heavy precipitation. The long history of the city's repeated flooding is publicly commemorated on the numerous plaques still affixed to the facades of churches and other public buildings in central Rome, most conspicuously on the facade of the Church of Santa Maria sopra Minerva. One of the plaques at the Minerva informs us that the 1598 flood was so catastrophic that on the day before Christmas that year, "the Pontiff [Pope Clement VIII Aldobrandini] pronounced a curse upon the waters of the Tiber, never before so haughty."

Despite the constant drenching and drowning, most of the population continued to huddle together in the lowest-lying floodplain (especially in the Campo Marzio neighborhood), which corresponds to what is now the *centro storico* of Rome. In the seventeenth century, the city's inhabitants came nowhere near to filling the original urban area enclosed by the walls built by their ancient forebears. (In fact, they would not do so until the end of the nineteenth century.) Between the populated urban core and the rings of walls was the wide swath of the rural *disabitato* (uninhabited zone) filled with vineyards and patrician villas. Naturally, the *disabitato* also afforded Romans the privacy and space for the kinds of interpersonal activities, legal (courting, partying) or otherwise (rape, kidnapping, homicide), that could not be carried out as easily in the town center under constant surveillance by police and nosy neighbors.

As numerous contemporary descriptions of the city by foreign visitors and local administrators report, appalling numbers of Romans—at least half the population—lived in chronic poverty or excruciatingly close to it. Beggars were omnipresent, especially around churches, frequently disturbing liturgical services with their boisterous shouting for alms. In Italy, the aristocracy and what can be termed the "middle class" together comprised no more than 20 percent of the population. Of the remaining 80 percent, only a small number had steady, decent employment that might guarantee a lifestyle above bare subsistence. To make things worse, the overall economy of the entire peninsula was in a steady, unstoppable decline throughout the century, Italian manufacturing and commerce having

lost its competitive edge to its northern European rivals. The situation in Rome was no better than in the rest of the peninsula, for the city produced nothing by way of exportable manufactured goods or foodstuffs. Just getting enough to eat each day was a challenge. The agricultural productivity of the Papal States was inadequate and extremely unreliable, as it was all over premodern Europe.

Yes, within the city of Rome, the papal administration and numerous charitable organizations (confraternities) handed out much free food, mostly bread, to the poor. But this charity was never enough and it was hampered by rules and regulations. In the midst of the great famine of 1648, a distraught Roman mother was pushed to utter desperation when her family was declared no longer eligible for public assistance and its ration of bread was taken away from them. The poor woman ended up killing herself and her three children. Therefore, when Romans recited the traditional Christian prayer, the "Our Father," the verse "Give us this day our daily bread," was prayed as a deeply felt, literal supplication upon which their lives often depended. Their daily loaf of bread, the *pagnotta*, was by far the most important staple of their diet, and Romans watched carefully and often anxiously the fluctuations in its composition, weight, and price—all determined by law—as both indications and effects of the ups and downs of the economy.

Famine of epidemic proportions was as frequent as flooding and often drove the population to the brink of rebellion. There were times, especially during the pontificate of Pope Innocent X Pamphilj (reigned 1644–55), when the popes thought twice about venturing out of the Papal Palace. In November 1647, seeking fresh air and relaxation with a coach ride among the gardens and vineyards of the city, Pope Innocent was accosted by a mob of angry, starved Romans, crying out for bread. Innocent weakly tried to assure them, "Do not worry, bread will, indeed, be found." "Yes," the mob shouted back, "it will be found right in your house." And while they were at it, they hurled a further reproach to His Holiness, to the effect that "it was time that his government be taken out of the hands of a woman!" The frightened, humiliated pontiff made a beeline for home and took to his bed: "He shortly thereafter fell sick to such a degree that they feared for his life and thus prayers were offered for his health and the Blessed Sacrament was exposed for veneration in the Church of Santa Maria della Pace." That order for the exposition of the Blessed Sacrament came not from a

Vatican official, but rather from the pope's sister-in-law (widow of his brother, Pamphilio Pamphilj, who died in 1639) and the effective second-in-command in Rome at the time, Donna Olimpia Maidalchini Pamphilj, reputed to be the pope's former lover. She is the woman the hungry Roman mob denounced. The Romans, hungry or well fed, hated Donna Olimpia, and for good reason, as we shall see in due time.[10]

Bernini, of course, did not have to worry about his daily bread, since from the very start of his career, he was extremely well compensated. In fact, one of the lifetime offices conferred on our artist by Urban VIII, that of "commissioner and inspector" of the Piazza Navona water supply, came with a salary in the form of both cash and foodstuffs: each month he received 5 scudi in silver coin and each day a provision of four *pagnotte* (the standard Roman loaves of wheat bread), two *biscotti* (twice-baked, oven-dried bread), two *ciambelle* (round sweet bread) and, to wash it all down, two jugs of wine. However, perhaps in his childhood, living in a family of thirteen children with a sole breadwinner (Pietro his father), Bernini had truly experienced, at least on occasion, some degree of, if not poverty, then economic hardship. Pietro's employment as independent sculptor, after all, was precarious: between one commission and the next, there was inevitably a gap in time and salary. Perhaps this helps to explain why as an adult Bernini often seemed preoccupied with money. The preoccupation could only have grown, of course, when the adult Bernini himself became head of a large, extensive, multigenerational family of which he was the principal financial support. Therefore, it would not have been simply childhood memory that made him money-conscious.

However, Bernini, we are told by both Domenico and Baldinucci, was not preoccupied with food in itself and for himself. Except for a hearty appetite for fruit, Bernini was extremely moderate in his eating habits; the dinner menu at Casa Bernini was always simple and spare. The Chantelou diary adds the further detail that Bernini considered sitting down to long, elaborate meals simply a waste of time, one that also brought with it the danger of overeating. But Bernini did like his sweets, and not only in the form of fruit. At the end of his stay in Paris, Chantelou's wife presented the artist with a farewell basket of sweets. They were probably meant for his long return journey home, but instead, the artist set to devouring them right then and there in her presence. The exquisitely refined Madame Chantelou must have been taken aback at the sight. Yet, given his constant,

nervous, high-strung level of activity, it is understandable that Bernini would crave the fast-energy source of sugar supplied by such confections and his beloved fruit. Moreover, in consuming much fruit, Bernini may have also been heeding the advice of medical science, which at the time recommended a diet rich in fruit for individuals (like our artist) who had overheated "choleric" personalities.

Given the chronic, massive poverty and daily scrabble to feed oneself and one's children in Bernini's Rome, it is not surprising that, as in Naples, the rate of abandoned babies was shockingly high in the papal city: an average of 946 cases annually according to the seventeenth-century statistics (1619–60) of the venerable Ospedale di Santo Spirito in Sassia, the principal depository for unwanted infants. (Some of these unwanted infants, of course, were illegitimate births whose evidence had to be eliminated.) The economy of Rome was essentially based on the service industry, that is, supplying the needs of the church (in everything from buildings to wax candles) and providing the luxury clothing, gourmet foods, and elegant home furnishings of the papal court and smaller princely courts, both secular (for example, those of the Colonna and Orsini) and ecclesiastical (especially those of the cardinals). In order to survive and consolidate their power, these lesser courts, too, had to impress and win allegiance through the external *magnificenza* of their lifestyle.

When the Berninis arrived in 1606, as for many years before and after, Rome was a very male city: 66,281 males to just 39,449 females. No wonder there were also 918 prostitutes busy at work. Clergy and religious of all types, totaling about 6,000, were of course an even more conspicuous percentage among the population, many of them employed in the Curia (the papal bureaucracy) and the city's ninety-two parishes. The two worlds—that of the prostitutes and that of the clergy—did meet with some frequency, although not always for the purposes of conversion of the former by the latter. One of the Italian spies of the English King James I, for example, reported that in the summer of 1614 Cardinal Felice Centini was caught red-handed in the house of "his" prostitute, "cum maximo omnium scandalo," to the greatest scandal of all. Normally, Italians, tranquilly accepting the inescapable bodily drives of Mother Nature, had a high tolerance for sexual peccadillos, but less so in the case of sanctimonious cardinals. The same Centini, by the way, a Franciscan friar and later inquisitor general, served on the committee of inquisitors that condemned Galileo in

1633. Two years later, Centini's nephew, Giacinto Centini, along with his clerical sorcerer-accomplices, was beheaded by order of the Roman Inquisition. The execution was a spectacular public event attended by thousands. Giacinto's crime? Believing that his uncle would become the next pope, he had used "black magic" in an attempt to hasten the death of Pope Urban VIII, then predicted as imminent by astrologers. Pope Urban himself suffered nothing but frayed nerves in the process, unlike the two poor Roman children kidnapped and murdered by the clerical sorcerers who needed young, fresh blood for their satanic Urban-elimination ritual.

Although sorcery and superstitious practices were things of everyday life in Baroque Rome, the population was of course duly shocked by the details of the Centini sorcery case, probably more so for the fate of the innocent children than the thought of having almost lost the by-then unpopular Pope Urban. Another clamorous crime of the time also involved a vowed religious, a reformed prostitute turned nun who poisoned twenty of the other nuns in her convent, Le Convertite (The converted women— converted from prostitution, that is). The unnamed homicidal nun was hanged for her crime and as in the Centini case, her public hanging supplied well-attended free entertainment for the population. Naturally, scandalous news of this type was rigorously suppressed whenever possible. The papacy was determined to project to the world, for the edification of Catholics, Protestants, Jews, and Muslims alike, a whitewashed image of the city as "Roma sancta," a model of piety and upright behavior at all levels. But the contemporary versions of police blotters (such as the diaries of the governor of Rome, who functioned as the city's chief of police) and court records tell another, more truthful story, as do the blunt reports of private diarists, foreign agents, and the anonymous freelance journalists who produced handwritten, weekly news bulletins known as the "avvisi di Roma." (The *avvisi* were the direct precursors to printed newspapers and supply us with a wealth of usually reliable information about the city, both official news and delightful gossip.) There is hardly a crime that occurs today that did not take place in Baroque Rome: murder, rape, theft, extortion, kidnapping, and, yes, even sexual abuse of minors by clergy, such as most notably the Fathers of the Piarist Order, which had to be temporarily suppressed by the papacy in 1646.[11]

Where exactly the Bernini family first settled in 1606 upon arrival in Rome we do not know. By 1609 they show up in church records as living in

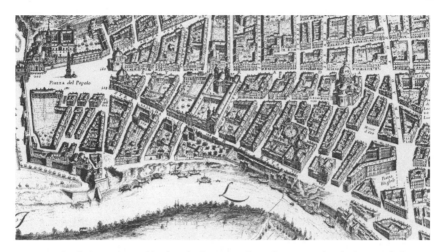

MAP 1 ➤➤ The Ripetta neighborhood of Rome, where the Bernini family first resided in the city. Giovanni Battista Falda, *Pianta di Roma*, 1676, detail. Photo: Author.

the parish of San Lorenzo in Lucina, a wedge of the city also known as "Ripetta," lying between the Tiber River and the main north-south thoroughfare, the Via del Corso (map 1). Many artists lived in the same neighborhood, including the famous Annibale Carracci of Bologna, the leading painter of his age and one of the founding fathers of the new Baroque style. Before his death in July 1609, Carracci apparently had occasion to meet the boy Gian Lorenzo and examine his earliest attempts at sculpture. Gian Lorenzo, the great Annibale supposedly declared, "had in tender youth reached the same point in his art that others could boast of reaching only in their old age."

In January 1611, Pietro's monumental relief for Santa Maria Maggiore, the *Assumption*, was unveiled to hearty applause from all quarters. Having pleased both patrons and populace, he was next commissioned by the Borghese to do yet another relief of similar dimension and complexity, the *Coronation of Pope Clement VIII*, for the same Pauline Chapel. For greater convenience, Pietro moved his family closer to his place of employment, constructing a home across the street from the basilica upon land acquired from its canons in October 1614 (map 2). Several years later, in 1625, the same canons granted to Pietro and his descendents the distinct privilege of a family burial vault within the basilica. A simple white marble slab on the floor still marks its location to the right of the main altar near the

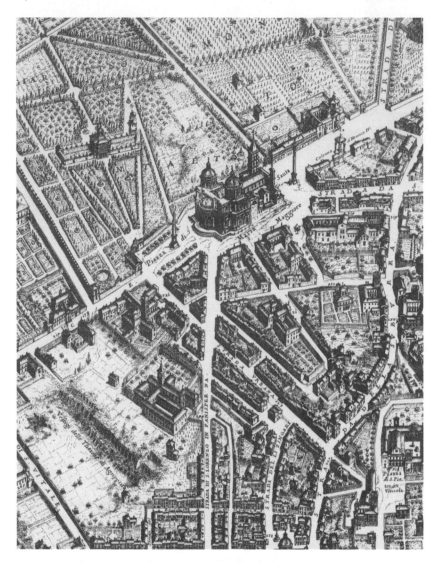

MAP 2 ↦ The Santa Maria Maggiore neighborhood of Rome. In 1615 Pietro Bernini built his home opposite the basilica (just below the word "Maggiore" in this view). Giovanni Battista Falda, *Pianta di Roma*, 1676, detail. Photo: Author.

communion balustrade (fig. 38). Pietro and Gian Lorenzo were both buried there, though all identifiable traces of their physical remains have long since disappeared.

Pietro's house (at today's Via della Liberiana, 24, at the corner of Via di Santa Maria Maggiore) was to be the Bernini family home until the early

1630s. Sometime after Pietro's death in August 1629 but before November 1634, the new head of the family, Gian Lorenzo, moved their home and his studio closer to his place of employment, St. Peter's Basilica.

Bernini's new house near St. Peter's was located in what was then a residential neighborhood known as Santa Marta located immediately behind the apse of the basilica and taking its name from a church on the site long since razed, together with the rest of the residential buildings (map 3). The Berninis remained there until 1643 when the by then wealthy family took up residence in a more spacious home purchased in December 1641 and refurbished over the two years. The new house, later amplified with purchases of property around it, was on the poetically named Via della Mercede, "Ransom Street," after the nearby community of the medieval religious order of the Mercedarians (their mission was to ransom Christian hostages in Muslim lands).

Not far from the fashionable Piazza di Spagna, the new house still stands today at the modern address of 11 Via della Mercede, within the parish of Sant'Andrea alle Fratte (St. Andrew at the Thickets) and the larger civil district of the Rione Colonna (map 4). For reasons unknown (but probably simple historical accident), the neighborhood was popular with artists: in premodern times, members of the same profession seem to have tended to cluster together, living and working in the same neighborhoods. However, at the time, Bernini had the distinction of being the only artist in Rome, beside Pietro da Cortona, to possess such a large, distinguished (though not patrician) house. It remained Bernini's home until his death in November 1680 and that of his heirs until the early nineteenth century when they moved to the now all but forgotten "Palazzo Bernini" on the Via del Corso (today's number 151, between Via Borgognona and Via Frattina).

But to return to the Via della Mercede: on the building next door to Bernini's original home (today's number 12, which he also owned but rented out to the Portuguese De Sylva family), tourists will today find a commemorative plaque honoring the artist. Placed there by city officials in 1898 on the three-hundredth anniversary of his birth, it solemnly declares that "Popes, princes, and throngs of people came here to bow reverently before Bernini, the sovereign of all arts." Even though Baroque popes and princes never exactly "bowed reverently" to even great artists like Bernini, the boast is not unjustified (fig. 39).

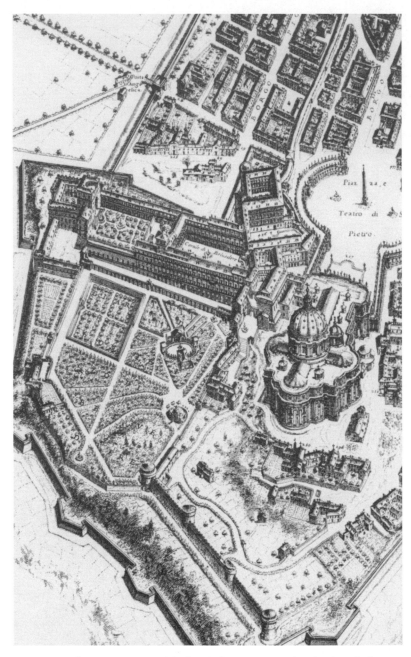

MAP 3 ➻ The Santa Marta neighborhood of Rome. Bernini lived and worked in one of the houses opposite the apse of St. Peter's Basilica from circa 1630 to 1642 Giovanni Battista Falda, *Pianta di Roma*, 1676, detail. Photo: Author.

MAP 4 ➻ Map of Rome showing Bernini's home (1643–80) on Via della Mercede located in the center of this view, immediately below and two blocks to the right of what is here identified as Piazza di Spagna. Giovanni Battista Falda, *Pianta di Roma*, 1676, detail. Photo: Author.

But Via della Mercede was to be in Bernini's distant future. We must backtrack in time to 1606 when we last left the boy Gian Lorenzo, newly arrived in Rome at the age of eight. In Rome he continued his long apprenticeship under his father, who at some point also began training his two younger sons in the art of sculpture, Francesco (who, however, died young in 1627 at the age of twenty-three) and Luigi, born 1610. Surviving his oldest brother by one year and one month, Luigi was to distinguish himself as an invaluable member of Gian Lorenzo's workshop but also as the perpetrator of the biggest, most public scandal to rock the domestic tranquility of respectable Casa Bernini, as we shall see in due course. In addition to training under his father, we know from Chantelou's diary that as a boy Gian Lorenzo spent some time studying drawing in the workshop of the prominent painter and architect Lodovico Cardi, more commonly known as "Il Cigoli." Cigoli, another Tuscan, worked alongside Pietro in the Pauline Chapel, executing the ambitious though less than successful eye-deceiving fresco on its massive cupola. Within two years, Domenico tells us, Gian Lorenzo was supposedly producing works of art, in effect, as an independent artist: "He had already begun working as sculptor: his first piece was a marble bust located in the Church of Santa Potenziana [that is, Pudenziana]; he had also carved other small statues such as his age permitted him to accomplish, for he was then only ten years old." Baldinucci reports the same news, specifying in his appended catalogue of Bernini's works that the bust here in question (in the Church of Santa Prassede, not Pudenziana) is that of Bishop Giovanni Battista Santoni, majordomo of Pope Sixtus V. In the *Vita Brevis*, the brief biographical sketch mentioned in our survey of the Bernini biographical sources, the artist's eldest son, Monsignor Pietro Filippo, makes the same claim about the production of this first bust at so prodigious an age, but without identifying the sitter.

Despite all the assertions of these early sources, the most prominent Bernini scholars have debated the issue for decades and have never been able to agree about either the bust's attribution or its dating. Some say that the Santoni bust in Santa Prassede is in fact by Pietro alone; others see it as a collaborative work between father and son. Those who give it securely and only to Gian Lorenzo are, it would seem, a minority. All, however, reject Domenico's precocious dating (1608) and argue for chronologies that extend from 1610 to 1616. The same endless disagreement over attribution and dating is also true for all those "other small statues" mentioned

by Domenico and surviving today in museums from Berlin to Los Angeles (mostly table-top pieces of Hellenistic inspiration featuring small children sporting or struggling with animals) and in Roman churches (small funerary portrait heads). It would be tedious to go through this list and sort out the pros and cons of each attribution and dating. Suffice it simply to point out that in the midst of all this scholarly dispute there is virtually unanimous consensus that the very first sculpture by the hand of Gian Lorenzo alone is the small mythological group in Rome's Galleria Borghese, *The Goat Amalthea Nursing the Infant Zeus*, perhaps executed as early as 1609 but certainly no later than 1615, when Gian Lorenzo was seventeen years old.[12]

Bernini himself made similar bold claims about his precociousness, according to Chantelou's diary (quoting the artist who by then was sixty-seven years old, and therefore far removed from his childhood memories): "The Cavaliere told Colbert that he at the age of eight had done a *Head of St. John* which was presented to Paul V by his chamberlain. . . . He said that at six years he had done a head in a bas-relief by his father, and at seven another, which Paul V could hardly believe was by him; to satisfy his own mind, he asked him if he would draw a head for him." This *Head of St. John* has disappeared and is otherwise undocumented, so there is no way of confirming Bernini's claim. As for the two "heads" in his father's bas reliefs, there may be some truth to the tale. Although dismissing Bernini's fanciful, self-mythologizing chronology, some scholars see this as plausibly referring to the small portraits in Pietro Bernini's two renditions of his *Coronation of Clement VIII* for the Pauline Chapel, Santa Maria Maggiore, that is, the now missing first version of 1612 (rejected by its patrons for reasons unknown) and the extant replica, still on site, of 1614. Even if the work of the boy Gian Lorenzo, this contribution of his would have been done considerably later than he claimed to Chantelou: specifically, between the ages of fourteen and sixteen years. Nonetheless, we can sum up this discussion of Bernini's earliest works by pointing out that, although none of them were done as early as either the artist or his first biographers claim, they were still done early enough for Bernini to merit the labels of child prodigy and boy wonder, or as his contemporaries called him, "un mostro d'ingegno," a monster of genius. Yes, the wonders began early and would continue throughout the rest of Bernini's life, well into his seventies.

FALLING IN LOVE WITH THE BOY BERNINI

Whatever these first Roman works were and whenever they were made, they eventually caught the marveling attention of Scipione Borghese, the "cardinal nephew" (a kind of prime minister) of the then-reigning pontiff and his maternal uncle, Paul V (fig. 2). After the pope, Cardinal Scipione was the most powerful man in Rome throughout Paul's reign (1605–21) and, fortunately for Bernini, his love of art was as great as his love of money and male physical beauty. We will have occasion to pry a little more deeply into his personal life later in this chapter, as he was soon to be a determining force in Bernini's rapidly rising fortunes. At a certain point, probably between 1608 and 1610, the good cardinal secured for Pietro and Gian Lorenzo that most precious of encounters in Baroque Rome: a private, face-to-face, lengthy audience with the pope. It was to be the first of many in Bernini's long life, a privilege shared by few in that century. Domenico describes the dramatic scene as one in which the boy artist enchants the marveling pope with his perfect, self-confident poise and, even more so, by his execution, right then and there, at the pontiff's request, of a masterfully wrought drawing of the head of Saint Paul. It was this performance that inspired Pope Paul to deliver his prediction about Bernini becoming the Michelangelo of his age. Two results immediately ensued: instant public recognition on the streets of Rome for the young artist ("from then on he was universally acclaimed and pointed out as a young person of extraordinary promise") and, more important, complete, free access to the magnificent collection of art within the Vatican.

Bernini lost no time in immersing himself in this new treasure. He spent entire days endlessly drawing and learning from these masterpieces to his heart's content, especially the ancient sculpture, and of that, especially the *Apollo Belvedere* and the *Laocoön*:

> It is not to be believed with what dedication he frequented that school and with what profit he absorbed its teachings. Almost every morning, for the space of three years he left Santa Maria Maggiore . . . and traveled on foot to the Vatican Palace at St. Peter's. There he remained until sunset, drawing, one by one, those marvelous statues that antiquity has conveyed to us and that time has preserved for us, as both a benefit and dowry for the art of sculpture. He took no refreshment during all those days, except for a little

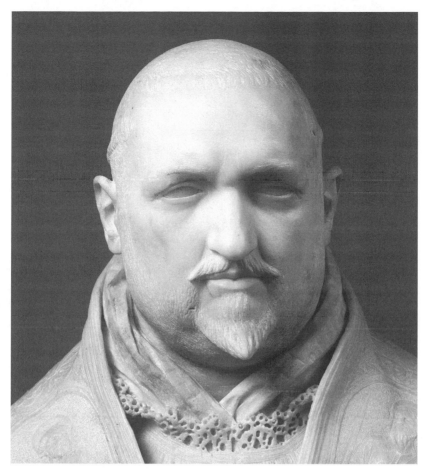

FIG. 2 ➤➤ G. L. Bernini, *Pope Paul V* (detail), ca. 1622–23, Galleria Borghese, Rome. Photo: Scala/Ministero per i Beni e le Attività culturali/Art Resource, NY.

wine and food, saying that the pleasure alone of the lively instruction supplied by those inanimate statues caused a certain sweetness to pervade his body, and this was sufficient in itself for the maintenance of his strength for days on end. In fact, some days it was frequently the case that Gian Lorenzo would not return home at all. Not seeing the youth for entire days, his father, however, did not even interrogate his son about this behavior: Pietro was always certain of Gian Lorenzo's whereabouts, that is, in his studio at St. Peter's, where, as the son used to say, his girlfriends (that is, the ancient statues) had their home.

Bernini was to maintain the same kind of intense work schedule for his entire life, spending as many as seven hours a day in uninterrupted, exhausting labor well into his seventies. Whenever his assistants tried to get him to rest or end his workday earlier than he desired, he would repel them, saying: "Let me be, for I am in love." So reports Baldinucci, who adds: "It is not easy to describe the love that Bernini brought to his art; he himself used to say that going to work was for him like entering a garden of delight." In Bernini's day, people would have unquestioningly accepted his obsessive creative drive not only as love but as yet another blessed case of divine furor. It was, in their eyes, his privileged share of the supernatural creative spark that God deigns to instill in a few chosen geniuses in each century. Similarly they would have applauded his incessant attempt to dazzle and amaze the world through his art—while outdoing his rivals—as a praiseworthy manifestation of the pursuit of worldly glory, honor, and immortality. The desire for glory drove men to achieve great things for themselves and society, it was believed, and accordingly, this virtue was cultivated through the humanistic education of the day, as it had been since the Renaissance.

Yet today we cannot help but wonder what psychological forces fed Bernini's compulsion to excel. Whence the relentless need to create, and in creating to stupefy, and in stupefying, to win the praise of his contemporaries? Bringing modern thinking to bear on Bernini, we ask: Was this drive also a manner of compensation for deep-rooted feelings of inferiority? Did he crave public love and applause because they were withheld from him as a child? Was he in rivalry with a domineering sculptor father? His father, we are told by Bernini's eldest son, Pietro Filippo, in teaching his young son, would never show satisfaction with what the boy produced in his drawing exercises: "And whenever he would show his drawings to his father, Pietro would express displeasure over them, always responding that what Gian Lorenzo was showing him would never be surpassed by the next one he would do." The pedagogical aim of this frustrating withholding of approval was to spur the boy to ever greater effort and thus ever higher achievement. But did the same pedagogy also instill in the boy a chronic sense of inadequacy? There are those who might ridicule such psychoanalyzing of a larger-than-life figure like Bernini. But today, post-Freud, who can pretend that even prodigies like Bernini are exempt from the dynamics of the human psyche? Having said that, however, we must resign ourselves

to the fact that we can never answer such questions with any certainty. Bernini is long dead and cannot be interrogated. In any case, that degree of introspection and self-knowledge would have been alien to him and his world. In the end, even in our world, despite all the enlightenment of modern psychological and social sciences, human beings fundamentally remain mysteries not only to other human beings but also often to themselves.

But let us return to an area of Bernini's life that we can explore with some reliability: his formal artistic education. In addition to his study of the ancients, Bernini also engaged in intense drawing from the "modern" masters of the High Renaissance, especially (according to the list supplied by Domenico) Michelangelo, Raphael, and Raphael's closest disciple, Giulio Romano. The fourth and final name on this very short list of "moderns" and the only artist then still alive among those mentioned is Guido Reni of Bologna, one of the greatest of the early Baroque painters. Bernini seems to have made Reni's personal acquaintance in 1642 during one of the elder painter's Roman sojourns.

Though Bernini hardly ever spoke of lesser masters in an appreciative way, a rare exception is Sienese painter Ventura Salimbeni (died before November 1613), a transitional figure between Mannerism and Baroque of secondary rank who left many works in Rome, Florence, Perugia, Pisa, Genoa and, of course, his native town. Unknown today except to specialists and the Sienese, Salimbeni was praised by Bernini as "the premier painter of Siena" when he visit the Tuscan city en route from Paris to Rome in November 1665. Bernini even asked his local host to take him to see all of Salimbeni's works on view in the city. Bernini's own painting style, however, is far different from Salimbeni's. Perhaps the closest comparison to Bernini's painting would be with his Spanish contemporary Diego Velázquez, but the similarity in style seems to have been coincidental. It is unlikely that Bernini had the opportunity of studying Velázquez's paintings when first training in that art at the order of Pope Urban VIII or even later. Velázquez's first trip to Rome in 1629–30 may have offered an opportunity for the two men to meet, though there is no documentation of such an encounter. Nor is any direct contact documented during the Spanish painter's second trip to the city in the 1650s, by which point Bernini's painting days seem to have long been over.

According to Domenico, a further result of that fateful first encounter between the young Bernini and Pope Paul V was the pope's subsequent

decision to entrust the boy to the tutelage of Cardinal Maffeo Barberini. This decision was to have (literally) monumental consequences in the third decade of Bernini's life, for Barberini would one day (August 1623) become Pope Urban VIII, one of the greatest papal patrons of art, especially of Bernini's art. Our two other biographers, Monsignor Pietro Filippo Bernini and Baldinucci, claim that it was "by providential design" that Cardinal Maffeo happened to arrive on the scene while the young artist was drawing his head of Saint Paul for the pope and was immediately given this mentoring charge over the boy. A nice story, but probably not true. Whenever Maffeo entered Gian Lorenzo's life as mentor, it would have been well beyond the artist's boyhood and most likely not before the summer of 1617, when the cardinal definitively reestablished residence in Rome after a series of papal missions that had kept him away from the city for many years. Gian Lorenzo, in 1617, was nineteen years old.

Be that as it may, Maffeo took an instant liking to Bernini, or rather, an instant *love*, for the charming, talented youth seems to have simply enchanted the cardinal, as he was to enchant many a future patron: "As Barberini would later say with the passing of years, he felt himself from that moment on drawn by affection for Bernini, stirred by a certain interior impetus of most benevolent propensity toward him and especially desirous of assuring every success for the youth." In other words, Barberini was smitten. So smitten, in fact, as Domenico proudly declares, that "Cardinal Maffeo took complete possession of Bernini as if he were one of his own." Actually, the original Italian text literally and more emphatically says, "He appropriated Gian Lorenzo entirely to himself." In his conversations with Chantelou later in life, Bernini himself confirmed that he had enjoyed this special relationship with Barberini: "He was always eager to quote Pope Urban VIII, who loved him and valued his qualities from his earliest years."

It was a love that was to profit Bernini greatly. Bernini actually did go on to become the Michelangelo of his age under Urban's lavish patronage and relentless prodding toward ever greater accomplishments. Unlike the stormy relationship between the morosely neurotic Michelangelo and the warrior-pope Julius II, however, the rapport between the courtly, extroverted Bernini and the very urbane, humanistically trained Urban seems to have been conflict-free. This makes it all the more strange that nowhere in

the sources do we ever hear speak of Bernini's reciprocating his beneficent patron's tender love. Did Bernini find Urban lovable? Should we simply assume that he did? Or was Bernini's narcissism too deep for him genuinely to reciprocate affection? Or was the artist, instead, maintaining his emotional guard, heeding the wise advice of Battista Guarini's *Il segretario*, a contemporary handbook of administrative procedures and courtly protocol:

> The wise man will indeed let his prince assume an attitude of familiarity with him, not being able to do otherwise; however, he, the servant, in turn, must never behave in like fashion toward his prince. Patricians [*i grandi*] are like lions, who can never be so tamed that they forget they are lions. And since they are ever mindful of their greatness even while dreaming in their sleep, as well as when they relax or play, the shrewd servant must never abandon his demeanor of respectful subaltern. If he is indeed compelled at times to accept the favor of interacting with them a bit more familiarly, this must be done with a necessary quantity of reserve and judgment.

Yes, Bernini wept (supposedly) at the death of another papal patron, Gregory XV, and again later, in Paris, when taking his leave from King Louis XIV. But on these occasions it is more likely that he, the skilled, shrewd Baroque courtier (and seasoned actor), was simply putting on a necessary show of emotional distress for his own self-promotion and protection. It is called dissimulation. It is the art of hiding your true self behind a mask of silence or politely evasive answers to potentially troublesome questions. It is one of the defining characteristics of the Baroque "mentality," including Bernini's. Widely discussed in contemporary treatises on politics, moral theology, and courtly etiquette, dissimulation was a trait and a habit born out of sheer necessity in that age—the ancien régime—of absolutism and confessionalism. It was a mechanism of self-defense in the face of autocratic, and often despotic, government and at times violently enforced religious orthodoxy, both Catholic and Protestant. With spies lurking everywhere, dissimulation was considered nothing less than an indispensable survival tool, if not an outright virtue. Moreover, what one called dissimulation could be—and, in fact, was—seen as the exercise of the patently moral virtue of "prudence," another much-beloved and invoked principle

of the Baroque code of behavior. Because one can never truly understand Baroque behavior, including Bernini's, without understanding the politics of dissimulation, some further discussion is in order.[13]

"I Beg You to Dissimulate"

Bernini may have wept while saying goodbye to King Louis XIV in Paris but once back home, his tears were dry. Showing no interest in the newly established French Academy in Rome, contrary to his promises to its proud founders, King Louis and his chief minister Colbert, Bernini was warned by one of his alarmed Italian acquaintances in Paris, the Abbé Francesco Buti (or Butti), to put on some display of interest to avoid unpleasant consequences: "I beg you to dissimulate, as you know how to do when you wish to." Bernini obeyed. He knew what Torquato Tasso, celebrated epic poet and critic of the late sixteenth century, had long before observed: a talent for dissimulation was an essential item in the survival kit of the courtier. The same wisdom applied to anyone interacting with social superiors of any sort, for they had the power to break a person over one displeasing remark or action. This was also the fundamental message of the popular manuals of courtly behavior of the day such as Lorenzo Ducci's *De arte aulica*, already then translated into English as *The Courtier's Art* and a copy of which was in Luigi Bernini's personal library. One of Ducci's chapter titles says it all: "The appetite for one's self-interest must by the courtier be masked underneath an external desire for the service of his prince." To mask: in other words, to deceive and to dissimulate.

"To be unable to dissimulate is to be unable to live," declares Bernini's dear friend and protector, Queen Christina of Sweden in her *Maxims*, repeating what was actually a common sentiment of the age. That message is at the heart of Torquato Accetto's famous treatise of 1641, *On Honest Dissimulation*, the Baroque handbook par excellence on the art of survival in an age of divine-right, absolute (but nonetheless insecure and paranoid) government, secular or ecclesiastical. That included papal "Roma sancta": according to the worldly-wise Marie Mancini (niece of Cardinal Jules Mazarin and Louis XIV's first love), in Rome "dissimulation and hate among families reign more supreme than in other courts." Galileo was only the most clamorous of the cases in Baroque Rome of those persecuted for speaking the truth as they saw it or questioning the version of reality put

forth by the propaganda machine of the absolutist powers that be. (Much of Bernini's art, by the way, served admirably the purposes of the propaganda machine of the absolutist papal monarchy and its version of Christianity.) Another of Bernini's older contemporaries, Paolo Sarpi, author of the antipapal history of the Council of Trent, himself admitted: "I wear a mask, and indeed must do so, for without it no one could live safely in Italy." Sarpi, nonetheless, was physically attacked by would-be assassins, sent, he was sure, by the papal curia. Sarpi's contemporaries would have no trouble believing the latter charge for, as French scholar Gabriel Naudé (librarian to, successively, Cardinals Francesco Barberini, Richelieu, and Mazarin) reported, in Rome there was only one unpardonable sin:

> In Rome, atheists are pardoned, sodomites are pardoned, libertines and many other kinds of rascals. But never is there pardon for those who speak ill of the pope or the Roman Court or seem to call into question the absolute power of the pope.

The enforcers of repressive government and repressive religion were everywhere in Europe, and therefore everywhere men and women were forced to retreat self-protectively into themselves. As Louis d'Orléans, another astute observer of the times and human nature, writes in a diatribe against King Henri IV of France: "Being a secret and hidden animal, man withdraws within himself like an oyster, and only opens up when and to whom it pleases him to do so. His thoughts cannot be made transparent by the brightest light or the sun's most blazing rays, and this is why it is as difficult to judge them as it is difficult to judge a false or genuine diamond in the darkness of night, or a beautiful or ugly painting amidst dark shadows." Of course, the closer one was to the seat of power in the royal courts (including that of the pope), the greater the danger and, thus, the more pervasive and more adept the practice of dissimulation. As another victim of the Roman Inquisition—burned at the stake in Campo dei Fiori in 1600— Italian philosopher Giordano Bruno pointed out, "Orators, courtiers, and those who in any event know the rules of behavior are more effective at civil conversation when they employ the hidden dissimulation of artifice . . . for not a small part of art is to use it while dissimulating it."

Bruno's phrase concerning art invokes a well-known aesthetic principle first enunciated by the ancient Roman poet Horace, "Ars est celare artem,"

"the goal of true art is to hide art." Bernini was well aware of the principle and practiced it in his own life. In fact, it represents one of his great professional achievements, as Domenico reminds us: "He was so adept at imitating, without affectation, what was most perfect in nature that anyone who studied his works was left in doubt as to which was greater, his artistry or his mastery in hiding it." As Bernini himself remarks in a conversation about the remodeling of an elaborate, artificial waterfall at the château of Saint-Cloud in France, "Art should be disguised with an appearance of naturalness." The same subject becomes the topic of discussion in act 2, scene 4, of Bernini's comedy *The Impresario*, when, in summarizing his father's theatrical production, Domenico reports that "Bernini used to say that the best part of all his comedies and their sets consisted 'in making that which was, in fact, artificial appear real.'" That success, of course, depended on deception, deception so clever and so technically proficient that it drew astonishment and applause from one's audience.

The clever deception Bernini practiced with such success on stage and in his works of art and architecture also found its way into his personal interactions, especially with patrons and other figures of power. Dissimulation again. Bernini always played it closed to the vest. He would not compromise his security by saying too much or by giving offense with sharp words. Here is Domenico describing his father's modus operandi when asked to judge the works of other artists:

> However, when it was not possible to praise a work, he preferred to remain silent, rather than to speak ill of it. When it was absolutely necessary for him to comment about a painting, he found ways to say nothing even while saying something. For example, it happened one day that he was asked by a cardinal to give his opinion about a cupola that had been painted by an artist in the employ of the same cardinal and who, in fact, had not done such a good a job in this case. Finding it distasteful either to stay silent or to speak the truth, Bernini simply remarked, "The work speaks for itself," repeating that line three times with great energy. The cardinal, who was fond of the artist in question, readily interpreted Bernini's remark as one of praise for the author of this work, whereas many artists who happened to be present laughed silently among themselves, exchanging telling glances with each other.

Of course, in not wishing to criticize the unnamed artist's cupola fresco, Bernini was also striving not to offend that artist's powerful cardinal-patron. In fact, offending a cardinal entailed far greater risk than offending a mere artist. Especially if the cardinal in question was (as I would here conjecture) Scipione Borghese, nephew of Pope Paul V and patron of the Florentine artist we have already encountered, Lodovico Cardi, known as Il Cigoli. In the cupola of the Pauline (or Borghese) Chapel of Santa Maria Maggiore, Cigoli painted a grandiose fresco, *The Immaculate Virgin in Heaven with God the Father*, whose deficiencies immediately became the object of harsh criticism, generating a debate that became a cause célèbre.[14]

Dissimulation, the wearing of a social mask, made life safer and easier for the citizens of Baroque Rome, especially those living within the inner sanctum of papal absolutism like Bernini, employee of the papal court. But this same survival "virtue" now makes it harder for us centuries later to sort out the truthful and the sincere from the feigned and the artificial in the records of their lives. In the nineteenth century, the patriotic historians of the newly created nation of Italy summarily dismissed all Baroque behavior as little more than pretense and ridiculous posturing by a servile, conquered people. Without going that far, we must nonetheless apply a healthy dose of skepticism when evaluating the utterances and actions of Baroque men and women. This is especially true in the case of such a long-term, prominent player in the labyrinths of intrigue in the courtly world as Gian Lorenzo Bernini. In that world, one didn't survive as long and succeed as grandly as Bernini did without being a clever, dissimulating strategist.

In this social-political context, we can readily understand why Bernini never had any close, trusted friends or confidants at any point in his life, outside, we presume, of his family. But even family members could be unreliable: as we shall see, his own brother—Luigi again—betrayed him by sleeping with his mistress. The only exceptions may have been two Jesuits, both of them VIPs of Baroque Rome, scholar-theologian Cardinal Sforza Pallavicino and Gian Paolo Oliva, long-time preacher to the papal court and General of the Jesuit Order. Yet another contemporary, Fulvio Testi, a well-known poet and diplomat who served as Roman agent of the Duke of Modena, boasts in one of his official reports of the love shown to him by Bernini—"He loves me so much it is a marvel." Thinking like ever-suspicious Baroque courtiers, we are obliged to wonder: Can we take what

Testi says at face value? Or is he simply exaggerating to impress his employer with his social connections? Or was Bernini, on his part, feigning love for Testi in order to maintain a useful contact with the representative of a powerful lord? "Damn me if you can trust anybody nowadays," exclaims despairingly Zanni, one of the characters in Bernini's sole extant theatrical script, *The Impresario*. In the same script, Gratiano, the central character (a playwright and scenographer) and clearly Bernini's alter ego, declares to his servants: "Come now, shall I tell the truth? You're a bunch of sly characters—we all are." So is anyone to be trusted in this world? Bernini's answer in both the play and his life was, "No, not really."

BERNINI COMES OF AGE

Picking up again the chronological thread of our story, we last left the boy Bernini immersed in the ecstatic study of what he jokingly called his "girl-friends" (the ancient sculptures) and the High Renaissance paintings and frescos in the Vatican. He made so many drawings of these works, in all their detail, that, as Domenico points out, "whoever were to examine these innumerable sketches could not help but agree that, in the long course of an entire life, no man would have been able to observe with his eyes as much as Gian Lorenzo had drawn with his hand in the space of these three years." (Unfortunately, only a tiny percentage remains of this huge mass of drawings.) This feverish frenzy was soon to result in Bernini's first mature sculpture in the round, featuring a heroic nude, the *Saint Lawrence Burning on the Grill*. Both Domenico and Baldinucci boast that Gian Lorenzo was only fifteen when he carved the work; scholarly consensus places it instead in his nineteenth year (1617). In any case, though smaller than life-size, this full-figure sculpture represents a decisive, giant leap forward in the young Bernini's artistic development.

Even if not the work of a fifteen-year-old or the first universally acclaimed masterpiece of Bernini's adulthood (that honor goes to his *Apollo and Daphne* of 1622–25), the *Saint Lawrence* is nonetheless something truly remarkable. Among its many distinctions, it represents the first time that any sculptor, much less a teenage one, dared to depict in cold, colorless marble such a challenging, intricate scene involving the contrasting elements of fire, flesh, hair, wood, and metal, at the same time capturing the inexpressibly subtle emotional state of the martyr. And Bernini did so with

convincing yet seemingly effortless naturalism, achieving effects in marble only considered possible in painting. So anxious was Bernini to capture the full effect of fire's heat on human flesh, we are told, that he exposed his own naked thigh to a blazing brazier and observed in a mirror the grimaces of his face. (In the finished statue the beatific Saint Lawrence is not at all grimacing, but never mind.) It was a herald of the greater things soon to come in swift succession from Bernini's hand, all further manifestations of his prodigious talent for rendering in hard stone the exquisite multitextured, multitonal, "coloristic" details of his subject, be it a portrait bust or a mythological scene. The art of sculpture, which, contemporaries lamented, had lagged far behind painting in its development since Michelangelo, was about to catch up and reach astounding new degrees of achievement in the course of the seventeenth century. This was due in large part to one man: Bernini.[15]

From this point on and all the way through his old age, the pace of Bernini's professional life—the rate of his artistic evolution, the expansion of his technical capacities and creative imagination, the uninterrupted execution of ever more ambitious and ground-breaking works in various genres, the reception of ever more prestigious and ever more monumental commissions, the bestowal of public recognition and international honors in increasingly distinguished forms—the pace of all this becomes so great that it is simply impossible to do it all justice in a single volume. We must content ourselves with quickly identifying some of the major milestones along the way. Purchased by banker Leone Strozzi for his Roman villa and now in Florence's Uffizi Gallery, the *Saint Lawrence* was immediately followed by the even more sensual athletic male nude, *Saint Sebastian.*

The Sebastian statue represents the first commission from Bernini's mentor, Cardinal Maffeo Barberini. Barberini, we might mention, bore an unusually ardent devotion, unusually ardent even for those times, toward this virile early Christian martyr, collecting images of the saint and showering him with public tributes especially after becoming Pope Urban VIII. ("This saint seems to exact prominent and exceptional honors from Your Holiness," noted the canons of St. Peter's Basilica about Urban, when discussing his desire for the erection of a major chapel in Sebastian's name there.) In the same year (1617) as the *Lawrence* and the *Sebastian*, Bernini scored yet another first in his professional career: a commission to sculpt the portrait of a reigning pope (Paul V), certainly the most prestigious

portrait commission to be had in Rome. This papal portrait was to be followed by many others, in multiple reprises, of all eight popes of Bernini's adulthood, except the last, Innocent XI. As to Innocent, not exactly a fun-loving personality, Bernini has instead left us an amusing—or horrifying, depending on your point of view—caricature rendered in pen on paper, depicting His Holiness in the form of a giant, repulsive, dried-up cricket (fig. 37).

In 1618 came two other milestones: the first payment made directly to Gian Lorenzo for a work sculpted by him, a now missing marble statue of Saint Sebastian for the Aldobrandini family, and the first appearance of Bernini's own name in a legal contract. The contract came from the Barberini family commissioning putti for their family chapel in Sant'Andrea della Valle. Until now all the work done by Bernini had been contracted through his father, who also received the full fee. At the end of that same year, or early in the next, Bernini's professional status officially passed from apprentice to master, when he was admitted to the sculptors' guild, the Università dei Marmorari, having reached his twentieth birthday. Fraught with perhaps even more significance is the astounding fact that in October 1618 Cardinal Maffeo (as we read in a letter to his brother Carlo in Florence) was planning to have Gian Lorenzo complete an unfinished (and unidentified) sculpture by none other than Michelangelo. What greater honor could one possibly imagine? Being considered worthy to pick up where Michelangelo himself had left off! Further signs of trust in the young Bernini's talent were the commissions he subsequently received (from, respectively, Scipione Borghese and Ludovico Ludovisi) to restore two prized statues from Roman antiquity, the *Borghese Hermaphrodite* and the *Ludovisi Ares*.[16]

As worthy of applause and honor as Bernini's accomplishments were up to this point (the conclusion of his twentieth year), they were soon to pale in comparison with the unveiling of his next major works of sculpture, a "brilliant series [that] contains within it no less than an artistic revolution," that is, *Pluto and Proserpina* (also called the *Rape of Proserpina* or *Persephone*), the *David*, and, above all, the *Apollo and Daphne* (fig. 3). As contemporary sculptor Peter Rockwell has stated, "Any sculptor who looks at Bernini's *Apollo and Daphne* can only come away astonished." But his other two Borghese works also provide grounds for astonishment. The three marble groups were all done for Scipione and all within just four short years, 1621–25. They came with an admirable prelude in the form of

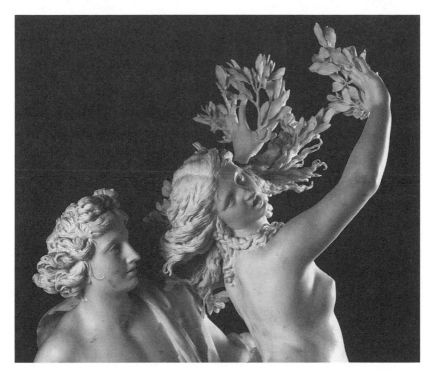

FIG. 3 ➤➤ G. L. Bernini, *Apollo and Daphne* (detail), 1622–25. Galleria Borghese, Rome.
Photo: Andrea Jemolo/Scala/Art Resource, NY.

Bernini's *Aeneas and Anchises* (1618–19), also in Cardinal Scipione's collection, but with perhaps a few touches by his father Pietro.

Each of these Borghese groups, in its own way, is a tour de force, for the daringly intricate yet utterly harmonious complexity of its composition, the profound, magnetic power of its emotional charge, and the stupefying, convincing naturalism of its execution. Never before had marble statues been so palpably alive. Their proprietor, Cardinal Scipione, used to exclaim in a tone of mock lament, that from the day those statues entered his home at the Villa Borghese, visitors ceased to be interested in any of the other countless treasures and delights in the sumptuous estate, flocking there just to see the Bernini statues. If Bernini had felt himself in competition with Michelangelo and the great sculptors of antiquity—and he most certainly did—he now had proven himself their worthy peer with these works, all happily together today in Galleria Borghese, Scipione's villa turned public museum. And had Bernini produced nothing else in his life but these four

statues, they alone would have sufficed to ensure him a place of supreme distinction in the annals of Western sculpture. If there were any doubt of his ability before, it had all disappeared: Bernini was an original artistic genius, and a new age had dawned in sculpture, the Baroque. True, there were many Bernini-haters (like Giovanni Pietro Bellori, as we shall see) who denied both propositions, out of either jealousy or academic ideology, but history has effectively silenced them. Bernini has won.[17]

"WHY SHOULDN'T CARDINAL SCIPIONE'S PENIS GET WHAT IT WANTS?"

Praise we must this "miraculous series" of statues, but at the same time one cannot help noting two disturbing ironies. One, that some of the amazing virtuoso carving of the *Apollo and Daphne* group was actually done by someone else, not Bernini, who always claimed the work as entirely his own. And, two, that these sublime works of art owe their existence to one of the sleaziest characters of Baroque Rome. To varying degrees, these same ironies will remain true of the rest of Bernini's career: on the one hand, the narcissistic habit of diminishing or denying the contribution of others to the design or execution of his works, and, on the other, the pragmatic willingness to work serenely and amicably with and for any rich, powerful, cash-carrying patron, no matter his character or reputation. Bernini, in short, was good at turning a blind eye when it suited the advancement of his career.

As far as the first issue is concerned, yes, it was at the time perfectly acceptable for master sculptors to employ other sculptors who were specialized in the carving of certain features, just as master painters executing a large, complex canvas would pay specialist painters to fill in, say, the architectural background or the natural landscape. It was also a matter of virtually unanimous opinion that in the evaluation of a work of art, the master artist's *concetto*—his creatively brilliant design—counted for far more than the "mere" technical execution of that design. Patrons, moreover, knew well that in the case of famous, busy artists—Bernini's older contemporary, Peter Paul Rubens, is a prominent example—the final work "by their hand" would inevitably represent a fair amount of workshop assistants' handiwork.

However, when he produced the *Apollo and Daphne*, Bernini was still a young, only locally known sculptor at the very beginning of his adult career, not the time-tested master of a large, busy workshop who could be granted license to pass off the work of his assistants as his own. Bernini was still proving himself, which meant doing all the work on his own. Furthermore, in the case of the *Apollo and Daphne*—in which we witness the breathtaking moment of transformation of the beautiful woman into a laurel tree—we are not talking about small, incidental detail. Instead, the carved portions in question represent "the most astounding metamorphosis of all, the transformation of the hard and brittle marble into roots, twigs, and windswept hair." These features are what audiences since 1625 have marveled over and what even back in seventeenth-century Rome caused master sculptors and laypeople alike to sing the highest praises of Bernini. In fact, these parts of the statue were all done by Giuliano Finelli, a Tuscan sculptor of enormous creative talent, not just a stone carver with mere technical ability. Finelli, who helped carve other Bernini statues in the 1620s, is today recognized and praised as an original, independent master in his own right. At no point did Bernini or his first biographers, Domenico and Baldinucci, ever acknowledge Finelli's contributions to the *Apollo and Daphne*.

Finelli eventually left Bernini's employment in anger and disgust, for he had too much self-respect and ambition. Being part of the Bernini studio then was similar to working today for a large, famous architectural firm or fashion design house. To work for the "Bernini brand" meant that one had to agree to total professional anonymity and unquestioning submission to the dictates of the master. And this was a master who guarded his interests with ever-cautious and at times paranoid scrutiny and political maneuvering. Master Bernini, yes, paid his assistants fairly, but he hogged all the credit for the final product. It is therefore not surprising that a fair amount of conflict was regularly generated between Bernini and his studio collaborators—even his most trusted, faithful, long-term assistant, Mattia de' Rossi—over the issue of public credit for what issued forth from the Bernini workshop.

The most celebrated conflict was, of course, between Bernini and Francesco Borromini. Borromini was one of the other truly great architects of Baroque Rome. As a young man, he worked on Bernini's first massive,

multifaceted commission, the Baldacchino in St. Peter's Basilica. Like Finelli, Borromini too eventually ruptured relations with Bernini in anger and disgust, confessing (as Borromini's nephew, Bernardo Castelli, reports in a 1685 biographical sketch of his uncle's life), "I do not mind that he has the money, but I do mind that he enjoys the honor of my labors." In the biography of his father, Domenico passes off some of the conflict as merely the case of students who were "ungrateful" to their beneficent master. But even Domenico admits that of all the scores of men who passed through the Bernini workshop over a span of several decades, one man alone, architect Giovanni Battista Contini, "was perhaps the only one, among all those who frequented the Cavaliere's school, to truly love and be loved by his master." Naturally Domenico did not intend this statement as a criticism of his father, but it is in fact quite an indictment of Bernini and his at-times irascible, narcissistic, and imperious personality as Impresario Supreme of Baroque Rome. Of the multitude of disciples and collaborators, only one "to truly love and be loved by his master"?[18]

The second irony attached to the exquisite Villa Borghese sculptures is their connection with one of the most unsavory characters of Baroque Rome, Cardinal Scipione Borghese. Unsavory? The famously affable, good-humored man celebrated by his contemporaries as the Delicium Urbis, "The Delight of the Town"? He who loved fine art, restored ancient churches, and, in the aftermath of the great Tiber flood of 1607, rode out on a mule to bring comfort to the afflicted population? The "Delight of Rome" was in reality a Dr. Jekyll and Mr. Hyde personality whose public face was one of charming cordiality but who, in private, could be as ruthless as any sociopath in his mad pursuit of money, power, and pleasure. His was a life "utterly given over to pleasures and pastimes," as the Venetian ambassador reported. No wonder the very marble in which Bernini first attempted to capture Scipione's likeness revolted against the endeavor and cracked open to expose a sinister black gash across the cardinal's forehead and through his entire skull. These things, gentle reader, are allegory, as the nineteenth-century British novelist would say. Of course, his contemporaries knew well the truth about the private Scipione—there were no secrets in Baroque Rome—which is why the cardinal's fearful courtiers and other favor-seeking sycophants showered him with such public praise. Yet note that no one, not even his own true supporters, ever went so far as to praise him as intelligent, refined, pious, or tenderhearted.

Two of Bernini's statues for Scipione echo the traditional theme of "Beauty and the Beast" (*Pluto and Proserpina, Apollo and Daphne*); we might well add a third, the beast Scipione coveting the beauty, Art. This is the man who, yes, passionately loved fine art but had no qualms about using whatever immoral means to obtain it. He stole Raphael's *Deposition* from a family chapel in Perugia and imprisoned two artists (Domenichino and the Cavalier d'Arpino) in order to confiscate, without compensation of any type, valuable paintings in their possession (over one hundred canvases in the case of the Cavalier d'Arpino). Scipione went through the pretense of formally purchasing seventy-one canvases from Cardinal Sfondrati but never paid the 3,000 scudi owed him. The means he used to accumulate real estate—another of his great loves—were no less dishonest, as the Duke of Altemps and his heirs discovered first-hand to their grief and financial detriment: his "means" were to sign a legal purchase contract and simply "forget" to hand over the cash, no matter how many times reminded by the seller, even one of ducal status such as Altemps.

Yet, it is not that Scipione lacked the money to purchase for a fair and honest price art or real estate or anything else he desired. Thanks to the lucrative pensions, benefices, and outright cash gifts shamelessly poured upon him by his nepotistic uncle, Pope Paul V, Cardinal Nephew Scipione amassed one of the most astounding personal fortunes of the entire century. (And speaking of shameless acts, Paul V is the one who had the brazen audacity to inscribe his own name, in large letters, front and center on the new St. Peter's facade, as if—as a contemporary pasquinade lamented—the basilica were dedicated to him the pope, and not the Prince of the Apostles.) Scipione's detailed financial records have survived and show that his average annual income between 1605 (the year of his uncle's ascent to the papal throne) and 1633 (the year of his death) was over 200,000 scudi; in 1613 and 1614, it reached the astronomical sums of, respectively, 666,534 and 755,560 scudi. To make some sense of these figures in today's economy, know that 25,000 scudi in Baroque Rome had, roughly, the purchasing power of at least one million dollars.

But multimillionaire Scipione did not feel secure in his status. And woe to anyone who was perceived as a rival—or worse, actually tried to stand in his way. One such unfortunate man, in fact, a true, consciously active rival, was Cardinal Pietro Aldobrandini, Scipione's still-powerful predecessor as papal nephew during the reign of Clement VIII (1592–1605). According to

an eyewitness, Scipione was hell-bent on bringing about "the extermina-
tion of the greatness of the Aldobrandini family, in order to eliminate a
powerful enemy." Not even Cardinal Aldobrandini's huge, secret tribute
payment of 50,000 scudi in 1614 was enough to appease Scipione, who was
threatening to seize one of the family's fiefdoms near Ravenna. And all this
is just the tip of an iceberg whose true dimensions undoubtedly still lie hid-
den among the unpublished documents of the Roman archives. It has been
said, paraphrasing Balzac's *Père Goriot*, "Behind every great fortune there
lies a great crime." In Scipione's case, there were many.[19]

The details about the Aldobrandini case come from the secret report
of one of the Italian spies of King James I of England, Giacomo Antonio
Marta, distinguished university professor of jurisprudence, a sincere Cath-
olic who was gravely concerned about the conditions of his church, espe-
cially the scandalous behavior of its supreme leaders. The well-informed
Marta supplies even more intimate details about Scipione's private life and
lusts. Once installed, Bernini's *Apollo and Daphne* provoked a bit of scandal
among some of Scipione's more puritanical acquaintances for its sensual
depiction of the nubile, nude Daphne. So a face-saving moralistic Latin in-
scription written by Maffeo Barberini (an accomplished poet) was attached
to its base to deflect further criticism: "The lover who pursues fleeting out-
ward beauty grasps only branches and bitter fruit." However, as far as its
owner, Scipione Borghese, was concerned, neither the fair Daphne nor the
delectable Proserpina of the earlier *Pluto and Proserpina* represented the
least temptation. For the cardinal's eyes, instead, the real "near occasions
to sin" were the maidens' equally nude male pursuers, pretty boy Apollo
and beefy athlete Pluto.

Rumors about Scipione's homosexuality have been long acknowledged
by historians and generally dismissed as inconclusive. But that has now
changed with the recent publication of Marta's espionage reports, which
substantially confirm his sexual orientation. One of the reports, dated
June 19, 1612, in discussing an upcoming Roman dynastic marriage, men-
tions that the future bride has an older brother, who is so beautiful that
the beauty of an angel pales in comparison and "whom Cardinal Borghese
loves to the point of insanity." Accordingly, the report continues, Scipione
wants to have the handsome young man promoted to the cardinalate so
that "through the chain of this abominable turpitude [namely, a sodomitic

relationship], he would be more greatly bound to the Borghese faction."
A later report of January 1615 tells of more troubling news: "In the ante-
chamber of 72 [code name for Scipione Borghese] a youth, eighteen years
of age, has been found murdered. He is of the greatest beauty one can paint
with a brush. He was in a state of undress and this, they say, is how he left
72's bed. They say that the two of them had exchanged insulting words and
the youth had been killed by 72's servants who were guarding his bedroom
but who have since fled. The matter raises great suspicion given the boy's
beauty, 72's nature, the place where the body was found, and the fact that
72 professes to know nothing."

In view of these reports any uncertainty that the well-known relation-
ship between Scipione and his intimate friend and majordomo, Monsignor
Stefano Pignatelli (d. August 1623), was homosexual in nature all but dis-
appears. To the great scandal of the Roman court, Scipione was inseparable
from his beloved but morally compromised, notorious friend, even after
"books had circulated . . . recounting the vices of Stefano's life, vices so
numerous that not even St. Peter's cupola would be able to cover them."
In this ecclesiastical twosome, Pignatelli was definitely the dominant one:
members of the Roman court alternately giggled and wrung their hands
over his undue influence upon the great Cardinal Scipione—so feared by
the rest of the population but so utterly submissive to Pignatelli's com-
mands and desires. At one point, Scipione's uncle, Paul V, banished Stefano
from Rome in order to protect his nephew's reputation. But poor, heart-
broken Scipione fell into such a deep depression that the pope was forced
to recall Stefano from exile. Even Pope Paul found it hard to say no to
his spoiled nephew: Scipione eventually prevailed on his uncle to make
the most unworthy Pignatelli a cardinal despite the fact that "cardinals and
ambassadors did not fail to relate to the pope the grave crimes with which
Pignatelli had stained himself" (this language often referred to sexual sins).
Paul balked at the request, but in the end gave in and elevated Pignatelli
to the purple in January 1621. *Pasquino*, the ancient statue just outside
Piazza Navona that served—and still serves today—as the public voice of
Rome's witty but anonymous satirists, of course, had something mordant
to say about this shameful promotion. This is simply business as usual, it
explained (through the usual vehicle of slips of paper glued to its base or
to the wall behind): "Why is everyone so surprised? Spain campaigns for

her candidates, France for hers; everyone wants his own man to be made cardinal. So why shouldn't Cardinal Scipione's penis get what it wants too, its own man in the College of Cardinals?"

This is the patron to whom Bernini owes the beginnings of his public career in Rome, both his earliest fortunes as newly arrived boy wonder and, later in the mid-1620s, his first universally acclaimed success as independent master sculptor. In the Bernini biographical texts and "authorized" sources of papal Rome—as in many art historical studies relying on them—you will find, of course, not a hint of the unsavory side of Scipione's character, only warm, unconditional praise of the cardinal as lover of art and patron of talent. As for Bernini, we can be sure he and his father knew the truth of Scipione's "nature." The worldly-wise Pietro must have had at least a few moments of fear for his son's safety when the lad first caught the cardinal's excited attention ("the cardinal prince was quite enthralled by Gian Lorenzo," Domenico assures us) and later became his direct employee. The court records of Baroque Rome are filled with accounts of young boys raped especially by older and socially prominent men—like, for instance, Luigi Bernini himself, as we shall see later on in our story. Yet if there were any uncomfortable moments between Bernini and Cardinal Scipione, the primary sources are silent about them. Despite it all, Bernini seems to have enjoyed with this powerful patron a long-lasting, mutually beneficial working relationship. "Una mano lava l'altra," one hand washes the other, as the Italian proverb says. Bernini got fame, fortune, political protection, and generous opportunities to exercise his genius; Scipione got a tremendous boost to his public image as a respectable patron of the arts, in addition to works of sculpture whose social, aesthetic, and monetary value far surpassed the price he originally paid for them.

In another notorious case of Bernini's willing commerce with unsavory patrons, we meet the infamous Donna Olimpia Maidalchini, the real power behind the throne for most of the reign of her brother-in-law and reputed former lover, Pope Innocent X (1644–55). During her reign of terror as the "first lady" of Rome—she was effectively "la popessa" in the eyes of many Romans—Donna Olimpia was one of the most hated figures in the city. Much of that hatred was, regrettably, rooted in justifiable grounds. However, again, you will find no criticism of Donna Olimpia in the earliest Bernini biographies. In fact, because of the long-lingering contempt and disgrace attached to her memory, you will find hardly a mention of her at

all. Yet we know from independent sources that Bernini collaborated and otherwise interacted with her on several noteworthy occasions—on one occasion he even sent her a huge bribe of 1,000 doubloons in a moment of desperate need (hoping to prevent the demolition of his bell towers at St. Peter's). Bernini was, of course, acutely well aware of Donna Olimpia's character and reputation, but whatever he personally felt about her he kept to himself. The same holds true for another of his patrons who was less than morally exemplary and much criticized by contemporaries as ruthlessly ambitious and licentious, Cardinal Antonio Barberini, Jr., whom we shall meet later in these pages.

Throughout his career, as with Scipione Borghese, Bernini was to refrain entirely from making any public judgments about the rich and powerful. He just followed the money, their money. In any case, to utter even the vaguest public criticism of the rich and powerful in Baroque Rome was downright dangerous. Every wall had ears. "As you know only too well, the streets of our neighborhoods are frequented by spies sent by the [Papal] Palace and the governor [of Rome]," warned one contemporary compiler of anonymous news bulletins (*avvisi*) from the city. "As far as the personal interests of the powerful are concerned, one should either keep quiet or else praise them. The ink of those pens that are not used to celebrate their names usually end up mixed with blood," so warned Antonio Lupis in a letter to the outspoken ecclesiastical critic the Reverend Ferrante Pallavicino. (Pallavicino was the prolific author of vicious political satires, most of them widely published best-selling books in their day—*The Postman's Stolen Mailbag*, *The Rhetoric of Whores*, *The Celestial Divorce*, *The Hermaphrodite Prince*.) The warning was prophetic: Pallavicino's career as critic of the papacy and the secular princes came to an abrupt, violent end when he was just twenty-five years old, beheaded in 1644 by the order of Bernini's dear friend, Pope Urban VIII.[20]

THE TENDER AND THE TRUE

Returning to Bernini's first major, free-standing statue for Scipione, the *Aeneas and Anchises*, we hear Baldinucci praising the work for its great naturalism, which would become a celebrated hallmark of Bernini's sculpture. The biographer describes how in Bernini's "imitation of nature," to use Baroque artistic parlance, we can already see "a certain coming closer

to the tender and the true, toward which even then at that age [twenty years] Bernini's excellent taste was leading him." By "the tender and the true" Baldinucci means Bernini's unsurpassed ability to capture his subject in cold marble— not only the physical reality (soft human flesh, for instance)—but also the inner, psychological reality, such as the poignant, subtle emotions communicated through the faces of the figures. *Tenero* (tender or soft) and *tenerezza* (tenderness or poignancy) are key words, with simultaneously physical and emotional denotations, in the artistic vocabulary of Gian Lorenzo Bernini, especially his portraits. And portraits are what above all kept the young artist busy in those early years in Rome, for he soon established himself as a leading portraitist of prelates, princes, and patricians of all ranks.

One of the more successful and famous of these early busts (now seen by few in the refectory of Santa Maria in Monserrato in Rome) is that of the distinguished prelate Monsignor Pedro de Foix Montoya. A jurist of the papal tribunal, the Segnatura, Montoya was a cold, cerebral, and bleakly ascetic Spaniard with grim, emaciated features. Just the type of forbidding presence capable of putting the proper fear of God into any misbehaving or excessively fun-loving citizen who ended up having to face him in court. Yet, while in no way flattering the monsignor in the depiction of his physical traits, the young Bernini succeeded in capturing his personality and spirit so brilliantly that in the end we are irresistibly drawn to the man.

At the same time, no one, including Montoya himself, complained about the fact that Bernini had not flattered him. On the contrary, they marveled over the uncompromising, true-to-life final product. As Cardinal Maffeo Barberini famously joked, it was more alive than the desiccated Spanish prelate himself: "Hearing someone remark that 'this is Montoya turned to stone' at the moment in which Monsignor Montoya himself happened to arrive on the scene, Cardinal Maffeo approached the prelate in a spirit of jest and touched him, saying: 'This is the portrait of Monsignor Montoya,' and, turning to the statue, added, 'And this is Monsignor Montoya.'" And as demonstration of the social capital attached to a Bernini portrait, we are told that "this Spaniard paid him extremely well, but left his portrait in Bernini's studio for a long time without sending for it. Bernini was rather surprised and spoke to several people about it, who explained to him that, as many cardinals and prelates saw the portrait in the studio, this did honor to Monsignor Montoya, for these same cardinals, ambassadors, and prel-

ates stopped their carriages when they saw him in the street to talk to him about it, which pleased and flattered him, as before he had been remarkable in nothing." This is no modest exaggeration on Montoya's part: his name would have long been banished to oblivion—in fact, immediately after his death—were it not for Bernini's sculpture.

However, the culmination of all of Bernini's portrait art, as well as "a milestone in the history of sculpture and one of the finest portraits of all time," is by virtually universal consensus his "speaking likeness" in marble of Cardinal Scipione Borghese (fig. 4). Actually, we need to use the plural here, since Bernini was obliged to quickly sculpt a replica of the first bust, when, in the final stages of finishing, an ugly crack opened up, as mentioned, across the forehead of the original. Domenico refers to it as a mere "blemish," one of several untruths in his account of the Scipione Borghese portrait. Bernini was still a boy, a "picciol'artefice," when he executed this work, boasts Domenico with gross inaccuracy, whereas in fact Bernini had been thirty-four years old (documentation dates the bust to 1632–33). Domenico also claims that Bernini feverishly sculpted the second bust in just three days; Baldinucci, instead, reports a more credible fifteen. More believable and often repeated, even if not perhaps entirely true, is Domenico's tale of the bust's unveiling in which the ever-playful Bernini teases Scipione by first showing him the defective bust, prompting the cardinal's spirits to deflate at the sight, whereupon they soar again at the surprise unveiling of the second, blemish-free version. Actually it too has a crack in the marble (in the lower region of the cardinal's garment), never mentioned in our sources, presumably exposed during the finishing process, but one that is far less noticeable. This marble, too, refused to be a fully cooperative accomplice in Bernini's endeavor to celebrate and immortalize the sordid Scipione Borghese.

As is surprisingly the case for so many of Bernini's celebrated works, little documentation survives of the origins of the Scipione Borghese portrait. We are not even sure who commissioned it. Was it Pope Urban or Scipione himself? It has been described as a possible "labor of love" for a sickly and soon-to-die patron. Yet it is doubtful that Bernini or anyone besides Stefano Pignatelli had any real love for Scipione. The obese fifty-six-year-old cardinal, beset by gout and other ailments brought about by a dissolute lifestyle, died shortly after the unveiling in September 1633. Morally repugnant and physically decrepit as Scipione was when he sat for

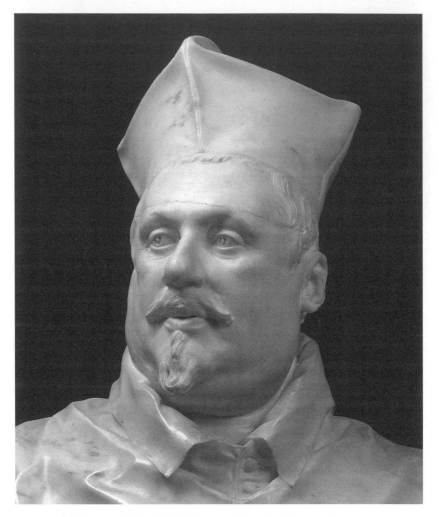

FIG. 4 ⇥ G. L. Bernini, *Cardinal Scipione Borghese* (detail), 1632 (first version; note the large crack across his forehead). Galleria Borghese, Rome. Photo: Scala/Ministero per i Beni e le Attività culturali/Art Resource, NY.

this portrait, the final result is a likeness of amazing liveliness, so compellingly attractive for having captured the very spirit and flesh of its sitter. Like the Montoya portrait, the Scipione bust serves to illustrate Bernini's pronouncement: "It is in imitation that the whole beauty of art resides. Imitation alone renders objects delightful and endearing to viewers; so that, for example, a disgusting old woman seen in real life provokes nausea, whereas

when seen in a well-executed painting [or sculpture as in this case], the same woman is a source of delight."[21]

Apart from Bernini's superb technical expertise in carving marble, what made such a physically and psychologically "truthful" and "tender" portrait possible was the artist's astute skill as an observer of humanity. He captured with his eyes, and therefore his sculpting tools, not just the outer reality of the human beings before him, but also and perhaps even more important, their inner reality as well. It is no coincidence that the several contemporary descriptions of Bernini's physical appearance all mention the penetrating glance of his black eyes: "such a piercing look that by his glance alone he could instill terror." It must have been uncomfortable to look Bernini straight in the eye. As both artist and courtier struggling to survive in a dog-eat-dog environment where people's facial expressions and speech were used as much to hide as to reveal, Bernini had to become an expert in "reading" people. And in this he would have been guided not only by instinct, but also by the best-selling handbook of human physiognomy—the "science" of discerning a person's character through a careful reading of his or her physical traits—the *De humana physiognomia* by Giambattista della Porta. Probably influenced by della Porta's drawing of systematic parallels between the human and animal populations, Chantelou's description of Bernini's face likens it to a specific beast of nature, a mighty bird of prey: "His face resembles an eagle's," the Frenchman notes, "particularly the eyes." Entirely appropriate for one who made his living as a master observer. And for one who aggressively and at times fiercely pursued the object of his attractions and aspirations.

The same large, penetrating black eyes are also the one physical constant in all of the many portraits and self-portraits that we now have of Bernini (figs. 5, 6, 18). Spanning most of the artist's lifetime, from circa 1612 (self-portrait drawing, Museo Horne, Florence) to the late 1670s (another self-portrait drawing of 1678–80 at the British Museum), they offer further opportunity for a glimpse of the real Bernini under the many, obstructing layers of idealizing myth in the early published biographies. The first mature self-study of the artist is the fetching portrait in oil in the Galleria Borghese, dated around 1623 (fig. 7). It probably coincides with the beginning of Bernini's intense immersion in the practice of painting imposed upon him by Pope Urban VIII. Urban had grand (but never realized) dreams of Bernini's accomplishing for him in the Benediction Loggia at St. Peter's

FIG. 5 ↠ G. L. Bernini, *Self-Portrait*, ca. 1612. The earliest known self-portrait. Fondazione H. P. Horne, Florence. Horne inv. 5567.

what Michelangelo had achieved for Julius II on the Sistine Chapel ceiling. Unfortunately, though Bernini was an excellent painter, monumental narrative scenes such as traditionally adorned the wide expanses of the walls of the Vatican were beyond his ability. What is left of Bernini's canvases are mostly human faces, close-up, against a dark, empty background, just as we see in this self-portrait of 1623. What we also see there is a skinny young man with longish, unruly black hair, a pronounced but regular nose, dimpled chin, and full, sensual red lips. (In his engraved portrait of

a younger, smiling Bernini published in 1622, Ottavio Leoni—who must have known something of the private life of his sitter—heightens the sexual charge of Bernini's presence by giving him rather angular, protruding satyr-like ears.) The artist's face is intelligent and introspectively intense, handsome but with little traces of *tenerezza*. His expression is inscrutable, as if the young man were not sure of what he was seeing. Was he a puzzle to himself? Was he still suffering from the painful insecurity of youth?

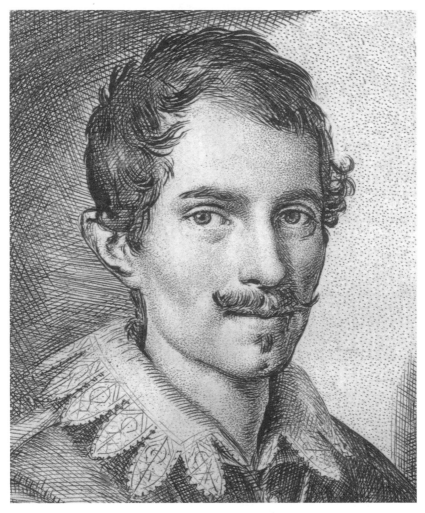

FIG. 6 ➤ Ottavio Leoni, *Gian Lorenzo Bernini* (detail), 1622. Author's collection.

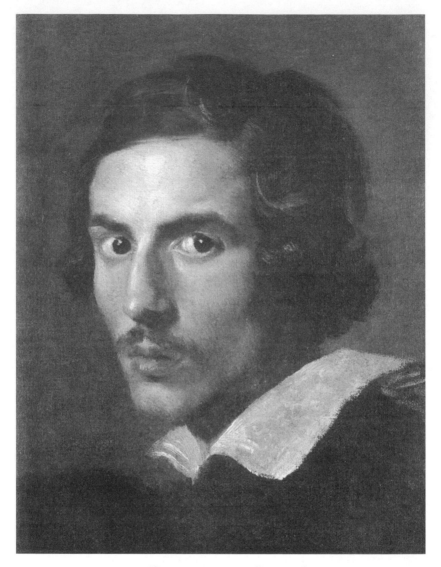

FIG. 7 ➤➤ G. L. Bernini, *Self-Portrait*, ca. 1623, Galleria Borghese, Rome.

The intense leanness of Bernini's face becomes more pronounced, taking on a feverish tinge, in the next few likenesses we have of him, all from the 1630s (figs. 8, 18). This is no wonder, given the frenetic pace of his artistic production in that period. No wonder, too, that as a young man Bernini also suffered terribly from migraine headaches, so much so that he could hardly tolerate the mere reflections of sunlight. In fact, says Baldinucci, be-

cause of the "hotness" of his natural temperament Bernini was in a state of general ill health until the age of forty. After that, his natural heat cooling off with age, his constitution became reliably robust, despite occasional, even serious bouts of "fever" reported by other sources. This physiological turning point coincided with Bernini's marriage, although the Florentine biographer does not make that connection. Son Domenico and Parisian friend Chantelou also note Bernini's exceptionally "ardent" or "fiery" nature. Domenico even goes so far as to label it *ira,* wrath: "Rather stern by

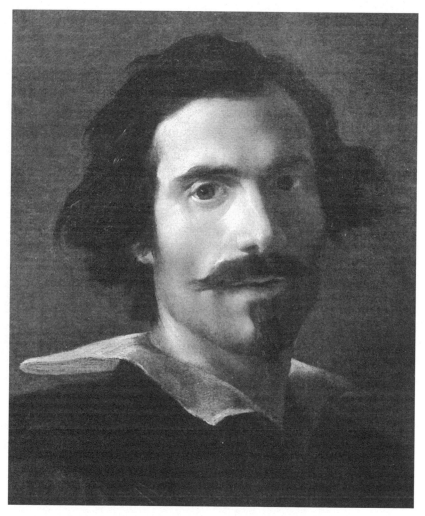

FIG. 8 ➺ G. L. Bernini, *Self-Portrait,* ca. 1630, Uffizi, Florence.

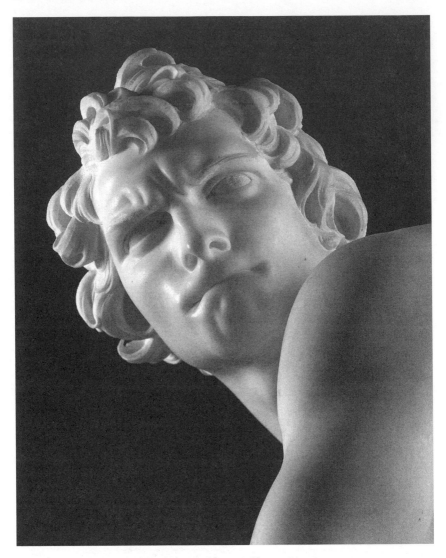

FIG. 9 ⤭ G. L. Bernini, *David* (detail of face, a self-portrait), 1623–24.
Galleria Borghese, Rome. Photo: Andrea Jemolo/Scala/Art Resource, NY.

nature even in matters that were well done, he was driven in his work and passionate in his wrath, which used to inflame him more so than others. But it was to the force of this wrath that he attributed his ability to work much more than others."[22]

In premodern medicine, all human temperaments were classified according to four fundamental psychological types—sanguine, choleric,

melancholic, and phlegmatic—manifesting in combinations of four basic physical states—hot, cold, dry, and wet. The classification derived from the universally accepted ancient medical theory of the four humors or principal fluids of the body: blood, yellow bile, black bile, and phlegm. As his contemporaries would have understood immediately, Bernini was unambiguously a "choleric" type, characterized by a high energy level, a quick temper, the need for a simple, spare diet, and, says della Porta in *De humana physiognomia*, also frequent sexual intercourse. Bernini's "choleric" self is captured quite explicitly in another self-portrait by our artist—in his Borghese statue of David, the young, fiercely concentrated, Old Testament hero, about to slay the (unseen) giant Goliath with a mighty hurl of his readied slingshot (fig. 9). Whatever religious, literary, or political meaning the statue may have had for its patron, it is not surprising that the young and wildly ambitious sculptor would have chosen to personalize the subject by endowing both the face and body of David with his own features. Bernini was then in active, conscious competition with the "giants" of his profession, Michelangelo and the ancient masters of sculpture. And with this *David* and his other statues for Scipione Borghese, he succeeds in "slaying" them all. An act of incredible arrogance on the part of a fledgling sculptor—presenting himself as another David? Yes—but one that turned out to be, in this case, well justified.

BERNINI REJOICES

On January 28, 1621, after an exceptionally long reign for those times, Pope Paul V Borghese came to the end of his days. In this same year, Philip III of Spain also died, Bernini's sister Camilla was married to the otherwise unknown and curiously named Bonus de Bonis, and in Leiden mechanical innovations to textile weaving were inaugurated, leading to the production of less expensive goods, eventually ruining the economy of northern Italy. Back in Rome, according to well-informed diarist Giacinto Gigli, Pope Paul died—"they say"—a virgin, noting that sexual fact as if it were a matter of marvel, even in the case of supreme pontiffs. It had been a momentous pontificate politically—an intense showdown with defiant Venice in the Interdict Crisis, the worsening of the plight of Catholics in Protestant England, and the beginning of what was to be the calamitous Thirty Years' War.

But, most important for what concerns us here, the Borghese reign brought with it the infusion of a new artistic spirit in papal Rome, one that would dominate the rest of the century. The austere, somber, cautious style of ecclesiastical art and architecture of the Counter-Reformation of the previous fifty years came to an end. It gave way, encouraged by the pleasure-loving ways of papal nephew Scipione Borghese, to a bold new style of greater color, movement, light, emotion, and playfulness—in other words, the Baroque. The Baroque style actually had its origins in the Bolognese Annibale Carracci (died 1609) and the Lombard Caravaggio (died 1610). But it was to be, above all, the Neapolitan-turned-Roman Bernini who would give full expression to this new, experimental, and at times even revolutionary spirit in art. Yet, in doing so, Bernini proved that this new style could be in harmonious accord with the perfectly orthodox, conservative propagandistic aims of the aggressively reassertive papal monarchy. In other words, old wine in dazzling new wineskins. People would flock in droves to the Seat of Peter to drink piously and obediently of this spiritually inebriating drink. Bernini had arrived on the scene at the right time and place.

By the end of Paul's reign, Bernini, aged twenty-three, was newly but decidedly established within the highest echelons of artistic patronage in Rome. He had come a long way in a short while. But the fact that he was already so intimately dependent on the papal family—the Borghese—and those in its immediate sphere for patronage and protection represented not only a blessing but also a liability. Whatever he had accomplished thus far could all be wiped out in a single moment, that is, in the election of a new pope. The new pope could be uninterested in art (art appreciation was not a prerequisite for the job) or hostile to Bernini's previous patrons and therefore to Bernini as well. Guilt by association was a sentence frequently passed in Baroque Rome. If that occurred, Bernini would have to scramble to rebuild his network of patrons and protectors, or worse, leave the city altogether. Thus he was afraid, very afraid, as the cardinals sealed themselves off from the world in conclave to elect a new "Vicar of Christ." Domenico tells us, however, that "his fears were very soon quieted by the elevation of Cardinal Alessandro Ludovisi to the papal throne. . . . It is not to be believed how greatly Bernini rejoiced in seeing elected as his prince the same person who had shown such enthusiasm for his artistic efforts and who just a short while before had been a guest in the artist's own home with

liberty and open familiarity." Saved by the conclave's puff of white smoke. Bernini could breathe a sigh of relief. It had also been a remarkably short interval between papal reigns, the new pope being elected on only the second day of the conclave, February 9. But Bernini would have to live through this same anxiety-ridden sequence of papal death, conclave, and election six more times in his lifetime. He came out a winner most of the time.

The new pope, Gregory XV, had indeed been and would continue to be a good friend to Bernini. Bernini had already done his portrait as cardinal, probably a chalk drawing, now lost. Moreover, neither Gregory nor his papal nephew Ludovico Ludovisi seems to have held Bernini's Borghese connections against him even though there was no love between the two families, the Ludovisi and the Borghese. Too bad Gregory got to enjoy the papal throne for only two and a half years. Though his reign was short, however, this pontiff was to confer an honor upon Bernini that the artist would enjoy for the rest of his life, the privilege of being called "Cavaliere," Knight. To thank Bernini for having executed a series of masterful papal portraits in bronze and in marble, on June 30, 1621, Gregory inducted him into the chivalric Order of the Cross of Christ, the same reward bestowed on a number of other artists (including his rival, Francesco Borromini) for their service to the papacy. From then on, Bernini was to be referred to as "Cavalier Bernini" or simply "Il Cavaliere." We can see the newly knighted Sir Gian Lorenzo sporting the insignia of his new honorific fraternity in Ottavio Leoni's 1622 engraved portrait. It is the only portrait of Bernini that shows him smiling and carefree (and with satyr's ears!). The knighthood also came with a small annual pension, one of many pensions or benefices that would be bestowed on Bernini or his family by appreciative popes, helping the Bernini family reach the status of multimillionaires by midcentury.

The several portrait busts of Gregory are the sum total of Bernini's work for this pope. But Bernini was also busy during the Ludovisi papacy with other portrait busts of eminent personages (three cardinals, Alessandro Peretti Montalto, François Escoubleau de Sourdis, and Giovanni Dolfin; and a layman, Antonio Cepparelli), as well as some of the works that have already come up in our discussion, most notably, the Montoya bust and four of the five Scipione Borghese statues. The now very frightened Scipione, by the way, fearing for his life at the hands of his implacably hostile successor in the powerful office of papal nephew, Cardinal Ludovico Ludovisi,

quickly made a gift of his precious *Pluto and Proserpina* to Ludovisi, hoping to appease his nemesis. Ludovisi (reports another diarist and long-term resident of Rome, Dutchman Teodoro Ameyden) "threatens Borghese one day with imprisonment, and the next with death, in order to reduce him to a state of utter terror and thus seize all his wealth and benefices."

On January 30, 1622, Bernini pulled off another artistic and technical tour de force with the unveiling of the sumptuously complex wood, stucco, and papier-mâché catafalque at the solemn ceremonies in honor of Pope Paul V on the first anniversary of the pontiff's death and the transfer of his body to its permanent resting place in Santa Maria Maggiore. (In Baroque Rome, "catafalque" refers to a temporary but usually colossal funerary monument used to represent the deceased at memorial services in absence of the body.) Though not the designing architect, Bernini helped execute the massive structure (nearly 60 feet in height and 33 in diameter) in just five weeks. His principal contribution came in the form of thirty-six, larger-than-life statues, sixteen of them representing virtues of the deceased pontiff—it must have been news to the Roman populace that Paul V had possessed so many virtues. This meant that Bernini had to come up with distinctive designs for all the figures and execute them at a rate of one statue per day. This rate of production and the jaw-dropping finished product helped establish him as a veritable *stregone*, a "wizard" of artistic creation, able to conjure up designs and works of art with amazing, seemingly magical speed. Bernini would be commissioned to do several other catafalques in the course of his long career, this becoming yet another of his artistic specialities.

The same year, 1622, marked another important first in Bernini's life: his first work for a Roman fountain, a genre of sculpture and architecture that was to account for a great deal of his lasting fame, to this very day. *Neptune and Triton*, a monumental statue, served as the prominent centerpiece of a large basin fountain in the Villa Montalto, the largest villa of all Roman history, property of Cardinal Alessandro Peretti Montalto, nephew of Pope Sixtus V. The vast, exquisite villa is, sadly, no more—it occupied the now completely developed and rather blighted terrain between Santa Maria Maggiore and today's Stazione Termini. But the statue survives: purchased by English painter Joshua Reynolds in 1786, it is now in London's Victoria and Albert Museum.

By July 8, 1623, Gregory XV was dead. He had made sure during his time in office to quickly enrich his family, especially his nephew, Cardinal Ludovico, so as to establish a lasting financial and political foothold in Rome for the Ludovisi. The family legacy does endure in Rome today, most notably as the name of an upscale neighborhood, the Quartiere Ludovisi, in the vicinity of the Via Veneto and the American Embassy. The Quartiere is the site of the family's estate, once extensive with much lush parkland, but sold off to developers and covered over with brick, asphalt, and concrete in the late nineteenth century in the gross speculation that followed Rome's designation as capital of the newly formed nation of Italy.

The Ludovisi were never to produce another pontiff, even though naturally Cardinal Ludovico had hopes in the aftermath of his papal uncle's death. Unlike during the conclave of 1621, the cardinals who were gathered and locked up in the Sistine Chapel in the summer of 1623 to elect a new Vicar of Christ did not come to a quick, easy agreement. The exceptional heat of the summer season did not help to accelerate the process. Scores of cardinals and their *conclavisti* (personal secretaries sequestered in conclave) fell ill to what was probably malaria, and several died. Among the seriously ill was Bernini's friend and tutor, Maffeo Barberini. Barberini himself believed that he had been poisoned (by means of a bouquet of flowers) and was treated accordingly by his doctors. (Fear of poisoning among the rich and powerful in the courts of Baroque Rome was widespread, and for good reason.) The real culprits in prolonging the agony of indecision were, above all, the two warring, now-disenfranchised cardinal nephews Scipione Borghese and Ludovico Ludovisi. Outside the conclave, in the streets of Rome, as was usual in time of *Sede vacante* ("empty Seat"), that chaotic interim between papal reigns, lawlessness—murder, rape, looting, and sundry violent acts of revenge—prevailed. Meanwhile, inside the family home at Santa Maria Maggiore, far away from the Vatican and the cardinals in conclave, Bernini waited, holding his breath.[23]

IMPRESARIO SUPREME

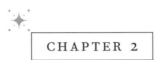

CHAPTER 2

"Pretty-Beard Urban"

The cardinal who emerged half dead but overwhelmingly victorious from the malaria-stricken conclave of 1623 had in fact been a dark horse until practically the last moment. This we know from the scrupulous scorekeeping notes that he kept after each tense round of voting. "He," of course, is Cardinal Maffeo Barberini, who has already figured prominently in our story. Bernini must have jumped for joy when he heard the news. Yet another tried-and-true friend on the papal throne! And one who was young enough (fifty-five) to promise a long reign of large-scale commissions and gifts and rewards. Maffeo assumed the name Urban VIII, in honor of his revered eleventh-century crusading predecessor, Urban II. But the name also fit his "urbane," refined personality and attractive, though somewhat vain and fastidious, personal appearance. *Urbano dalla barba bella*, "Pretty-beard Urban," was the saucy nickname pinned on him by one of his critics, and it stuck (fig. 10).

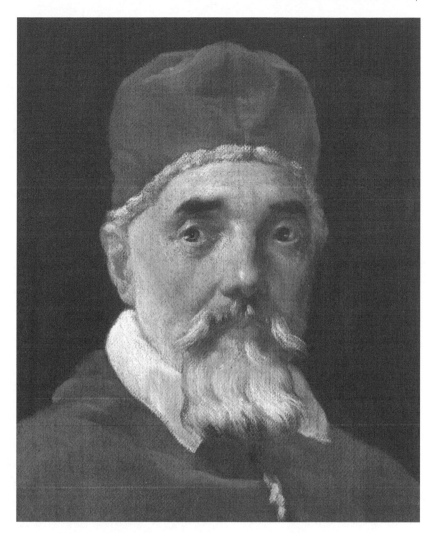

FIG. 10 ➤➤ G. L. Bernini, *Pope Urban VIII*, ca. 1631–32, Galleria Nazionale d'Arte Antica, Palazzo Barberini, Rome.

Though a dark horse among his peers, Cardinal Maffeo, in the silence of his heart, was expecting that victory from the beginning of the conclave. Years earlier, at the age of sixteen or seventeen, during his university studies in Pisa, it had been predicted to him that he would one day become pope. The prediction came from Don Andrea Lorestino, a shadowy, unkempt Sicilian cleric who was later imprisoned by the Inquisition. Lorestino dabbled in astrology, as did many other ecclesiastics in Baroque Italy.

Even Maffeo himself practiced the art. This was true especially after he became pope, when the stakes of his ambitions and decisions were fearfully high. In a letter to his employer, the Duke of Modena, Bernini's poet-diplomat friend Fulvio Testi declares: "The Pope is a most expert astrologer and has the nativity charts of all the cardinals." Testi's information is amply confirmed by several other accounts, among them, most authoritatively, an official dispatch to the Venetian Senate by its ambassador to the Roman court, Alvise Contarini: "Pope Urban regulates his life largely according to the motion of the stars, of which he is very knowledgeable, even though by heavy punishment he has forbidden their study to everyone else."

The young Maffeo vividly remembered Lorestino's prediction, for he later described it to one of his close associates who in turn featured it prominently in the anonymous biography of Maffeo's prepapal years, the *Sincero racconto della Vita del gran Pontefice Urbano VIII dalla sua pueritia all'assuntione al Pontificato* (Truthful account of the life of the great pontiff Urban VIII from his childhood to his elevation to the papacy), most likely authored by his long-term personal secretary, Francesco Adriano Ceva. Though respectful of Urban, the *Sincero racconto* gives the lie to idealizing, "authorized" accounts of Maffeo's behavior in conclave that paint a picture of cool, detached, well-behaved piety. In fact, he fully participated in the impassioned politicking and crude, behind-the-scenes intrigue of the all-too-human, frequently rowdy process. At one point, overhearing an insulting remark made by Cardinal Crescenzi, the wildly enraged Maffeo jumped to his feet, ready to propel his dinner plate of steaming calamari against the offending prelate. Fortunately his secretaries restrained him, keeping him from an act of impropriety that would have immediately disqualified him for the papal throne. On another occasion, we find him deep in the night making his way to Scipione Borghese's cell for another round of secret strategizing, having donned a wig and a fake beard to disguise himself.[1]

Tempestuous fits of irrational anger were to be a disturbingly recurrent feature of Maffeo's behavior even after his election, with no one to restrain the Supreme Pontiff. Galileo Galilei, humiliatingly forced to recant his "heretical," revolutionary scientific views (he dared to teach that the earth was not the center of the universe, in contradiction of the Bible) is only the most famous victim of the pope's wrath. For a long time Galileo had avoided the Inquisition's condemnation—until something he did or wrote personally infuriated his former friend, the emotionally unstable Urban, who abruptly

turned on the scientist. The prevailing theory about this violent change of heart was that the pope suspected that he himself was Galileo's model for the narrow-minded, silly character Simplicio (Simple One) in the *Dialogue on the Two Great Systems of the World*, but would Galileo have been so impolitic? Another of Pope Urban's victims was the dutiful curial bureaucrat Cardinal Domenico Cecchini, whose diary provides a vivid description of one especially chilling, almost ghoulish, candlelight cross-examination of the hapless prelate by the nearly psychotically irate pontiff. As for Bernini, despite his long years of association with Urban, he seems to have escaped the worst of Urban's temper tantrums, though he did suffer his wrath on occasion. When his ill-fated bell tower for St. Peter's was unveiled in June 1641 and found greatly wanting, our artist was reprimanded by the pope to such an extent that he "fell ill and was in great danger of death," according to Roman diarist Giacinto Gigli.

The unpredictable, irascible, astrology-addicted Urban was also an accomplished poet. Even after assuming the papal tiara, he continued to spin out elegant verse in Latin and Italian, in a classicizing but thoroughly pious manner. His aim was to set a chaste Christian standard against that of the reputedly licentious but enormously popular poet Giambattista Marino, the founding father of Baroque poetry in Italy. Urban could not have been very happy in 1622 when Marino took up residence in Rome for several months on his way back to his native Naples, after an extended, honorific stay at the royal court in Paris. (There is no indication, however, that Marino and Bernini, two Neapolitans of kindred aesthetic spirit, ever met in this period.) Urban must have been even less happy over the great postmortem honors shown to Marino at the Mancini residence on September 10, 1625, with the Spanish ambassadors, Cardinal Maurizio of Savoy, and other prelates and nobility in attendance.

Disapprove though he did of Marino's sensual, exuberant poetry, in matters of art and architecture, Pope Urban was, nonetheless, a man of the new age of the Baroque. Not only did he continue the new liberated artistic trend that was set in motion during the Borghese pontificate, he helped bring it close to its apex—the apex comes in the reign of Pope Alexander VII (1655–67)—through the spectacular, sumptuous embellishments that he ordered for St. Peter's Basilica—above all, Bernini's Baldacchino, the theatrical gilt-bronze canopy towering over the main altar as a stately, ceremonial frame. Urban, says Domenico, was a man "capable of illustrious

and glorious undertakings," and wherever those undertakings concerned art and architecture (as they often did), Bernini was the pope's man from the start. "On the very same day of his election, the new pope had the Cavaliere summoned to his presence and addressed him with these words: 'It is a great fortune for you, o Cavaliere, to see Cardinal Maffeo Barberini made pope, but our fortune is even greater to have Cavalier Bernini alive during our pontificate.'" Despite his exalted new status, Urban insisted on maintaining the emotional-social tone of his earlier relationship with Bernini. They were to be pals, as before, despite the huge, shiny papal tiara now on Urban's head:

> Urban made it clear to Bernini that he wanted to be treated by him with the same familiarity with which the artist had treated him while a cardinal. Urban gave orders that Bernini was always to be granted free access to his own quarters without prior appointment. The pope, moreover, wanted him at the dinner hour to join him at table and remain there until it came time for his afternoon repose. In fact, it was the Cavaliere's custom to accompany Urban to his very bed, close the shutters for him, and only then take his leave from the pontiff.

Putting the pope himself to bed! What greater pontifical intimacy could an artist possibly enjoy?

In bed was, in fact, where Urban was obliged to spend a great deal of the first two months after his election recuperating from the near-fatal case of malaria that had struck him during conclave. The papal coronation, always a much-awaited glorious spectacle within the spectacle-studded public life of Baroque Rome, had to be postponed by several weeks. With the new pope nowhere to be seen in public, the Roman population soon concluded that he was dead and that they were again without effective governance. This threatened a renewal of the dreaded lawlessness of *Sede vacante*. The subsequent scene described by Domenico as mere comic relief in his biography—the Curia's attempt to quell the anxiety of the common masses—instead reveals the "wizard" status that the twenty-five-year-old Bernini had already acquired for himself in the eyes of the public. (Some might reject the anecdote as a fabrication by Domenico, but, to me, it rings true.) Once the newly elected pope had regained a bit of strength, it was decided

that, although quite debilitated, the still uncrowned Urban would at least appear briefly at his window to disprove rumors of his demise:

> Word of the scheduled papal appearance was officially announced and there was nobody who, either stimulated by curiosity or desirous of verifying the truth, did not betake himself to St. Peter's Square onto which gave the window chosen for the papal benediction. Rising from his bed, the pope made his way to the appointed window, holding on, and not without extreme effort, to the arms of his assistants.
>
> However, the gesture was in vain, for the people began to shout that "This was not their Pope Urban, but rather his corpse, which, thanks to some artifice on Bernini's part, was being held intact and moved about as if alive; that they had seen the Cavalier Bernini just a few moments before at that very window and this, therefore, could be nothing more than an invention of his for giving motion to an already dead body."[2]

"THE MICHELANGELO OF HIS AGE"

Although he had many works to complete for other patrons (Scipione's statues, Cardinal Roberto Bellarmino's tomb, as well as busts of Monsignor Montoya, Antonio Cepparelli, Archbishop Carlo Dal Pozzo, and Duke Paolo Giordano Orsini), Bernini was soon caught up in—or rather, gladly gave himself to—the whirlwind of Urban's grand schemes. These were enterprises that Urban set in motion for the embellishment and aggrandizement not only of St. Peter's Basilica, the papacy, and the city of Rome, but also, of course, his own personal glory and that of the Barberini family. Following the time-honored practice of all those who ascended to the papal throne, Urban summoned his closest relatives from Florence to Rome and showered them with highly paid sinecures in the papal bureaucracy and outright, lavish gifts of cash, all at the expense of the papal treasury. Without their direct pipeline to the papacy through Urban, the Barberini would have in all likelihood remained just another wealthy merchant family of Italy.

Before long, Bernini was working exclusively for the pope and his family (among them, especially papal nephew Cardinal Antonio). In so doing, Bernini would fulfill Paul V's prophecy and secure his status as "the

Michelangelo of his age." On extraordinary occasions, when it was po-
litically expedient, Urban would release Bernini's services to other patrons
such as the prime minister of France, Cardinal Richelieu, and the King of
England, Charles I, whose portraits Bernini sculpted in marble (respec-
tively, 1636–37 and 1641–42). Urban's own portrait in marble was, of
course, one of the very first commissions Bernini received from the pope,
who also set Bernini to doing portraits of his parents and various other
Barberini family members (such as his uncle and mentor, the bearded,
dignified Monsignor Francesco Barberini, now at the National Gallery,
Washington, DC). Fine, lively portrait busts of Urban, with benignly twin-
kling eyes, still survive in the Galleria of Palazzo Barberini and the National
Gallery of Canada in Ottawa and are just two of several—in stone, metal,
and paint—that Bernini created to immortalize the Barberini pope.

Pope Urban, in turn, lost no time in showering Bernini with new sala-
ried offices that came with both privileges and responsibilities. The ver-
satile Bernini was not only to serve as, in effect, "Minister of the Papal
Public Image," but universal factotum as well. (Alexander VII would later
follow Urban's example in his dependence on Bernini as a kind of general
contractor.) In 1623 or shortly thereafter, Bernini became, in rapid succes-
sion, chief curator of the papal art collection, director of the papal foundry
at Castel Sant'Angelo, commissioner of the fountains in Piazza Navona,
and superintendent of the fountains of the Acqua Felice aqueduct sys-
tem. Later, Urban would also put Bernini in charge of the Acqua Vergine
aqueduct system, which feeds his famous Barcaccia Fountain (1627–29) in
Piazza di Spagna. Today, the inhabitants of first-world cities and towns
take for granted the availability of clean running water and so might think
that being put in charge of so mundane and utilitarian an aspect of urban
life as the water supply was both beneath Bernini's dignity and beyond his
interests. But few things in Rome were as vitally important as water. Rome,
like any city, could not survive without a reliable, abundant source of po-
table water. It was literally a matter of life and death. Bernini's new aquatic
authority, therefore, made him an extremely important man in town.

But that importance went further. In seventeenth-century Rome, the
public, ornamental display and delivery of water happened also to be a vital
component of the propaganda campaign of the self-congratulatory papacy
in conscious emulation of its predecessors in governance, the emperors of
ancient Rome. Water—the giver of life—was a powerful symbol eagerly

exploited by the popes—the custodians of the giver of life—in the form of spectacularly ostentatious fountains. Repair of the ancient aqueducts and the wider distribution of their waters throughout the city was a high-priority task of nearly all popes, beginning with the reign of Renaissance pope Nicholas V (1447–55). (Before then, Romans got most of their water straight from the Tiber River.) It was under Nicholas's ambitious tutelage that the city first began its slow but steady reascent to vibrant glory after the long, rotting decay and doldrums of the Dark Ages and the Middle Ages. Water made this possible. As for the Baroque papacy—the papacy of Bernini's lifetime—the first display fountain of that era was the grandiose Fontanone dell'Acqua Paola (the great fountain of the Pauline water) on the Janiculum Hill, built by Pope Paul V Borghese and finished in 1612. Bernini had no role in that project—he was still a boy—but he would soon make his decisive mark on this feature of Roman topography as well. Today when we think of the fountains of Baroque Rome, do we not think, above all, of Bernini? We think first of his Fountain of the Four Rivers in Piazza Navona, but there are many others that owe their design or some distinctive feature to his hand. Even Nicola Salvi's eighteenth-century Trevi Fountain would not have been possible without the example and inspiration of Bernini. As far as fountains are concerned, as with virtually all areas of Roman artistic endeavor, "what Bernini didn't himself produce, he directly supervised, and what he didn't supervise, he influenced."

The monumental display fountain was an art form (involving sculpture, architecture, and hydraulic engineering) for which Bernini clearly had a special genius and happily expended his energies. This might have been because the chronically overheated ("choleric") Bernini himself derived great delight and solace from the sight of water, especially water in motion. It was a soothing balm to his fiery nature. One of Bernini's rare moments of true, serene pleasure during his difficult, uncomfortable stay in Paris in 1665 involved the sight of the River Seine, as his French companion Chantelou recalls: "Our evening drive was rather short; he wanted to go on the Pont-Rouge and stopped the coach on it for a good quarter of an hour, looking first from one side of the bridge, and then the other. After a while, he turned to me and said, 'It is a beautiful view; I am a great friend of water; it does good for my temperament.'"

However, the most spectacular of the projects that Bernini carried out for Urban were indoors, at the very heart, in fact, of St. Peter's Basilica: the

Baldacchino over the main altar (and Peter's tomb) and the decoration of the four massive piers supporting the cupola. The four-piers project features the first colossal statue of the artist's career, that of the thunderstruck but still majestic Saint Longinus, the legendary centurion who pierced the crucified Christ's side with his lance but was converted to Christianity in the process. Yet from the onset of Urban's pontificate there was another monumental project dear to the pope's heart: the painting of the visually and ceremonially important Benediction Loggia on the facade of St. Peter's Basilica, the balcony from which newly elected popes gave (and still give) their first papal blessing *urbi et orbi*, "to the city and the whole world." Such an expansive, prominent public space would ideally be filled with grandiose, multifigured narrative scenes in fresco. Getting this job done had eluded the previous popes. Urban was determined to finally see it through, and in the process play Pope Julius II to Bernini's Michelangelo in producing frescoes so epic as to rank alongside those of the Sistine Chapel.

Urban therefore ordered Bernini to dedicate his spare time to mastering the techniques of painting. Bernini obeyed. Having probably already received some instruction in his boyhood from his father (who was a painter in his early career), the artist at one point boasted "that he should really have been a painter rather than a sculptor because he produced with a certain ease." Thanks to that "certain ease," according to both Domenico and Baldinucci, Bernini produced at least one hundred and fifty paintings in his lifetime (all oil on canvas as far as we know). Unfortunately, only a small fraction of that production—no more than forty works—survives today as confirmed Bernini autographs, and almost all of them are small canvasses comprised of single, close-up human faces against an empty, dark background. They are done with loose, but masterfully expressive brushwork in dramatic chiaroscuro but a limited, somber palette, and have, as mentioned, something in common with the style of Bernini's Spanish contemporary, Diego Velázquez.[3]

Despite this endless production of small canvases, Bernini as would-be monumental fresco painter disappointed Pope Urban. Domenico claims that the Benediction Loggia project was put to an end by a near-fatal illness that struck Bernini. However, there is no indication that he had prepared for the job or ever returned to it after his health was restored: there are no surviving preparatory drawings or related references in the written documentation. Painting was, as Baldinucci observes, simply a pastime

for the artist. Even the great Bernini had his limitations, and this—painting on the grand scale—was decidedly one of them. He once complained about princes who force their subjects to undertake projects for which their "talents and experiences" are not best fitted. That complaint specifically referred to the order given by Pope Urban for him to construct new defense fortifications for Rome (just as the versatile Michelangelo had done for Florence). But Bernini could just as well have been remembering the pontifically forced venture into the realm of large-scale fresco painting. As for Urban's request for military fortifications, that was one of the rare occasions Bernini simply said no to the pope.

Bernini, nonetheless, took great delight in looking at paintings and proved to be a great connoisseur. In Chantelou's diary we find our artist spending much of his spare time examining canvasses with sincere pleasure and discussing, with well-informed historical and technical expertise, matters of style and attribution. Curiously, despite his deep love for the artworks of others like Guido Reni and Annibale Carracci, Bernini never mentions anywhere having purchased a work of art for himself and never discusses a work of art (by another artist) within his own collection. Yet we know he did acquire art, whether through purchase or gift. The 1681 inventory of Bernini's possessions compiled at the time of his death lists some one hundred thirty works of art, in both sculpture and painting, of all sizes and quality. (This tally does not include his numerous clay sketches, small decorative or fragmentary pieces, and the twenty-seven caricatures, presumably by Bernini, in the "first room next to the Galleria.") A few of the paintings, the inventory specifies, are by Bernini himself, as his sons must have pointed out to the inventory taker. But unfortunately all the rest bear no attributions and are only very scantily described. Most, if not all, of the portraits of Bernini family members and the well-known patrons of his career like Pope Urban, Scipione Borghese, and Francesco d'Este are assuredly by Bernini. Also Bernini's are many of the sculptures, whether finished or not. A few are easily recognized: the clay model of Bernini's *Truth Revealed by Time* and the *Faun Teased by Children,* a collaborative work in marble with his father (now in the Metropolitan Museum, New York). Some of the sculptures possibly represent ancient pieces, like the portraits of the Roman emperor, but we are left to guess this on our own.

Of the canvasses owned by Bernini, it is safe to say, about fifty must be by other artists. Some are identified in the inventory as being "of good

hand" or "of very good hand," implying that that "hand" was not Bernini's. Still other works represent types of composition that seem to have been beyond Bernini's interests or capacities as a painter, that is, landscapes, still lifes, and large, busy narrative scenes with multiple figures and detailed backgrounds, such as those in his collection depicting the pagan myths of Galatea and Latona. There is also a *Diana at Her Bath*, the kind of naughty, sensual pagan scene much condemned by Roman preachers (like his Jesuit friend, Gian Paolo Oliva) for its exposure of female flesh. This too is marked as being a work "of good hand," but whose? In one case alone can a secure attribution be given: the series of four related landscapes listed as a group in the inventory are in all probability the *Four Seasons* commissioned by Bernini, circa 1655 from Gaspard Dughet. This now little known artist who earned the singular distinction of receiving a commission from the great master himself was at the time an extremely popular landscape painter, who happened also to be Nicolas Poussin's brother-in-law. The four paintings have survived and are today in the Museum of Fine Arts in Bordeaux, France. Beyond that, we have no clue as to who was responsible for the other landscapes, the many devotional paintings, the several representations of the animal kingdom and baskets of fruit, and the one canvas given the title of *Room Full of People in Conversation with Their Master*, which decorated the walls of Casa Bernini. Had Bernini's sons themselves not even bothered to learn and pass on this valuable information? Were they so uninterested in art?[4]

FIRE IS NEVER A GENTLE MASTER

Frustrated as he was to be in his attempt to get Bernini to paint the great Benediction Loggia, Urban was to have phenomenal success, instead, in his other grand schemes for the embellishment of St. Peter's. The Baroque eye hated vacuums and voids, and for Urban and many others, the recently completed St. Peter's was still too much of an empty cave. To remedy that situation he also needed an architect, and so Bernini was ordered to start studying architecture as well. And this he did, supposedly by himself, without a single mentor among the many practitioners in Rome, simply by studying the great structures of antiquity and the Renaissance and by reading the classic manuals in the field from Vitruvius to Palladio to Scamozzi.

This was not so unusual in early modern Europe, that a painter or sculptor would become a master architect without extensive formal training. The essence of architecture, it was believed, was something held in common with the other visual arts: a talent for aesthetic design creatively unique but nonetheless consciously rooted in and guided by the sacred principles of tradition. For the rest, the mere technical details—constructing foundations, building walls, installing roofs—one simply hired masons and other craftsmen. Be that as it may, Urban and Bernini, as ambitious as they were self-confident, were fully conscious that in adding to the fabric of St. Peter's they were simultaneously tampering with and making history. They were also conscious of fulfilling a prophecy made a decade earlier by the artist Annibale Carracci, who predicted, supposedly in the boy Bernini's presence, "Believe you me, there is to come one day some prodigious genius who, in the center of this basilica and at its far end, will create two great structures befitting the vastness of this temple." To which, the boy was moved to exclaim to himself with his whole heart, "O that I could be that person, that such a wonderful prediction could come true in me!" (An inspiring story, but is it true? Annibale died in 1609, a recluse during the last several years of his life, severely debilitated by clinical depression and physical ailments.)

The big and, as it turns out, permanent change in Bernini's professional life once he became artist to the pope was that he no longer had the luxury of working quietly by himself on small, comparatively simple, private commissions. The projects placed upon his shoulders by Urban and successive popes—the Baldacchino, the Colonnade, the Cathedra Petri (Chair of Saint Peter)—were spectacularly colossal, multimedia, long-term affairs, beyond the physical capacity and the technical competence of any single artist. Thus Bernini was soon obliged to assemble and manage a huge, bustling workshop of collaborators and subcontractors. Fortunately, Bernini's genius—with help first from his father and later his brother Luigi—extended as well into the realm of business management, both in terms of personnel and finances. It was this multifaceted talent that enable him to become "Impresario Supreme" of Baroque Rome. True, there were to be, later in life, especially right after his death, some allegations about suspicious irregularities in his financial bookkeeping, but they never rose to the level of official investigation, much less prosecution. And, yes, there was a steady volume of discontent among the ranks of Bernini collaborators,

but that never really posed a threat of any kind to his productivity or to the advancement of the Bernini brand.

This one aspect alone of managing a large workshop—that of having to deal with a horde of artistic temperaments, at times as hot-headed and sensitive as his own—required expert psychological skill as well as the patience of Job. However, the task was made much easier by the fact that his collaborators were made to live and work in fear, reverential or begrudging as it may be, of Bernini's well-known *terribilità*, his own fierce, intimidating personality. This was another quality, *terribilità*, that Bernini shared with Michelangelo. Fire is never a gentle master, and certainly not in Bernini's case. Let us recall Domenico's description of his artist-father: "His eyes [were] likewise black and with such a piercing look that by his glance alone he could instill terror. . . . Rather stern by nature even in matters that were well done, he was driven in his work and passionate in his wrath, which used to inflame him more so than others." Quoting Michelangelo, Bernini himself said of the "inflamed" intensity of his labor: "I shit blood when I work." Like it or not, if you wanted steady work in Baroque Rome during Bernini's long heyday, you often had to put up with the artist and his tantrums and mad intensity. Thanks to papal protection and the vast scope of his papal commissions, Bernini had all but a monopoly on the art market of Rome—that is, the most lucrative, high-end portion of that market— essentially for decades, from the late 1620s to the early 1670s.

No wonder then that, once Bernini settled into his new role as Impresario Supreme of Rome, resentment, rivalry, and open conflict with other independent artists were not slow in coming. If there had been no widespread ill will before, then certainly on February 5, 1629, when the announcement was made that Bernini had been given the prestigious, powerful job as official architect of St. Peter's, an immediate explosion of shocked indignation rumbled the artistic community of Rome. How could the pope have passed over the older, more experienced men, professional architects, who had labored long and hard in the city? And to think that Bernini, a young upstart with no formal architectural training, was replacing a venerable master of the stature of Carlo Maderno himself, one of the foremost architects of his generation, who had helped to build the new St. Peter's. How could the pope do such a thing? Quite easily: he was pope, the prince, the absolute, divine-right ruler of Rome, and could do whatever he pleased, or very close to it.

The pope's powerful cardinal nephew, Francesco Barberini, the pope's second-in-command, could likewise do what he wanted, and therefore in 1630 Cardinal Francesco forced the prestigious Accademia di San Luca, the Roman professional association for artists, to name Bernini as its *principe*, its director, dispensing with the normal, democratic election process. (Beginning in October 1624 Bernini had served the Accademia for a time as one of the unpaid teachers, *rettori*, of its Sunday art classes.) In the same year, 1630, and until 1642, Cardinal Francesco also sponsored an "Accademia del Disegno," a drawing school for young artists, which he placed under Bernini's supervision in his residence, the Palazzo della Cancelleria. The activity, funded with Barberini money, naturally further enhanced Bernini's status as a recognized "master" on the Roman art scene.

Should anyone have been surprised at the two pieces of news, the abrupt Barberini fiats of 1629 and 1630 on Bernini's behalf, knowing how the patronage machine worked in papal Rome? Favorites were favored, and big favorites were favored big-time. And in Urban VIII's estimation, there was no greater artist deserving of favor—including appointment as august *architetto di San Pietro*—than Bernini, a young man as charming as he was ingenious. Among the ranks of the disaffected, we have already mentioned sculptor Giuliano Finelli, who collaborated on the *Apollo and Daphne* statue and other projects. By 1629 Finelli had had enough of Bernini the imperious impresario and in disgust severed relations with him forever. Finelli no longer wished to work within the darkness of Bernini's shadow. Another alienating factor, according to an anonymous eyewitness informant of biographer Filippo Baldinucci's, was Bernini's paranoid suspicion of the relationship that seemed to be developing between Finelli and the estimable painter-architect, Pietro da Cortona. Though it was still early in his career, Cortona was already showing signs of becoming a full-fledged rival to Bernini and, like him, enjoyed high-level Barberini patronage. At the height of his career Cortona would also command a large share of the upper-end art market in Rome, and according to Roman sculptor and writer Orfeo Boselli, who had interacted with both men, Cortona and Bernini were birds of a feather when it came to their professional conduct: "Both of them are the most insatiable politicians ever in this business, because they keep away all those who can work on a level equal to them, and they give opportunities to work either to those who depend on them or to their pupils and eulogists."

It is hard to deny that a certain tinge of paranoia colored Bernini's personality as he struggled to establish and maintain his position of power in Rome. And his contemporaries recognized this: at one point Bernini's fierce and jealous protection of his professional turf and privileges led him to be described by art biographer Giambattista Passeri as "that dragon custodian who kept watch over the gardens of the Hesperides," referring to the ferocious, repulsive beast that guarded the goddess Juno's golden apples in Greek mythology. Bernini, of course, had reason to be paranoid: he was an object of great envy. As he well knew, envy usually does not sit quietly in the shadows, but takes steps to actively remove or undermine the cause of its discomfort. At the same time, what we call "paranoia" Bernini may have considered simply the degree of prudent vigilance needed to survive in the unstable, faithless, zero-sum environment of the Roman court. Again, let us recall the exasperated complaint of his alter ego, Gratiano, in *The Impresario*: "Damn me if you can trust anybody nowadays."[5]

There was no one more upset about the February 1629 announcement of Bernini's promotion to architect of St. Peter's than Francesco Borromini (fig. 11). Borromini's working relationship with Bernini had begun in the mid-1620s; in fact, he had been one of Bernini's most vital collaborators on the Baldacchino project. Although only one year younger than Bernini, the talented Borromini, unlike Bernini, had been formally trained in the architectural profession; he had been born into a large, distinguished Lombard family of architects, masons, bricklayers, and stucco workers who had long served on the many building projects of Italy. He was also kinsman (through his mother's family) to his revered master, Carlo Maderno, to whom he owed the beginnings of his career in Italy (where he moved in 1619) and whom he probably hoped, if not expected, to succeed as architect of St. Peter's. We have already heard Borromini complain about Bernini's taking all the credit for the Baldacchino project. The complaint was recorded by Borromini's nephew, Bernardo Castelli, who also tells us that in 1629 a panicky Bernini, having become architect of St. Peter's with no formal training or experience in the profession, had made all sorts of promises to Borromini so that the expert would not abandon him in his hour of need. Bernini never made good on his promises. However, according to Domenico, Borromini's resentment of Bernini went far deeper: Borromini believed that Bernini "had robbed him" of no less than "all the greatness that was rightfully his."

FIG. 11 →► *Francesco Borromini*, contemporary engraving.

Borromini is not entirely to be faulted for feeling the way he did. Certainly he and many other artists would have had more flourishing careers and greater acclaim had Bernini not been on the scene. The gloomy, morose Borromini would have also had greater success had he not been so irascibly eccentric and inflexible. If Bernini was "high maintenance" as a person, Borromini was a hundred times more so. But is it the case, as Bernini's rivals would have us believe, of a mean-spirited, jealous, and rapacious Bernini who actively maneuvered to undermine the success of Borromini and other talented artists? This is often the message in popular accounts of Bernini's life, not only today but in our artist's own time, most notably in *The Lives of the Painters, Sculptors and Architects Who Worked in Rome and Died from* 1641 *to* 1673, by the aforementioned Giambattista

Passeri. To be sure, Bernini was not always blameless in the conduct of his professional relationships. Bernini may have been expert in the carving of angels, but he was far from one himself. However, as far as the charges of greed and financial misbehavior that we will later hear raised by the artist's opponents—such as grand larceny at the expense of the papal treasury— they have yet to be confirmed in the surviving documents. And, in any case, despite the presence of a domineering, attention-grabbing Bernini, Borromini and Bernini's other architectural rivals (especially Pietro da Cortona) still received numerous distinguished commissions through which to prove to the world their artistic valor and establish solid, long-term careers. Bernini-the-raptor did not grab the whole bag for himself.

As for Bernini's personal relationship with Borromini, it is difficult to assess that much-publicized rivalry, often sensationalized in the popular press. Although the rivalry spanned several decades of their lives, documentation is scant, fragmentary, and rife with unverifiable claims by partisans on both sides. (One such claim is from Passeri, who says Bernini made a secret deal with Agostino Radi to cheat Borromini of money due him from the Baldacchino project). Even straightforward facts such as Bernini's 1632 recommendation of Borromini for the prestigious Sant'Ivo alla Sapienza commission (the church of the University of Rome) can be interpreted in either a conspiratorial or benign manner, depending on the eye of the interpreting beholder. Was that recommendation an act of genuine good will or did Bernini just want Borromini out from his immediate vicinity?

What we do know is, as the Roman agent of the Duke of Savoy reported in October 1661, that the two men did "not get along, directly opposing each other in every matter." Not surprising in the case of two men whose architectural visions—not to mention their very personalities—were so fundamentally divergent: Borromini the always bold and at times wild experimenter versus Bernini, at heart a classicizing conservative. (Bernini a conservative? Yes, at least when it came to designing buildings and certainly when compared to Borromini: awe-inspiring as they may have been, Bernini's architectural innovations were usually less daring than Borromini's.) We also know that at the height of the bell tower crisis at St. Peter's (as we shall see in the next chapter), Borromini was one of the loudest of Bernini's critics, exaggerating both the seriousness of the problem (by claiming that Bernini's new tower threatened to bring down the entire facade of the basilica) and our artist's role in causing the peril, rather than

that of Carlo Maderno, who first built the inadequate foundations. Despite the animosity between them, the two, as far as we know, never came to direct blows or had any sort of face-to-face public showdown.

For his part, Bernini appears to have harbored less animosity toward Borromini than Borromini did toward him. There is a brief but telling moment in Chantelou's diary reporting a conversation between Bernini and various acquaintances in which Borromini was being criticized as a "man of extravagant ideas." At one point Chantelou repeats to the group a bit of unflattering and apparently false gossip about Borromini, namely, that he arrogantly required King Louis to pay him before he would begin to work on a proposal for the Louvre design. Rather than letting this untruth simply pass, Bernini instead rose to Borromini's defense: "The Cavaliere intervened saying that it was unfair to Borromini to spread this story around." This, in Italian, is called an act of *delicatezza* (empathetic sensitivity) and is certainly not what one would expect on the part of a bitter rival.

But, what about the case of the Fountain of the Four Rivers in Piazza Navona? It is sometimes asserted or insinuated that in the late 1640s Bernini stole that prestigious commission away from Borromini through clever subterfuge. Certainly Bernini did use clever subterfuge to win that commission. But was the goal specifically to undermine Borromini or to gain the much-needed good graces of the papal family at a time when Bernini's fortunes were depressingly low? Indications seem to point far more to the latter conclusion than the former. Of course Borromini (to whom the fountain commission had never been formally granted) could and did take Bernini's "stealing" of it as a personal attack. But who would not judge Bernini's Fountain of the Four Rivers in Piazza Navona to be a far more delightful, inventive design than what we find in Borromini's more mundane proposal, known through a surviving drawing? The greatest adversities and conflicts in Borromini's life, again, were caused by his own clearly disturbed personality. His untamed inner demons would ultimately bring him to take his own life, by means of a sword, in August 1667.[6]

"WHAT THE BARBARIANS DIDN'T DO, THE BARBERINI DID"

Bernini's gigantic Baldacchino over the high altar of St. Peter's was finally inaugurated on June 29, 1633, that date chosen as it coincided with the

popular Roman (and papal) feast of Saints Peter and Paul. Over 90 feet (28.5 meters) in height, this majestic frame for the basilica's "main stage" had taken nine years to execute at the staggering cost of 200,000 scudi, or about eight million dollars in today's money. Quite simply, nothing like it had ever been seen before. Those who came to see it in the basilica must have felt as they were dreaming or having a supernatural vision. Even today the sight is jaw-dropping. Combining and reshaping traditional forms in a completely new creation (as Bernini was to do in so many of his works), the colossus succeeded brilliantly in providing an appropriate cover for the papal high altar. And it did so without overwhelming or becoming engulfed by the space beneath the cupola. Solidly stable, it nonetheless seems to dance in slow, graceful motion, thanks to the lively undulating spiral columns and crown of "dolphin's back" arches, glistening as they turn in space thanks to their expertly applied gilding. Eventually copied all over Europe (most notably, Louis XIV's church at the Invalides), it was roundly applauded, together with its creator, Bernini, and its patron, Urban VIII.

Of course, there was criticism. Perhaps the most personally stinging for Bernini was that of the official *soprastante* (superintendent) of St. Peter's and a prominent member of the Florentine artist community in Rome, Agostino Ciampelli. One of the Baldacchino collaborators, Ciampelli was then still known as Bernini's brother-in-law even though, as mentioned, his (first) wife, Bernini's sister Agnese Bernini, had died long before in 1609. Ciampelli publicly dismissed Bernini's creation as a *chimera*. For early modern architects, these were fighting words. What Ciampelli was saying was that the Baldacchino was some freakish, monstrous hybrid—the original Chimera of Greek mythology was a fire-breathing mix of lion's head, goat's body, and serpent's tail—that Bernini had conjured up out of his own foolish fantasy with little regard for the rational rules and revered traditions of art. (It was the same accusation that Bernini and others were to level at Borromini). No wonder Domenico Bernini makes no mention of Ciampelli in his biography of Bernini, most pointedly in describing another of his father's commissions for Urban VIII, the restoration of the church of the early Christian martyr Saint Bibiana (Vivian). Ciampelli and Pietro da Cortona each contributed to the interior decoration of the church a series of frescoed scenes from Bibiana's life and death under Emperor Julian the Apostate, but Domenico acknowledges only Cortona's contribution, despite Cortona's being an open rival to Bernini.

Another criticism of the Baldacchino, spread with great indignation among the people of Rome, was that in order to collect the 6,200 kilograms of metal needed to create the structure, Pope Urban had ordered that the bronze beams be stripped from the portico of one of the most revered and most intact of all ancient Roman monuments, the Pantheon, then officially known as the Church of Santa Maria ad Martyres (Saint Mary at the Martyrs). The stripping of the Pantheon turned out to be quite a messy publicity crisis for the Barberini papacy, inspiring one of the most clever, most often quoted of antipapal pasquinades produced in seventeenth-century Rome: "Quod non fecerunt barbari, fecerunt Barberini," What the barbarians didn't do, the Barberini did. This poetic bit of satire came from no less than a prelate of the papal curia, the Reverend Carlo Castelli, protonotary apostolic, canon of Santa Maria in Cosmedin, and Roman agent of the Duke of Mantua. The line would have been, of course, understood by the Roman people as also referring to the frenzied greed with which the Barberini family had enriched itself with money, titled estates, and benefices, at the expense of the church's treasury and the city's inhabitants.

In response, the papacy simply put a face-saving pious spin on the situation, pointing out that it was the will of God, who had deliberately preserved the Pantheon bronze from the ravages of the pagans to be used for the higher goals of defending the city (some of the bronze was used for armaments) and of embellishing the greatest temple of Christendom, St. Peter's. So declares a plaque placed on the portico, still visible to this day. So declares, as well, Domenico (minus mention of armaments), who in fact proudly identifies his father as the originator of the plan: "He thus recommended this material [bronze] to Urban, suggesting further that they use the bronze architraves still in place in the ancient portico of the Church of the Rotonda. These beams had been preserved by a special act of Divine Providence from the voracity of the Emperor Constans. Constans, having removed the tiles, likewise of bronze, with which the Pantheon was covered, was not able, however, to remove the beams as well since, as we can wisely conclude, Heaven was saving them for a better purpose, in honor of the Prince of the Apostles."

The grand irony in all this is that the most recent examination of documentation has shown that the actual amount of Pantheon bronze given to Bernini for the Baldacchino was minuscule, a mere 1.8 percent of the total removed from the monument. Moreover, even this minuscule amount was

all returned to the Fabbrica di San Pietro (Office of the Works) unused and untouched. Bernini found sufficient bronze from other, safer, more reliable sources—safer and more reliable because, as he well knew, the precise chemical composition of the Pantheon bronze was a mystery and could prove extremely dangerous when added to the volatile mix of other metals used to forge the final product. Explosions at metal foundries were tragically common enough back then. There is furthermore no evidence whatsoever that it was Bernini who suggested using the Pantheon bronze in the first place.

As for the Pantheon itself, Bernini, in reality, revered the ancient monument, later opposing the disfiguring "renovations" desired by Pope Alexander VII. Moreover, despite the common myth, Bernini had had no role in the design or construction of the two bell towers (the infamous "asses' ears") added to the Pantheon by Urban VIII in the 1620s. On the other hand, Bernini's respect for the Pantheon did not translate into a respect for all ancient monuments. In 1640, when asked by Pope Urban to build a more sumptuous fountain at Trevi, Bernini had no qualms about plundering the ancient tomb of Cecilia Metella on the Via Appia for raw materials for the job. Fortunately, the proposed plundering was stopped by a barrage of protests from private citizens. The Trevi Fountain renewal project came to a halt, not to be completed until the mid-eighteenth century according to a splendid, Bernini-inspired design by Nicola Salvi.[7]

A mixture of enthusiastic praise and bitter controversy also marked the completion of the other major addition to St. Peter's by Bernini (commissioned by Urban VIII in 1628 but finished only in 1640): the embellishment of the four supporting piers at the crossing of the nave, that is, the visually prominent space under the vast cupola and immediately surrounding the main altar. As awe-inspiring as those architectural titans might have been in their stark, unadorned essence to us, to the Baroque eye, their bare surfaces were sorely in need of ornamentation, lots of it. Another goal of the project was to devise suitably magnificent settings for the most precious relics in the custody of St. Peter's, three of which related to the very Passion of Christ. Bernini served as director of this costly, long-term, multimedia project, involving the labor of many artists and artisans. In the end, however, its most conspicuously beautiful element proved (and still proves today) to be Bernini's own bold, colossal but still gracefully elegant statue of *Saint Longinus*, ten years in the making. Not surprisingly, there was

a fair amount of tension and mutual recrimination between Bernini and the sculptors involved in carving the other three colossal statues, which, in close proximity to each other around the main altar, were thrown into inevitable competition.

One of the artists was François Duquesnoy, born in Flanders, then considered second only to Bernini in his reputation as sculptor. Had he not died young (in 1643), Duquesnoy would have undoubtedly given Bernini a serious run for his money in subsequent years for the title of leading sculptor of Rome. Widely disseminated but false rumors of the time alleged that Bernini had engaged in foul play to undermine the accomplishments of this potent competitor. One of the charges—that well into the process Bernini switched the arrangement of the four statues under the cupola so that the sunlight most favored his, to the detriment of Duquesnoy's finely wrought *St. Andrew*—is recorded not only by art biographers Giovan Pietro Bellori and Giambattista Passeri but also in the famous diary of the English traveler John Evelyn, who visited Rome in 1644: "It is said that this excellent sculptor died mad to see his statue placed in a disadvantageous light by Bernini the chief architect, who found himself outdone by this artist." According to another artist-chronicler who visited Rome in the seventeenth century, the German Joachim von Sandrart, Duquesnoy also believed that Bernini had delayed the delivery of marble to his work site in order to undermine the success of the final product. Though both untrue, these charges are significant inasmuch as they prove how willing contemporaries were to believe the worst about Bernini. Was it all simply jealousy or was there something in the way Bernini conducted his affairs that fueled such gossip?

There were also tensions between Bernini and another sculptor involved in the four-piers project, Andrea Bolgi. Bolgi, then twenty-four years old, was one of Bernini's disciples—in fact, the one most favored by the master once Giuliano Finelli had fallen from grace. Bolgi's heavy, gawky *St. Helena* is without a doubt the least successful of the four colossals adorning the piers of St. Peter's. There are diplomatic allusions to the tensions with Bolgi in a document describing the challenges faced by Bernini in certain of his projects for St. Peter's, most likely dictated by Bernini himself, found among the Bernini family papers at the Bibliothèque nationale in Paris. Bernini, the document claims, had generously given Bolgi the commission and assisted him in its design, but in the end the master was bitterly "deceived" by an ungrateful pupil. (Nonetheless, Bernini kept on display in his house

until his death a painted portrait of Bolgi, most likely by Bernini himself.) In their biographies Domenico and Baldinucci are silent on the issue, unlike in the case of the fourth sculptor who worked with Bernini on the pier embellishment project, Francesco Mochi, who produced the dramatically dynamic, if not completely successful *Saint Veronica*. Mochi depicts the piteous matron Veronica rushing forward in a breathless, stupefied state, after having just discovered the miraculous image of Jesus's face which her savior had imprinted on her veil.

In reviewing the list of Bernini's so-called students and disciples—the much-older and more experienced sculptor Mochi was, in reality, neither—both Domenico and Baldinucci single out Mochi by name as among those who were shamefully deficient in their love for Bernini. Mochi, we are told, "showed himself on many occasions most ungrateful toward his Master." We know few of the details of this conflict, but there is an amusing reflection of it in the June 22, 1658, entry in Pope Alexander VII's personal diary: there the pope reports the advice offered to him to the effect that the task of transporting certain of Mochi's statues from St. Peter's to the Porta del Popolo (where they are still today) should not be given to Bernini for, it is feared, they are likely to suffer some "accident" in the process. In any case, to Mochi assuredly goes the prize for having delivered to Bernini the cleverest put-down our artist probably ever received in his life. Once Mochi's wind-swept *Veronica* was installed, a sarcastic Bernini questioned the sculptor as to the source of the beleaguering wind that was coming toward the agitated matron and the Jesus-imprinted veil she holds out for display. "Why, from the big crack that you made in the cupola," quipped the quick-witted Mochi, wounding Bernini exactly where he felt most vulnerable. This brings us to the story of the great controversy that arose in Rome when Bernini completed his work on the piers of St. Peter's. It was the first major crisis of his career.[8]

"THE CUPOLA IS FALLING!"

It was a grave charge that haunted Bernini from at least 1636 (when most of the work on the piers was finished) to literally the last month of his life, when he was finally and fully exonerated by a special papal investigation committee. The formal exoneration came on November 12, 1680. Instead of rising in joyous elation, Bernini collapsed shortly thereafter—within

two or three days—suffering a stroke that lead to his death just two weeks later on November 28. What was this charge responsible for shortening Bernini's life? That Bernini had fatally undermined the stability of the cupola of St. Peter's by recklessly weakening the four massive piers that support it. He had, it was alleged, weakened the structure by excavating the solid masonry of the piers in order to make room for new stairwells and corridors within them. Aggravating his assault on the revered basilica, Bernini, it was further alleged, carved the original external niches more deeply and hollowed out entirely new ones above them. All this was, in fact, untrue. Bernini's interventions were all prudent, carefully working with what the original architects had put there (including the two sets of niches, upper and lower) and that they had planned for the future development of the piers (for example, the insertion of stairwells and interior passageways).

Nonetheless, one day, some alarmist noticed a crack in the cupola and ran out of the basilica shouting: "The cupola is falling! The cupola is falling! And Bernini is to blame!" (Note that this is a separate affair from the later controversy—which we shall come to—over the cracks in the basilica's facade caused by Bernini's new bell tower, which also supposedly threatened an apocalyptic collapse of the church's structure.) The identity of that rumor-mongering alarmist is in this case known: Ferrante Carli. Carli is all but forgotten today, even to scholars, but this learned, if infamously cranky and contentious, lawyer and writer had been secretary to Cardinal Scipione Borghese and much involved in the world of the arts in Rome as collector and dealer. Baroque Rome had more than its share of gossipy busybodies and viperous troublemakers and Carli was definitely in their number. According to Francesco Mantovani, Roman agent of the Duke of Modena, Carli hated Bernini so much that he wanted to see him *esterminato,* "exterminated."

What Bernini had done to inspire so much hatred in Carli is unknown, but fortunately for Bernini, Carli died in 1641 without reaching his goal of exterminating or inflicting serious harm on the artist. The same informative Mantovani had mentioned in an earlier dispatch to his duke that "already for quite some time" the newly appeared crack in St. Peter's cupola had been a matter of public discussion, with the blame being put on Bernini. However, he continues, "those in the know" were attributing the anti-Bernini charges simply to envy. The crack in the cupola had in fact been there well before Bernini initiated his work on the piers, the benign

and all but inevitable effect of the natural settling of the cupola over the years. (Of course, Rome being in a seismically active area, the ground-shifting caused by earthquakes also contributed cracks to its edifices, no matter how solidly built.)

Nonetheless, a formal memorandum of warning (author or authors unknown) was drawn up in 1636 and distributed to the members of the Fabbrica of St. Peter's, the congregation of cardinals who oversaw all construction projects relating to the basilica. The memorandum claimed that the danger was so great that the niches, stairwells, corridors, and chapels within the piers should be filled in as quickly as possible. This would have had the effect of undoing all of Bernini's modifications and adornments. Yet in response to these charges we find no mention in the surviving documentation in the Vatican archives of any official investigations, accusation, exonerations, or modification of the pier embellishment plans at this time. Apparently, neither the pope nor the Fabbrica took the matter seriously at that point.

As for Bernini himself, during the Carnival season of 1637, a Roman *avviso* tells us, the artist intended to make the cupola affair the subject of his own annual satirical comedy staged in Casa Bernini. His goal was, of course, to show what little gravity he attached to the charges against him. Yet this public nonchalance was simulated, for the same *avviso* reports that Bernini had at the same time made contingency plans to flee to Naples, should disaster strike. Furthermore, Bernini used his access to powerful papal nephew Cardinal Francesco Barberini to suppress a planned 1638 satire against the artist by the seminarians of the Collegio Capranica focusing on the same cupola controversy as well as on the artist's own defects of character. (Bernini could give, but he most definitely could not take.) Although Bernini weathered fairly well these attacks of the late 1630s, according to Tod Marder, "the issue of architectural competence . . . dogged him throughout his life."

Deep fears about the collapse of the cupola due to Bernini's alleged ineptitude continued to circulate in the decades between the first 1636 alarm and a renewal of that alarm in 1680 so insistent that it prompted a formal papal investigation. In their biographies both Domenico and Baldinucci discuss and resolutely refute the cupola charge openly and at length. Baldinucci even attaches to the end of his narrative a long summary of the technical report of the papal commission convened in November 1680 that

definitively exonerated Bernini. However, neither biographer acknowledges how long the charge had stood, relating it simply as a matter that arose in the last month of the artist's life, with no mention at all of the decades of haunting insinuations and controversy that had preceded the 1680 culmination of the affair.

The fact of the long-standing nature of the rumors and fears surrounding the stability of St. Peter's cupola we learn from a long, impassioned digression on the question inserted in *L'ateista convinto dalle sole ragioni* (The atheist converted by the force of reason alone), a book published in 1665 by a prominent member of the circle of Cardinal Antonio Barberini, his *vicario generale* at the time, Filippo Maria Bonini. One of the characters in this theological dialogue, who seems to be a well-informed citizen of Rome, paints a dire picture of the allegedly menacing physical conditions of St. Peter's, which includes the dangerous accumulation of rainwater in the cupola. His description is at the same time a diatribe against Bernini (who goes unnamed, however) culminating with the indictment "Behold the evils that are caused by the recklessness of those who, with arrogant impudence, wish to insert their hands into the work of glorious men!" With these hysterical words in our ears, we shall leave this story here and pick it up again in our last chapter.[9]

HEAD OF THE CLAN

What we have seen thus far has been only a fraction of the numerous offices and commissions—as burdensome as they were prestigious—given to Bernini during the reign of Pope Urban. With all this weight on Bernini's shoulders, one would think that he would have had neither time nor energy for much of a personal life. But indeed he did. To begin with, on the family front, with the death of his father on August 29, 1629, Bernini, still unmarried, became *pater familias*, the moral and legal head, of the entire clan. (Recall that Bernini had twelve siblings, eleven of whom, plus their mother, were still alive at this point.) For the second time that year—in February he had been elevated in one quick jolt to the august role of architect of St. Peter's—life was, all of a sudden, completely different, not only at work, but now also at home.

Bernini's new status meant that he now had absolute authority over and ultimate responsibility for his family's well-being and destiny. As codified

by the ancient Romans and still in force with some modification in the law of papal Rome, the power of the male head of the family—in legal terms, the *patria potestas*—was awesome. Out of socioeconomic necessity, fathers routinely made extreme decisions over the destinies of their powerless children: they forced them into painful, loveless marriages or into the cruel celibacy and social isolation of unwanted religious vocations. Under the legal shield of *patria potestas* fathers at times even forced adolescent sons to be castrated so as to prepare them for lucrative careers as angelic-voiced *castrati* singers, much desired in the courts of Italy, including the choir of St. Peter's. The father of an impoverished family could even sell a child into slavery. Moreover, the same degree of power could be and was legally exerted upon wives by their husbands—and by brothers over unmarried sisters, in the absence of their fathers. On the basis of the principle of *patria potestas*, a husband could even legally imprison his wife in his own private jail for certain crimes, like adultery and theft.

The frequently tragic and scandalous results of these acts of paternal (or marital) absolutism fill the pages of police blotters, diaries, and other documentation of the age. The victims were far more often female than male. Written and published during Bernini's lifetime, the candid memoirs of Hortense and Marie Mancini, nieces of French prime minister (and friend to our artist) Cardinal Mazarin, are vivid but sad reminders of the unhappy plight of even aristocratic, educated women who, despite their wealth and social connections, could not escape male tyranny, turn where they may. At least Hortense and Marie were not forced into convents, not on a permanent basis, that is. Though some women found the all-female world of the convent a welcome release from the suffering of patriarchal marriage and nonstop childbearing, it is safe to assume that the majority did not, since they were usually confined behind the convent walls against their will. These prisoners would, moreover, have made convent life unhappy, if not psychologically toxic, even for those few women who had chosen to be there.

The ill-fated daughter of Prince Marcantonio Borghese, a nun in the Roman convent of SS. Domenico e Sisto, was probably one such prisoner of the veil: she ended up hanging herself in her convent cell. Coincidentally, for the church of that same convent, in the years 1649–52, Bernini designed a chapel, the Cappella Alaleona, upon commission from a nun

of that distinguished Roman family, Sister Maria Eleonora Alaleona. In erecting this chapel, Maria Eleonora, it is suspected, may have been seeking to perform a public act of expiation for a certain notorious sin that had been the talk of Rome. The sin in question was not hers, but that of a close relative. The unnamed relative, also a nun (in the monastery of Santa Croce in Montecitorio), had in May 1635, at the age of eighteen, tried to smuggle a lover into the cloister within a sealed trunk. The attempted delivery was botched and the unfortunate man died of suffocation. Behind this historical episode worthy of the bawdy anticlerical tales of Boccaccio lies one woman's personal story of loneliness and despair.[10]

As for married women, those who had been battered or abandoned by their husbands had no good options. Given the few viable alternatives and the scant protection offered by either church or state to a woman who found herself victimized, even violently, by the abusive men in her life, it is no wonder that the Sicilian "witch" Girolama had such a successful career in Bernini's Rome during the reign of Pope Alexander VII (1655–67). For a fee, Girolama supplied a widespread, secret network of female clients with her effective, home-brewed poison that could (and apparently did) kill off abusive husbands and other offending men without leaving any incriminating traces. The case was so clamorous—cases of female revenge upon abusive men usually are—that Cardinal Sforza Pallavicino digresses for several pages in his biography of Pope Alexander to recount it in detail. Girolama's public beheading in Campo dei Fiori in July 1659 drew an enormous crowd of spectators, despite the great summer heat, some of whom paid money for a good viewing site from nearby apartments. Perhaps Bernini was among the onlookers. Did Girolama's case, we wonder, inspire in him greater compassion for women, or just greater fear?

What kind of *pater familias*, head of the clan, was Bernini? Unfortunately, there is nothing in our primary sources that affords us any intimate insight into the question. Knowing his strong-willed, fiery character, however, we can safely assume that he ruled with an iron fist and according to traditional notions regarding the conduct of family affairs. (However innovative he may have been in his art, Bernini appears to have been completely conventional in his social values.) What he was in his workshop, he must have been in his home: a demanding, autocratic, ever intrusive, micromanager of household affairs. When he himself later became a father,

we can likewise be sure it was he who had primary say over the destinies of his sons and daughters: career, marriage, or convent. The children must have learned early that there was no negotiating with daddy.

Bernini undoubtedly loved his children, but in all the surviving documentation we find few explicit references to his paternal affection. This, however, was common for the times: virtually all of the most-heeded manuals of child pedagogy of early modern Europe warned against open displays of affection by parents toward their children, for that would spoil them and make them unwilling to obey their parents. Fear, rather than love, was to be the motivational force in the psyche of the child. Bernini didn't castrate any of his sons—at least not physically. Yet having a father with such a powerful, assertive, larger-than-life personality must have been emotionally difficult for at least some of his male offspring. Bernini no doubt chose the husbands of his three married daughters just as he probably chose the convent of the two who became—or were obliged to become—nuns.

At least the two daughters were allowed to enter a convent, SS. Rufina e Seconda in Trastevere, without the dreaded, imprisoning rule of cloister. This meant they could leave the premises and interact with the outside world—they went about dressed in deep, penitential purple—without the need for papal dispensation. Nor did these women take on the burden of legally binding vows of any sort: they instead "subjected themselves to the traditional rules of religious life merely motivated by an observance of pure love," remarked an admiring Jesuit historian of the age, Filippo Bonanni. Hence, according to canon law, they were not a monastic community but only a "pious institute."

However iron-fisted and patriarchal he may have been in his duties as leader of the clan, Bernini was conscientious and hard-working on behalf of the material well-being of his extended family. His ceaseless artistic labors were a reflection not merely of some transcendent impulse to create (or psychological drive to prove himself), but also of economic necessity. In other words, he needed the income. The survival and flourishing of such a large, upwardly mobile family required money—money to secure the basic requirements of life, as well as to meet the enormous expectations of how a family with pretensions to an exalted status was to live, eat, work, dress, entertain, and in general comport themselves. The bulk of the pressure fell on the head of the clan, Bernini. It fell on him for the first time in August 1629 with the death of his father; it would only become greater as

the artist rose in worldwide esteem, got married, and produced children of his own, nine of them.

In descriptions of Bernini's character, one regularly finds references, whether sarcastic or diplomatic, to his supposed avarice, his immoderate love of money. British art historian Cecil Gould, for example, remarked, "All his life, Bernini showed an excessive respect for money." On another occasion, American scholar Howard Hibbard, explaining Bernini's curious decision in 1638 to do the bust of Sir Thomas Baker (a total stranger and mere country squire), claimed that the artist, "already rich, was always acquisitive." (Baker had promised to pay Bernini an extravagant sum for his portrait.) Even one of the most learned and circumspect of Bernini scholars, the eminent Rudolf Wittkower, felt obliged to point out: "To be sure, Bernini adored money." While there is no disproving the claim of avarice, what no one seems to have considered are the sheer economic realities that forced the artist to accept lucrative commissions and demand extraordinary compensation for his work. Bernini had a huge family and a huge workshop to support. He was their principal breadwinner. Bernini, therefore, needed money, lots of it.[11]

As already mentioned, one of the major household decisions Bernini made sometime after his father's death in August 1629 was to move the family closer to his place of work. This new home was just behind St. Peter's Basilica, in the district called Santa Marta, named after a nearby church (demolished in 1930) located on a circular street that ran around the western end (the apse) of the basilica. The former house at Santa Maria Maggiore, however, remained in the family's possession. As for Santa Marta at the Vatican, we are afforded a brief but uncensored glimpse of Bernini's ordinary domestic life there through the records of the criminal court of the governor of Rome: on November 28, 1634, a fire broke out shortly after midnight at the Bernini home in Santa Marta. Since its origins were suspicious, an official investigation took place, and a forensically detailed report was drawn up. The fire, it was suspected, was deliberately set by someone in the adjacent household of Benedetto di Paolo Drei, a master mason who also worked, like Bernini, for the Fabbrica of St. Peter's.

In the end, arson could not be proven. Yet doubts lingered: why at that late hour were Benedetto and his wife up and about and fully dressed in their daytime clothes? And why did no one of the Drei household rush to help put out the fire when they first noticed it? Was there friction between

Bernini and Drei? These questions go unanswered by the police report. But unique within the surviving Bernini documentation, it is still an object of great curiosity. Among the interesting data communicated by the report is what it tells us of the composition of the Bernini household. At this point the still unmarried Bernini was living with his mother, Angelica (who, in ill health, had to be carried out of the burning house on a mattress), his likewise unmarried brother and right-hand man, Luigi, various servants and young artists of his workshop, whose names show up in other Bernini documentation, including Stefano Speranza of Borgo San Sepolcro and a French sculptor known in Italian as Niccolò di Giovanni Sale. It was fortunate that so many able-bodied men lived with Bernini: they helped save the household goods from the fire by quickly tossing them out the windows.[12]

AN ENCOUNTER WITH DEATH

The 1634 fire that threatened to wipe out Bernini's home and earthly possessions was followed the next year by an even more terrifying near-calamity that almost wiped out his very existence. "Nearly terminating the Cavaliere's life, a great illness forced him to his bed with an extremely high fever and life-threatening seizures. This illness was the result of the artist's endless laboring, his habit of undertaking more than one project at the same time—all of them arduous—and, above all, his incessant working of marble, which absorbed him so intensively that he indeed seemed to be in a state of ecstasy and as if he were sending out through his eyes his own spirit in order to give life to his blocks of stone." According to Domenico, Bernini was thirty-seven years old at the time, which would put us in 1635. But we can't always trust the biographer's chronology, and no other source confirms the fact of a life-threatening illness in this decade of the artist's life. In any case, it was this illness that supposedly ended Urban's dream of having Bernini execute the fresco decoration of the Benediction Loggia at St. Peter's.

Though it brought Bernini to the brink of death, this undiagnosed illness (malaria?) was also a moment of triumph: it provided the opportunity for extraordinary displays of esteem and affection not only from the pope and the Roman court, but also from the entire city of Rome, all "faced with the fear of losing Bernini." Yet again what seemed initially to be a defeat or near defeat for our artist turns out to be a victory; it's the story of Ber-

nini's life, as spun by his son Domenico. Of all the outpouring of concern and care, the greatest came from the pope himself. Pope Urban sent his personal physician to examine Bernini twice a day and report back to the pontiff after each visit. On one of the visits the papal physician brought a special gift from Urban, an extraordinarily expensive and powerfully effective medicine: "A single drop of this liquid, simply coming in contact with one's lips, would revive the vital forces in marvelous fashion." Domenico does not identify the wonder drug, but it was most likely *giulebbe gemmato* (gemmed julep), extremely costly because it contained pulverized precious and semiprecious gems. Whatever medicinal compound it was, Domenico calls it "a gift truly worthy of the affection of that pontiff, who, had it been possible, would have wanted Bernini embalmed and rendered eternal and the Cavaliere subsequently gained each day a greater degree of health."

Urban also sent his second-in-command, cardinal nephew Francesco Barberini, to look in on the patient and convey the pontiff's special apostolic blessing. Francesco's younger brother, Cardinal Antonio, with whom Bernini enjoyed a closer relationship, also attended the sick man "almost continuously" at the artist's house. At times, all three of the Barberini cardinals, the aforementioned Francesco and Antonio, as well as Antonio Senior (Urban's brother), more commonly known as the "Cardinal of Sant'Onofrio" after his titular church, would all be present together at the bedside of the convalescent. That certainly had all Rome talking. The personal visit of one cardinal was honor enough, but three at once? There was now no questioning Bernini's status at the Roman court. And any lingering doubts were effectively wiped out by the visit to Bernini's bedside of yet another distinguished member of the Roman court: the pope himself. This visit, executed with all due pomp and circumstance involving a great retinue of cardinals and courtiers, counts as one of Urban's most public and extraordinary signs of favor toward Bernini, for such gestures on the part of reigning princes were few and far between, as Bernini and his astonished neighbors well knew. This rare demonstration of papal esteem would repeat itself three more times in Bernini's future, with two visits to Casa Bernini by Alexander VII (June 1662 and June 1663) and one by Clement IX (July 1668). Queen Christina of Sweden also came to visit, at least four times, beginning in 1656. On none of these later occasions, however, was the artist ill; the two popes and the queen came simply to pay their respects to Bernini and examine his works of art in progress.

According to the chronology established by his son, Bernini's near-death experience was soon followed by a resurrection. That resurrection came in the form of an advantageous marriage with a young, beautiful, socially respectable woman, whom we shall meet later in this chapter. Although Domenico narrates the facts of his father's grave illness and his wedding one right after the other, he does not connect them overtly in a chain of cause and effect. But his original audience is likely to have done so: the fact of a life-threatening illness preceding a major moral turning point in one's life (in this case, Bernini's "settling down" into stable, respectable marriage, ending the waywardness of his prolonged bachelorhood) would have been easily recognized by Domenico's readers as a familiar commonplace of hagiography, that is, the literature of the lives of the saints. (Another link in the chain was the disastrous conclusion to Bernini's love affair with Costanza Bonarelli—another woman we shall meet momentarily—but Domenico is careful to keep readers from making that connection by mentioning the affair only briefly, deceptively out of sequence and without a date, two chapters and twenty-five pages earlier.) The "lives of the saints" was a literary genre that exerted much influence on Domenico's narrative, as it did on all of Roman Baroque culture. Italian culture was thoroughly saturated by the deeds and wonders of these saintly heroes, recounted for both popular entertainment and pious edification. They came packaged in many different forms: published tales in print, staged theatrical dramas, and in various media of the visual arts, painted and carved, but especially in fresco cycles of scenes from a saint's life, as on the walls of the Roman Church of Santa Bibiana, restored and embellished by Bernini in 1624–26. This body of literature is especially relevant to Domenico, since one of the unspoken goals of his biography is to prove that Bernini, if not a canonizable saint, came pretty close to it by the end of his life.

Bernini, after an unspecified length of time, fully recovered from his illness. But from then on, death became a more conscious presence in his life. How could it not have been? His son informs us that beginning in midlife Bernini "every Friday, for the space of forty years, attended the devotions of the Good Death at the Church of the Gesù." The "devotions" were prayer services (with sermon) held weekly at the Jesuit mother church in Rome under the auspices of the order's "Congregation of the Good Death" (in Latin, the Bona Mors) to help prepare for a "good" death, namely, a pious one, accompanied by the church's sacraments, which brings you to

heaven and not to hell. Additionally, as part of their weekly coming together the sodality members—Bernini included, we presume—engaged in what was then called "the pious exercise of the discipline." What was this "pious exercise"? In order to subdue their unruly flesh and its unholy desires, as well as to show their abhorrence of their sins, the humble faithful whipped their bare backs, often to the point of drawing blood, with the *flagellum*, the small cat-o'-nine-tails much in use in the Catholic Church as a penitential practice until the early 1960s.

The congregation itself was formally constituted in 1648, but such "devotions"—preparing the Christian faithful for a "good" death—had been a central part of the Jesuit popular mission for years, having been given a major impetus by the 1620 publication of Jesuit theologian Roberto Bellarmino's *De arte bene moriendi* (The art of dying well). The purpose of such devotions was, yes, to reassure the men in the pews of God's mercy and encourage them with attractive visions of the rewards of eternal life in heaven. But there was also still a fair amount of "fire and brimstone" in those sermons and manuals to frighten sinners into conversion with visions of eternal damnation. As a result, despite the protestations of his biographers about his complete trust in a merciful divinity, Bernini was to remain frightened of death and what came thereafter for the rest of his life. No wonder he was so good at creating tombs and other funerary monuments: it was all very vivid to him.[13]

BERNINI SLASHES A LOVER'S FACE

Though his close encounter with death in 1635 could not have left Bernini an unchanged man, his recovery did not mark the beginning of a clean new chapter in his moral life. No, he still had too much libido left in him and too much testosterone-driven need to conquer and possess women. Moreover, what greater antidote to the fear of death but love and sex?

Sometime in 1636 or 1637 Bernini found a willing playmate, a lusty, independent-minded, strong-willed woman capable of matching his passion and his ego. Her name was Costanza Piccolomini Bonarelli (fig. 12). She was young and presumably beautiful, at least in Bernini's eyes. His sensually wrought marble bust of her (today in the Bargello Museum in Florence) shows a full-faced (*facciosa*, the Italians would say), smooth-skinned woman, in a state of partial undress, full of vitality and self-possession.

FIG. 12 ↠ G. L. Bernini, *Costanza Bonarelli* (detail), 1636–38, Museo Nazionale del Bargello, Florence. Photo: Scala/Art Resource, NY.

But let's be honest: she is by no means a classic, fine-featured beauty. Despite her fashionably braided hair, there is something not very refined about Costanza, especially in her nose and chin, neither of which is exactly dainty or delicate. Furthermore and more important, she was married, and the wife, no less, of one of Bernini's collaborators, sculptor Matteo Bonarelli. (We can't help but notice the irony of her baptismal name: Costanza, meaning "constancy" or "steadfastness.") The affair between Bernini and

Costanza was hot for a while but, after a year or two, it went up in flames—
and in a very public way. In March 1638, four years after the arsonous fire
in the family home at Santa Marta, yet another fiery blaze struck the Bernini
clan. It was fierce enough to threaten the life of at least one member of the
family and to attract the attention of the police. In fact, we know of the
Bernini-Costanza affair and some of its sensational details because in its
violent disintegration a crime was committed—by Bernini himself—and
the whole matter became a huge public scandal in Rome. This episode, the
most outrageous of Bernini's libertine bachelor years, involved even more
than a love triangle: not only Bernini and Costanza and Matteo, but also
Bernini's younger brother, Luigi.

To enter into this story we can do no better than turn to a document
already mentioned in our story, that single letter today surviving from Ber-
nini's mother, Angelica. (The rudimentarily educated Angelica most likely
had to dictate the letter to someone more literate than she.) Here it is for the
first time in unabridged English translation:

To the Most Eminent and Most Reverent Lord Cardinal Barberini,

Most Eminent Lord, Angelica Bernini, Your Eminence's most humble
servant, once again now pleads for your assistance, having on earlier oc-
casions begged your mercy, for the viscera of Christ, that you might deign
to apply some remedy to the great perils that presently threaten her. The
Cavaliere, her son, having no respect for either the law or Your Eminence's
authority, yesterday arrived here fully armed, in the company of other men,
intent on killing his brother, Luigi. He entered the house by forcing open its
doors, moved not at all by the tears that his mother, with no concern for her
own dignity, was shedding at his feet. After searching the entire house, he
then went, sword in hand, to Santa Maria Maggiore, with no respect at all for
that sacred place. He searched every corner of the rectory, with disdain for
God and the proprietors of that house, as if he were master of the world.

I need not emphasize to Your Eminence the grave error of his behavior,
or the scandal and the amazement that it provoked in all those who saw
him running, drawn sword in hand, after his brother. He caught up with
Luigi near the street that goes to Santa Bibiana and then followed him all
the way back to Santa Maria Maggiore. Many of the priests of the basilica, of
course, attempted to defend its sacred rights, seeing how he was kicking the
doors of the church with utter disdain. However, the priests gave up after a

short while, fearing his great power. His sense of power, it seems, has today reached a degree whereby he has no fear whatsoever of the law. Indeed, he goes about his affairs with an air of complete impunity, to the great sorrow of his mother and the marvel of all Rome.

His mother, therefore, begs you once again, for the viscera of Christ, that you deign to make use of the authority with which God has invested you, for no other reason than to ensure that justice be done to and for all. She throws herself at your feet, full of tears, in order to beg you to move to act on behalf of so distraught a mother as she, and restrain the fury of this son of hers, who at this point thinks that anything he chooses to do is perfectly legitimate, as if over him there were neither masters nor law.

What words to come from a mother's mouth, and an Italian mother at that. And addressed to someone who was no less than second in command, after the pope, in all of Rome, Francesco Barberini. (Angelica appealed to the prelate because he was not only a personal friend of the artist's but also Bernini's employer at the Fabbrica of St. Peter's, which he governed as Cardinal Prefect). As disturbing as Angelica's news of Bernini's insane public attempt at fratricide is her indictment of his personality as thoroughly narcissistic, if not sociopathic. Surely she exaggerates. Angelica's letter tantalizingly evokes a family drama worthy of Baroque opera or a tragic-comic epic poem (*Bernini furioso!*). Fortunately, other fragments of surviving documentation fill out the picture that she only partially presents. Angelica does not give any reason for Bernini's insane fury, but we know from other eyewitness accounts that what provoked it was in fact something disturbing enough to cause temporary insanity: the discovery that his own brother was sleeping with his mistress.

How the suspicion first came to him we do not know, but once it did, Bernini moved quickly. He hatched a clever plan, announcing to his family one evening that the next day he would be leaving the city for some destination in the countryside. Early the next morning Bernini went through the pretense of departing, but instead of exiting the city he made a beeline to his studio, whose windows conveniently gave onto Costanza's home. (Costanza was then living, like Bernini, at Santa Marta, since her artist-husband likewise worked in St. Peter's Basilica.) The crushing sight that then greeted Bernini's eyes was that of Luigi exiting the house with a half-dressed Costanza, who was there at the door saying good-bye to her lover

with whom she had spent the night. Bernini went berserk. Reeling in shock by so profound a betrayal, he went off in mad pursuit of his brother, as described in Angelica's letter. He had also made provisions for an appropriate revenge on his faithless mistress: he ordered one of his servants to go to Costanza pretending to bring her a gift of two bottles of wine. In presenting Costanza with the wine, the servant was, at the convenient moment, to slash her face with a razor. The servant found Costanza still in bed lounging around, and the act of revenge was carried out just as orchestrated by Bernini. The face-slashing strikes us today as a shocking act of monstrous violence, but, in fact and unfortunately, in Renaissance and Baroque Rome it was a common, conventional public ritual of revenge, a *dispetto*, all too routinely carried out by men upon their faithless female lovers or misbehaving prostitutes. One wonders if Costanza was left with a permanent scar on her face. What a bitter reminder that would have been of the whole dreadful episode.

Fortunately Bernini was prevented from killing his brother. Luigi was wise enough to flee Rome immediately, eventually ending up in Bologna. Angelica's letter is undated, but Luigi's abrupt disappearance from the weekly payroll of the Fabbrica of St. Peter's allows us to assign a date to this astounding episode in Bernini's personal life: March 1638. Luigi was to return to Rome in late 1639, his services having been requested by Cardinal Francesco. Luigi, however, took the precaution of writing in advance to make sure that his (now securely married) brother approved of his return. Approve he did, because without Luigi's expertise, especially as engineer, Bernini was handicapped in his ability to carry out some of the complicated architectural projects for the Barberini. Luigi never married, and at the age of sixty-three he was once again forced to flee Rome for a crime worthy of the tabloids, his violent sodomizing of a young workshop assistant, as we shall later see.

As for Costanza, surprisingly, whatever her husband's initial reaction to her infidelity might have been, her marriage to Matteo survived the episode. Matteo died in 1654, and in his will refers to Costanza as "my most beloved wife." Was he merely parroting the conventional formula? How many times, instead, in the angry heat of their inevitable domestic squabbles, had Matteo cursed her as *una puttana*, a whore? Certainly that is what the respectable Roman matrons would have muttered to themselves in disdain as Costanza passed them on the street. Or perhaps in the face of

her affair with Bernini, Matteo reacted simply and coolly, as any shrewdly practical-minded man would: there were advantages, monetary or otherwise, of having a wife who could draw favors from so high and mighty a personage. In other words, Matteo may not have been averse to, in effect, pimping his wife, if only in a passive, laissez-faire fashion. Sad to say, police records of the time reveal that Roman husbands—and not just brutes from the lowest classes—did occasionally "put their wives out to earn," as they termed it back then. We cringe at the thought that Matteo might have been this type of spouse, but we can't exclude the possibility of such cold calculation on his part (just as we can't prove it), since we know next to nothing about him as a person. Certainly in carrying on his affair with this married woman, Bernini must have had reason to believe he would suffer no serious harm from an avenging husband, despite the fierce male code of honor in force then.

Be that as it may, in the end Bernini may have soothed Matteo's feelings by making some sizable cash contribution to his pocketbook. We know that the professional working relationship between the two men continued even after this dreadful episode: at the time of his death, Matteo was carving a large marble relief of the *Visitation of Mary* for the Siri Chapel in the Santuario della Misericordia in Savona, Italy, whose remodeling had been commissioned from Bernini by the banker brothers Alessandro and Giovanni Battista Siri.

As for Bernini and his servant, the two perpetrators of the real crime in the eyes of the law (the slashing of Costanza's face), the artist was fined the large sum of 3,000 scudi while his servant-accomplice was sent into exile. However, Bernini never had to pay a penny; he was soon formally absolved by a personal decree of Pope Urban himself. The pope apparently took a "boys will be boys" attitude to the episode, even though the "boy" in question was forty years old. This is likewise the attitude of Bernini's son Domenico, who vaguely mentions some misdeed committed by his father on Costanza's account (conveniently omitting the most incriminating details), for "thus does love blind us." Why does Domenico bring up this compromising issue at all? Because in the end it gives him occasion to boast even further of his father's greatness by repeating Urban's own description of Bernini from the aforementioned writ of exoneration: Bernini, the pope declares, was "an exceptional human being, a sublime genius, born

by directive of Divine Providence, in order to bring illumination to this century for the glory of Rome." In absolving Bernini, Urban may have also recalled the response to artistic misbehavior of his predecessor, Pope Paul V, who agreed with Horace's *Ars poetica*: "Pictoribus atque poetis omnia licent [Everything is permitted to painters and poets]: we have to accommodate these great men because a superabundance of spirit makes them great but also provokes strange behavior in them."[14]

Bernini's mother, Angelica, could not have been entirely happy with the pope's exoneration of her son: more fuel to feed his narcissism! There is no stopping him now, she probably lamented to herself. (Apparently there was no stopping Costanza either: at her death, she left a seven-year-old daughter, Olimpia Caterina, presumably the issue of another extramarital liaison, since her one and only husband, Matteo, had died eight years earlier. No wonder that in her will Costanza left one-third of her worldly possessions to the convent of Le Convertite, that is, to a community of reformed prostitutes turned nuns, in exchange for their prayers for "the salvation of her soul.") However, the pope did put a stop to Bernini's wild ways. Summoning the artist to his presence, Urban "suggested" that the artist get married and offered his help in finding the best match in Rome. Bernini was smart enough to know that, however graciously put, the pope's suggestion was a command. Urban was pouring too much money into Bernini's career as papal image maker and was not about to have his huge investment undermined by scandals—there were already enough of those among his clergy. Although Bernini's first reaction to the pope's suggestion of marriage, according to Baldinucci, was "repugnance," he eventually and begrudgingly gave in, the pope having agreed to leave the search for the bride in Bernini's own hands. Domenico discusses the topics of Costanza and marriage in two separate chapters and makes no connection between the violent end of the liaison and Bernini's decision to wed. But the fact is that in May 1639, a little more than a year after that blowup, Bernini was married. The sexual escapades of Bernini's bachelorhood (presumably) came to an abrupt end.

It would be naive, by the way, to assume that Costanza was the only sexual affair in the first forty-one years of Bernini's unmarried life. But in defending himself, Bernini might have cited the consistent message of the medical experts of his time, who, contrary to church teaching, advised that regular sexual intercourse was necessary—at least in the case of men—for

the maintenance of good health. Being unmarried did not exempt one from this "law" of nature, the church's own law notwithstanding. Italians accept Mother Nature as she is.

The reputation as a sexual wild man that he had earned for himself prior to 1639 seems to have stayed with Bernini for a long time thereafter. This would explain why his authorized biographer, Baldinucci, felt obliged to interrupt, abruptly and awkwardly, the flow of his account of Bernini's life at one point to insert a strident but untruthful disclaimer about the moral tenor of Bernini's earlier life, to the effect that

> although it may be that up until his fortieth year, the age at which he married, Cavalier Bernini had some youthful romantic entanglements without, however, *creating any impediment to his studies of the arts or prejudicing in any way that which the world calls prudence*, we may truthfully say that his marriage not only put an end to this way of living, but that from that hour he began to behave more like a cleric than a layman. (Emphasis added.)

The Costanza affair with its violent, felonious conclusion, of course, gives the lie to such patent whitewashing. In Chantelou's *Journal*, we catch the elder Bernini likewise whitewashing his earlier life, when lecturing Prime Minister Colbert's handsome young brother-in-law on the virtue of temperance: "Turning then to Monsieur de Ménars, Bernini addressed a little exhortation to him, saying he was young and handsome and at that age one must take good care not to abandon oneself to pleasure; in his own case, God had put out a hand to save him, for, although he had a fiery temperament and a great inclination to pleasure in youth, he had not allowed himself to be carried away and had saved himself from it."

In Domenico's biography there is no corresponding disclaimer about the moral status of Bernini's early life. Nor does Domenico mention a spiritual conversion or moral turning point at any stage of his father's life, much less the need for one. Furthermore, as in his description of Bernini's artistic genius, technique, and style, Domenico nowhere mentions or alludes to any sort of evolution or growth or fundamental change on the part of his father's religious faith. He instead leaves readers with the impression that the unfolding of Bernini's life of faith was simply a single, unchanging continuum, one, undifferentiated, powerful current of piety, beginning, presumably, from childhood and enduring until the final moments of his

earthly existence. Bernini's misbehavior in the Costanza affair was simply an isolated event. Are we to believe Domenico? I bet Bernini's wife did not.

Did the newly married Bernini change completely overnight? Not likely. At least not within the confines of his psyche and its lingering compulsions. By insisting on the nearly monklike piety of the postmatrimonial Bernini, both Domenico and Baldinucci are guilty of exaggeration. Likewise, Domenico is guilty of characterizing all of Bernini's religious art, in each period of his life, as a direct, personal manifestation of his deep spiritual faith. (Baldinucci, instead, never makes this claim.) Domenico's claim has, by and large, been accepted, becoming near dogma in Bernini studies today, and a staple description of Bernini's art in both textbooks and more critical studies. But is it true? The fact is that even the earliest religious works produced by the bachelor Bernini—the *Saint Lawrence*, the *Saint Sebastian*, the *Saint Bibiana*, the *Saint Longinus*—are imbued with the same poignant spiritual air of his later works. For instance, regarding Bernini's statue *Saint Bibiana*, created in the mid-1620s, Domenico declares that it is "for both its tenderness and devotion, indeed, a miracle of art," and that his father "used to claim that 'it was not he who had created the statue, but the saint herself who had sculpted and impressed her features in the marble.'"[15]

Yet at the same time he was carving *Bibiana* and *Longinus* Bernini was not living the exemplary faith life of his more mature years. He was still a bachelor doing what Italian bachelors were notorious for doing in those days: sowing their wild oats, while paying only lip service to the demands of religion. True, there is a difference between religious belief and moral conduct—one can occasionally slip into bad behavior and still be a sincere, conscious believer, conscientiously striving to live the ideals of one's faith. However, the Costanza affair, in its duration and gravity (she was a married woman, the wife of Bernini's collaborator), does not strike at least this reader as having simply been one unpremeditated, brief, and isolated moral lapse in the artist's earlier life. Rather, there is good reason to suspect that it reveals the behavior of a religiously lukewarm adult whose sexual-emotional life was hardly dictated by the counsels of religion—no matter how forcefully he might protest the sincerity of his Catholic faith if interrogated by his pastor or, God help him, by the Inquisition. Certainly Angelica's desperate letter to Cardinal Barberini leaves the same impression. This is

not to say that Bernini was some sort of closet atheist or agnostic—and certainly he was never a member of any secret, anti-Catholic fraternity whose goal was to blow up the Vatican (as he is portrayed in Dan Brown's entertaining but entirely fictional *Angels and Demons*). It is simply to caution against what too many art historians have done and continue to do: blithely posit a simple, direct, trouble-free correspondence between faith and art over the entire course of Bernini's career. Whatever else we know or don't know about his faith, it is clear that Bernini was a far more devout, more conscientious Catholic after the age of forty-one.

In any case, it is hardly radical to suggest that all of Bernini's unbridled sexual aggression, given free reign for decades, could not have disappeared overnight. This flies in the face of all that we know about the human species, except, perhaps, in the case of a very few exceptional saintly souls. And Bernini is decidedly not to be counted in that number. There may perhaps have been, post-1639 (the year in which he wed), no more violent adulterous affairs such as the one with Costanza, at least as far as we know. Nonetheless, what is known, for example, of the content of Bernini's many theatrical productions—as we shall soon see—is evidence enough that the picture of a perfectly devout older Bernini painted by the official biographies is overstated. Persons of monklike religiosity do not write and produce plays that contain scandalous content or that otherwise promote unedifying moral behavior, comic though it might be, as Bernini often did in his theater, in keeping with the Dionysian spirit of the Carnival season for which he wrote and produced his plays.

Furthermore, as trite as it might sound, the highly charged sensuality of so many of Bernini's works of art must have represented to some unknowable degree a socially acceptable vehicle for the sublimation of his curtailed sexual drive. This is not to reduce his work to the status of mere manifestation of libido, but it is to acknowledge that Bernini did indeed have one—a libido, a much-pronounced one, as his own mother would admit—which inevitably found expression in and gave a certain charge to the products of his imagination. Yes, the biblical *Song of Songs* had long justified the use of erotic imagery in depicting saintly ecstasy, the ineffable union of the human soul with the Godhead, but why, to a degree matched by few of his contemporaries, predecessors, and successors, did Bernini so overtly infuse the erotic into his art, most notoriously, of course, in his *Saint Teresa in Ecstasy*?

We'll have occasion to ponder that question in the next chapter, but, first, one last word on the Costanza affair before, having made so many references to Bernini's marriage, we finally meet his bride.

Bernini Purchases a Bride

Even after the affair was entirely over and he was settled in his marriage, Bernini did not entirely forget Costanza. True, the artist gave away his marble bust of her to Cardinal Giovanni Carlo de' Medici. (We don't know exactly what occasioned the gift or what its objective was, but it was always good to make powerful cardinals happy through expensive gifts, especially one whose brother was Grand Duke of Tuscany.) Yet note that this gift was not made until several years after Bernini's wedding; the bust remained in open view in his studio in Via della Mercede until 1645 or 1646, when it went to its new home in the famed art collection of the Medici grand duke in Florence. Bernini also held onto the double portrait he had painted of himself and Costanza, side by side, even longer, in fact, until his death. His wife could not have been very happy over the presence of that marble bust or that double portrait, but she had no choice but to defer to her husband's wishes. Sometime after Bernini's death but before the 1706 household inventory, a member of the family, however, finally decided to cut the double portrait canvas in half. Was this an act of delayed anger or shame against the memory of the notorious affair, or did the family simply want to recycle the self-portrait of their father for another purpose? Unfortunately, the whereabouts of the severed portrait of Costanza is unknown today, and it is a matter of scholarly debate as to which, if any, of the surviving Bernini self-portraits corresponds to the one severed from the canvas in question.

Bernini also immortalized Costanza's fleshy features in yet another work, one within St. Peter's. If you look carefully at the face of the allegorical figure of Charity on the magnificent tomb he created for Pope Urban VIII, you will see Costanza. Bernini's contemporaries had immediately recognized this, and a comparison with his earlier bust of her confirms the identity. The tomb, begun in 1628, was not finished until 1647. It seems the Charity figure was largely executed in 1639, dating, therefore, to after the end of the affair. Despite the brutal finale of the affair, Bernini seems to have continued to love the inconstant Costanza. But it was time to move on, and so he did: "The Cavalier Bernini remained so mortified

when he caught his brother coupled with the woman whom he loved, that he never was able to find peace until he himself succeeded in taking as his wife the most beautiful woman that Rome has to offer." So spoke the Duke of Modena's Roman agent in reporting the news of Bernini's marriage to Caterina Tezio on May 15, 1639.

The marriage took place in the center of Rome in the small Church of San Tommaso in Parione, behind the Chiesa Nuova, mother church of the Oratorian order. San Tommaso survives to this day, though it is largely ignored, inasmuch as it is, architecturally and artistically speaking, not terribly distinguished, at least not when compared to so many other Roman churches. It, however, had a family connection: the bride's mother, Eugenia Valeri, had the special privilege of burial rights there. The church also was intimately connected to one of Rome's most beloved saints, Filippo Neri, affectionately known as "Pippo Buono," who had died only decades earlier in 1595: Neri had been ordained to the priesthood within its walls. Apart from his works of charity and personal holiness, Neri was founder of the popular Oratorian order of priests and brothers, one of the zealous new reform orders (together with the Jesuits and Theatines) that grew to prominence in Italy after the Council of Trent in response to the assaults and victories of the Protestant Reformation. Their evangelizing took the form of more effective popular sermons and simple catechetical instruction, as well as devotional services that, like their Jesuit counterparts, exploited the powerful and entertaining attraction of music and the visual arts to capture souls for the Roman Catholic Church. Bernini, therefore, would have found the Oratorians most congenial. It was also in their lavishly decorated mother church, the Chiesa Nuova (also known as Santa Maria in Valicella), that the artist would have seen his first major work by Peter Paul Rubens, a splendid altarpiece of 1608, *The Virgin and Child Adored by Angels*.

Interestingly, the Bernini-Tezio marriage contract specifies that the union was taking place with the express "blessing and approbation" of His Holiness Pope Urban VIII. Why, we wonder, was it necessary to add that specification? To use the papal name as a shield warding off any opposition and criticism? In addition to giving his personal blessing to the union, the pope, furthermore, exempted the couple from the usual legal obligation of having to publish their marriage banns in advance of the ceremony. He likewise dispensed with the obligatory examination of the witnesses to the

marriage. Clearly neither the pope nor Bernini wanted any publicity for his wedding or any scrutiny of his suitability as a husband. Having sown so many oats all over Rome, did Bernini perhaps fear hostile testimony coming forward at this point to delay or even block the marriage?

As with Bernini's mother, we really do not know much about his bride, Caterina Tezio. Caterina was born in Rome in October 1617; therefore, in 1639 at the time of the wedding she would have been twenty-two. Caterina came from a solidly upper-middle-class family. Her father, Paolo, was a lawyer and enjoyed special status as "citizen" of Rome (not all the city's inhabitants, even permanent ones, had a right to that title). He also earned a living as procurator for the court of Modena in Rome, as well as enjoying further benefits deriving from his service to the Barberini family, of which he was a faithful client. Given her family's socioeconomic profile (and presuming some degree of progressive thinking on her father's part), Caterina may have had some schooling beyond the usual female training in domestic matters, but there is no evidence to prove this. The person responsible for steering the bride-seeking Bernini in the direction of the Tezio family was apparently an unnamed priest of Filippo Neri's Oratorian order: perhaps it was the same Orazio Giustiniani, director of the Vatican Library, who acted as Bernini's legal proxy at the drawing up of one of the marriage contracts (specifically that of May 11, 1639, concerning the dowry). Bernini was given the choice of the two Tezio daughters; he chose the younger, more attractive one.

With Caterina, Bernini struck gold. His bride was entirely "the kind of woman he desired, so much so that, as he later said to Pope Urban, he could not have created a better one on his own, had he been able to sculpt her of wax according to his own taste: docile without blame, prudent without guile, beautiful without affectation, and with such a mixture of gravity, affability, goodness, and industry, that one could well call her a gift reserved by Heaven for some great man." The two stay married for thirty-four years. (She died in July 1673, seven years before her husband.) Bernini recognized the extraordinary patience required of any woman who would become his wife. In negotiating the marriage with her father, Bernini "declared that he intended to treat her exquisitely if she will prove capable of tolerating his nature, which is neither easy nor ordinary." Again, this detail comes from the Duke of Modena's agent, usually a reliable source of information.

Discussing marriage later in Paris, Bernini himself self-servingly declared (and with likely reference to his own long-suffering wife then still alive): "In the end a woman's pride lies in her ability to suffer with forbearance the imperfections of her husband, however great they may be and whatever they are." Regarding the financial terms of Bernini's marriage, the Duke of Modena's agent also reveals that against all tradition and convention Bernini refused Paolo's extravagantly generous offer of a dowry of 15,000 scudi. Like all fathers with marriageable daughters, Paolo had assuredly been saving up for the occasion for years. Dowries among the upper classes of Baroque Italy were always, and necessarily, extremely high, for their magnitude—their *magnificenza*—was yet another way that the family involved proved its social status and the value of the woman in question. (Patrician dowries could at times equal five times the yearly income of the family's estate.) Instead, in this case, the roles were reversed: Bernini paid—he, the husband, to the future father-in-law—the sum of 2,000 scudi out of his own pocket. This was no hardship for our artist: Bernini was worth over 100,000 scudi at that point, which put him securely in the ranks of the millionaires of Baroque Rome. These negotiations were all done "in a most secret manner," not surprisingly so, since they were so contrary to the usual legal-financial terms under which marriages were contracted. Bernini was, in effect, purchasing his bride. Why this unusual step? It may have been pure ego, and yet another further manifestation of Bernini's chronic need for control. This was an abiding trait of his character throughout his life, professional and personal.

It even drove him on the day of his wedding to take "his future wife to his house, strip her of her own clothing and dress her in garments supplied by him. He then sent back to her father the clothes with which she had come, thus signifying that he was now master over his wife." This "stripping of the bride" was an old, well-known ritual of male dominance, made famous by Boccaccio's popular tale (popular among patriarchal men, that is), "The Patient Griselda," versions of which show up across all of European literature, including in Chaucer and Shakespeare. The patient Caterina submitted to her husband's demands: she must have been consoled by the fact that she was at least marrying one of the most famous and wealthy artists in the whole city, and one who was not at all bad to look at. Her husband set her up as mistress of a large, wealthy household; she was no longer a mere servant of her father. Caterina, as female head of a family

of means, would have enjoyed a considerable domestic arena within which to exercise her own authority, although under her husband's rule.

Unfortunately, like her mother-in-law, Angelica, Caterina is silent in the surviving Bernini sources except for one revelatory document, her last will and testament, drawn up the year before she died. Just as Angelica had on one occasion boldly denounced her son Gian Lorenzo's lawless behavior, Caterina too had the courage to speak out against an act of injustice perpetrated by her husband. In her last will Caterina made specific provision for completely equal inheritances for all her daughters (except the two who had entered the convent). This would appear to be a reasonable move on the part of a mother, but actually, it was in open defiance of the wishes of her husband, who had planned a different and unequal distribution of bequests to his female offspring, favoring the child he refers to in his will as "Angelica, my first-born and most beloved daughter." Bernini was quite annoyed by this act of independence and feminist egalitarianism on his wife's part. Seven years later when it came time to compose his own will, he had still not gotten over his anger. In that will, Bernini, speaking contemptuously of his wife's "so-called will," advises his daughters that should Caterina's will be found legal and valid and should they accept the bequest left them by their mother, they would get not a penny from him. We do not know what decision the Bernini daughters made. But what a sad note upon which to end a marriage, and over what amounts to just a few scudi a month, and this on the part of a man who by then was a millionaire several times over.[16]

This battle of the testaments is, however, the only sour note between Bernini and Caterina we find in the documentation. Admittedly it is a loud one, all the more distressing because Bernini carried out the struggle with his wife, as it were, from his own grave. True, at the death of his wife in 1673 Bernini retreated for a few days of prayer at the Jesuit house at Sant'Andrea al Quirinale. Presumably deep grief moved him to such seclusion, and not a mere public display of expected mourning. But we have no documented clue as to the real content of his heart under the circumstances. The only other explicit clue to the tenor of the emotional relationship between Bernini and his wife are a couple of passages within Chantelou's account of Bernini's stay in Paris in 1665. Happily, they are more reassuring. While at Louis XIV's court, though treated truly royally by the king and though having the familiar company of his son and trusted household servants,

Bernini complained of sorely missing his wife and children, especially during the empty hours of his melancholy evenings. At a certain point later, Bernini received word from Rome of a near-fatal illness on Caterina's part and burst publicly into tears. He remained in a visible state of deep depression until news of her recovery arrived several days later.

The other reassuring—though not infallible—sign of the couple's affection for each other is that the marriage produced eleven children, six girls and five boys, a record not too far from that of his own parents in size and gender distribution. Two of the eleven Bernini children, however, died in childhood: Paolo (1644–46) and Francesca Giuditta (1653–58). The nine who survived childhood—and were still alive at the time of their father's death in 1680—are: Pietro Filippo (1640–98); Angelica (born 1646); Agnese Celeste (born 1647); Paolo Valentino (1648–1728); Cecilia or Angela Cecilia (born 1649); Dorotea (born 1650); Maddalena or Maria Maddalena (born 1652); Francesco Giuseppe (born 1654); and Domenico Stefano or Stefano Domenico (1657–1723). We might point out that the first Bernini child was born only eight months and eight days after the couple's wedding: A premature birth? Or did Bernini do some "test driving" before finalizing the purchase of his bride?

Bernini's offspring may have been large in number but it proved small in talent, none of the children even remotely approaching the level of achievement and worldly fame, in any field, of their father. Not a spark of genius or originality in the whole bunch. The eldest son, Pietro Filippo, had a distinguished enough career as a prelate and functionary within the papal curia. He is, coincidentally, the only one of whom we have a certified portrait (not done by his father, but by a little-known artist). It shows a slimly built prelate with a pleasant enough face, which, however, communicates not a glimmer of intellectual brilliance or depth of spirit. His only conspicuous feature is the size of his nose. Without his father's active, behind-the-scenes maneuvering and machinations at the papal court, Pietro Filippo, needless to say, would never have gotten so far in his curial career and is remembered today only because of his father. Alexander VII's diary contains several allusions to Bernini's lobbying the papal court on his children's behalf, an activity that Bernini himself explicitly tells Chantelou is essential, if one is to extract favors from princes. Likewise thanks to his father's encouragement and maneuvering, Bernini's younger son Francesco became an ecclesiastic like Pietro Filippo, though of far less distinguished rank.

As for the women, two daughters, Agnese and Cecilia, as we saw, entered religious life in the same convent, SS. Rufina e Seconda in Trastevere, and the remaining three were all married off to wealthy, respectable husbands from the minor aristocracy. Normally in patrician or near-patrician families like the Berninis, given the exorbitant scale of dowries at the time, fathers could afford to allow only one daughter to marry; Bernini's liberality toward his daughters in this case was exceptional. That is all, unfortunately, we know of the Bernini women. Middle son Paolo had a brief, unenthusiastic career as a sculptor. Today there exists only one known work by him, an oval marble relief of the Child Jesus, done in Paris and now in the Louvre. However, during its execution, Paolo's sculpture was "touched up" by his father so many times—as Chantelou's diary reveals—that it must be classified as a collaborative work. At least Paolo did not disappoint in his marriage; his wife, Laura Maccarani, came from an old, illustrious Roman family. Again, normally in patrician families, in order to keep the family patrimony intact, only one son, usually the eldest, was allowed to marry, carry on the family name, and inherit the entire estate (this was the widely respected practice of primogeniture). The remaining sons typically made ecclesiastical or military careers for themselves. Not so in Casa Bernini. Evidently eldest son Pietro Filippo had made it clear early enough that a career in the church would suit him fine (as it suited third son Francesco), so the marriage lot and primogeniture fell to Paolo. Youngest son Domenico likewise entered ecclesiastical life, but after his father's death, decided celibacy was not for him, so he too married. His wife must not have been of especially distinguished family for neither Domenico himself nor any other source boasts of the socioeconomic status of his in-laws.

Domenico may have married on mediocre social terms, but with respect to enduring public distinction, primacy among the Bernini children, in fact, goes to him. This is thanks to his several published works of ecclesiastical history, lives of saints and near-saints, and of course the biography of his father, which, again, despite its mythologizing and other defects, remains our primary source about Bernini's life and character. Although not exactly stunning examples of their genres, Domenico's writings are, nonetheless, respectable enough in terms of the informed intelligence of their conception, execution, and content. These several volumes gained him the esteem of his contemporaries, even if the preface of the Venice 1737 edition of

Domenico's *Historia di tutte l'heresie* (History of all heresy) grossly exaggerates in calling him "one of the famous writers of our century."

How did Bernini feel, especially at the end of his long life, in seeing that not one grain of his prodigious genius passed on to any of his children? Was it sorrow or relief? Sorrow that there would be no Bernini dynasty in art? Relief that his own fame would not be eclipsed by any of his progeny, as occurred with his own father? Certainly he would have been distressed to know that the Bernini name itself would be extinct by the mid-nineteenth century with the death of his last direct descendant, Prospero Bernini, who left only one adopted daughter, Concetta Caterina Galletti.[17]

"MAKING WHAT IS FAKE APPEAR REAL"

In lamenting the absence of his family in Paris, Bernini mentioned that back at home his wife and children used to "entertain him in the evening." The family entertainment in question apparently took on, on occasion, a rather formal, public, and ambitious form. In his private diary, Pope Alexander VII notes on February 27, 1658, that Don Mario Chigi (his brother) that evening was going to Bernini's home, where the children were to perform an "operetta," a staged (or partially staged) musical drama or comedy. The Berninis, it seems, were a sort of Roman Baroque Family von Trapp, though they didn't take their show on the road. The diary does not specify which operetta (whose music? whose libretto?) and under whose direction they were performing, but from what we know of Bernini's well documented and much-exercised talent in the field of theater as playwright, stage designer, actor, and director, it may likely have been he who had conceived and produced this family performance; only the musical score had to be outsourced. Again, one wonders how he ever found the time amid his many labors! It makes one realize that at least one of Bernini's claims about himself was no exaggeration: in his old age, "he used to say that 'if he could gather together all the hours of leisure he had had during his entire life, they would barely add up to a month's worth of time.'"

Later in his diary Pope Alexander also happens to mention that "this evening they [not identified] will perform music for us, with lyrics by Bernini." As is well known, lyrics set to music were virtually always compositions in verse, whether written for the occasion by poets of the day or appropriated from famous masters of the past like Petrarch, Tasso, or Marino. In the case

of a mere family production, the technical quality of the poetic verse did not need to be high, and even an unschooled amateur lyricist like Bernini could have easily come up with something adequate for the circumstances. The papal diary entry is not the only reference to Bernini's activity as a poet; it is also noted in the first published obituary appearing two months after the artist's death (January 1681) in the popular French monthly *Le Mercure galant* (presumably written by the journal's editor, Jean Donneau de Visé). The *Mercure* assures us that Bernini "wrote very fine verse." Alas, none of that verse survives. What kind of voice did Bernini-the-poet have? He may have included poetry in the many plays he wrote and produced. Of this sizable production, unfortunately, the script, or rather, about 40 percent of the script, of a single untitled play survives, known in English as *The Impresario* (it contains no poetry). Yet, fortunately, documentation of this realm of Bernini's artistic activity, though fragmentary, adds up to a sufficient amount of data and description from which we can draw a reliable picture of Bernini the man of the theater.

But first let us note the obvious: as immediately evident in the spectacular, dramatically "staged" nature of his works of art—be they statues, funerary monuments, or chapels—Bernini always performed as a "man of the theater" no matter what the commission. The script of *The Impresario* contains a wonderful line—or sound bite—spoken by its main character, Gratiano (clearly Bernini's alter ego), that describes the underlying theory of not only Bernini's theater, but the rest of his art as well: "Ingenuity and design constitute the Magic Art by whose means you deceive the eye and make your audience gaze in wonder." Another sound bite is supplied by Domenico in discussing his father's theatrical productions: "And Bernini used to say that the best part of all his comedies and their sets consisted 'in making that which was, in fact, artificial appear real.'" So too for his works of art. Of course, the Protestant "heretics" might have sarcastically said the same thing about the particular form of Roman Catholic Christianity then being propagandized by the papacy, with the very effective visual assistance of Bernini's art.

Domenico credits Pope Urban's nephew, Cardinal Antonio Barberini, Jr. (fig. 13), with prodding a reluctant Bernini into staging the comedies that the artist had written as mere diversions while recovering from his grave illness of 1635. The biographer may be correct in identifying Cardinal Antonio as the catalyst for Bernini's theatrical career, but other reliable

FIG. 13 ➤➤ *Cardinal Antonio Barberini the Younger,* contemporary engraving, ca. 1645.

sources indicate that Bernini had begun staging public productions of his comedies as early as 1632. Baldinucci, with no indication of chronology or mention of convalescence, simply states that Bernini "composed and produced" his "fine edifying plays" at Antonio's "urging and expense." He also tells us that other plays performed in Rome—not of Bernini's creation—utilized stage machinery he had invented, which would speak well of Bernini's quickly formed reputation even in the realm of scenography and theatrical special effects. Especially close to the artist throughout his life, Cardinal Antonio made profitable use of Bernini's talent as scenographer in the famous musical spectacles sponsored by Casa Barberini, that is to say, in Antonio's productions held in the theater of the Palazzo Barberini.

During his 1639 Roman visit, John Milton attended one of these Barberini performances, *Chi soffre, speri,* "Let he who suffers, have hope," featuring a slice-of-life musical intermezzo staged by Bernini, *La fiera di Farfa,* "The fair at the abbey of Farfa." These Barberini plays were full-scale, multimedia events as extravagant and costly in their staging, costuming, and musical accompaniment as any Broadway production today.

By means of such high-profile cultural patronage, the ambitious Cardinal Antonio aspired to be, as he himself openly admitted, another Scipione Borghese. But like Scipione's personality, Cardinal Antonio's had its dark side. Even before receiving his red hat, Antonio was well known for his less than spotless moral conduct and for the sordid company that he kept. In 1628, when Urban had first publicly announced his intentions to admit his emotionally immature, spendthrift, decadent nephew to the cardinalate, the uproar of protest was deafening. But to no avail. The barely twenty-year-old Antonio became cardinal, and neither his manners nor his morals showed any sign of improvement. It would take twenty-five years and a long exile from Rome to finally put the fear of God into Antonio and turn him into a more or less respectable ecclesiastic.

Populated with lowlifes, Cardinal Antonio's household at the Palazzo Barberini was "notoriously profane, castigated for its immorality and licentiousness," but the prelate's protection kept the arm of the law from punishing the patently criminal behavior that was a commonplace occurrence under his roof or on the streets of Rome by his servants and bosom buddies. Described by contemporaries as ruthlessly ambitious and narcissistically arrogant, the worldly Cardinal Antonio, it was rumored, resembled Scipione in the scandalous conduct of his private life. In Antonio's case, it is, however, more difficult to establish the truth: he is protected (thus far) by the ambiguity of the documentation. Is there some truth to the gossip about him? Where there was smoke, was there also fire in Casa Barberini? One of the apples of Antonio's eye was Gualtiero Gualtieri, a handsome young man with a high social profile (his mother was a Pamphilj) who served in Antonio's court. But the infatuation was apparently not entirely mutual, for as a well-informed diarist of the age noted, Gualtieri once crudely complained of the cardinal's importuning: "I have him up the ass all night, let him leave me alone in the daytime."

Antonio and Gualtieri soon thereafter had a bitter falling out, and the cardinal abruptly dismissed the young man from his service. After some

wandering in search of a new arena for his charm and talent, Gualtieri later died in battle fighting the Protestant Swedes under the banner of the Holy Roman Emperor. Yet a rumor immediately began to spread that Gualtieri's death was no ordinary casualty of war and that Cardinal Antonio was involved in the young man's demise. It was too easy to believe that he had plotted to get rid of an inconvenient and now hostile former intimate. Unfortunately for Antonio, even Gualtieri's maternal uncle, Cardinal Giambattista Pamphilj, fully believed the rumor and still carried a burning resentment over the affair in his heart when in 1644 he became Pope Innocent X. As we shall see, soon after Innocent's election, Cardinal Antonio, together with his brothers, Francesco and Taddeo, was obliged to flee for safety to Paris rather than face criminal charges in Rome (for financial corruption at the expense of the church's treasury) that the new pope was determined to file against them. But in Innocent's mind, Antonio's crimes went beyond the mere financial, which is why of the three brothers, Antonio would be obliged to remain in exile the longest.

Also the subject of gossip of a sexual nature was Cardinal Antonio's close relationship with the famous castrato Marc'Antonio Pasqualini, nicknamed somewhat ambiguously "Malagigi" after the sorcerer of Arthurian legend featured in Ariosto's best-selling epic poem, *Orlando furioso*. Antonio showered money, gifts, and personal attention on Pasqualini, and who could blame contemporaries from assuming that Pasqualini returned these favors through his performances not only on stage but also behind closed bedroom doors. When, together with a cast of other castrati, Pasqualini first performed in Paris (the opera *Orfeo*), having gone there in the company of his patron-in-exile, Cardinal Antonio, there was "unleashed a torrent of homophobic discourse" from the well-sharpened, anti-Italian literary tongues of the French capital. That torrent was in large part directed at the detested Cardinal Mazarin, criticized for exposing Paris to this moral corruption from the South, Cardinal Barberini and his court of castrati. Mazarin was mocked as the "Sicilian sodomite"—he was certainly not Sicilian—and as the "pimp" and "minister of outrageous voluptuousness" in service to the debased Cardinal Antonio and Pasqualini, for whom he procured "pleasures which are not strictly polite to say."

The short, swarthy, and haughty castrato Pasqualini can be seen today in the Metropolitan Museum of Art in a sensual, full-length portrait, painted by Cardinal Antonio's courtier-artist, Andrea Sacchi. The portrait,

it seems, was originally owned by another man of the church, Cardinal Giulio Rospigliosi, the future Pope Clement IX. In Sacchi's canvas, Malagigi, standing erect while fingering the keyboard of an elaborately carved, gilded clavicytherium (a small, upright harpsichord), is being crowned by the god Apollo. Pasqualini is fully clothed, while Apollo is shown completely and heroically naked, his fully exposed (and, unlike those of Pasqualini), fully intact genitalia occupying the physical center of the canvas. As with all castrati, Pasqualini's sexual identity and appetite were the object of much wild speculation. It was only inevitable that Cardinal Antonio's enthusiastic patronage of and undisguised fondness for him would make the gossip mills of Rome draw luridly inconvenient conclusions about their relationship. On the other hand, Cardinal Antonio enjoyed the company of women of loose morals while also professing openly his great love for the celebrated singer-musician of the day, Leonora Baroni. But "La Baroni" may have served as a convenient screen for the cardinal to distract attention from more troublesome rumors circulating about his sexual preferences.[18]

Bernini, for better or worse, did not have to cavort with castrati in his theatrical pursuits. He simply recruited members of his family and workshop to serve as actors in his plays, training them himself. Even though his productions were homegrown and home-staged, they were, for Bernini, dead-serious endeavors. The theater—writing, directing, and producing his comedies—was no mere pastime for Bernini. It was a major preoccupation throughout his adulthood, extending well into old age. It thoroughly engaged his imagination, his intellect, and, of course, his time and energy. As in his every endeavor, he assumed full control of the productions, at least those offered at his own home. With some exaggeration, the distinguished English traveler to Rome in 1644 John Evelyn notes in his diary, as an aside to his description of the Baldacchino: "It is the work of Bernini, a Florentine sculptor, architect, painter and poet, who, a little before my coming to the Citty, gave a publiq Opera (for so they call shews of that kind) wherein he painted the scenes, cut the statues, invented the engines, compos'd the musiq, writ the comedy, and built the theatre." In truth Bernini never wrote music or built full-fledged theaters, but he did know a great deal about theater construction. And he did write scripts (or at least detailed plot summaries), design stage scenery and special effects machinery, and direct his actors in their performances. While in Paris, Bernini spoke often and with obvious pride about his own plays. He would even

recite from memory extensive portions of his scripts. Baldinucci tells us that "sometimes it took an entire month for Bernini to act out all the parts himself in order to instruct the others and then to adapt the part for each individual." Anti-Bernini art biographer Passeri snidely remarks that the master, in fact, kept his poor, oppressed workshop students "in chains" throughout the year just to prepare for the brief Carnival season of Bernini's theatrical productions. Fire is never a gentle master.

Even though Passeri's remark was meant as a stinging criticism, it is a further indication of how deeply invested Bernini was in this dimension of his creative self. The theater clearly served as a valuable and valued, if not psychologically necessary, vehicle of self-expression on all manner of subjects, including art and politics. According to a recent hypothesis, it may have even been pursued as a vehicle of further professional training in the expression of the *affetti*—the broad array of emotional states—the convincing, genuine, and stirring depiction of which was, in turn, one of the goals of his sculpture and painting. At the same time, in his love and pursuit of theater, Bernini was entirely a man of his times: he was doing what so many of his literate contemporaries were doing in Rome. The period of the Roman Baroque represents one of the golden ages of theater in Italian history, if not in quality, most certainly in quantity. In its variety it embraced the entire spectrum of society ranging from bawdy, improvised comedy in the public squares to the carefully crafted moral-pedagogical-devotional works produced in the Jesuit colleges and female convents. There were those zealous preachers like Bernini's Jesuit friend Gian Paolo Oliva, who violently opposed most forms of nonreligious theater as dangerous occasions to sin. But their attempts to persuade the authorities to suppress the Roman theater were fruitless to the point of comedy. And at times even to the point of tragedy, as our diarist Gigli relates: In February 1648 (Carnival time), a certain Father Giovanni Battista, confessor to the cloistered nuns at San Silvestro, persuaded some of the more zealously ascetic sisters to campaign to cancel their already scheduled theatrical performance, planned for the entertainment of the nuns and their lay patrons and friends. A number of equally zealous unascetic nuns arose in strenuous opposition to the threatened cancellation. This ignited a bitter struggle: "The nuns came to physical blows among themselves, some were wounded with knives, another was killed, and yet another thrown into the well, and

still another one later died on February 15th. The city executioner was sent into the monastery and she who had committed the homicide was herself punished with death."

Most of Bernini's productions were staged under his private sponsorship at his own home. On occasion he designed the scenery and special effects for productions sponsored by the papal families, specifically, the Barberini, the Pamphilj, and the Rospigliosi. The plays produced at Casa Bernini were comedies of manners, as was Bernini's 1646 production for Donna Olimpia Maidalchini, most likely as another way of ingratiating himself with that power-broker sister-in-law of Pope Innocent X Pamphilj. As in his other works of art, Bernini plundered elements from traditional theatrical genres (for example, the improvisational, somewhat lowbrow *commedia dell'arte* and the more learned, fully scripted Renaissance *commedia erudita* based on ancient Roman models). From these, he created a new, personal hybrid. That hybrid is hard to define, though it has much in common with the *commedia ridicolosa*, a distinctly Roman form of popular theater in the age of the Baroque. The typical Bernini play was a mixture of bawdy humor and audaciously biting social-political satire aimed especially, and not surprisingly, against the hypocrisy of the court. "Bernini's clever remarks," Domenico boasts, "would subsequently be repeated by all the mouths of Rome; indeed, many times they reached the ears of the pope himself [Urban VIII] that very same evening. Seeing Bernini the next day, the pope would have him repeat his witticisms again, giving unconcealed signs of pleasure over them."

Bernini's satire took no prisoners. He mocked even high-ranking prelates, some of whom took offense not without reason, like the anti-Barberini Cardinal Gaspar de Borja, who had the misfortune of being one of Bernini's targets in his 1634 production. The hot-headed Spaniard Borja, Bernini was warned, would never forget such an offense and would seek his revenge. But Bernini did not care, for he was then very much under the protection of Pope Urban, or, later in 1646, of the Pamphilj pope's fearsome sister-in-law, Donna Olimpia. In fact, in his play for Donna Olimpia, Bernini shocked his audience by poking fun even at his former patrons, the Barberini, then in self-imposed exile from Rome, shielding themselves in Paris from the wrath of their enemy, Pope Innocent. Moreover, in the same play, Bernini went so far as to make an unflattering reference to the

reigning but chronically indecisive pope and his, shall we say, "intellectually challenged" nephew, Camillo. As an observer of the Roman court reported at the time, "It was a miracle that Bernini did not end up in prison!"

Much of the comic spirit of Bernini's plays derives from the fact that many of them were written to provide free, public entertainment for Carnival (Mardi Gras). The notorious Carnival season was the annual ten-day explosion of rowdy, and at times scandalously licentious, celebration preceding Lent, which entailed forty days of fasting, abstinence, and sober, churchgoing behavior, whether sincere or not. "Semel in anno licet insanire," the ancient Roman proverb counseled: "Once a year, you are allowed to go crazy"—and this advice the modern Romans took much to heart in giving free rein to their Carnival spirit. Even cardinals participated in the morally relaxed merriment of Carnival, a fact denounced in vain by that outspoken Jesuit preacher of the papal court, Niccolò Zucchi. Zucchi, we are told, "fece un gran gridare" (screamed his head off) over the situation. As Zucchi also and accurately pointed out, Carnival was nothing but a remnant of paganism—one that no amount of clerical denunciation ever completely succeeded in eradicating from Baroque Rome. Only in the 1670s would spoil-sport, sourpuss Pope Innocent XI have some success, but even that was only temporary.

At the same time, few spoke out against what today would probably be considered the most morally offensive of the public "entertainments" of the traditional Roman Carnival, the races of naked Jews and hunchbacks. These represented categories of persons whom seventeenth-century Romans considered "freaks" of nature who deserved to be ridiculed and pelted with rotten food as they ran down the Corso. (Pope Alexander's diary on one occasion marks for special note the Carnival race of the Jews, but there is no clue as to what he felt about the matter beyond the telling fact that he did nothing to stop it.) The Jews also provided the occasion to serve up another more gruesome form of Carnival entertainment: an elderly frail Jew was forced into a barrel whose interior was covered with exposed nails, and then the barrel was pushed down Monte Testaccio, to the cheering crowds of Romans, "especially the nobility," reports an eyewitness. The crowds of spectators eagerly awaited to see in what miserable condition the poor victim exited from the barrel at the foot of the hill—bloodied and lacerated, to be sure, but dead or alive? In a city whose population routinely attended public executions for their entertainment value (as in the case of the Sicilian

"witch," Girolama), that this anti-Semitic barrel toss was also considered an enjoyable and respectable spectator sport in papal Rome should not surprise us.

As for Bernini, he seems not to have subjected the Jews to any mean-spirited public scorn in his own theater—none of the many summaries of the contents of his plays given by those in attendance mentions the Jews. But he does not fail to allude to the Jewish connection with the Roman Carnival by including a Jew in his play *The Impresario*: that play, written for Carnival, opens with the Jew, a merchant in secondhand clothing, negotiating with a scheming courtier, the kind of scene that would always guarantee a laugh or equally gratifying derision at the expense of the Jews. As an orthodox Roman Catholic, nonetheless, he too would have accepted the church's universally taught tenet that the Jews, along with all others (including Protestants and Muslims) who were not members of the "one, true church"—namely Catholicism—would automatically go to hell for eternity after death. We are reminded of this teaching by Bernini's Jesuit friend, Cardinal Sforza Pallavicino: describing the number of deaths caused by the bubonic plague of 1656, His Eminence reports this about the Roman ghetto (where, since 1555, Jews had been forced by papal law to live in unhealthy, crowded confinement): "As for the ghetto, although it was commonly feared that the plague would result in a great slaughter due to congested living conditions there, in fact, the contagion's fury tempered itself in that neighborhood, resulting in the offering up of only a few of those unhappy victims to Satan."[19]

To return to Bernini's Carnival entertainments, as his sole surviving script, *The Impresario* necessarily receives much attention in any discussion of the artist's theater. But it is not entirely typical of his productions, first of all for the fact of having been written down, line for line. A recent, persuasive new interpretation is that the play is singular among all of Bernini's plays, written as an isolated act of artistic self-defense and self-promotion during the bleak period of the artist's career in the early anti-Barberini and anti-Bernini years of the reign of Pope Innocent X. Although unfinished, it is easy to assume that in the end the genius of its main character and Bernini alter-ego, playwright-scenographer Gratiano, would triumph over those who doubted and opposed him. Thus the play might be more aptly titled after Bernini's statue produced in the same period and with the same brooding mindset, *Truth Revealed by Time*. Like much popular traditional

theater (most notably the *commedia dell'arte*), Bernini's plays would not have been formally scripted—not line for line, that is. They would have depended to a large degree upon improvisation deriving from the roughly sketched outline of a plot, which in turn came from familiar stock situations, dialogues, characters, and slapstick comedy.

In Bernini's case, since his plays were filled not only with coarse humor and witty but also merciless political satire that could anger the powers that be, it was safer not to commit things to print. This is why today only one script survives from so many years of playwriting. Bawdy humor and political satire, while not entirely absent from *The Impresario*, are nowhere as pronounced in it as one would expect from descriptions of Bernini's productions left by those who actually attended his plays. Finally, though there is much talk about stage design and special effects machinery in *The Impresario*, the actual provisions for these elements in the script do not begin to approach the degree of sophistication, originality, and awe-inspiring daring for which Bernini is so praised by his contemporaries. Most famous are his recreations on stage of a flood of the Tiber River and a fiery conflagration, stunts that sent audiences fleeing in panic. On one occasion, a gentleman in the audience actually died in the chaotic rush to escape the flames. The death is acknowledged by Domenico, but placidly and with an utter lack of sensitivity to the sadistic nature of his father's prank. By contrast, in his reminiscences of Bernini, Charles Perrault would point to this irresponsible theatrical stunt ("everyone thought they would suffocate in the rush to escape from that false conflagration") and the death it caused as revelatory of a troubling side of the artist's character, as would perhaps a modern-day psychologist. Yet at the time, such extreme manipulation of the audiences' emotions was considered both funny and in some way cathartic. Certainly, in his mechanically and politically daring theater, Bernini loved playing with fire, literally and metaphorically.

Bernini's theatricality, as mentioned, was not confined to Carnival comedies. He brought his experience of the theater to bear on his artistic, especially architectural, design, no matter the season, genre, or patron. Bernini experienced the world, if only unconsciously, in terms of theatrical performance. Even—or especially—when he was designing chapels (for example, the Cornaro Chapel with its *Saint Teresa in Ecstasy*) and churches (above all, Sant'Andrea al Quirinale), his fundamental visual model was the stage. (If Bernini were alive today, I daresay, he would be making his

living on Broadway.) Moreover, even in "designing" his own personal life, he mixed theater with reality. As we shall see in chapter 5, in Lyon, France, in 1665 en route to Paris, to escape importuning crowds of visitors Bernini resorted to a classic trick of masquerade and identity-switching taken right from the theatrical books by having his majordomo impersonate his master. On other occasions, having to outsmart the competition in a zero-sum world of resources, he behaved very much like the clever, conniving courtiers he portrayed in his own comedies. "Come now, shall I tell the truth? You're a bunch of sly characters—we all are," we heard Bernini's alter ego, Gratiano, remark in *The Impresario*. Bernini demonstrated the truth of that self-confession with his own behavior.

In the late summer 1640, living in his rented quarters at Santa Marta (which had become even more cramped since his recent marriage), Bernini found out that the Oratorian Fathers had been bequeathed a residential property, larger than his present accommodations but happily still close to his place of work, the Vatican. While still working out the legalities of the bequest, the Oratorians, it seemed, formally rented the palazzo to sculptor Andrea Bolgi—a former collaborator and no friend of Bernini's, as we have seen. Not caring about the fact of the already signed rental contract, Bernini was determined to get that property for himself. Working secretly behind the scenes, he used his Vatican connections to tie the hands of the Oratorian Fathers and have the property, instead, declared "Reserved for the Papal See," a legal and not unusual, if annoying, practice in Rome at the time. Accordingly, an official wooden plaque was affixed to the door of the residence, announcing to all that the property was now *pro Papa,* for the pope's exclusive use. This *pro Papa* reservation, however, meant that Bernini, as papal architect, could claim use of the palazzo ahead of all other nonpapal comers, like Bolgi. Bernini would, of course, be happy to pay rent, but would do so at a lower rate than that charged to Bolgi. The Oratorians were not happy, nor was Andrea Bolgi, who had thought he was the legal tenant.

An inquiry was held to confirm exactly when the *pro Papa* reservation had gone into effect: was it before or after the property had been formally leased to Bolgi? This was the crucial legal detail. However, those in the know refused to cooperate because, working for or with Bernini, as one potential witness confessed, they feared the artist's retaliation. Bernini's father-in-law, Paolo Tezio, was called in to act as intermediary between the

Oratorians and the deviously clever, emotionally volatile but papally protected artist. But to no avail. In the end, it took the intervention of someone on high to resolve the conflict. That someone, whom our source for this episode simply calls "Cardinal Barberini," was presumably Cardinal Antonio Senior, who had a close, friendly association with the Oratorians. The cardinal calmed the waters by offering a generous monetary contribution to the Oratorians to compensate them for their trouble and, in turn, the Oratorians agreed to rent the palazzo to Bernini. But there was a catch: the rent would be at the same price fixed for Bolgi. This did not at all please the arrogant Bernini, who felt entitled to a better deal. Claiming now that his wife had changed her mind and decided the house would not really be suitable for her family, Bernini abruptly withdrew from the negotiations, after all the trouble he had caused.

This is all that we know of this complicated episode from the fragmentary surviving memorandum drawn up by the Oratorians, but it is enough to remind us of the darker side of Bernini's personality: aggressively self-interested to the point of callously stepping over anyone who got in his way (as, in this case, Bolgi), even to the detriment of his integrity. The Oratorian priest who drew up the aforementioned memorandum, by the way, was Father Virgilio Spada. Later, in his role as architectural advisor to Popes Innocent X and Alexander VII, Spada would again cross paths with Bernini under even more unpleasant circumstances.[20]

"To Our England Your Glorious Name"

In addition to the need for frequent sexual intercourse, another of the characteristics of the classic "choleric" personality, according to Giambattista della Porta's bestseller manual on human physiognomy, was the desire for frequent travel. This was a further manifestation of the general restlessness troubling that category of persons. Restless though he was, the desire for travel was, however, one trait that Bernini seems not to have shared with his fellow cholerics. Bernini's imaginative world may have been cosmically expansive, but his physical world was rather well circumscribed. He was very much the Roman homebody. Having moved there in 1606, Bernini spent most of his life in the city itself. He seems to have agreed with Pope Urban VIII, who would repeatedly remind the artist: "You were made for Rome and Rome made for you." Certainly the great quantity of work he

had to do in Rome left him little time for travel, but even so, there is no evidence that Bernini ever expressed any interest in seeing new places and meeting new people in the world beyond. Perhaps he felt that he already lived in the most beautiful, most interesting, and most fulfilling place on earth.

We never hear of Bernini taking a real vacation, certainly never a break from work lasting more than a couple of days. Furthermore, except for his 1665 journey to Paris, virtually all his trips beyond the wall of Rome were work-related and limited to nearby towns such as Castelgandolfo, Ariccia, and Tivoli. One summer (1648 or earlier) he did accept an invitation to a party in Bracciano at the country home of his friend Duke Paolo Giordano II Orsini, but this was likely done to please a prince-patron rather than himself. In the summer of 1652 he took one trip to Rieti some forty miles northeast of Rome to check up on three nieces, Suor Maria Angelica, Suor Anna Maria, and Suor Giovanna Lorenza Salvietti (known locally as the "monache Bernini," the Bernini nuns) in the monastery of Santa Lucia. He ended up being commissioned to design the Santa Barbara Chapel in the town's cathedral. In April 1656 he went to the seaside locality of Palo, just south of Ladispoli, seeking a cure from a lingering case of fever; but again that was not a journey he made willingly and happily. As for the place of his birth, Naples, he never once returned there after leaving it as a boy, nor did he ever have a commission from anyone there. Beyond his aversion to travel, he may have had an aversion toward Naples itself, perhaps because it was under Spanish control.

Since Bernini would not go to the world outside Rome, it came to him, both in the form of international commissions and an unbroken stream of foreign visitors to his studio. For most of the seventeenth century Rome was the undisputed artistic capital of Europe, the place where each year countless young artists came to perfect their skills and older wealthy collectors came to purchase art, ancient and modern, to fill their galleries back home. With so much coming and going, what occurred in Rome on the artistic front was soon reported back to all parts of Europe. Certainly by 1633 with the unveiling of the completed Baldacchino, Bernini began to attract much attention. Arriving in Rome, foreign visitors flocked to his studio. Even the more casual sightseers—of course all above a certain social rank—Bernini generously allowed into his studio to watch him work, as long as they respected his rule of complete silence. For the more

professional visitors Bernini made time for conversation and even some instruction, as we learn, for example, from the memoirs of English sculptor Nicholas Stone, Jr., German painter Joachim von Sandrart, and Swedish architect Nicodemus Tessin, Jr., all of whom interacted with Bernini during their Roman sojourns.

His fame spread to all parts of Europe, and it was only inevitable that sooner or later commissions would arrive from abroad. The first came in the spring of 1636 when a letter was delivered by special diplomatic courier at Bernini's home at Santa Marta: it was from King Charles I of England commissioning his portrait in marble. The letter began: "Signor Cavalier Bernini, the fame of your sublime genius and of the illustrious works that you have so felicitously brought to fruition has extended beyond the frontiers of Italy and, indeed, nigh beyond those of Europe itself, and has brought to our England your glorious name, exalted above those of all men of talent who have exercised your profession to this day." This was Bernini's first commission from a foreign head of state and a non-Catholic one at that. (His first actual "foreign" work had been a 1622 portrait bust of French Cardinal François Escoubleau de Sourdis commissioned in Rome but sent to Bordeaux, where it remains today intact, if slightly damaged.)

Though a Protestant king, Charles was nonetheless a lover of art, especially the Baroque. He, moreover, had a Roman Catholic wife, Queen Henrietta Maria of France, daughter of King Henry IV of France and Marie de' Medici. Henrietta also happened to be god-daughter to the reigning Pope Urban VIII, whose interests she promised to serve at the English court. Since the early sixteenth century, Rome had not extended formal diplomatic recognition to England or any Protestant country, and would not do so for two more centuries. But under Henrietta's influence, a papal representative (to the queen, that is, not the king) was allowed into the country for the first time since the Reformation and through the work of the various priests whom she brought to her court, several prominent courtiers converted to the Roman religion. The papacy was, to be sure, hoping for even more—perhaps even the return of England to the "one true faith." This is why Bernini was allowed by Urban to take time from his work for the pope to oblige this Protestant king who was technically an enemy of the papacy.

In fulfilling the commission, Bernini had yet again to do the impossible. As if creating a true-to-life resemblance of any living, breathing human in

hard, cold, white marble were not difficult enough (as he frequently pointed out), he had to create one of a person he had never even seen. But it was a challenge he had already faced in his career, in doing the portraits of, for example, Bishop Santoni and Archbishop Carlo Dal Pozzo. In any case, even with the sitter right before you, sculpted portraits were so difficult to do, Bernini once remarked self-defensively, that even the great Michelangelo refused to do them. Yet, in the case of King Charles I, Bernini, once again, succeeded brilliantly and to the complete satisfaction of the king, who had sent a triple portrait of his somewhat melancholy likeness painted by his favorite artist, Anthony van Dyck. (Van Dyck's portrait remained in the Bernini family collection for many years; it is now at Windsor Castle.) For his labors, Bernini was rewarded with a ring of truly royal quality valued—depending on which source you believe, English or Italian—anywhere from 4,000 to 6,000 scudi. Since we today have little sense of the worth of a scudo, you might be inclined to say: What, only one lousy ring? To arrive at some idea of the actual value of the king's compensation, know that, for example, construction workers employed on Bernini's St. Peter's Colonnade project in the 1660s were paid anywhere from 60 to 120 scudi per year. It would have, therefore, taken a well-paid semiskilled manual worker a full thirty to forty years to earn enough to buy such a ring for himself, should he have been so insanely inclined. Bernini, be assured, was happy to receive his ring.

Thrilled by Bernini's bust of her husband, Queen Henrietta Maria soon requested a portrait of herself. But it was not to be. She would have gotten her bust had she not procrastinated so long in sitting for the painted models, again by Anthony van Dyck. But by 1642 England became embroiled in the turmoil of a civil war that put an end to many royal endeavors, including that portrait project, and which ultimately led to the king's execution in 1649. Tragedy overtook his Bernini bust of Charles I as well: in 1698 it perished in a massive fire that consumed Whitehall, which served as the main residence for English monarchs. Nonetheless we know what the original bust looked like from a marble copy, several drawings, and an engraving. As for Henrietta Maria and Bernini, by the way, they may have finally met in person in France when they were both guests at King Louis XIV's court in the summer of 1665. Neither Chantelou nor any other source makes mention of such an encounter, but it is hard to imagine they did not see each other. In exile from England, Henrietta was then living in

the same house, the royal castle of Saint-Germain, to which Bernini frequently traveled to consult with Louis and sketch him for his portrait.

Bernini's bust of King Charles I was the first in a genre not only in which our artist was to excel but also which set the visual conventions for centuries, the official portrait of secular absolutism. (He had, as we saw, already executed many portraits of ecclesiastical absolute rulers, namely, the popes, but these were rendered more accessibly human, as was appropriate in the case of the "Supreme Shepherd" of the Lord's flock.) The culminating piece in this series is the bust of King Louis XIV of 1665, about which we will hear more later. Domenico boasts that not long into the reign of Urban VIII, the "greatest potentates" of Europe entered into a veritable competition with each other to obtain a work by Bernini's hand (even if not a portrait bust), but in the end few succeeded. "Bernini did not work for just anyone," as Domenico somewhat condescendingly but accurately remarks.

So why, soon after completing the bust of Charles, did Bernini next agree to do a marble portrait bust of someone who was not royalty but merely "an ordinary country gentleman" and "young man of no particular achievement"? Was it simply money? The gentleman in question, another Englishman, Squire Thomas Baker, was extremely rich and in 1638 promised to reward Bernini "just as King Charles did, and not a penny less." Or do we accept Bernini's own explanation? Namely, that he wanted to show the English what he was capable of achieving in a portrait bust when not handicapped by having to produce a likeness from a third-party painting, rather than from the live subject sitting before him. Whatever Bernini's real motives, the bust was completed, and he was handsomely rewarded to the amazing tune of 6,000 scudi, if the figure supplied by Baldinucci is to be trusted. (Contrast that figure with the 3,000 scudi Bernini was paid for all his work on the colossal Four Rivers Fountain project in Piazza Navona.) Bernini, by the way, was forced to work secretly and slyly on Baker's bust, for Pope Urban had expressly forbidden him to accept the commission. Bernini lied to the pope and did it anyway, assigning a portion of its execution to one or more of his assistants. The *King Charles I* bust had been executed by the gracious and extraordinary concession of the Holy See to please a foreign head of state, and Urban did not want it to have any competition in England in the form of another Bernini bust. As far as we know,

the pope never found out about Bernini's disobedience, an amazing fact, since it would have been extremely difficult to crate and ship such a large, costly object from Bernini's studio all the way to England without someone blabbing the news all around Rome.

Unlike Charles's portrait, the Baker bust survived the great turmoil and many accidents of English history and resides today in London's Victoria and Albert Museum. It is lively and captivating in the best Bernini fashion, but one wonders if the sculptor has produced a caricature of a somewhat foolish dandy instead of a true likeness of Baker? What one sees of Baker's undistinguished, blank face with its self-satisfied smile is almost overwhelmed by the abundant cascades of his wavy hair and intricately detailed folds of his lace collar. Take away all that hair and all that lace and you are not left with much of a man. Was Bernini mocking the English squire? Was this his way of showing that he believed the socially insignificant Baker had been "guilty of an audacious act of overweening vanity in commissioning a bust of himself"?[21]

Bernini's next portrait bust, that of Cardinal Richelieu, prime minister of France, was once again a subject worthy of the exalted status of our artist. Unfortunately, Bernini labored yet again under the daunting handicap of having to work from a painted portrait and not from a live sitter. The finished bust is an exquisitely rendered likeness of a disturbingly stone-cold and forbidding power broker (fig. 14). It makes some of us shiver just to be in its presence. More important, it did not please Bernini's French patrons, not because it was unflattering, but simply because it did not resemble the minister, or so they said. Bernini never went on to do the full-length statue of Richelieu, as was the original intent. (Rival Francesco Mochi, instead, did the statue, which must have thoroughly irked Bernini.) In addition to patron dissatisfaction, politics may have also intruded: a mere prime minister, and a foreign one at that, did not merit a full-length statue from the hand of the pope's own artist, and it may have been pressure from the papal court to keep Bernini from accepting the commission. But Destiny ordained that Bernini would work for the French court again, despite the extreme reluctance of the papacy, not to mention his own.

French supremacy in Europe was slowly on the rise, and the court of Paris would later in the century flex its muscle with great success over both the papacy and Spain. Spain was the other major power in the triangular

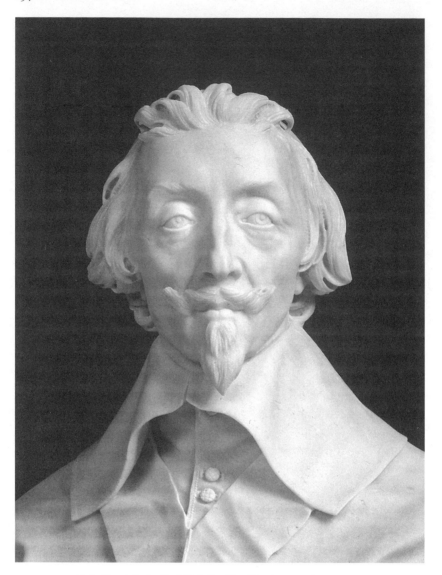

FIG. 14 ➤➤ G. L. Bernini, *Cardinal Richelieu* (detail), 1640–41, Louvre, Paris. Photo: Réunion des Musées Nationaux/Art Resource, NY.

struggle that troubled the entire continent and that continually played itself out in Rome, even—or especially—in the symbolic form of art patronage. Spain was ultimately the losing party in this struggle and over the seventeenth century slowly ceded its influence in Rome to France. Yet Bernini did not weep over Spain's loss, for our artist apparently did not have much

affection for the Spanish. Chantelou documents various of Bernini's disdainful remarks about the Spanish, especially regarding their lamentable lack of taste in art. Another Parisian eyewitness to Bernini's conversations at the French court, Colbert's assistant, Charles Perrault, reveals in his bluntly—and deliciously—frank *Memoirs* that, in fact, Bernini was "openly contemptuous of the Spanish."

Over his lifetime Bernini therefore, and not surprisingly, produced very little for Spanish patrons. The most conspicuous work was his monumental bronze crucifix (dating to circa 1653–54) for King Philip IV, destined for the Pantheon des Reyes of El Escorial (it is now in the sacristy of the chapel there). In contrast, Bernini's majestically elegant design for the bronze memorial statue of Philip IV in Santa Maria Maggiore was done at the request of the basilica's canons and executed by his collaborator, Girolamo Lucenti. Dating to shortly after the king's death in 1665, it was installed in the basilica's portico, now glowingly regal after its last superb restoration. In 1680, at the end of Bernini's life, his workshop produced a couple of smaller but opulent works for the extravagant Spanish ambassador to Rome, Gaspar de Haro y Guzmàn, the Marchese del Carpio, as he is known in Italian: a luxurious miniature replica of his Fountain of the Four Rivers and a small, gilded bronze version of the Louis XIV equestrian statue redone as a portrait of King Charles II of Spain. Both had been ordered as gifts for the Spanish king; Bernini, who was in the last months of his life, of course, merely supervised their execution. Sometime shortly after Bernini's death, the same Marchese del Carpio—a potentate to whom one simply never said no—also asked for and received from Bernini's sons the gift of one of his self-portraits on paper. The marchese, in turn, sent the drawing to Spain as yet another gift to his boss, Charles II.

The Bernini family in this case probably parted with the portrait willingly. It was a small price to pay to ingratiate oneself with one of the most powerful men in Rome. Both Bernini in the last year of his life and his sons in the years immediately following their father's death seem to have been actively cultivating Spanish favor through their relationship with Carpio (who went on to become Viceroy of Naples), most likely to compensate for the souring of their rapport with the French court. This meant swallowing years of accumulated distaste for the Spanish crown, but such was the price of survival in Baroque Rome. A bitter pill a day kept the enemy at bay.[22]

FOR WHOM THE BELL TOLLS, OR NOT

In their status as foreign commissions, the *Charles I* and *Thomas Baker* busts were brief parentheses during the Barberini-dominated chapter of Bernini's career. His time and talent were otherwise until July 1644 claimed by the pope and the papal family, the Barberini. In addition to the Baldacchino and the embellishment of the four piers of St. Peter's, Bernini decorated the basilica with other monuments aiming, explicitly or implicitly, to defend and publicize papal absolutism. Among them, the tomb of medieval papal benefactress Countess Matilda of Canossa and the newly embellished side chapel for display of the precious relic of the so-called Chair of St. Peter's. The relic, however, would later receive, under Pope Alexander VII, a more glorious and definitive setting of Bernini's design in the apse of the basilica. There is much truth to that pope's remark recorded by Monsignor Pietro Filippo: "If one were to remove from St. Peter's everything that had been made by the Cavalier Bernini, that temple would be stripped bare." Though engaged in monumental projects that would endure the centuries, Bernini, surprisingly, was also set to work from time to time on smaller, ephemeral tasks for lesser ecclesiastical functions. These include the temporary decorative apparatus (in wood, stucco, and canvas) for the canonization of Saint Elizabeth of Portugal and, even, on at least three occasions, large floral displays for the papal feast of Saints Peter and Paul and for the inauguration of the Baldacchino. There seemed to be no medium—not even flowers—that resisted the magical touch of Bernini's artistry.

But back to the monumental ornamentation for St. Peter's: a further embellishment that was supposed to endure the centuries but lasted only several highly troubled, controversial years was the ill-fated bell tower that Bernini designed and built for the facade of the basilica. This commission would ultimately represent if not the only, then certainly the most heart-wrenching and damaging failure of his career. The idea of adding bell towers to St. Peter's facade was not Bernini's. From the time the facade had been completed under Carlo Maderno in the early part of the century, it was intended to be flanked by twin bell towers. After all, what is a church without bell towers? In fact, construction of the towers had begun under Maderno long before Bernini: the last bays at either extremity of the facade are actually Maderno's bases for the towers that never got built. Unfortunately, in the absence of the completed bell towers, the facade looked, and

still today looks (despite later modifications), much too wide for its height. Sometime in the mid-1630s (the earliest evidence relating to this project is a November 1636 woodworker's bill) Pope Urban ordered Bernini to finally finish the towers. Following a complicated process of design and redesign and careful testing of the foundations, the first of the two towers (the southern one) was built and unveiled on June 29, 1641.

However, even before its official unveiling, Bernini's tower had come under attack for aesthetic reasons, especially its crowning element, the finial. Simply put, people didn't like the way it looked. Nonetheless, the work went on. When the tower was completed (with the exception of a permanent finial in stone), Giacinto Gigli's *Diario romano* reports: "A few days [after the ceremonial unveiling and inaugural festivities] a third of the said bell tower was dismantled because it was unsatisfactory, and the Cav. Bernini, who was responsible for it, having been reprimanded by the pope, fell ill and was in great danger of death." Several months later, on September 28 of the same year, 1641, we have the first alarming report of cracks in the facade caused by the new bell tower, threatening, it was alleged, a major collapse of the facade and further damage to the basilica itself. According to a Roman *avviso* of that date (September 28, 1641), the pope severely reproached Bernini for refusing to heed the advice of others, as if the decisions thus far had been simply the artist's alone. They had not been. On the contrary, as the most recent investigation of this bitter affair has shown, a large part of the blame goes to the megalomaniacal Pope Urban, who had pressured Bernini into building ever more elaborate, heavier towers. Even more blame goes to Carlo Maderno, who had built the weak foundations upon which the bell towers rested.

Strangely, despite the anxiety-raising appearance of cracks and the lingering criticism of Bernini's design, work proceeded as planned on the second (north) tower. The project could have gone forward only with the full consent of the pope and the Fabbrica, the congregation governing all construction projects at St. Peter's. Therefore, many parties were complicit in the crisis that was to explode later.

Work on the second tower, however, halted abruptly in July 1642 with only its first story built. The reason had nothing to do with structural worries or aesthetic concerns. It was, rather, a shortage of money. The papal treasury was being drained by the breathtakingly costly War of Castro then being waged by Urban VIII out of purely dynastic ambition against

Odoardo Farnese, Duke of Parma and Piacenza. (To further aggrandize his family's status, Urban decided it would be nice to add Duke Farnese's fiefdom of Castro in northern Lazio to the Barberini real estate holdings. The problem was that, even though unable to repay an old papal loan, the duke did not want to sell and did not hesitate to send his formidable army marching toward Rome to defend his ancestral honor.) The two clamorous sagas—that of the bell towers and that of the War of Castro—were left unresolved by the time of Pope Urban's death in July 1644. As we shall see in the next chapter, both the town of Castro and Bernini's bell towers were to share the same fate: complete destruction. Whatever grief Bernini experienced in this first Barberini phase of his bell tower saga was to pale in comparison with what was to be heaped upon him in the next and concluding phase under Pope Innocent X Pamphilj.

By July 1644, therefore, no bells were tolling at St. Peter's as Pope Urban—and Bernini—had hoped by that late date in his pontificate. But on the twenty-ninth of that month, a bell of a different type, the famous "Patara," the great bell on the Capitoline Hill, tolled in a slow, solemn fashion, communicating a message that the Roman population immediately understood: the pope was dead. Genuine grief and collective sorrow at the death of popes are things of the relatively recent past in the history of Rome. Before the twentieth century, news of a papal death was usually accompanied by a sense of relief or anger or indifference. "Muore un papa, se ne fa un altro," the old Roman saying reminds us: "One pope dies, they simply make another." In the case of Urban's death, the prevailing public sentiment was, however, rage—sheer, incandescent, long-pent-up rage. As we hear in the summary of one historian of the Barberini pontificate, the maledictions hurled upon the hated, dead pontiff were venomous: "Urban the new Nero, should have been buried alive in Nero's tomb. He had denied Christ in his pursuit of wealth. A heretic, the pope had befriended the Protestant forces during the Thirty Years' War. He should be cursed to the stars for the torments he had inflicted on Rome for more than twenty years. He was an impious, unjust tyrant who was a rebel to God and destined for the eternal flames, where he would await his equally damned nephews." An astute chronicler of the Roman scene of our period and no lover of the Barberini, jurist Teodoro Ameyden, concluded with satisfaction: "The multitude of pasquinades and great infamies spoken and written against all

the popes that ever were are not equal to the number said of Urban alone."
Not an enviable position to occupy.

Who can blame the Romans for being furious? The War of Castro had
cost more than five million scudi and had not yet come to an end. Thanks
to this foolish war of dynastic ambition on Urban's part, Rome had lived
under fear of another sack, this time from Duke Farnese's militia. The pop-
ulace had been bled for years by constantly rising taxes imposed by Urban,
desperate for cash to pay for his war. The Barberini clan had also been
enriched beyond measure during Urban's reign, again at the expense of
the pocketbooks and well-being of the populace. Like Paul V before him,
Urban had bungled papal policy with respect to the Thirty Years' War; his
successor would have to deal with the disastrous aftermath of that policy
at the war's conclusion in 1648. Among the Roman intellectuals and the
other members of the cultural elite, Urban's reputation had been irremedi-
ably stained with the grave injustice inflicted upon Galileo Galilei, tried
and condemned by the Inquisition at Urban's direct, irrationally angry in-
sistence in 1633. To be sure, Galileo had made scientific and diplomatic
mistakes and had his own character defects, but the fact was, and is, that the
earth moves around the sun and not vice versa, no matter what the Bible
and the Jesuits said.

Castro is forgotten and the Thirty Years' War is a distant memory of
history, but the Galileo case remains alive even today. It is perhaps the
most shameful moment in the enduring legacy of Urban's pontificate, one
that stirs emotion and sparks debate, now as then. The shocking outcome
of the Galileo trial and the heightened vigilance of the Inquisition with its
omnipresent spies had caused an immediate and permanent chill to descend
upon the intellectual life of Rome. Famed English poet John Milton vis-
ited Rome during the post-Galileo years in 1638 and 1639, interacting with
many of the city's cultural leaders, "their learned men," as he describes
them in his celebrated oration in defense of freedom of the press, the
Areopagitica of 1644. He found the Roman intellectuals depressed, some-
what paranoid, and frustratingly impotent:

> When I have sat among their learned men, for that honor I had, and been
> counted happy to be born in such a place of philosophic freedom, as they
> supposed England was, while themselves did nothing but bemoan the ser-
> vile condition into which learning amongst them was brought: that this was

it which had damped the glory of Italian wits; that nothing had been there written now these many years but flattery and fustian [that is, ridiculously bombastic, empty language].

In the end, Milton returned home a more convinced Protestant and happy to be an Englishman. The Galileo condemnation sent prominent members of the Barberini court who supported the scientist and the new scientific speculation fleeing, literally or metaphorically, for safety. Papal favorite Bernini did not have to flee in any sense, but the lesson was not lost on him: don't rock the boat.

When Urban died, there was a part of Bernini that must have sighed in relief. He had survived, relatively unscathed, that long, tumultuous pontificate, especially its final, disastrous years. Despite ground rumblings of all sorts, the artist had managed to stay upon the high pedestal where Urban had placed him. Yes, there had been many glorious artistic commissions, but they came at a high psychological price, the constant anxiety of dealing with Urban, the constant game-playing forced upon the courtier in dealing with a patron who, he well knew, could turn on him at the drop of a hat. From contemporary handbooks on the realities of court life, from literature, and from his own eyewitness experience, Bernini was well acquainted with the often swift and bitter fate of the "Fallen Favorite." He understood the fundamental principle of court life: if you want to survive, tow the party line, play it completely safe, dissimulate whenever you have to, and above all, don't anger your prince. No courtier is invulnerable from the all too frequent, sudden, and violent shifts in mood and judgment of an absolute ruler. Pope Urban had been such an unstable character, but to varying degrees all the popes of Bernini's lifetime proved capable of such volatility.

Therefore, our artist was expressing a genuine fear when later in Paris he protested against the plan of his French hosts to keep him longer in France in direct violation of papal permission: "The pope could easily ruin me!" he exclaimed, not without, we can be sure, a tinge of genuine desperation in his voice. As for the all-important matter of religion, Bernini somberly believed in its literal, religious sense. As he once wittily commented in the context of architectural orthodoxy when criticizing his rival Borromini: "It is a lesser evil to be a bad Catholic than a good heretic." With his usual hyperbole, Domenico praised his father's speculative acumen in matters of theology: "So high did the acuity of his genius ascend" that he

could "not only succeed in intimately penetrating these most sublime mysteries [of the faith], but also raise probing questions about, and offer logical accounts of the same." However high they ascended, Bernini's theological investigations, we can be completely sure, were nonetheless, in no way original, innovative, or pioneering. In matters of orthodoxy, religious as well as political, it was his policy to play it safe. Novelty is heresy. Such was the lesson deeply instilled in him during the Barberini pontificate.

When he died in July 1644, Urban had to be buried in a temporary grave in the crypt of St. Peter's. His tomb monument, although commissioned from Bernini many years earlier in 1627, was not yet finished and would not be until 1647. Had he lived to see it, Urban would have surely felt it well worth the wait. Bernini's splendid creation, a harmonious blend of sculpture and architecture, bronze and marble, is an eminent milestone in the already long, glorious history of papal tombs. In this genre, as in so many others in architecture and sculpture, artists who came after Bernini would find it extremely hard not to follow in his footsteps or at least copy some feature of his design. Bernini was prodded by the Fabbrica and the Barberini heirs to hurry his work on the tomb, since Urban's body needed a resting place that was not only permanent but also safe (or safer) from the anger of the mob. The mob would, in fact, have destroyed Bernini's bronze statue of Urban on the Capitoline, had a special police guard not been posted to watch over it. They instead vented their rage against an unprotected substitute, a stucco image of Urban in the courtyard of the Jesuits' Collegio Romano.

But at the same time Bernini was apprehensively thinking about his own personal safety and immediate future. Universally known as the Barberini artist par excellence, he too, and not just his effigies of Urban and kin, were vulnerable to attack by the angry mob. Even more worrisome was the coming to power of a new pope: Would he be friend or foe? Rather than wait, Bernini took action: On July 16, 1644, while the pope lay dying, he wrote to his powerful friend and second-in-command at the French court, Cardinal Jules Mazarin (fig. 15). "Jules Mazarin" was the Italian-born and raised Giulio Mazzarino, whose acquaintance the artist had made in Rome in 1632. In 1644 Bernini was now writing to follow up on Mazarin's earlier invitations to enter the service of the French royal crown. In his reply of August 27, Mazarin reaffirmed his offer, in the belief that he had finally coaxed Bernini into French service. He had caught the most prized catch of the

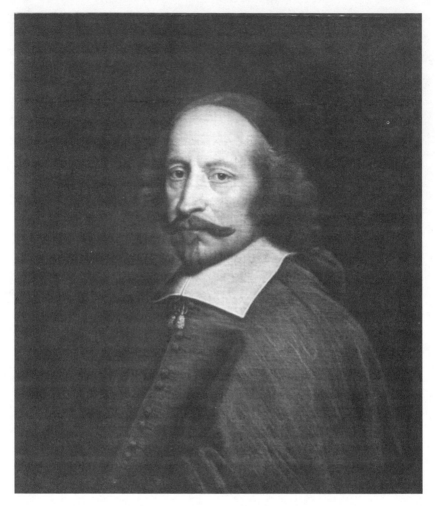

FIG. 15 ⇢ Pierre Mignard, *Cardinal Jules Mazarin*, 1661, Musée Condé, Chantilly.

European art world! Taken in by Bernini's dissimulation, the minister even included *brevetti*, official letters of commission from Louis, detailing his royal pension and confirming his official post as "Architect to the King." Instead, as it turns out, even the clever Mazarin, consummate politician, had been fooled by Bernini. In reality the artist had made and would make no commitments while anxiously awaiting the results of the papal conclave. If he could help it, he really would prefer not to move to France.[23]

The 1644 papal conclave began on August 9. Once again, the poor cardinals were forced into their sealed, cramped enclosure within the malarial Vatican in the very dog days of the late Roman summer. Fortunately, unlike the conclave of 1623 that had sickened numerous cardinals and killed several, this time around there was no widespread outbreak of fatal disease. But forty-nine days later, what did issue forth from this conclave in the form of a new pontiff would represent near deadly disaster for both Bernini and the Barberini.

BERNINI'S AGONY AND ECSTASY

CHAPTER 3

"A UNIVERSAL FATHER SO COARSE AND SO DEFORMED"

If there was one thing about the new pope over which almost everybody seemed to agree, it was the fact that he was ugly, distressingly ugly. And in a society so intimately defined by its cult of beauty, that was decidedly a handicap. In fact, as one chronicler reported at the time, many protested "that it was ridiculous to elect as Universal Father someone so coarse and so deformed that his children would never even dare approach him, so repulsive to the sight was he." Yes, in September 1625 poet-scholar Girolamo Brivio had delivered a learned discourse in praise of ugliness to an audience of cardinals and scholars assembled in the Roman home of Cardinal Maurizio of Savoy, but surely his tongue was in his cheek. Not even the exquisite talent of the greatest portraitists of the time—Bernini, Alessandro Algardi, and Velázquez—would be able to hide the fact that Giovanni Battista Pamphilj, aged seventy, elected on September 14, 1644, as Pope Innocent X, was not a handsome man, under any light, from any angle (fig. 16).

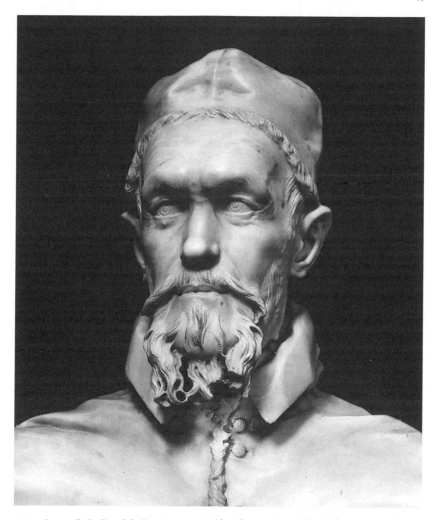

FIG. 16 ⤳ G. L. Bernini, *Pope Innocent X* (detail), ca. 1650, Galleria Doria-Pamphilj, Rome. Photo: Alinari/Art Resource, NY.

Quite a striking contrast with his predecessor, the fastidiously elegant "Pretty-Beard Urban" (fig. 10). But there were many other points of contrast, of greater consequence, between Innocent and Urban, as the Roman populace and all Europe soon found out, if they did not know already.

To begin with, former nuncio (papal ambassador) to the court of Madrid, Pamphilj was pro-Spanish in his politics, unlike the Francophile Urban. He was so pro-Spanish that the French court had hurriedly dispatched

its heaviest hitter, Cardinal Jules Mazarin, to Rome to block Innocent's election, but the prelate arrived too late. Once in power as chief minister of France, Mazarin would do all he could to undermine and personally annoy the Pamphilj pope and would be quite successful at it, especially since it was so easy to annoy Innocent. Innocent was as hotheaded as Urban, if not more so. As fiercely as he was anti-French, the new pope was also anti-Barberini, even though he had owed his ascent to the cardinalate (and, thus, to the papacy) to Pope Urban. Innocent was anti-Barberini for all the same reasons the Roman populace was anti-Barberini, above all, for the family's obscene self-enrichment at the expense of the papal treasury and the tax-paying populace. The Pamphilj, of course, would end up doing the same, though not to equal extreme, if only because they were a smaller family and had a shorter pontificate during which to do so.

Even before Pamphilj's election, Rome's talking statue and political satirist Pasquino had predicted:

> If Pamphilj the new pope it turns out to be,
> then all the Barberini will get ready to flee.

All expected the Barberini to be subjected to a thorough, formal, humiliating investigation of all their financial accounts. Indeed such an investigation was duly announced. It promised to be a public reckoning from which the Barberini brothers, even in their most optimistic moments and despite all their cooking of the books, could never hope to exit unscathed. Looking northward to the haven of a welcoming French court, they soon began to plot their escape, not an easy thing to do with all of Rome awaiting their next move. The most morally compromised of them, Cardinal Antonio, was the first to go. Together with his confidante, Francesco Butti (whom we shall meet up with later in King Louis's court), he fled Rome for Paris on the night of September 28, 1645, disguised as a humble *carbonaio*, a charcoal-man. Then, several months later, on January 16, 1646, Cardinal Francesco and his brother, Taddeo, disguised as hunters, also made their anxiety-filled exit from the city under the cover of darkness.

Bernini, who for the past twenty years had cast his lot so thoroughly with the Barberini, could have greeted the news of Innocent's election only with the utmost of dread. Nonetheless, he decided to stay in Rome for the moment and try to win over the new pope. His charm, after all, had not di-

minished with age. But he would not use that charm on the pope: a shrewd, well-informed observer of the Roman court, Bernini knew at once that if he were to succeed in gaining the grace of the new pope, he would first have to win over the not-so-secret power behind the Pamphilj throne, Innocent's sister-in-law, Donna Olimpia Maidalchini. An astute political manager and ambitious dynastic matriarch, Olimpia had been in large part responsible for steering the less savvy Pamphilj up through the ranks of the ecclesiastical hierarchy, all the way to the papal throne. Her enduring power as *prima donna* in Rome is yet another determinant feature of the Pamphilj pontificate through to its end in January 1655.

And it was a fact known throughout all of Europe. In response to a scolding by Pope Innocent for having extended such shamefully favorable terms of peace to the Protestants at the conclusion of the Thirty Years' War, the Holy Roman Emperor, Ferdinand III, retorted that the real shame, instead, was Pope Innocent's, for he had "placed his government in the hands of a woman about whom all the heretics were laughing." As such, Olimpia was the woman all Rome loved to hate. The Muse of Hateful Satire, Olimpia inspired an endless deluge of the most embittered and at times clever invective. She was nicknamed La Pimpaccia ("Nasty Pimpa"). The name comes from that of a stock character of the *commedia dell'arte*, Pimpa, the conniving, overbearing, bitchy female companion (variously girlfriend or servant) to the ludicrous scoundrel, Pulcinella, who in English is known as Punchinello or Punch. (Olimpia's nickname was, therefore, a slam against Innocent as well.) Another slur arose from a witty play on words involving her baptismal name: *Olim pia, nunc impia*, Latin for "formerly pious, now wicked."

To be sure, in all the incandescent hatred and disgust poured down over Donna Olimpia there was a certain degree of misogyny—how dare a woman succeed so well in the man's world of papal politics! However, even the most dispassionate of judges of her behavior would have to conclude that she was not a very likable, let alone lovable, human being. She let nothing stand in the way of her financial and political ambitions, using and abusing her own children and grandchildren as pawns in the frenzied race to the top. Even her official portrait in marble, circa 1650, by Alessandro Algardi (Bernini's equal in the art of the patrician portrait bust) does nothing to disguise her disagreeable personality. With her scowling, swollen face and billowing widow's veil she looks like a fiercely frilled dilophosaurus

(one of the dinosaurs famously featured in the movie *Jurassic Park*) in the attack mode, ready to spew copious venom at anyone who gets in her way (fig. 17).

One searches the record in vain for any trace of genuine love or affection expressed in word or deed for Donna Olimpia on the part of anyone close to her, including her own children and grandchildren. Presumably some did come from Giambattista Pamphilj himself. Earlier in life, the two, it was said, had carried on a sexual relationship. This was not mere idle gossip spread by the fantasy-filled imagination of the foolish, uneducated masses. This detail of the pope's personal life was considered credible enough to be included—in properly allusive diplomatic circumlocution—in an official

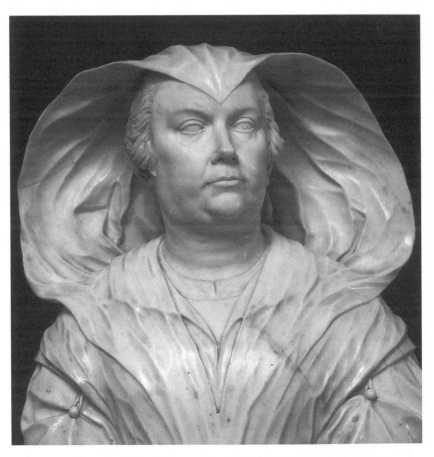

FIG. 17 ↦ Alessandro Algardi, *Donna Olimpia Maidalchini Pamphilj*, ca. 1650, Galleria Doria-Pamphilj, Rome. Photo: Alinari/Art Resource, NY.

dispatch of the Venetian ambassador to Rome, a report that was read to the entire Senate of Venice. This *segreto di Pulcinella*, the secret known to all, was at the heart of the reproach delivered to Olimpia by a senior member of the cardinal of colleges, the eminent and morally upright Cardinal Giovanni Battista Pallotta, during an explosive encounter between the two on the streets of Rome. Their coaches had become deadlocked on a narrow public street while attempting to pass each other from opposite ends. Neither would budge for the other. A shouting match soon developed, not between their coachmen, as was usual, but directly between Olimpia and Pallotta themselves. Amid the volley of insults flung at Olimpia, the prelate let it be known to Her Ladyship, among "other similar abusive words," that "it was simply a disgrace that the governance of Rome was in the hands of a *puttana*." The *puttana*, the whore, to whom the cardinal referred was, of course, she. Our source for this slice of life from Baroque Rome is diarist Gigli, who explains: "It was public rumor that Donna Olimpia had slept with her brother-in-law before he was pope, and people were constantly whispering about this." Such was the stature and the reputation of the ally to whom Bernini was to turn in his hour of need in the wake of Innocent's election to the papal throne.[1]

That hour of need did not arrive immediately. Life did not change for Bernini overnight with the election of the new pope—psychologically, yes indeed, but materially not until several months into Innocent's pontificate. Even though he did not make any special demonstration of affection or esteem toward the artist as Urban had at the beginning of his reign, the newly elected Pope Innocent at the same time made no overt moves against him. He did not, for example, strip Bernini of any of the job titles and responsibilities bestowed on him by Pope Urban, most notably that of architect of St. Peter's. In fact, it was in his position as architect of St. Peter's that Bernini was commissioned by Innocent in October 1645 to complete the decoration of the still largely barren nave of St. Peter's (together with its side chapels) that had been added to the basilica by Pope Paul V. The decoration of the nave was a project of gigantic proportions, employing a brigade of almost forty artists. It involved the paving of the enormous expanse of the floor of the nave and the sheathing of its pilasters and the walls of its six huge chapels with appropriately decorative and precious polychromatic marble. In addition, a multitude of decorative elements had to be created: fifty-six medallion portraits of the popes, 192 large angels, 104 over-life-size

doves, and six pairs of equally over-life-size allegorical figures in the span-drels above the arches of the nave chapels.

Under the new, anti-Barberini Innocent X, Bernini was also allowed to continue undisturbed his work on the tomb of Urban VIII. Significantly the pope made no attempt to banish the monument of his predecessor to any location other than the place of distinction for which it had been always destined, right in the apse of St. Peter's. At its unveiling on February 28, 1647, Pope Innocent was quite moved by the sight of the exquisite final product and spontaneously remarked—if Domenico is to be believed—to Cardinal Panciroli, his secretary of state, "People speak ill of Bernini, but in fact he is a great and rare specimen of a man." Nonetheless, until all the obstacles between Pope Innocent and Bernini were overcome sometime in 1648, Pamphilj patronage largely ignored the artist, favoring, above all, Francesco Borromini and Alessandro Algardi.

Bernini's hour of need arrived sometime after the pope turned his atten-tion to the vexing problem of the still unfinished bell towers at St. Peter's. But even here, it was not necessarily Innocent's anti-Barberini (and thus anti-Bernini) sentiments that caused him to investigate Bernini's work. Desiring to ready St. Peter's Basilica for the Jubilee year of 1650, when hundreds of thousands of pilgrims and tourists would pour into Rome to marvel at its sights, Innocent was obliged to attend to the question of the unfinished towers and, in particular, the cracks on the facade and on the ceiling of the Benediction Loggia. The cause of the cracks had to be deter-mined and a solution applied. What followed was a long, complicated, and drama-filled process that here must be reduced to a few simple summary sentences.

By late 1644 a special committee of inquiry was assembled, with an ini-tial detailed, nonpartisan technical report drawn up by the chief papal archi-tectural advisor, Oratorian priest Virgilio Spada. We have already encoun-tered Spada in the previous chapter as the one responsible for recording for posterity the story of Bernini's less-than-honest attempt to outmaneuver the competition over the Oratorians' rental property near St. Peter's. In the course of the following year, the Congregation of the Fabbrica, as over-seers of the basilica's physical plant, also met five times to examine the case, as well as to solicit and evaluate technical opinions and designs for new towers from various architects and other experts on the basis of which the pope would deliver his final decision. The diagnoses of the problem ran the

gamut from extreme alarm over a predicted catastrophe (namely, the impending collapse of the facade), with an imprudent Bernini being its direct cause, to a cautious but serene description of the situation as one of natural settling inevitable in all major constructions, which would take care of itself over time, with Bernini innocent of any professional misjudgment.

The situation—cracks in the structure of the most venerable shrine in Christendom—lent itself easily to hysteria. And so, the investigative process was a convenient occasion for all our artist's enemies, most especially Francesco Borromini, to have free play against the detested Bernini, even if they were not convinced that he was really culpable. As they furthermore knew, they could now attack Bernini with impunity, since the reigning pope had no particular sympathy for the artist. Innocent would not be personally offended by their assault and would make no move to punish them. "All the more goaded by an ancient itch and the present controversy," Borromini, of course, was principal spokesman for the extreme alarmist position. He shouted the loudest, "claiming in desperate words" that "the great facade of St. Peter's has already begun to show signs of the threat of complete collapse. And along with it, will go, as well, a good deal of that famous temple itself." However personally disagreeable he may have been, Borromini was at the same time a respected, experienced master architect and therefore his charges could not be easily dismissed. As in the case of the cracks in St. Peter's cupola, also said to be caused by Bernini's inexpert interventions in the piers, once again our artist was being charged publicly and shamefully with professional incompetence. But now there was no benevolent Pope Urban to protect him. He could be utterly ruined.

Well into the investigation, Pope Innocent himself seemed convinced by the nonalarmist explanation of those experts who had concluded that it was necessary only to lighten the bell tower (that is, the completely finished south tower) by removing its attic story while reinforcing its foundations. This viewpoint—held by the much-respected architect Martino Longhi, among others—was pro-Bernini inasmuch as it recognized that the problem lay in Maderno's defective foundations, not Bernini's alleged imprudence. It advised saving, not demolishing, his towers (recall that the first story of the second, northern, tower had also been completed under Pope Urban). With his mind seemingly decided, the pope awaited the concluding report of the Reverenda Fabbrica di San Pietro before announcing the official course of action. On February 20, 1646, the Fabbrica met once

again to discuss and deliberate upon all the results of the expert consultations. The cardinals were, however, deadlocked in their assessment of the evidence and therefore could arrive at no final collective resolution. Just days later, on February 23, the pope, instead, announced his own resolution. It was as unexpected as it was dramatic, representing a seemingly sudden, radical shift of mindset. In a brief statement read by his delegate before the Congregation of the Fabbrica, Innocent ordered the total dismantling of the towers, with new ones eventually to be built according to another design by some other architect.

No explanation was given for this surprise decision—so big a surprise that it leads one to suspect that someone close to and trusted by Innocent had at the last moment succeeded in coaxing the pontiff into this extreme new view. Bernini always suspected Virgilio Spada, and publicly said so, as we know from Spada's own written response to the artist's grievances against him, in a letter known by the title, *Sopra doglianze fatte dal Cavalier Bernino* (Regarding complaints made by the Cavalier Bernini), sent to an unknown third party in June 1658. Domenico's biography (like Baldinucci's) names no names but clearly indicts Spada, for he reports that "a certain minister of his, ill-intentioned toward the Cavaliere and likewise provoked by Borromini, took advantage of this convenient opportunity [a long papal coach trip] for filling the pope's ear with much chatter." Innocent's order of February 23 raises many unanswered and now unanswerable questions, but, regrettably, after so much time, energy, and grief, strangely and abruptly, the paper trail ends here. No further mention of the bell towers is to be found anywhere in the archives of the Congregation of the Fabbrica. If Spada was in fact the culprit, he had won the day. Unfortunately for Bernini, the prelate was to continue in his role as trusted architectural consultant even during the next pontificate, that of Alexander VII. Under Alexander, Bernini and Spada would again face each other in bitter opposition over the design of the Colonnade of St. Peter's.

The dismantling of the towers took place slowly over the course of some ten months, from the date of that surprise papal order until January 1647. Bernini, however, did not sit back passively. According to the gossip reported by the Duke of Modena's agent in Rome, to prevent the dismantling, Bernini attempted to purchase the intervention of Donna Olimpia with an enormous gift of 1,000 doubloons. To her son and papal nephew, Camillo, another potential ally, the artist gave something even more valu-

able, the diamond ring worth 6,000 scudi that the artist had received from King Charles I of England as reward for his portrait bust. For Donna Olimpia, Bernini also agreed to produce one of his popular comedies for the Carnival season of 1646, no small favor in terms of time, talent, and energy. The untitled production satirized self-righteous pious hypocrites, with shocking swipes also at Bernini's former patrons, the exiled Barberini. The play was filled to scandal-raising degree with sexual double entendres. People expected further trouble for Bernini for these theatrics, but as this was all happening at the home of and under the sponsorship of the mighty and untouchable Olimpia, no retaliations were forthcoming. However, Bernini's gifts and favors failed in their immediate purpose, to prevent the demolition of the towers—the failure may not have been due to lack of trying on the part of at least Donna Olimpia—but, as we shall see, they were to later succeed in achieving another of Bernini's goals, the winning of a major papal architectural commission.

According to the same Modenese source, Bernini was also held financially responsible for the loss of the towers. This financial liability, according to yet another source, the private diary of the well-informed lawyer-archivist Carlo Cartari (1614–97), took the form of the seizure of 30,000 scudi's worth of Bernini's bond investments in compensation to the papal treasury. It is not clear, however, whether the seizure was permanent or whether Bernini suffered any real financial loss in the end. As for the actual costs of the failed construction project, in his 1694 book, the *Tempio Vaticano*, Carlo Fontana (who was then *architetto di San Pietro*) reports that Bernini's bell towers cost over 100,000 scudi to build and about 12,000 to dismantle, with much of the salvaged travertine later redirected to other construction projects around Rome. Fontana's *Tempio Vaticano*, a historically well-informed, intimately detailed, and lavishly illustrated history of the construction of the new St. Peter's, had been initially commissioned (as stated in its opening chapter) by Pope Innocent XI to dispel any lingering concerns about the stability of the basilica's structure. In it Bernini is exonerated of any guilt in the bell tower affair. But it was, of course, too late: Bernini was long dead and the bell towers long ago destroyed. "The city of Rome," Domenico assures us, "mourned the destruction of so beautiful a work [the bell towers] and shortly thereafter the pope as well regretted his mistake in heeding the advice of that minister." As so must we. To this day St. Peter's does not have proper bell towers. The bays built by

Maderno to support them were finally crowned in the late eighteenth century by small decorative clocks, still in place, designed by Giuseppe Valadier under commission from Pope Pius VI. The absence of bell towers means that the facade, still too wide for its height, ends up looking "somewhat like a Beaux-Arts train station." Heavy and earthbound, it is deprived of that exhilarating upward thrust supplied by lofty bell towers soaring toward the heavens. It is here tempting once again to say, with our nineteenth-century British novelist: These things, dear reader, are allegory.[2]

BERNINI SINKS AND TERESA FLOATS

The pious Bernini, his son claims, responded to this bitter reversal of fortune with serene patience and fortitude: "The Cavaliere, the subject of all this talk, alone kept silent . . . enduring this bout of ill fortune without false ostentation of a steady spirit or useless laments." Likewise, Baldinucci praises Bernini for his "steadfastness," "resoluteness," and "the absolute control of his emotions" in the midst of these anguishing trials: "Thus he lived tranquilly and carried his work on with great diligence." Some readers will be skeptical of these claims. Are we really to believe that the notoriously choleric Bernini had been somehow completely transformed into a silently resigned, all-accepting, patiently suffering saint or Baroque Buddha?

This is, in fact, not at all the man we see in the three extant self-portraits dating from his early maturity (when he was in his late thirties and early forties), today in the Uffizi (fig. 8), the Galleria Borghese (fig. 18), and the Prado. In all three we see, instead, a tense, apprehensive Bernini with a drawn, feverish look. In those years, Bernini knew few truly calm days, judging from these self-portraits. Of course, in the aftermath of the bell tower failure, Bernini had every reason to be even more apprehensive and tense. Both his reputation and bank account could be fully demolished, like his bell towers. And this came at a time in which his family was growing at a rapid rate: yet another child (his second daughter) Angelica arrived in 1646, then Agnes in 1647, followed by Paolo Valentino in 1648. Further adding to the heartbreak of these years of public disgrace were the deaths of his two-year old son, the first Paolo, his mother Angelica, and his younger brother Vincenzo, aged forty-three (a canon of the Lateran Basilica), the

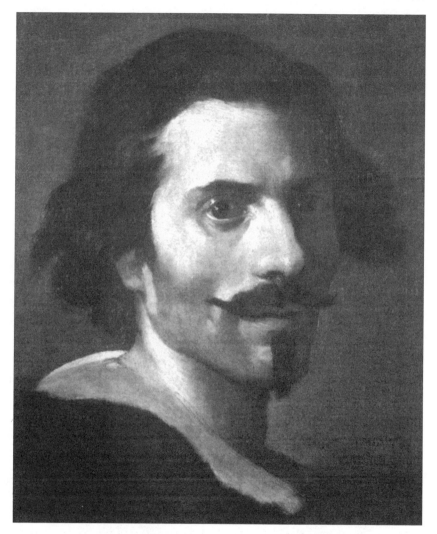

FIG. 18 ➤➤ G. L. Bernini, *Self-Portrait*, ca. 1638–40, Galleria Borghese, Rome.

three dying respectively in 1646, 1647, and 1648. This quick succession of deaths, with lingering memories of his own close encounter with death, helps explain why in this period Bernini began attending the Bona Mors (Good Death) devotions at the Church of the Gesù immediately after the founding in 1648 of the pious sodality of that name, based at the Jesuit mother church. Though Bernini's name does not show up on what survives

of the official membership list or other records of the sodality, attendance at these weekly prayer sessions was a practice he kept, on and off, for the remainder of his life, if biographer Domenico is to be believed.

The reason for Bernini's serenity in these years of trial, claims Domenico, was his absolute confidence that one day he would be vindicated. So strong was his conviction that he carved it in stone. Sometime in 1647 for his own personal solace, Bernini designed and began to execute an over-life-size marble group, *Truth Revealed by Time*. (If Bernini, by the way, was as devout a Catholic as his official biographers claim, why, we wonder, did he not sculpt for his consolation, instead, a statue of *Our Lady of Good Counsel* or some other piously soothing and fully clothed Christian icon?) In this work, Bernini gave, or intended to give—the project was only half completed—visual representation to an old, familiar saying used to console victims of injustice: Fear not, for sooner or later time will reveal the truth. He was not the first artist to do so, for the theme was traditional and popular in art, as it was in literature. But what is distinctive about Bernini's rendition is its literal nature—that is, making the very act of unveiling the central focus of the representation. Bernini completed most of the figure of Truth, but never got around to carving her companion, Father Time. But we know something of what he had in mind for the entire finished composition thanks to a surviving preparatory drawing in Leipzig and the artist's own verbal description of it in the Chantelou diary.

In the finished worked as envisioned by Bernini, old, winged Father Time strips the clothing from a young, sensually fleshy, fully receptive woman who smiles in return, happy to have her naked truth exposed for the whole world to see. (Bernini's taste for women seemed to run in the direction of the pleasingly plump, such as we see in the paintings of his older contemporary Peter Paul Rubens.) It is a consoling philosophical message about time and truth, but might it also have served double-duty as a convenient pretext for the satisfaction of rather unphilosophical male, voyeuristic desires, just like the Old Testament story of Susanna and the Elders or the mythological scene of Diana at her bath? In Bernini's full-length, swirling statue, Truth has already been stripped of her garments (fig. 19). No modest *Venus pudens* type, she is almost completely nude and is seated, with her arms and her legs spread open. Within traditional iconographical conventions, the specific positioning of the legs in profane images of naked men and women was a means of communicating sexual messages to the viewer.

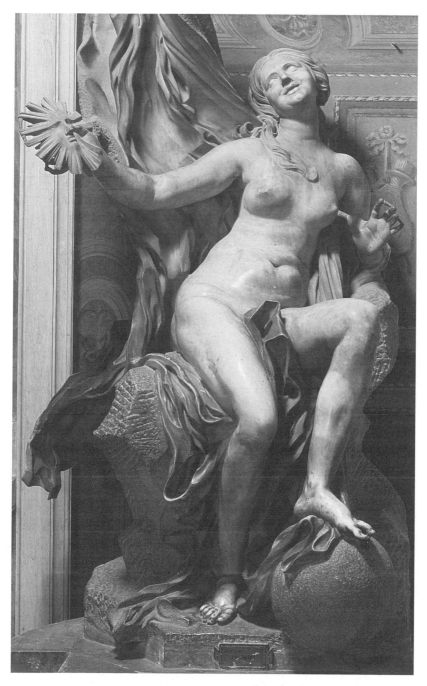

FIG. 19 ➻ G. L. Bernini, *Truth Unveiled by Time*, 1646–52, Galleria Borghese, Rome.
Photo: Scala/Art Resource, NY.

But does it really require knowledge of iconographical conventions to recognize the sexual charge of the spread legs of a naked female? With its strategically placed drapery, Bernini's statue is, to be sure, merely suggestive, not blatant as in truly profane scenes. Even so, in the artist's preliminary drawing of the entire composition, Father Time looks, oh dear, as if he is about to mount, not merely unclothe, Miss Truth.

The sculpture of Father Time, however, was never begun. Was it due to boredom on the artist's part—it's more fun to carve a naked young woman than a shriveled old man—or did the return of public favor make the piece lose its emotional urgency? Nonetheless, years later while in Paris in 1665, surprisingly, Bernini still spoke of the sculpture as an active work in progress. In Paris Bernini also boasted with an air of amusement that "it was a saying current in Rome that Truth is only to be found in Bernini's house." Bernini and his biographers, furthermore, all claim that from the start it was the artist's intention that the statue remain in perpetual custody of the Bernini family, "because," as the artist's last will and testament explains, "by seeing it, all my descendants will be reminded that truth is the most beautiful virtue in the world inasmuch as it is eventually revealed by time." The statue did in fact remain in possession of the Bernini heirs until 1924, when it was purchased by the Italian government and placed in the Galleria Borghese. However, despite his supposed purely philosophical intentions, Bernini, instead, had attempted, not long after it was completed, to make pragmatically crude, political use of the statue: he offered it to Cardinal Mazarin as a way of gaining the French minister's further good will and protection. (Mazarin ended up refusing the offer, annoyed that Bernini would not accept his invitation to move to Paris.) So, Truth had almost departed from Casa Bernini, as a victim of favor-seeking opportunism.[3]

"If you want to see what a man knows, put him in a difficult position." So explained Bernini to a French interlocutor in 1665 about the challenges he was then facing in designing the new royal palace of the Louvre. The remark could easily be applied to so many of the other professional challenges of his life, but it certainly applies to this juncture in his career in the immediate aftermath of the bell tower failure. While we may not believe their claims about Bernini's supposed Buddha-like acceptance of his misfortune, Domenico and Baldinucci are correct in stating that in the midst of these terrible trials, Bernini did bring forth one of the most beautiful works

ever to issue forth from his imagination and his hand, the Cornaro Chapel in the Church of Santa Maria della Vittoria featuring the celebrated statue *Saint Teresa in Ecstasy* (fig. 20). No longer the official artist of the papal family, Bernini was now free for the first time in over two decades to accept commissions from whomever he wished. So, in January 1647, just as the last remains of his luckless bell towers had disappeared from the facade of St. Peter's, he agreed to design and build a chapel for the eminent Cardinal Federico Cornaro. The chapel was to be in honor of both Cornaro's illustrious family and one of his favorite saints, the recently canonized (1622) Spanish Carmelite nun and mystic, Teresa of Avila. Cornaro, retired patriarch of Venice and a member of the most powerful family of the Venetian republic, had plenty of money at his disposal. His small but sumptuous chapel, a theatrically orchestrated ensemble of sculpture, painting, architecture, richly colored marble, and cleverly devised natural lighting, ended up costing him the breathtaking amount of 12,089 scudi (namely, close to half a million of today's dollars). Of that sum 2,000 went to Bernini just for his work on *Teresa in Ecstasy* alone. Unfortunately the luxury-loving and freely spending cardinal—his account books survive and give the lie to claims of his pious, ascetic character—did not live to enjoy his chapel for long: he died in June 1653 just a year after its completion in the summer of 1652.

Public response to the chapel, it would seem, was overwhelmingly positive. An anonymous *avviso* from Rome of July 27, 1652, with no reason to flatter Bernini, tells us that upon the public unveiling of "the extremely beautiful chapel" earlier that month "the Cavalier Bernini received and continues to receive a universally favorable response and great applause for the extraordinary perfection, beauty, and originality of both the statue and the chapel." Even the anti-Bernini art critic Giambattista Passeri described the chapel as "a work of perfect beauty." As for Bernini's own assessment of his work, our artist professed never to be pleased with his works once they were completed. But he must have been satisfied enough with his Teresa chapel to announce, with either self-deprecating wit or false modesty, "This is the least bad work I have done." Bernini's satisfaction, however qualified or temporary, was well justified. Although he had experimented in earlier projects with almost all the individual visual techniques employed in this chapel, Bernini here brings them all together in a perfected, highly dramatic and deeply satisfying seamless ensemble, his famous *bel composto*

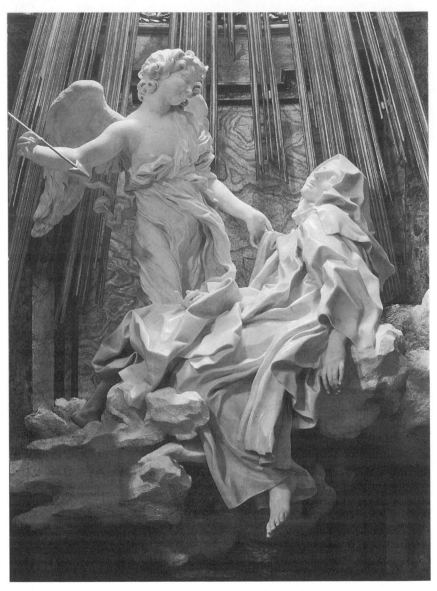

FIG. 20 ›‹ G. L. Bernini, *Saint Teresa in Ecstasy*, 1647–52, Church of Santa Maria della Vittoria, Rome. Photo: Alinari/Art Resource, NY.

("beautiful whole"), one that pleases both scholarly expert and ordinary tourist alike.

The centerpiece, of course, of this (literally) staged mystical experience is the statuary group of the swooning, orgasmic Teresa and the sweetly smiling angel whom we see in the act of piercing the nun with a golden arrow. The rapturous episode is known as Teresa's "transverberation," literally, the "striking through," the wounding, of her heart by the angelic arrow, a sign of divine favor and mystical union with the godhead. The *tenerezza*—tenderness, poignancy—of Bernini's sculptural style reaches a stirring new level in his *Saint Teresa in Ecstasy*, as he also dazzles us with the brilliance of his technical achievements. Upon her glowing cloud, the saint (who experienced miraculous episodes of spontaneous levitation during her lifetime) appears to float in midair, unsupported by anything visible to the spectator. It is a cliché to use the term "theater" or its derivatives in describing the Cornaro Chapel, but it is unavoidable and fully warranted in this case. Moreover, in doing so, we are simply borrowing the customary vocabulary of Bernini and contemporaries. Along with *magnificenza* (magnificence), *meraviglia* (marvel), *stupore* (stupor), and *inganno* (deception), *teatro* is one of the most common, most beloved words in the language of the Baroque. Like the world itself, art was considered a "stage" where spectators expected to be surprised and delighted by the clever deceptions perpetrated upon them by the genius-artist in his artful imitation of reality. And Bernini, in this regard, was the "supreme trickster."[4]

"Not Only Prostrate, But Prostituted as Well"

Today Bernini's *Saint Teresa in Ecstasy* remains one of his most popular works, just as Teresa of Avila remains one of the Catholic Church's most popular saints. Yet the reason for the popularity of Bernini's *Teresa* is not merely artistic or religious, it also, let us be honest, has a lot to do with sex. The statue titillates our senses as it provokes our wonder, if not our shock, about this blatant melding of the spiritual and the sexual, within a Catholic church in the city of the popes during supposedly morally vigilant times of the Counter-Reformation. The Cornaro Chapel has been labeled "the most astounding peep show in art." This is not simply a postmodern, desacralizing response of the twenty-first century. Shortly after its unveiling, an anonymous critic denounced Bernini's statue for having "dragged

that most pure Virgin down to the ground," while "transforming her into a Venus who was not only prostrate, but prostituted as well." Although this is the only documented censure of the statue thus far uncovered in the archives, we presume the anonymous author was not alone in seventeenth-century Rome in taking offense at the statue for its alleged blasphemy, for profaning the sacred. Certainly for its degree of sensuality, Bernini's *Saint Teresa in Ecstasy* has no counterparts in Western art among the representations of the same scene, earlier or later. So we wonder: What was going on in Bernini's head as he designed and executed this statue? What was he thinking? How did he justify in theological terms his interpretation of the scene?

To begin with, Bernini could have responded to his critics using the words of Saint Paul: *Omnia munda mundis*, "To the pure of heart all things are pure" (Letter to Titus 1:15). For example, the anonymous French author of a guidebook to Rome, of circa 1677–81, in describing the statue sees nothing sensual nor sexual at all: for him the saint is "depicted in the act of rising abruptly from her bed out of the terror she feels at the apparition of an angel, doing so with a movement that very well expresses her feeling of fear mixed with a certain degree of submission—and in this one cannot find anything more natural and more perfect." More important, Bernini could and would have pointed out that his artistic depiction essentially conformed to the saint's own detailed description of her experience. Bernini is likely to have consulted, if not her autobiography directly, then perhaps one of the various Italian retellings of the scene here in question, her transverberation. One such retelling from within the artist's immediate cultural circle was published by his old friend from the Barberini days, Agostino Mascardi (d. 1640). Monsignor Mascardi was the first holder of the chair of "eloquenza" (rhetoric, or in today's terms, communication) at the University of Rome, "La Sapienza" (Wisdom). Bernini paid Mascardi the homage of twice executing his portrait—a learned, pensive face framed with the frizzy, disheveled hair of an absentminded professor—both in oil (location unknown) and in a chalk drawing, now at the École des Beaux-Arts, Paris.

Mascardi's oration on Teresa was first delivered in 1622 to a community of Carmelite priests and brothers in Genoa on the occasion of her canonization and was later published in his extremely popular collection of essays and orations, the *Prose vulgari* (editions in 1625, 1626, 1630, 1635, and 1645,

to cite only those preceding the building of the chapel). Unlike the saint herself, who simply speaks of the simultaneous pain and pleasure of her heart-piercing encounter with God's angelic emissary, Mascardi follows the conventions of Catholic hagiography and specifies the nuptial—and therefore, erotic—nature of Teresa's experience. In so doing, he places it in an entirely familiar, well-established, and completely orthodox category: that of the "mystical marriage" of an ascetic female virgin with the Divine Bridegroom, Jesus Christ. Saints Catherine of Alexandria and Catherine of Siena are two well-publicized and widely illustrated cases of this phenomenon. But at the same time, Mascardi pauses to berate those sacrilegious readers who project the filth of their own earthbound imaginations unto Teresa's mystical experience. Like it or not, Bernini, Mascardi, and other orthodox commentators would have pointed out, the physical and emotional effects of mystical union with the Divinity, as our duly canonized saints have described, are the same as that of orgasmic, sexual union between two human beings.

The Bible itself, Bernini and Mascardi would have further explained, legitimized the spiritual appropriation of the frankly carnal language of nuptial union in the form of the Old Testament book the Song of Songs, also known as the Canticle of Canticles or the Song of Solomon. Literally a love song in verse between bride and groom, the Song of Songs contains such explicitly sexual lines as "Let him kiss me with the kisses of his mouth. . . . Take me away with you—let us hurry! Let the king bring me into his chambers. . . . Your navel is a rounded goblet that never lacks blended wine. Your waist is a mound of wheat encircled by lilies. Your breasts are like two fawns, twins of a gazelle." Entirely discarding the literal level, centuries of celibate male ecclesiastical commentators—from medieval monk Bernard of Clairvaux to Bernini's own Jesuit friend Gian Paolo Oliva—safely "tamed" this blatant work of secular love poetry into allegories of, variously, the union of soul with God, the church with Christ, the Virgin Mary with God, and even (as in Oliva's long, cerebral, antiseptic commentary) the rapport between the religious superior and his subject. This army of monks and priests subdued and coopted the sexual, rendering its literary and artistic use for the purposes of the faith morally acceptable.

This is all true. But also true is that Bernini took great liberties with the saint's autobiography, or, rather, one great liberty. His Saint Teresa is not the advanced-middle-aged, somewhat dumpy-looking, heavy-featured

matronly nun that we see in the more historically correct portraits done while she was still alive. She was all of forty-four at the time of her transverberation, having suffered years of atrocious, debilitating physical maladies, with, presumably as well, many years to her credit of rigorous, flesh-mortifying, penitential discipline like fasting, abstinence, and physical self-abuse in the form of whipping with a flagellum (cat-o'-nine-tails) and wearing a hair-shirt or a barbed-wire chain tightly against unprotected skin. (These were all widespread practices among Catholic nuns and priests, especially those of strict reform orders like Teresa's own Discalced Carmelites.) Such things do not leave you looking like a beauty queen. Instead, Bernini's Teresa is very much a young, attractive maiden, with fresh, glowing, wrinkle-free features and one naked, perfectly formed, lily-white foot sensually protruding from beneath her garment. That garment, furthermore, is not the coarse, limp, much-washed habit in cotton and wool of a poor, humble Carmelite with a limited budget for wardrobe. It is, rather, a silky, sumptuous, voluminous piece of apparel, looking more like the expensive, luxurious ball gown of a well-endowed, worldly patrician woman.

Certainly no other artist, in rendering the scene before or after Bernini, dared as much in transforming the saint's appearance. To be sure, Bernini was by no means the first artist to introduce explicitly erotic tones into the depiction of mystical experience; witness the earlier representations of the ecstasies of both Teresa and Margaret of Cortona by Bernini's older colleague, painter Giovanni Lanfranco. Nonetheless, one searches in vain for another artistic recreation of this scene charged with the same degree of sexual electricity and sensual luxury, here made all the more palpable because it comes in the form, not of a flat-surfaced painting, but a three-dimensional, sunlit, life-size recreation of the event. Clearly, we must again at least raise—with all due restraint—the issue of Bernini's own libido, perhaps here sublimated in an ecclesiastically sanctioned form. Likewise, it is difficult not to also talk of this kind of art, the Cornaro Chapel, as a pretext for male voyeurism, an association made all but inevitable by the two rows of animated male spectators (members of the Cornaro family, including Cardinal Federico himself) in the side theater boxes with which Bernini has framed his scenographic altarpiece.

Now, there are many who fiercely resent the intrusion of what they might consider trite or trivializing "pop psychology" into historical discussions, especially those bearing on spiritual questions. But who is going to

deny that Bernini had a strong libido? If he had a libido, then that sexual energy inevitably manifested itself to some degree in the fruit of his artistic imagination, even in religious contexts. None of this was conscious, of course, on Bernini's part. Instead, what was conscious was his desire, in a moment of deep professional crisis, to dazzle his audience with a spectacular display of the "marvelous," that near-obsessive object of Baroque pursuit and investigation, and not only in the visual arts. To raise the issue of sexual sublimation or male voyeurism is not to reduce Bernini's *Teresa* and all that it represents to these aspects alone. But not to raise the issue, with all due caution, is to be naïve, disingenuous, or simply uninformed about the dynamics of the human psyche.

There is no record of Bernini's being scolded by any member of the ecclesiastical hierarchy for his *Teresa* or for any of his works—at least not until the last decade of his life when he was ordered by the prudish Pope Innocent XI to cover up the naked breasts of one of the allegorical figures in his tomb of Pope Alexander VII. In its decree on the cult of the saints and sacred images (Twenty-fifth Session, December 4, 1563), the reforming Council of Trent had issued an admonishment to the effect that all "seductive, sensual charm" must be avoided in the production of religious images so that they "not excite to lust." But that one brief, generic line, buried among the hurriedly approved, last-minute decrees of the council, hardly represented one of the pressing concerns of the fathers of Trent. In fact, the issue of the cult of saints and sacred art had been addressed by the council in its very last session largely because of pressure from the late-arriving delegation of the French Catholic church. The French church at home was waging war with the Huguenots, who embraced a form of Protestantism opposed to all forms of religious art. For the papacy itself, strict enforcement of that 1563 decree never became a priority, at least not for long.[5]

"UNLESS MOVED BY SOMETHING EXTRAORDINARY THAT THEY SEE"

A more austere style of ecclesiastical art prevailed for a few decades after the closure of the Council of Trent, as a result of greater sensitivity on the part of the papacy to the issue of propriety. Most notoriously, Pope Clement VIII (reigned 1592–1605) ordered on-site inspections, one by one, of the churches of Rome. These visits often resulted in the removal of

paintings of naked saints (Saint Lawrence and Mary Magdalene are most often cited in the reports of the papal examiners) or the cover-up of nude statues, even of the scantily clothed body of Christ on certain crucifixes. But by the next pontificate, that of Pope Paul V Borghese, as we saw, the style of ecclesiastical art gave way to one of greater exuberance and greater sensuality. In those same initial decades following the Council of Trent, there were occasional zealous, bluenosed cardinals, bishops, and preachers who called for greater policing of art within churches, for example, in the form of the obligatory licensing of artists receiving commissions for sacred art and even of an "Index of Prohibited Art." But their edicts went unheeded and their calls fell upon reluctant, if not deaf, ears within the papal court. No new, stricter, enduring decrees applicable to the universal church ever came from the central command in Rome. It is instructive that Cardinal Gabriele Paleotti—the prelate who proposed the never-enacted idea of an index of prohibited images—himself never got around to writing the promised chapter on nudity in art in his treatise *On Sacred and Profane Images*, published, though incomplete, in 1582.

The papacy's relative nonchalance about the issue of sensual art in churches or, for that matter, in any context seems surprising, or even astounding, given the prevailing notions about the great power of lust that preachers and other moralists had consistently taught for centuries. The contradiction between the two attitudes is glaring and irresolvable. Lust was, by universal consensus of the preachers and moral theologians, one of the greatest dangers to the salvation of one's soul. With the Fall of Adam and Eve, lust had inextricably rooted itself within the human heart like an invincible, rebellious weed, or better, like an unquenchable spark that could easily break out into a major conflagration consuming all saintly resistance and overwhelming the beneficial effects of years of devout self-discipline on the part of even the most chaste of Christians. Entirely representative of the church's long-held views of the psychology of lust is the sermon in honor of the insipidly sweet Blessed (now Saint) Luigi Gonzaga given by Bernini's Jesuit preacher friend Gian Paolo Oliva. Oliva's sermon was addressed to a group of young Jesuits in formation but was really applicable to all categories of believers. Its message: Be ever on your guard! All it takes is that one tiny spark! The demon of lust is omnipresent and ready to strike! Custody of the eyes, above all! The same message is repeated in Oliva's sermon in honor of Saint Filippo Neri, in which he more specifi-

cally warns that the viewing of lascivious art—no matter how technically "fine" that art may be—creates a veritable tempest within us. Of course, Oliva's definition of "lascivious" would apply to a considerable amount of the artistic production of his century.

As Oliva, echoing generations of preachers before him, warns, lust is so violently powerful that a mere momentary glance at a titillating image—a patch of exposed flesh—is sufficient to ignite the appetite and overwhelm the chaste resolve of the most spiritually advanced individuals. Even if the image happens to be religious in nature. Even if the exposed flesh belongs to crucified Jesus Christ: "I know of a man who, while contemplating the humanity of Christ on the cross—it is shameful to say and horrendous just to imagine—sensually and foully polluted and defiled himself." (Self-pollution or defilement was the premodern moralist's synonym for masturbation. No wonder Pope Clement VIII covered up those crucifixes.) The latter blunt remark comes from the popular Franciscan preacher Bernardino of Siena, in his manual, *De inspirationibus* (practical rules for discerning evil "inspirations," or desires, from good). Though long since dead (d. 1455), Bernardino was still a much-heeded voice in the Counter-Reformation Catholic Church: his collected works (including the manual on "inspirations") were reprinted three times in just a few decades after the close of the Council of Trent (Venice, 1591; Paris, 1635; Lyon, 1650). And in 1625 the same saint even received the honor of having a church and female monastery dedicated to him in the very center of Rome, San Bernardino ai Monti, on today's Via Panisperna, just down the block from the Bernini home at Santa Maria Maggiore.

Despite the teachings of men like Oliva and Bernardino, the papacy—and therefore the Catholic Church as an institution—was by and large remarkably tolerant of sensual art, even in places of worship in Bernini's Rome. We may today find this ecclesiastical tolerance surprising, but given the historical context, it is easy to understand why the church not only tolerated but also (if only implicitly) encouraged the sensually charged religious art of Bernini and his many imitators. Wonder-provoking visual representations of the religious marvelous, such as Bernini's *Teresa*, despite the tinges of sexual ambiguity, are what brought the hordes of tourists and pilgrims into Rome each year, especially during the Jubilee years when their numbers reached into the hundreds of thousands. Even outside of the Jubilee years, the church realized that artistic spectacles of all kinds that

made a massive, direct appeal to the senses helped draw more of the faithful to their parish liturgies and devotions, serving as effective competition for the delights of profane theater and Carnival festivities. An explicit example of this are the lavishly staged "Forty Hours" (*Quarantore*) of Eucharistic adoration held during Carnival time. Bernini's landmark "Forty Hours" display of 1628 featured, according to an eyewitness description, a representation of the "Glory of Paradise shining with tremendous brightness without one's seeing any light except that which emanated from more than two thousand lamps hidden behind the clouds [of the Glory]." In other words, a jaw-dropping spectacle worthy of the Broadway stage. Indeed, the roots of Broadway are in Baroque Rome.

Imagination-capturing, spectacular representations of mystic saints like Teresa, furthermore, helped strengthen the loyalty of the faithful to the Roman Catholic Church. Such sights were meant to render them amazed at what their faith could work in the lives of human beings, under, of course, the proper guidance and control of the male hierarchy. The winning of their allegiance by magnificent, awe-inspiring art and architecture was the explicit, dominant motivation behind the vast expense of money and energy poured into the papal capital ever since the beginning of the Renovatio Romae, the campaign to restore the glory of Rome in the mid-fifteenth century. What one of that campaign's early promoters, Pope Nicholas V (reigned 1447–55), said self-defensively in his so-called "Testament" about the lavishly expensive new works of architecture he had commissioned was true of all the church's new art—painting and sculpture—as well, all the way to Bernini's Cornaro Chapel and well beyond:

> The only people who understand that the authority of the Roman church is greatest and supreme are the ones who have learned its origins and its growth from their knowledge of reading. In reality, the masses of all the others, ignorant of and thoroughly lacking reading ability, might seem to hear often from educated and learned men the nature and extent of those matters and to assent to their truth and certitude; but still, unless they are moved by something extraordinary that they see, all that assent of theirs rests on weak and feeble foundations and will slip bit by bit in the course of time until it lapses to virtually nothing. But actually popular respect, founded on information provided by educated men, grows so much stronger and more solid day by day through great buildings.

After 1517 and the outbreak of the Protestant Reformation, and even more so after 1563 (the close of the Council of Trent and the beginning of the Counter-Reformation), the self-publicity of papal art and architecture projects was directed toward not only the Catholic faithful but the Protestant "heretics" as well. As is obvious from even a superficial acquaintance with the ecclesiastical literature of Counter-Reformation Rome, the Catholic Church felt itself in constant competition with the Protestant churches, having to continually prove its legitimacy and assert its superiority against their strenuous and, for growing numbers of adherents, persuasive claims to the contrary. One of the church's self-legitimizing proofs was the wonder-working sanctity of its canonized members, for example, levitating mystics like Teresa of Avila. Displays of spiritual marvels like Bernini's *Saint Teresa in Ecstasy*, thus, bore the further implicit message: it is only within the fold of the one, true church, the Roman Catholic Church, that such mystical marvels, such heights of spiritual achievement, can ever be reached. "Why is everyone writhing?," a non-Catholic visitor to Rome once asked me, referring to the Baroque art of its churches with its many ebullient depictions of saints twisting and turning in ecstasy or near ecstasy. Everyone is writhing, ultimately, to advertise the joy of being a Roman Catholic, a privileged member of the "one true church," in the sunny land of the popes during the triumphal years of the Counter-Reformation. The dance of the saints was an invitation to a party of the blessed.[6]

La Pimpaccia to the Rescue

It was all well and good for Bernini, in January 1647, with his reputation sunk so low, to have won so prestigious and financially rewarding a commission from so prominent a personage as Cardinal Cornaro. But for him, it was not enough. Over the past three decades he had gotten thoroughly used to being on the very top of the artistic mountain in Rome—this by securing commission after commission from the man at the top of the political mountain, the pope. He was determined to do so again. And he was not going to wait for the completion of the Cornaro Chapel, which would (and did) take years. So he set his sights on another commission, a papal commission—in fact, one of the most desirable, high-profile papal commissions at the moment. Immediately after his election to the papacy in September 1644, Innocent and his family busied themselves in accumulating

all the trappings of a respectable family of the upper echelons of the Roman aristocracy. This required, above all, the construction of a large, stately urban residence for themselves, their most visible seat of power and status. It also required a properly decorated family funerary chapel in one of the city's churches, at least one suburban villa, and a feudal estate further afield from Rome. The ambitious and power-hungry Pamphilj soon secured all these trappings of power for themselves. In fact, they could claim an entire church as their own, Sant'Agnese in Agone, which they built in the center of Piazza Navona, already the location of the family seat in town. By enlarging and rendering more magnificent their old residence and by planting further architectural extensions of themselves in the immediate vicinity, they would turn the entire piazza into "their" territory, physically and symbolically.

The upgrading of Piazza Navona under the Pamphilj would eventually come to represent "one of the most sweeping and extravagant Baroque transformations of an urban site." Ironically, the contribution of the disgraced Bernini to that transformation stole and continues to steal the show in Piazza Navona. In addition to Sant'Agnese in Agone there was to be a grandiose public fountain in the center of the square (actually an oblong— the outline of an ancient Roman stadium formerly on the site), with eventually two smaller fountains at either extremity. Close, convenient access to running water, especially in the form of efficient, beautiful, public fountains, was essential not only to daily life; it was also one of the indisputable status symbols of any Roman family, even lower on the social ladder. In 1672 Bernini himself would petition successfully to have a private water conduit extended to his own home on the Via della Mercede in order to feed a small domestic fountain he built there.

With plans for the enlarged new family residence well under way, Pope Innocent's attention was focused on getting this central fountain designed and built. He had already decided to incorporate into its design an ancient obelisk lying in ruins along the Via Appia near the tomb of Cecilia Metella, which he personally went to inspect on April 27, 1647. Though one of the smaller of the several survivors from antiquity and of Roman—not Egyptian—manufacture, it would nonetheless be an impressive piece of "furniture" for his piazza. Symbols of the triumph of Christianity over pagan religion, ancient obelisks had been zealously reerected all over the city by the Counter-Reformation popes, beginning with and especially by

Pope Sixtus V during the five short but prodigiously busy years of his reign (1585–90). Thanks to Sixtus and his successors, Rome now boasts over a dozen of these majestic solar icons punctuating its urban landscape. For the central fountain-with-obelisk, Pope Innocent needed more water, so he simply took it away from the Trevi Fountain, which until then had been the principal display of the ancient Acqua Vergine aqueduct. He did so with glee, for he was thus able to communicate in symbolic form a political message about the diminished status of the Barberini in whose "territory" the Trevi Fountain was located. Although Bernini had been appointed by Urban VIII to the office of superintendent of the Navona water conduits, Innocent snubbed him on this occasion and gave to Borromini, instead, the task of extending the Acqua Vergine water pipes into that piazza for the benefit of the new central fountain. A further blow was dealt to Bernini by the pontiff, who completely ignored him when he took the next step of soliciting designs for the fountain from various prominent artists of Rome.

The archives do not tell us who won this competition—Domenico Bernini claims that no one came out victorious—but all indications are that Borromini's design held sway. Borromini himself claims that his design, incorporating reference to the four major rivers of the world, had, in fact, been formally chosen by the pope, but the documentation does not confirm his assertion. Bernini probably saw the design (one drawing still survives) and knew he could do better. And indeed he did. His exuberant design is much more dynamic and more delightfully original than Borromini's simpler, sedate plan. Nonetheless, it was from Borromini's earlier plan that Bernini appropriated the central, genial idea of the fountain as a mighty confluence of the four major rivers of the world. Bernini worked in secret on his design, eventually producing a small, three-dimensional, but highly refined model, not in the usual, plain terracotta, but in eye-catching silver. The challenge now was getting the pope to see it. There was no way Innocent would agree to even glance at a design once he knew it was from Bernini's hand. Bernini needed someone to run interference.

According to Domenico's version of the story, the person running interference in this case was the pope's nephew-in-law, Prince Niccolò Ludovisi, married to Donna Olimpia's daughter, Costanza Pamphilj. The prince, claims Domenico, "secretly requested from Bernini a design of his own creation for the Navona fountain, claiming that the design would be for his own personal pleasure and by no means for the eyes of the pope."

It is impossible to believe that the shrewd Bernini would have simply and ingenuously accepted this preposterous claim on the part of the prince and not suspected that Niccolò had ulterior (though benign) motives. But that is not the only deceptive part of Domenico's account. In truth, it was Bernini himself who, unsolicited by any member of the papal family, had decided on his own that he would come up with a fountain design and then find an accomplice within Casa Pamphilj to bring the *modello* to the pope's attention.

But was that accomplice really Prince Niccolò? No, it was not, say other, reliable third-party sources. And once we find out the identity of the key intermediary here, we can well understand why both official biographers, Domenico and Baldinucci, refrained from revealing so disreputable, so hated a name: La Pimpaccia, Donna Olimpia Maidalchini. We know it was Olimpia from three eyewitness sources: Borromini, the gossipy Roman agent (Francesco Mantovani) of the Duke of Modena, and an anonymous informant of Baldinucci himself (who suppressed that detail in the final published version of his biography of Bernini). We have already seen how Bernini, swallowing, as usual, any distaste he may have felt for an unsavory but nonetheless powerful patron, had turned to Donna Olimpia earlier in the bell tower crisis. He now turned to her once again, with an enticingly valuable silver *modello* of his fountain (and perhaps, more gold coins) in hand. The gleam of the silver and gold lighting up her avaricious eyes, Olimpia agreed to help him to steal away the fountain commission from whoever had it at the moment, if in fact it had been formally granted to anyone, for instance, Borromini.

Someone—most likely Bernini himself—came up with a clever strategy whereby the pope, caught off guard, would come face to face at close quarters with the *modello*. We pick up the story from Domenico:

> The pope was expected for dinner in the residence of his sister-in-law, Donna Olimpia, on Piazza Navona. Accordingly Prince Niccolò placed the *modello* strategically on a small table in a room through which the pope was obliged to pass after the meal. The prince was certain that, upon seeing the *modello*, the pope would at least inquire as to the identity of its creator. However, much more was accomplished than was hoped for. The pope indeed saw the *modello* and, upon seeing it, was sent into a state of near ecstasy for a half-hour's time, admiring the composition, nobility, and monumentality of the

structure. He then turned to the Cardinal Nephew and Donna Olimpia his sister-in-law and in the presence of his entire Privy Council burst forth with the following words: "This design could have come from no one else but Bernini and this maneuver staged by no one else but Prince Ludovisi. We now have no choice but to employ Bernini despite the opposition against him because anyone who does not want to use Bernini's designs must simply keep from even setting eyes on them."

As the anonymous Baldinucci informant remarks sarcastically, "From this [maneuver] one sees that Bernini was more clever as courtier than as sculptor and architect." And likewise the Modenese dispatch, while admitting that Bernini's design was done "with outstanding and marvelous artifice," accuses Bernini of "being astute and crafty to the highest degree" in devising this "more clever stratagem." But little did Bernini care about such criticism. From that moment on, the fountain commission was his. "The very next day" (supposedly), the pontiff summoned the (supposedly) unsuspecting artist into his presence and not only granted him the commission but also in effect offered his sincere apology: "With a display of affection, esteem, and majestic manner, Innocent explained to him—as if to excuse himself in the artist's regard—the various reasons and circumstances that had prevented him until that moment from making use of his services." If Domenico's account of the scene is in fact true, the pope's gesture was remarkable: absolute princes simply do not apologize to mere subjects and clients for anything.

What is assuredly not true is Domenico's claim that "the Cavaliere was completely unaware of what had occurred earlier [the successful strategy of having Innocent stumble across the model] and had had far different expectations of this summons from the pope." Even if he had not had any role in or knowledge of the aforementioned stratagem of trapping the pope into examining the fountain *modello*, the shrewd courtier Bernini would never have allowed himself to be blindsided. He would never have responded to an unexpected summons from the pope without doing his homework beforehand, that is, without interrogating the grapevines of the court to find out why the pope—who had until then largely ignored him—was suddenly calling him to his immediate presence. In any case, the audience marked the end of the estrangement between Innocent and Bernini. Our biographers supply no chronology for any of these events relating to the Piazza Navona

fountain commission. However, we know from another source (the pope's handwritten order to the project's supervisor, Monsignor Luca Torregiani, to get things moving) that Bernini's final design for the fountain had been formally approved by July 1648, and there is reason (namely, the reference in Domenico and Baldinucci to the Feast of the Annunciation, on March 25) to believe that the pope's impromptu encounter with the preliminary silver model took place in March of that same year. As for the fateful silver model, unfortunately, no trace of it remains. It is likely to have been later melted down by a desperate owner for its cash value.[7]

The completed fountain, inaugurated on June 8, 1651, fully met the expectations of Pope Innocent, who was the delighted victim of yet another of the playful Bernini's surprise tricks. Earlier that same month, Innocent, with his princely retinue, came to formally inspect the virtually complete but still waterless fountain. The pontiff was thoroughly pleased with what he saw, but was disappointed when Bernini explained that, regretfully, things were not ready for the water to be turned on. So, imparting his blessing on the artist and his crew, the pope turned to leave the construction site. As the honored guest was about to depart, the artist gave a secret signal to his workers, who immediately turned the water on, full blast. A startled Innocent abruptly turned on his heels to look back and what he saw sent him into ecstasy. For a half hour he marveled like a little child over the sight and sound of the ingenious play of the abundant cascading waters. "Signor Cavaliere," he exclaimed, "you have added ten years to Our life!" ("Good grief, ten more years of this guy!" some of the irreverent onlookers must have moaned to themselves.) But as usual, Bernini himself could only see the defects of the finished product: "He was never able to be truly satisfied with any of the numerous works he created, believing that they all fell very short of that beauty that he knew and conceived within his mind. Thus, it comes as no surprise to hear that one day, passing across Piazza Navona, he abruptly closed the shutters of his carriage windows in order not to see the fountain there, remarking, 'Oh, how ashamed I am of having done such bad work.'"

Even more discontented were the impoverished masses of the city of Rome, who in those years were suffering through a famine of uncommon severity. Not unreasonably, they bitterly resented the expenditure of money on yet another self-glorifying papal embellishment, money that came in part from new taxes imposed by Innocent on common and nec-

essary food items. The ingenious interplay of Bernini's expertly carved marble blocks marveled over by the city's better educated (and better fed) elite may have impressed the lower ranks of the population, but not enough to forget their empty stomachs. "Dic ut lapides isti panes fiant!" "Command that these stones turn into bread!" the satirical Pasquino exclaimed, borrowing the words of the Devil tempting Jesus in the desert (Matthew 4:1–3). "We don't want obelisks and fountains; it's bread we want! Bread, bread, bread!" the populace shouted so loudly and so vociferously that, as we have seen, the pope learned to be fearful of driving through the streets of Rome, thus exposing himself to the pent-up fury of his desperately hungry subjects.

Our sources do not record how Bernini responded to such protests. Presumably his response to the endemic poverty of the masses would have been the same as the church's. The church taught, simply, that the reality of chronic dire poverty (and, at the same time, extreme wealth concentrated in the hands of the "magnificent" few) was part of the fixed, divinely ordained natural order that could not be changed, but merely alleviated in temporary fashion through almsgiving. The division of the human race into rich and poor existed, in the divine plan, as a test and as a merit-gaining opportunity for the exercise of faith and virtue: for the poor, through their pious resignation and expiatory suffering; for the rich, through the practice of the corporal works of mercy (feeding the hungry, clothing the naked, sheltering the homeless, etc.). In Catholic theology of the day, as it had been in earlier ages and was to remain until the late twentieth century (with the temporary rise of the officially now out-of-favor "liberation theology"), there was no spiritual need for—and thus no effective incentive to—finding permanent systemic solutions to poverty by eliminating its causes within the unjust structures of the economy. The theologically conservative Bernini would have fully embraced this orthodox view of the socioeconomic reality.

But it could even be that Bernini was so absorbed by his own personal drama that he did not pay much attention to that of the starving masses. Bernini had created his Fountain of the Four Rivers in Piazza Navona in the same defiantly audacious mindset as he had his *Saint Teresa in Ecstasy*. In this moment of public humiliation, he was going to prove his worth beyond a doubt by simply dazzling the public with a never-before-seen display of visual beauty and technical virtuosity. He had been accused

of professional incompetence in constructing bell towers that threatened collapse: so what did he do in Piazza Navona? He created a fountain featuring a massively heavy obelisk that appears to rest perilously upon a thin platform of rocks under which there is nothing but a void. "One marvels not a little" at this fact, says Baldinucci in understated fashion, explaining that despite the widely perforated stone foundation, the structure's stability comes from the ingeniously and tightly assembled array of meticulously cut rocks. Nonetheless, the fears of a still-doubting public soon made themselves heard.

The occasion was a rainstorm, with violent winds, that struck Rome sometime after the completion of the fountain, sending buildings into collapse. A crowd nervously watched Bernini's fountain, believing that it would fall to the ground at any moment. Word was sent to Bernini to hasten to Piazza Navona, so that a proper preventative might be applied:

> When the crowd saw in the distance Bernini's carriage approaching the piazza at full speed, they began to take for a genuine danger that which, until then, they had perhaps believed merely out of the suggestion of their fear or the second-hand reports of their neighbors. All the greater did their alarm grow as they watched the Cavaliere, in a somewhat perturbed state, descend from his carriage, and with measuring instruments inspect the obelisk from a safe distance, as if he truly feared that it would collapse upon him. Having finished this visual inspection, Bernini ordered all the people to leave the immediate vicinity and in a tone of great preoccupation asked for some ladders and rope, with the intention of preventing the collapse.

> It is not possible to describe the various outcries and the sundry emotions that agitated the crowd of people filling the entire piazza, nor the expectation on everyone's part that they would witness the feared collapse before any effective remedy could be applied. Bernini gave orders for four pieces of thin rope to be tied, on one end, to the obelisk at the point where it rests on its pedestal and, on the other, attached, with the same number of nails, to four nearby houses. Once this was accomplished, a serene expression came over the Cavaliere's face and he departed the scene, in a state of complete jubilation, as if he had just successfully overcome some enormous challenge.

Domenico is alone among the documented sources to tell this amusing story of a bit of bold theatricality on Bernini's part that saved the day, but it seems unlikely that he would have made up such an anecdote. Even if not true in all its details, the picture it communicates of Bernini's self-confident, if also defiant and at times arrogant, personality is entirely in keeping with what we encounter elsewhere in the documentation. Domenico, by the way, does not date the episode, but the storm here in question may correspond to one of the two bouts of extraordinarily bad weather reported on August 9 and 26, 1653, by our Roman diarist, Giacinto Gigli. The later fact that the obelisk remained standing and undamaged in the wake of the strong, fifteen-minute earthquake that struck Rome on July 23, 1654, would have certainly put to rest any remaining doubts about the stability of Bernini's clever, reputation-saving design.[8]

A HEROIC BUST FOR A MOUSY PRINCELING

Not only did Bernini gain the pope's fountain commission, he gained his esteem to such an extent that "once a week—and many times in between—Innocent desired his presence in the Apostolic Palace, engaging him in most worthy conversation. As a result, the pope was often heard to remark that 'the Cavaliere was truly a man born to be in the company of great princes.'" Bernini was paid handsomely for his work on the fountain (3,000 scudi), but, trumped by secretary of state Cardinal Panciroli, Donna Olimpia could not make good on her promise to add to the reward by making one of Bernini's brothers (presumably Domenico) a canon of the Lateran Basilica, the same seat made vacant by the death of brother Vincenzo in 1648. Despite the rewards and newly recovered esteem, however, Bernini was never to regain the enviable near monopoly on papal commissions that he had enjoyed under Urban VIII. He did receive several other commissions from the pontiff, including those for a portrait bust (in more than one replica), the design of the second fountain in Piazza Navona (that of the "Moor"), the large bronze crucifix given by the pope as a gift to King Philip IV of Spain, and a statue of Emperor Constantine the Great for St. Peter's Basilica. The latter monumental project, however, made no real progress under Innocent; his successor, Alexander VII, revived it and, as we shall see, had Bernini bring it to its glorious completion.

Not under exclusive contract to the papal family, Bernini was free to accept commissions from other patrons. Among the most distinguished of those other patrons was Francesco I d'Este, the Duke of Modena, who commissioned a marble portrait bust in August 1650. Modena at the time was home of the court of the once glorious d'Este family, among the greatest cultural patrons of the Italian Renaissance. Francesco's family had been deprived of its ancestral homeland in the larger, wealthier city of Ferrara in 1598. In that year the papacy declared the legitimate family line extinct and confiscated the town as its own fiefdom. The family was therefore forced to take up residence in the third-rate Modena, where they made the best of their now much-reduced circumstances. But they never forgave the papacy for its act of larceny nor gave up seeking means of retaliation and retribution. During the long and active reign (1629–58) of Francesco I—"a man with enormous aspirations . . . though inclined toward treachery in politics"—those much-reduced circumstances were somewhat enlarged. This was accomplished by a strategic series of political alliances—above all, with France—and with the aggrandizing of the family's public image by the now tried-and-true method of architectural and artistic magnificence, that is, by building awe-inspiring buildings and commissioning superb works of art. If it worked for the popes, it would work for the Este family, and it did. Duke Francesco's commissioning of his portrait from Bernini was just one facet of this ambitious and successful dynastic publicity campaign.

Since the 1620s Bernini, as portrait sculptor, had been the universally acclaimed "image maker" of the rich and powerful. Nonetheless, Duke Francesco d'Este and his brother, Cardinal Rinaldo (coordinating the portrait project in Rome), initially gave equal consideration to sculptor Alessandro Algardi, who was also active and thriving in Rome at the time. This is a reminder that our artist was not without serious rivals, if not equals, in the art of the marble portrait, at least until Algardi's death in 1654, which left Bernini as the uncontested sovereign in that genre. Algardi was more attractive a prospect for the Este brothers, since he would cost far less, would produce faster, and in general be easier to work with. As Rinaldo wrote to Francesco in July 1650: "Bernini works only as a favor to friends or at the request of important personages. With him, one cannot fix in advance either a schedule or a price. Regarding the former, one must simply keep reminding him of the work to be done; as for the latter, it will not be an obstacle if one remunerates him sufficiently." In other words, keep

prodding him and keep the promise of glimmering gold and silver coins in front of his eyes. As was customary in princely commissions of this sort, however, no price was discussed in advance, the artist trusting in the reputation and the usual promises of the patron to "do the right thing," that is, provide a sufficiently "magnificent" reward once the bust was completed. Rinaldo and his agents made discreet inquiries about what kind and degree of compensation would be necessary here: What was Bernini going for these days? The prince's fear of falling short in this regard was very real, but it was rooted more in not wanting to risk public ridicule or disgrace for lacking in munificence—that is, for being "cheap"—than it was in the fear of alienating Bernini. These kinds of transactions—who was paid how much for what by whom—were carefully monitored and openly publicized through the rumor mills of Baroque Europe as a measure of the true social status of princes.

In the end, after the bust reached Modena in November 1651, Duke Francesco proved himself worthy of his noble rank by giving Bernini for one bust what he had received from the pope for the whole Fountain of the Four Rivers, a whopping 3,000 scudi. The sum was paid in cash, for the artist let it be known that he had enough jewelry and silverware, other customary forms of payment to artists. In the end, Bernini, too, proved himself worthy of his reputation by producing a properly "magnificent" portrait the awe-inspiring heroic representation of the absolute prince. In this case, as with the Thomas Baker bust, however, the statue is, in truth, more awe-inspiring in its heroic drapery and cascading, curly hair than in the mousy-faced princeling hiding behind it all. Again, working from painted portraits (actually, just two profiles, with no frontal view) supplied by Flemish artist Justus Suttermans, Bernini had to do the impossible—achieve a convincing likeness without ever setting eyes on his subject in real life. Bernini's apologetic letter of October 20, 1651, to Duke Francesco, sent in accompaniment of his finished portrait, begs the duke's pardon for the shortcomings of the work, but in the eyes of his patron, no pardon was at all necessary.[9]

The 1650 negotiations for the Duke Francesco bust mark the first documented direct connection between Bernini and someone who was to become, if he was not already, a long-term patron and friend, Cardinal Rinaldo d'Este, even if that friendship may have been, in reality, one of convenience. In surveys of Bernini's career the cardinal is usually passed

over in silence or haste, but as one historian has recently pointed out, all his commissions to Bernini over two decades, albeit mostly modest or un-executed, nonetheless "substantiate the impression that Rinaldo d'Este was one of Bernini's few lasting patrons outside papal circles." The audacious ecclesiastical pirate, Cardinal Rinaldo, was an extremely active player on the political chessboard of Baroque Rome, yet another of Bernini's patrons who did not always comport himself as a gentleman or a Christian. By now, the reader will have gotten used to the fact that in Baroque Rome, whether prelate or layperson, one did not rise to the top of the political pyramid by being a "nice guy." It took not only powerful family connections, but also a well-thumbed copy of Machiavelli's *The Prince*.

There were, to be sure, a few genuinely decent folk at the upper ech-elons, like, as far as we know, Cardinal Antonio Barberini, Sr., and Donna Anna Colonna Barberini, but Bernini happened not to have much interac-tion with them for whatever reason. Be that as it may, thanks to Rinaldo's patronage, the family's famed Villa d'Este, now one of the great tour-ist destinations of the Roman countryside, can claim that "Bernini Slept Here." The artist did so on a couple of occasions in the 1660s, yielding to his patron's commands to allow himself some brief repose or while execut-ing fountain commissions and repair work for the cardinal. Born in 1618, Rinaldo was son of Duke Alfonso III and Isabella of Savoy and younger brother to Duke Francesco I. In his youth Rinaldo had abandoned a military career to follow a more promising ecclesiastical path and moved to Rome. It was not the Holy Spirit who counseled this career switch. Rinaldo had not a drop of pastoral blood in his veins, as was obvious to all. Like most male members of his class, he was thoroughly a political animal, and not surprisingly, his earlier militantly belligerent spirit was long in dissipating, if it ever really did, even after he put on the garments of a prelate. In 1641, at the age of twenty-three, he was created cardinal deacon (never having pursued priestly ordination) and continued thereafter to climb the ranks of power within the Roman prelature. Even in his maturity in the 1650s at his now more spiritually exalted rank, "the bellicose cardinal was accustomed to surrounding himself with, in addition to members of his household staff, copious numbers of arms-bearing men."

Rinaldo owed much of his wealth and influence to his role as loyal and assertive cardinal-protector of French interests in Rome. He was, in fact, the principal exponent of those interests within the papal capital during the

middle years (1646–62) of the seventeenth century when the French ambassador was often not in residence because of political hostilities between France and the papacy. For his devoted service as leader of the French faction in Rome, Paris rewarded Rinaldo generously. His wealth increased exponentially when upon Mazarin's death in 1661, the deceased French minister's benefices and other income-bearing ecclesiastical holdings were transferred by the crown to Rinaldo. As for his relationship to Bernini, in addition to their Barberini connection, it would have been in their shared pro-French (or at least for Bernini, anti-Spanish) interests that the two men—the cardinal and the artist—would have found common ground. In the typically groveling Baroque manner, Domenico describes Rinaldo as "worthy prince of most affable manner" and "that sublime genius." "Sublime genius"? Apart from his astuteness in playing politics, one is at a loss to find justification for such praise.

There is likewise scant evidence in the surviving documentation of Rinaldo's affability. Note that this is the same person who for two anxious weeks in late April and early May 1646 caused all Rome to be held captive by fear of a bloody battle between the well-armed French and Spanish factions—all this havoc just to avenge an affront to his personal honor. The new Spanish ambassador, El Almirante de Castilla, Juan Alfonso Enríquez de Cabrera, had arrived in town and let it be known that he would not include Cardinal d'Este among the obligatory round of courtesy visits customarily carried out by a newly installed diplomat to the important personages in residence. But what if their carriages were to meet on the narrow streets of Rome or they themselves were to cross paths in the audience halls of another dignitary? Who would stop for whom? Who would defer to whom? Not I, declared the Spanish ambassador. Rinaldo was soon made aware of the Spaniard's insult and wanted nothing more than a showdown with this arrogant official representative of an state that was an enemy to France, and therefore to him as well. He would physically force El Almirante to stop, if he had to, should their coaches encounter each other in public.

All Rome was soon apprised of and in anxious alert over this ceremonial keg of diplomatic dynamite that could explode within their midst at any moment. The friction threatened to break out into military conflict, for both sides were filling their residences with hordes of armed soldiers and brigands from the countryside. Pope Innocent sought to quell the tension

by forbidding both parties from having contact with each other and by or-
dering Rinaldo to leave Rome. But the defiant Rinaldo said that he had no
intention of obeying. In the end, armed conflict did occur, with bloodshed
and loss of life, though mercifully not in the quantities originally feared.
Reconciliation was eventually brought between the two warring digni-
taries, but the whole tragically ridiculous affair could have been avoided
had Rinaldo not placed egotism and personal gain over public peace and
safety.

His appetite for armed showdowns unabated, Cardinal Rinaldo later (in
1661) had the nerve to cross swords with the reigning pope's own brother,
Don Mario Chigi, the Chigi likewise being no friends of France. Then, in
August 1662, provoked by the ongoing power struggle between France
and the papacy, a bloody skirmish between the papal Corsican Guards and
the soldiers of the French ambassador Créqui took place on the streets of
Rome. Here too the astute Cardinal Rinaldo was quick to derive personal
advantage in gratification of his French protectors, but to the direct and
bitter detriment of his own "spiritual father," Pope Alexander VII. Rinaldo
granted safeguard to the ambassador's wife and staff within his home, while
sending his personal guards to fight alongside the French soldiers against
the pope's military force. This episode, as we shall see (for Bernini was un-
wittingly dragged into its later consequences) was blown up into an inter-
national conflict by King Louis XIV, who used it as a pretext to humiliate
the papacy. In the end it required the convocation of a formal peace treaty
conference in Pisa. Cardinal Rinaldo was rewarded for his allegiance to the
French crown by Louis, who included in the formal terms of peace a siz-
able financial settlement by the pope to the Este family in compensation for
lands annexed by the papacy in the previous century. The Roman Curia,
not surprisingly, viewed Rinaldo's role in this affair with different eyes: at
one point after the initial military skirmish in August 1662, at a secret con-
sistory of pope and cardinals, one of the proposals made was that Rinaldo
be imprisoned in the dreaded dungeons of Castel Sant'Angelo.

Rinaldo may have behaved as a belligerent rascal with the Spanish and
the Chigi, but he treated Bernini only with respect and affection, show-
ering him with gifts and attention. Thus in Domenico's biography of
Bernini, Rinaldo is both a "sublime genius" and "worthy prince of most
affable manner." But is this how Bernini truly felt about the shrewd, op-
portunistic cardinal? Did Bernini not feel any moral discomfort, any pang

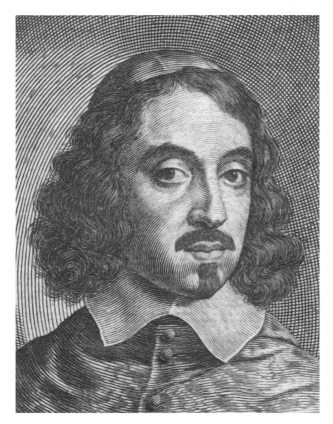

FIG. 21 ↠ Giuseppe Maria Testana (engraver), *Cardinal Rinaldo d'Este.*
From Giovanni Giacomo de' Rossi, ed., *Effigies, insignia, nomina . . .*
S.R.E. cardinalium (Rome, 1658). Photo: Author.

of conscience, in consorting with a man whose cold political machinations
were so detrimental to the pope and the general peace? The pope who most
suffered from Rinaldo's Francophile machinations was Alexander VII, a
rather decent fellow and one of Bernini's more likeable papal patrons, who
treated the artist with even more respect and affection than Rinaldo while
bestowing upon him a long series of glorious—and lucrative—papal com-
missions and generous rewards. Ignoring the obvious moral conflict here,
Domenico, like Baldinucci, simply records with untroubled pride Rinaldo's
extravagant remuneration to Bernini for a minimal amount of work at his
villa at Tivoli.

We are not told what reward Bernini received for his other, more
substantial work at the same villa, the Fontana del Bicchierone (Big cup

fountain), a giant artificial cascade that the artist designed in the 1660s. In 1653 Bernini had also provided Rinaldo with a design for a never-executed monumental staircase for the Barberini Casa Grande ai Giubbonari, which the cardinal was renting while shopping around for a permanent residence of his own in the city. Our artist probably also contributed to the design prepared by his closest architectural assistant, Mattia de' Rossi, for the re-modeling of Rinaldo's later Roman residence, the Palazzo Sannesi (today's Palazzo Maffei-Marescotti, near the Pantheon). Cardinal Rinaldo was also instrumental in securing Bernini's help in redesign and embellishment proj-ects at the Este family's estates up north in Modena and Sassuolo, but little remains of that work. As in the case of most of his patrons, Bernini outlived Cardinal Rinaldo, who died in September 1672. A flattering engraving by Giuseppe Maria Testana and published by Giovanni Giacomo de' Rossi in his best-selling album of official portraits of the Baroque College of Car-dinals, the *Effigies insignia nomina . . .* , shows a rather handsome Rinaldo, but devilishly so (fig. 21).[10]

THE PAPAL CORPSE LEFT TO ROT

In attempting to pry into the more domestic aspects of Bernini's life in the second half of Innocent's pontificate (by which time his public reputation was largely reestablished), we are, as usual, handicapped by the silence of our primary sources: they supply little beyond a bare recording of the mun-dane details of births, marriages, and deaths. Not even the usually gossip-filled anonymous news bulletins (the *avvisi di Roma*) and personal diaries reveal much about Bernini's private life for these years. We do know that in rapid succession, in 1649, 1650, 1652, 1653, and 1654, five more children were born to Bernini and his wife: Cecilia, Dorotea, Maddalena, Francesca Giuditta, and Francesco Giuseppe. We assume Bernini rejoiced over these births, just as we likewise assume he mourned, if perhaps to differ-ing degrees, when in 1651 and 1652, first his father-in-law, Paolo Tezio, and then his sister, Dorotea (aged sixty-one and never married), died. We assume he lived in fear during the ravages of the great mortality, the mys-terious *febbre maligna*, "malignant fever" (we now know it was typhoid) that struck the city in 1648–49, reaching horrendous heights during the summer of 1649. Bernini and his family seem, however, to have escaped that contagion unharmed. Fortunately the epidemic also spared the Spanish

painter Diego Velázquez, who arrived in Rome at the end of May 1649 for an extended visit, garnering much well-deserved professional attention as well as fathering an illegitimate child. It is not unlikely that the two artists might have met in Rome during the Spaniard's stay in the city, but there is, we are sorry to report, no documented notice of any personal contact between Velázquez and Bernini, despite the affinities between their styles of painting.

Having regained papal esteem but no papal monopoly, Bernini was lucky, nonetheless, in not having to deal with Innocent X on a regular, intimate basis during the last years of the pontiff's reign. Already given (like Urban VIII) to bouts of irrational, if not paranoid, rage at the beginning of his pontificate, Innocent did not mellow with the passing of time. His health declined, and bitter disappointments and defeats, both personal and political, piled up at a distressing rate. Innocent's one big military victory was entirely hollow: in the second and conclusive phase of the War of Castro foolishly begun by Urban VIII, Innocent defeated the Farnese enemy but at immense cost to the papal treasury and to the fiefdom of Castro itself. The town of Castro was completely destroyed and its inhabitants dispersed. Back at home, the distempered pontiff quarreled bitterly with many of his closest associates, abruptly firing some of them from their jobs or otherwise alienating them. The victims of papal wrath included two eminent personalities of the court: his secretary of state Cardinal Panciroli (the man who had gotten him elected pope), and his personal physician, the distinguished Portuguese Gabriele Fonseca, whose wonderfully wrought, tenderly pious portrait bust Bernini sculpted for the Fonseca family chapel (also of Bernini's design) in San Lorenzo in Lucina in the 1660s. The pope even fought with Donna Olimpia, finally summoning up enough gumption to actually bar her from the Vatican in the fall of 1650, only to call her back when he discovered that he was unable to manage his affairs without her. But Donna Olimpia never forgot this, or any, offense. Returned to grace, she resumed her role as before, but exacted her revenge on the pope at the very end of his life for this insult, as we shall see.

Also returned to papal grace slowly but surely were the exiled Barberini, to such an extent that on March 25, 1653, the two clans solidified their newly forged alliance through the marriage of Prince Maffeo Barberini (grandnephew of Pope Urban VIII) and Olimpia ("Olimpiuccia")

Giustiniani, Donna Olimpia's granddaughter. The unwilling sacrificial lamb, poor Olimpiuccia, a twelve-year-old girl, however, had to be literally dragged, kicking and screaming, first to the marriage ceremony and then after five months of violent resistance, to her husband's bed in order to finally consummate the union. But how could this be, the Barberini and the Pamphilj now friends, allies, and even relatives through marriage, after so much fiery rancor between the two houses? Ah, the fickleness of love and hate in Baroque Rome. What changed the papal mind and that of his sister-in-law were two factors. One, political pressure from the Barberini's powerful allies, the French, in the person of Cardinal Mazarin. And, two, the sobering if not frightening realization that once Pope Innocent died, the Pamphilj family would be defenseless against the many enemies it had made in so short a time, if they did not widen and thicken the web of protection surrounding them. The still powerful and wealthy Barberini would be an essential part of that web. In turn, the Barberini were happy to oblige the Pamphilj, so they could all return home and resume life as before in their Roman nest. Once again, "Una mano lava l'altra," one hand washes the other.

A further victim—but a fully deserving one—of Innocent's wrath in this period was his *sotto datario* (subdatary, in charge of preparing papal dispensations, graces, and other favors), Monsignor Francesco Canonici, more commonly known by the swashbuckling name of Mascambruno. The case of the infamous rascal Mascambruno was one of the most shocking, most talked-about scandals of the Roman court during our artist's lifetime. Although not a direct participant, Bernini would have followed the case with great personal interest as he and all Rome lived through this moral earthquake and its subsidiary tremors. As a professional courtier who wooed papal favors all the time and had occasional need of papal grace himself, Bernini could not afford not to pay attention. It therefore deserves a brief place in our narrative.

In January 1652, Innocent imprisoned and several months later publicly beheaded Mascambruno, a long-trusted prelate who effectively controlled the operation of one of the most important and most financially profitable divisions of the papal bureaucracy. Papal graces and dispensations in most cases did not come free of charge; everything came with a price, including marriage annulments. Therefore, income-processing bureaucrats like Mascambruno made out quite well even when they didn't resort to outright

felony as he did. Mascambruno had for years amassed a great fortune and a network of grateful clients by, among other things, falsifying papal documents on behalf of powerful and well-paying individuals. This went on for a long time even with the knowledge of Donna Olimpia, who had obtained that office for Mascambruno early in the Pamphilj pontificate and received a share of his ill-gained profits. But like all overconfident felons, Mascambruno one day went too far. For forty thousand gold pieces, he falsified a papal dispensation allowing jurisdiction over the crime committed by a certain Portuguese aristocrat, the Count of Villafranca, to be transferred from the severe Spanish Inquisition to the more gentle authority of the local bishop. The bishop in question, by the way, happened to be a relative of the misbehaving nobleman.

What was the nature of the misbehavior? The Count of Villafranca—a married man—had dressed his young male lover up as a woman and married him in a church ceremony presided over by a priest. *Amor omnia vincit*, love conquers all, as Caravaggio had reminded Baroque audiences with his disturbing depiction of a stark-naked, defiant Cupid smugly presiding over the trampled vestiges of socially respectable human endeavors like art and literature. But the count's extraordinary act of daring raises many practical questions—What did the count really to expect to accomplish by such a ceremony? What made him think he could get away with such a deed? Did a legitimate priest perform the ceremony? Did the count's wife and relatives know? Unfortunately, the primary sources give only these few bare facts about the case: the count attempted to marry his disguised gay lover in church. Bare though they be, these facts would appear accurate, for they are reported in more than one source, including our Roman diarist Gigli. In any event, in the eyes of the law, the crime involved was sodomy, punishable by burning at the stake. However the fake papal dispensation supplied by Mascambruno would have allowed the count to escape in all likelihood with a mere token of a penance administered by the local, friendly bishop who, as mentioned, was a relative of his. How all this got to the attention of the pope need not detain us here. However, one can easily imagine the absolute uproar it subsequently provoked in the papal curia and in all Rome. Two gay men marrying in a Catholic Church and nearly getting away with it with a forged papal dispensation!

The discovery of this outrageous treachery by one of his most trusted assistants left poor, battered Pope Innocent reeling in anger and shock,

poisoning the last already painful years of his pontificate. Always hard to live with, Innocent became intolerably so afterward. As for Bernini, as recipient of so many papal privileges for himself and his family members, he would have paid careful attention to what went on in the papal datary and would have been well aware of the scandal as it unfolded. Even though Mascambruno's frauds touched him not, there were probably many Romans who found it hard to believe that the fabulously wealthy, pontifically patronized Bernini had not somehow benefited from Mascambruno's scams. Used to malignant chatter about himself, Bernini would have just shrugged his shoulders at the suspicions. Little did he know that years later when his own brother, Luigi, was charged with the same crime of sodomy in likewise scandalous circumstances, he too would be desperately looking for ways to get around the justice system to rescue his kin from the heavy hand of the law.

Despite their twenty-year grand larceny at the public's expense during the reign of Urban VIII, the Barberini, unlike Mascambruno, were instead welcomed back to Rome with open arms by Pope Innocent. Cardinal Francesco was the first to arrive, in February 1648: he was received by Innocent, as a Roman courtier of the time assures us, "with the greatest of benevolence." We can be sure that Bernini was delighted to have his old patron back in the city, although he must have had a twinge of fear that he may have heard about his spoofing of the Barberini in his 1646 Carnival production for Donna Olimpia. The dearest of his patrons among the Barberini, Cardinal Antonio, would have to wait the longest (until 1653) before feeling safe to set foot again in Rome. In his case, Innocent's wrath was particularly slow in cooling, for the brassy, arrogant Antonio had especially earned the personal antagonism of the pope. At a party at the Villa Borghese, for example, Antonio had once gotten into a public fight with the future pope—still cardinal at that point—loudly threatening to break the legs of the greatly and most publicly humiliated Pamphilj. Such offenses were never forgotten in Baroque Rome. Even worse, when Cardinal Pamphilj's young nephew Gualtiero Gualtieri died under suspicious circumstances, the uncle blamed Antonio. We can be sure that Bernini monitored closely and anxiously the fortunes of Cardinal Antonio at all times, for as we saw, Antonio was the artist's principal patron within the Barberini clan. The wheel of Bernini's own fortune was tied to, or at least affected by, that of Cardinal Antonio, for better or worse.[11]

As for the other aforementioned disturbances within the papal court, including those involving Panciroli and Fonseca, though they sent shock-waves throughout the papal court, none of them ended up affecting Bernini in any direct way. Instead, a disturbance that rocked Innocent's pontificate from further afar—Westphalia, Germany—was to have a determining influence on our artist's professional life, if not during the reign of Innocent, then certainly during that of his successor, Alexander VII. Anything that may have distressed Innocent at home paled in comparison with the disaster that occurred in the larger and more significant arena of European politics in late 1648: the monumental defeat that the papacy suffered in the form of the Peace of Westphalia. Its shockwaves immediately reached Rome and continued to rumble in the city for decades. To explain something of papal politics and, therefore, life in Rome in 1648 and beyond, a brief digression is in order.

In the days not long ago when schoolchildren of the West had to memorize all the decisive dates of European history, one date never absent from any scholastic list was "1648." That year, it was drilled into us, marked, according to the traditional consensus of historians, the very beginning of a new age in European history, the Modern Era. This had everything to do with the Peace of Westphalia, signed in that year. The Peace of Westphalia put an end to the Thirty Years' War between Catholic and Protestant Europe. That long, savage conflict represented one of the most devastating military struggles in the history of the European continent before the twentieth century. Even more consequentially, in resolving that struggle, the powers of Europe convened the first modern diplomatic congress, the result of which established a new political order based upon a modern understanding of the statecraft of sovereign nations with all that entails for relations among themselves. That this traditional view of Westphalia is now disputed by scholars does not change the fact that it was a major turning point in European history. Moreover, as far as the papacy is concerned, there is no dispute: Westphalia did in reality mark the beginning of a dramatically new, if not at all welcome, age.

In Rome Pope Innocent had no reason to rejoice over the political and economic terms of the settlement. Ratifying in universal and perpetual fashion the principle of "cuius regio eius religio" (the religion of the ruler determines that of his dominions), the Peace of Westphalia was without a doubt the most momentous political event of Innocent's pontificate, for it

confirmed Protestant control over extensive German lands that the papacy had long struggled to return to the Catholic fold. The treaties represented a humiliating defeat of epic proportions for the papacy, because the increasingly politically irrelevant pope, his interests and his demands, had been completely excluded from all negotiations. All hopes of turning back the clock to 1516 (that is, to pre–Martin Luther) were completely destroyed.

For nearly a century, the papacy had refused to acknowledge formally any political compromise (beginning with the Peace of Augsburg of 1555) that recognized even the existence of legitimate Protestant governments within Christendom, as if those enemy states would all simply shrivel up and disappear just because Rome was pretending they didn't exist. But now the Holy See was finally obliged to surrender to the new reality of Europe, thanks to the Westphalian treaties, which had been signed by all the major Catholic powers, Spain, France, and the Holy Roman Empire (a preposterously misnamed but sprawling state ruled by the German Hapsburgs and covering most of Central Europe with extensions beyond in every direction). As far as its public stance was concerned, the papacy maintained essentially a delusional state of "business as usual." But even in its delusion, it could not hide the fact that it now had less money to live on and to hand out; for no less catastrophic than the religious and political defeat was the irreversible economic setback to the papacy brought upon by the terms of the peace treaty. The Catholic Church suffered monumental losses to the Protestants in the form of valuable income-producing real estate: entire dioceses and archdioceses, bishoprics and archbishoprics, numerous wealthy monasteries, abbeys, canonries, and many other types of ecclesiastical benefices and property, together with their immense annual revenues. Westphalia placed the once-fat papal purse on a permanent diet, though it would be three decades before the papacy began to seriously tighten its belt under Pope Innocent XI.

Helplessly, Innocent X had witnessed this disaster slowly developing over the course of the four protracted years of negotiations, receiving regular reports from his representative, the papal nuncio, Monsignor Fabio Chigi, stationed in Westphalia. After the ratification of the peace agreement, Innocent issued a formal, public condemnation, entitled *Zelo domus Dei* (Out of zeal for the house of God), published in the form of a broadside to be displayed in public forums of Rome and Catholic Europe. In it, Innocent, "with a deep sense of grief," he sighs, acknowledges the signing of

the treaties but vehemently declares the concessions granted "for all time" to "the heretics and their successors" (namely, the Protestants) to be "utterly null, void, invalid, iniquitous, unjust, condemnable, reprobate, inane, and without legal force or effect." However, the pope's protest fell on deaf ears among the political powers of Europe—none of them rushed to dry his tears—and the terms were applied as spelled out in the treaties. It was a most bitter pill for Innocent and those around him to swallow.

As was clear to all, that disastrous papal defeat was possible only because of the decisions of the major Catholic players at the negotiations: the Holy Roman Empire and France, both of whom had made major concessions to the Protestants, to the direct detriment of the papacy's economic and political well-being. They did so not only for the sake of peace but also for their own national interests. Innocent was furious with two of the Catholic leaders, Holy Roman Emperor Ferdinand III and King Louis XIV, both of whom are mentioned by name at the beginning of Innocent's condemnatory brief. And of these two Catholic powers, Innocent's rage would have been even greater toward France, who had already long shown itself to be no friend of the papacy's: the enmity between Innocent and Cardinal Mazarin is well known and well documented. At Westphalia, together with the Protestant Sweden, it was France who in the end derived the "lion's share of the treaties' benefit." In fact, so little identified with papal interests was Mazarin that France had entered the war on the side of the Protestants, for they shared a common enemy, the Catholic Hapsburgs. For the same reason, during the peace process France was headquartered with Sweden and the other Protestant powers in Osnabrück, rather than with the Catholic powers at Münster.

What happened at Westphalia in 1648 was to have an effect on Bernini's professional life, if not immediately during the Pamphilj pontificate, then certainly just a few years later. It certainly seems to have had a determining influence on the design of one of Bernini's most significant works of this pontificate, the Fountain of the Four Rivers in Piazza Navona. The fountain's central theme, a glorification of the worldwide reach—stretching over four continents—of the power of the Roman Catholic Church was, in part, Pope Innocent's defiant response to the humiliation of Münster and Osnabrück.

But Westphalia's real effects were not to be seen in Rome until the next pontificate. It turns out that Innocent's successor on the throne of Saint

Peter, Pope Alexander VII, was the same person who as papal nuncio in
Germany had lived through the trauma of Westphalia on the front lines,
Monsignor Fabio Chigi. Profoundly shaken by so massive a defeat to
which he had been an impotent eyewitness, Chigi returned to Rome reso-
lutely anti-French, thanks to France's brazen betrayal of the papal cause
in Westphalia. His pontificate was marked by an intense power struggle
between France and the papacy and, as we shall see, Bernini would become
a major symbolic but direct pawn in that struggle. Just as significantly, once
on the papal throne, remembering Westphalia, Chigi was all the more de-
termined to assert the power and the glory of Rome and the papacy. How
to do this? Through the usual papal method, that is, by cloaking the entire
city and along with it the papal office, with an even more awe-inspiring
mantle of visual *magnificenza*. Bigger, more splendid buildings and pub-
lic squares, filled with more stunning works of art and architecture. This
would prove to the world that the papacy was as strong, as resilient, and as
"magnificent" as ever. To those given to psychological analysis, it might
be tempting to see Pope Alexander's urban development campaign as a co-
lossal display of delusional overcompensation. Be that as it may, how this
all worked out we shall see in our next chapter.

Meanwhile, back in Rome during the Pamphilj years, it was late 1654
and the pope lay dying. His was a slow, painful departure, defying in its
length everyone's expectations. Donna Olimpia was busy preparing for the
inevitable, selling papal offices at discount rates, removing from the papal
apartments every scrap of furnishing, every utensil, every item of clothing
of any value of all, and carting away all the gold coins that had earlier been
moved from storage in Castel Sant'Angelo and placed under Innocent's
bed. Let us not be too harsh on Olimpia in taking these measures. After all,
if she did not take the money and the rest of the papal valuables, someone
else would. They were guaranteed to disappear once the pope closed his
eyes for the last time in the general looting of the papal apartments that tra-
ditionally occurred at the end of each pontificate. ("Since the ninth century,
it had been customary for a pope's servants to plunder his room as soon as
he died, as a kind of final bonus from their boss.") However, pathetically in
Innocent's case, so much was he hated and so bereft of loving, trustworthy
companions—he had alienated everyone—that not only was he left with-
out even sheets on his deathbed, but his very corpse was left to rot in a rat-
infested room. None of his own relatives would agree to put up the money

for any kind of burial, let alone a proper pontifical one. "I'm just a poor widow," whimpered Donna Olimpia, in offering her excuses for not paying for Innocent's funeral. She no doubt savored this final act of revenge upon the man whom she once loved but who had later publicly humiliated her in barring her from the Palazzo Apostolico in 1650.

Finally two of Innocent's former majordomos, Monsignor Scotti and Monsignor Segni, were moved by pity to pay the costs of a cheap coffin and an unceremonial interment, and so Innocent's rotting corpse was eventually laid to rest in an unmarked grave in the crypt of St. Peter's. With the pope finally buried, on January 18, 1655, the conclave to choose his successor began. Once again, all Rome waited with the usual mixture of dread and hope. Maybe finally they'll elect *un papa buono*, a good, holy, virtuous, and truly lovable pope. As for Bernini, this was the fourth time in his adulthood that he had to go through this period of grueling nervous expectation. How long would it last? Would the result be favorable or hostile?

You already know who, on April 7, 1655, after four long months of secret negotiations, intrigue, and pragmatic compromise, emerged onto the Loggia della Benedizione of St. Peter's to give his first blessing to the assembled masses as the new pope: Cardinal Fabio Chigi. Chigi was the son of a distinguished but no longer affluent Sienese family—his illustrious sixteenth-century ancestor, Agostino Chigi, had been personal banker to Michelangelo's pope, Julius II. Making a career within the papal diplomatic corps, Fabio Chigi had admirably served a variety of functions before obediently accepting the hardship assignment as nuncio at the calamitous peace negotiations in Westphalia, where we last left him. Chigi had been recalled from Westphalia by Innocent to serve as his secretary of state upon the death of Cardinal Panciroli. He arrived back in Rome in late November 1651, after what was, essentially, a twenty-eight-year absence spent in Ferrara, Malta, and finally Germany. Several weeks after his return to the papal curia, he was promoted to the cardinalate, as expected. Domenico Bernini claims that his father just happened to be in the Palazzo Apostolico the very day when Chigi made his first visit there after his return from Germany, and that it was once again a case of love at first sight, or rather, at the first new sight, since they had met each other decades before.

In his enhanced status of papal secretary of state, Chigi had every reason to imagine greater things for himself: a cardinal's hat (which indeed came quickly), and who knows—perhaps even the throne of Saint Peter. In view

of those great expectations, he needed to attend to his family's public image through the usual means of grandiose spending on artistic-architectural projects involving the family's property or soon-to-be-property. As a first step, he employed Bernini to renovate and embellish the family chapel in Santa Maria del Popolo. In undertaking the task, Bernini was adding to and completing the work of his illustrious predecessor, the great Raphael. He must have had at least a moment of nervous tremor at the thought. Once assuming the papal throne, Chigi would afford Bernini many other moments of nervous tremor by placing upon the artist's shoulders vastly more ambitious and more challenging commissions. And in the process, the dream team of Bernini and Alexander would permanently change the face of Rome in drastically "magnificent" ways.[12]

BERNINI AND ALEXANDER

CHAPTER 4

THE DREAM TEAM: POPE AND ARCHITECT

"Now here, indeed, does a new order of achievement present itself, in the form of works, all splendid in their magnificence and arduous in their execution, which the Cavalier Bernini so felicitously completed during the twelve years of this pontificate." With this grand announcement of the coming of a "new order" in Rome—one could almost hear a Baroque trumpet fanfare in the background—Domenico opens the Chigi chapter of Bernini's life, covering the years 1655–67. It is hard to find fault with the artist's son for doing so. The lofty language of Domenico's solemn proclamation is borrowed (as some in his original audience would have recognized) from Torquato Tasso's popular epic poem, *Jerusalem Delivered* and is in this case entirely justified. With the "dream team" of Bernini and Alexander at work—and at play—in the streets, churches, and public squares of Rome, the city, already a dazzling "theater" of marvels and

delights, received a further spectacular dose of Baroque urban renewal and embellishment unmatched by any other pontificate.

It was also to be the final dose. By the end of the Chigi years, with the exhaustion of the papal treasury and a decided shift in papal priorities, large-scale projects became few and far between. By 1667 Baroque Rome basically assumed the face that we now know and love, in possession of nearly all its most prominent visual features, certainly those most popular with tourists today. Missing were only the Trevi Fountain and the Spanish Steps, both eighteenth-century additions but nonetheless Baroque in inspiration. The creation of *Roma alessandrina,* the Rome of Pope Alexander, was, to be sure, not the work of Bernini alone—many other accomplished men of talent like Pietro da Cortona and Carlo Rainaldi played important roles as well. But to Bernini fell responsibility for the lion's share. His were surely among the most conspicuous contributions: the Colonnade of St. Peter's Square and, within the basilica, the Cathedra Petri, "Chair of Saint Peter," to mention just two of Bernini's exhilarating monumental additions to the city's wonders during the artistically industrious Chigi years.

The scope of Alexander and Bernini's endeavors reached even beyond Rome—most notably, to the papal hometown of Siena (namely, the Chigi Chapel and new cupola lantern of the cathedral) and the papal summer retreat of Castelgandolfo (renovations to the residence and construction of the new Church of San Tommaso di Villanova), the Chigi fiefdom of Ariccia in the Alban hills (the three churches of the Assunta, San Nicola, and the Madonna di Galloro), and the Roman port of Civitavecchia (its elegant shipyard, the "Arsenale"). For Bernini, there were also numerous other nonpapal commissions, both large (the Church of Sant'Andrea al Quirinale for the Jesuits; the new Louvre for King Louis XIV) and "small" (an allegorical mirror for Queen Christina of Sweden; a memorial statue of Philip IV of Spain for Santa Maria Maggiore; the Fonseca Chapel in San Lorenzo in Lucina for the family of Pope Innocent X's personal physician; the De Sylva Chapel in Sant'Isidoro for Bernini's Portuguese neighbors from Via della Mercede; the sundry fountain work at the Villa d'Este; renovations to the Roman hospital of Santo Spirito in Sassia and the sacristy of its church; and ornamentation of the famous Torre del Mangia clock in Siena's city hall building in Piazza del Campo).

As even the most sober, unenthusiastic observer of Bernini's life in this twelve-year period is obliged to admit, the number of the artist's projects

and the quality of his achievements are simply astounding. And all this in a man in his late fifties and early sixties of life, that is, at the onset of "old age," as then generally reckoned. In premodern Europe, you were lucky if you survived childhood; you were even luckier if you made it to age fifty with your body and mind in good working order, as did Bernini. Bernini simply defied all the average life-expectancy odds. At age fifty-nine, he also fathered what was to be his last child, Domenico his future biographer, born in August 1657. Even afterward however, we can be sure, Bernini continued his attempts at fatherhood, since Caterina his wife (born in 1617) still had a couple of childbearing years left. By the end of his life in 1680, Bernini entered that smallest and most exclusive of categories of premodern demographic achievement, those who survived fully active, mentally and physically, into the ninth decade of life.[1]

As for Pope Alexander (fig. 22), born in 1599, he was just one year younger than Bernini, which, again, places him among the senior citizens in the general population. However, with respect to his immediate ecclesiastical peer group, the Supreme Roman Pontiffs, he was a "youngster." As befits an ultraconservative institution ever anxious that only certifiably "good, safe company men" be placed in charge, the papacy was and has largely been the realm of old men. Alexander owed his election not to his age or his piety or his experience in the Roman curia—he had been mostly absent from the city for the previous twenty-odd years—but to his status as a relatively innocuous "outsider" whose politics had given no grave offense to anyone. His successful candidacy had been a pragmatic compromise, decided out of sheer frustration and gridlock among the varying contesting factions—the Spanish, the French, and, now, the newly organized reformist group of cardinals, the *Squadrone volante*, "the flying squadron," as they called themselves, determined to break the influence of the secular political powers (especially Spain and France) in papal elections.

Though he was elected with lukewarm support on the part of most within the conclave, news of Fabio Chigi's elevation to the papacy was met with enthusiasm on the part of the world outside the curia and outside Rome. Chigi did have a well-deserved reputation for, if not holiness, then at least sincere piety, a greater degree of personal integrity than was usual for the ranks of career ecclesiastics, and a generally affable personality. The latter feature was a much-welcome change after the many irascible years of Urban VIII and Innocent X. Despite his youth, however, Alexander was

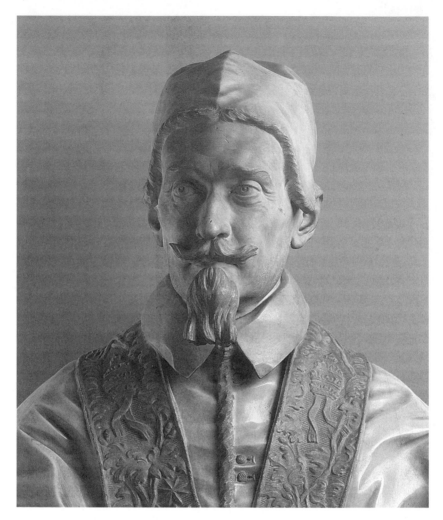

FIG. 22 ➻ G. L. Bernini, *Pope Alexander VII*, 1657. Private Collection. Photo by Arrigo Coppitz; courtesy of the J. Paul Getty Museum.

not expected to reign for long. From his earliest years, he had suffered from poor health, made all the poorer in the years serving as papal diplomat in the dreary, inclement climate of Westphalia. His greatest chronic health challenge was gallstones, for which he had endured while in Germany the unspeakable torture of surgery without anesthesia. In Germany he also lost all his teeth, which forced him to eat only mashed food. The lack of teeth must have made his speech somewhat ridiculous in its effect, especially

when attempting formal public oratory. (Fortunately, his moustache and goatee hid most of the visible signs of his resultant sucked-in lips.) After Alexander's reputation soured a few short years into his reign—thanks to his nepotism and building mania—the pasquinades would satirize the pope's *mal di pietra*, his "stone sickness." This was a play on words referring both to his gallstone ailment and his vastly expensive urban renewal program. To the same effect, again after his honeymoon with the public was over, Alexander would be satirized as "un papa di grande edificazione," "a pope of great edification," a witty reference to both his supposedly inspiring moral example and that same ambitious but costly building campaign of his.

Alexander himself was ever mindful of the precarious state of his health. As a constant visual reminder of that reality and of the perennially fleeting nature of all earthly things, his first commission to Bernini, just a few days after his election, was for a lead coffin and a marble skull. He was to keep these two gruesome *memento mori* ("remember you shall die") icons always within sight in his bedroom. Alexander, apparently, also kept in his personal quarters a miniature wooden model of the city of Rome. The latter is a fascinating item about which we would love to know more—how detailed was it? How exactly did the pope use it? Were the pieces movable as on a chess board? Unfortunately, the model is mentioned only in passing, and with no reference to Bernini, in a single source, the diary of Ferdinando Raggi, Genoese agent in Rome, to wit: "The Pope has all of Rome, in wood, in his room, a most singular and unusual thing, as if he had no greater concern than to beautify the city." As for the coffin, Alexander intended to be buried in it. But he also would need a tomb, so early in his pontificate—the papal diary first mentions the subject on August 9, 1656—he set Bernini to work on his properly elaborate funeral monument. However, Bernini's delightfully macabre tomb, so in keeping with Alexander's own sensibilities, was not to be unveiled until more than twenty years later, in 1678, by which time the pope had been dead for eleven years.

Alexander's first commission to Bernini, the just-described order for two small, simple objects (skull and coffin), is worthy of note for what it tells us about the daily practicalities of the working relationship between the pope and his architect throughout the Chigi pontificate. Contrary to what is often said or implied, it is unlikely that Bernini designed, much less made, these two artistically mundane items himself, nor would the

pope have expected him to. Throughout this pontificate, Bernini served Alexander not only as chief architect in charge of monumentally exalted commissions, but also as a general contractor who arranged for the execution of a host of small, humbler tasks for the pontiff, such as the making of lamps or the transportation of statuary. These jobs would then be carried out by members of the Bernini workshop, with some slight oversight on the master's part at strategic phases in the design or execution process. Bernini was no carpenter or metalworker and would not have built a coffin. As for the marble skull, this was a completely standard item of ornamental sculpture within the Roman Baroque artistic repertory—skeletons are everywhere in that art—that would have required no intervention on the part of the master himself. In Pope Alexander's private diary—his meticulous but telegraphically terse daily log (without editorial commentary, unfortunately) of agenda items, visitors, the latest news, and so forth—we find many references to minute tasks assigned to Bernini, even in the midst of the long-term, massive projects of the Colonnade, the Scala Regia (Royal Staircase), and the Chair of Saint Peter.

In delivering these two *memento mori* items to the pope, little did Bernini know that, shortly thereafter, their gloomy philosophical message was to soon and once again become frightfully relevant to his own personal life. In September 1655, six months into the new Chigi pontificate, Bernini was stricken with a severe case of malaria that gripped him for many long months. The first *avviso* reporting his illness (dated September 22, from the Roman agent of the Duke of Modena) calls it ominously *febbri terzane doppie*, double tertian fevers. In late April of the following year, 1656, Bernini, still fighting the infection, even took the extreme step of making one of his rare departures from Rome in search of a cure: he went to the seaside locality of Palo, just south of Ladispoli on the Lazio coast, presumably at the invitation of his friend, Duke Paolo Giordano II Orsini, since Palo was then a fiefdom of the ancient Orsini family who maintained a splendid castle residence there. The journey, however, was in vain. Bernini returned home still very much sick. And coincidentally, Prince Paolo Giordano himself died a short time later toward the end of May.

Once again, nonetheless, as in 1635 (if Domenico's chronology is to be trusted), Bernini's illness provided the occasion for a special display of deep concern and affectionate esteem from the highest echelons, as an anonymous news bulletin publicized: "His Holiness, who loves the Cava-

liere very much, sends to his home each day a personal representative . . .
to bring him presents in his name and to visit with him on his behalf."
So grave was Bernini's illness that at one point in October 1655, the art-
ist thought it best to draw up his last will and testament. This document,
so highly personal and potentially greatly revealing, is unfortunately now
lost, withdrawn by Bernini from the public notary's files in February 1656
for reasons unknown. It was eventually replaced by one (still surviving)
finalized in November 1680 at the end of his life.

This long convalescence would explain in part why in Alexander's di-
ary Bernini's name makes only one appearance during the entire first ten
months of the new pontificate—on November 9, 1655, there is mention
of his recommendation of a job seeker from Rieti, probably a personal
acquaintance of the artist's three nieces, who were cloistered nuns in that
town. There are other reasons for the absence of Bernini's name in Alex-
ander's diary in the early part of his reign. The friendship and working
relationship between the eventual "dream team" of pope and architect took
time to warm up. As cardinal in 1652, Fabio Chigi had already called upon
Bernini to renovate the family chapel in Santa Maria del Popolo, but the
two men would not yet have had much time to develop a real working or
social relationship. Even once fully warmed up, this relationship was, artis-
tically speaking, never monogamous. The pope routinely bestowed his pa-
tronage favors, even for large, conspicuous projects, upon other artists—as
in the eminent case of the renovated facade and piazza of Santa Maria della
Pace superbly executed by Bernini's rival Pietro da Cortona. Alexander,
of course, knew of the rivalry. That's why, for instance, on August 19,
1656, he inserted this cautionary reminder in his diary: "Make sure Pietro's
designs are not seen by Bernini, and vice versa." This nonexclusivity may
have been due to political caution on Alexander's part—he might have re-
membered the severe criticism that had been heaped upon Urban VIII for
placing so much responsibility and so many privileges in the hands of one
architect alone, Bernini. Or it could be that there were simply too many
projects to get done in a short period and that no one artist could do them
all, not even the titanic Bernini with his enormous workshop.

Finally, the pope himself did not begin his reign with his urban renewal
program already fully formed in his mind, much less "shovel ready,"
and therefore had no immediate need of Bernini. Not only were shovel-
ready ideas lacking, but more important, money was too. To his horror,

Alexander began his pontificate with the discovery that the papal treasury was in debt for a breathtaking 48 million scudi. It was to grow to a positively staggering 52 million at his death. Alexander eventually found ways to get around the nuisance of the debt, namely, by twisting the arms of pious Catholics to purchase more indulgences (more than a century after Martin Luther's protests, popes were still selling indulgences) and by lowering the interest rates given to holders of papal bonds by 0.5 percent to 3 percent. Nonetheless, his dreams and desires for the city were still to take a couple of years before they matured and coalesced into a more or less coherent overall urban plan.

Of course, the official biographers, Domenico and Baldinucci, would like us to believe that Bernini was granted a virtual monopoly over the grand papal schemes, from day one, especially since he had been granted the title of *Architetto della Camera apostolica*, architect of the Apostolic Chamber, that is, the pope's personal architect. For Domenico in particular, the Chigi pontificate is, more or less, a repeat of the glorious Barberini chapter of Bernini's life. To signal that fact, Domenico makes a claim about the commencement of the Chigi pontificate similar to that of the newly elected Urban VIII, that of an immediate summons from the pope who supposedly told Bernini that he wanted to hit the ground running, with Bernini at his side:

> The sun had not yet set on that propitious day on which the election of the new pontiff took place when the Cavaliere was summoned by Alexander and received with great displays of esteem and affection that were in conformity with both his new status as pope and old friendship with Bernini. . . . [F]rom the very beginning of his pontificate, Alexander, seeing that he had at his disposal a man of such rare genius, shared with Bernini those lofty ideas he had been nurturing in his mind for the adornment and glory of the temple of St. Peter's, of Rome, and of the State.

A grand expression of privileged intimacy, indeed. But, alas, not quite true, not in this case, nor in that of Urban VIII about whom Domenico makes the same claim. It is highly improbable that on that extremely busy first day of his pontificate, the pope (any pope) would ever have had time to meet with Bernini or any other artist, who would have been simply outranked by the hordes of secular and ecclesiastical dignitaries clamoring for

the new pontiff's attention. When they finally did meet, as for the content of their conversation, Alexander is most likely to have shared those very same ideas, as well, with the other architectural *virtuosi* of Rome, like Cortona and Carlo Rainaldi, upon whom he necessarily relied for transforming them into reality. And before Bernini got around to executing "those lofty ideas" of the pope, he had to attend to more mundane matters. After the initial reference to Bernini and the Rieti job-seeker in the papal diary, the next three entries all concern just simple repairs to be made by Bernini to the water supply in Piazza Navona and Piazza Colonna.[2]

On January 22, 1656, however, we begin to encounter Bernini's name in the papal diary on a regular basis—in fact, literally scores of times. (On one occasion the diary even notes that an ill-stored supply of tuna fish had given the Bernini family a case of food poisoning.) As of August 9, 1656, we begin to witness in the diary the stage-by-stage conception, maturation, and slow execution of those great projects of the new *Roma alessandrina*, all universally acknowledged milestones in the history of Western architecture, that were to keep Bernini and Alexander occupied for many intense years. The first to make its appearance in Alexander's diary—and commanding more attention there than any other project of his pontificate—is one that the diary and other documentation of the age simply call *il portico* or, in the plural, *i portici*. The "portico" project refers, of course, to the creation in front of St. Peter's church and for the first time, a true, spacious, dignified, and serviceable piazza as required by and worthy of the enormous basilica. (Today, the "portico" of St. Peter's more properly refers, instead, to its atrium, the covered entrance through which one enters the church and whose decorative pavement was also designed by Bernini.)

After a series of fits and starts, Bernini's ultimate design for the vast space turned out to be an immense oval piazza, based upon complex geometric calculations, with its expansive embrace of the surrounding Colonnade in the simple but majestic Doric order. Bernini was given the official commission on July 31, 1656. The contract stipulated that, in addition to his usual sum (200 scudi per year) due him as official architect of the Fabbrica, Bernini would be paid 60 scudi per month for a maximum of five years, the amount of time then estimated for the project's completion. In the event, it was not fully finished until eleven years later (May 1667), extending into the beginning of the next pontificate. Nonetheless, Bernini was not paid beyond the five-year limit. Everyone involved in the project should have

known better, as far as timing was concerned: a bewildering host of logisti-
cal and aesthetic obstacles had to be overcome in the process, all of them
brilliantly resolved by Bernini and his team. As usual, his younger brother,
Luigi, an engineering genius, was essential to Bernini's success.

Today, walking across the exhilarating expanse of St. Peter's Square, we
might be moved to congratulate Pope Alexander for having the bold deter-
mination and grand vision of creating and financing the project. Gratitude,
however, was not how the Roman population felt at the time. The massive
building and embellishment projects undertaken by the popes since the re-
birth of the city in the fifteenth century had always provoked protest for
their enormous costs. This was especially the case since, except for the repair
of the aqueduct system (and the elimination of a long open sewer running
through the center of town), these projects by and large did nothing to alle-
viate the plight of the mass of the population. Chronically poor and under-
nourished, most Romans lived in inadequate, expensive housing in a densely
packed city center that lacked paved streets, proper sewage, trash disposal,
and protection from the all-too-frequent flooding of the Tiber River. Pop-
ular protest, as we heard, was strident during the famine years of Innocent
X's pontificate coinciding with the construction of Bernini's Fountain of
the Four Rivers and other self-aggrandizing Pamphilj family projects. But
this time, in the 1660s, the situation was even more dramatically troubling.
The times were even more calamitous, financially speaking, and the pope
was about to undertake a project larger than any other in recent history,
one that, as anyone could easily see, would consume enormous amounts of
capital. In the end, as a recent, meticulous accounting concludes, the new
St. Peter's Square cost, conservatively speaking, about one million scudi.
This sum equaled "nearly half of the annual revenue of the Church in this
period." Thus, when word of the new Colonnade project spread around
Rome, the reaction was more incandescently outraged than anticipated.

The surest indication that protest against the Colonnade project was
severe is the uncharacteristically self-defensive tone of the earliest papal
documentation relating to plans for the piazza. This is true from the very
first official announcement of the project issued by the Reverenda Fabbrica
di San Pietro (the "Commission of the works" overseeing all construction
relating to the basilica). In that announcement the reason given for under-
taking the project is not, as customary for past papal projects, the greater
glory of God and of the Roman church or the urgent, utilitarian necessity

of ecclesiastical ceremony. Instead, simply and surprisingly, the sole reason given is "in order to assist the poor and other indigent residents of the city." This, the document adds, represents a direct, admirable manifestation of the profound *pietas*, sense of sacred duty, of the Supreme Pontiff himself toward his suffering flock. The poor relief, it was here understood and elsewhere specified, was to be in the form of job creation. In the end, as has been calculated from the scrupulously kept records of the Fabbrica, for the time period involved, the average number of workers employed by the Fabbrica went from its normal thirty to about one-hundred fifty. But this can hardly be called a massive amount of new job creation. It was certainly not proportionate to the massive amount of money spent on the new piazza. Significantly, objection to the Colonnade project came from one of the most senior and outspoken members of the Fabbrica itself, Cardinal Giovanni Battista Pallotta (the same fearless, tells-it-as-he-sees-it Pallotta who dared call Donna Olimpia a "whore" publicly and to her face). Expressing a widespread view, Pallotta pointed out in a formal memorandum, "It does not seem proper to build the structure that is now being proposed, a thing of pomp and ornamentation, in these times of great calamity and hardship. It could give foreigners [read: the Protestants] reason to slander us over the fact that instead of meeting the valid needs of our population, one hears of the expenditure of so much money and the appropriation of so much sacred land, for the sake of mere ornament and a structure that is not necessary."

Even more significant is the fact that Bernini himself, who in his exalted professional and social status usually considered himself above such fray, felt obliged for the first time to publicly respond to the protest. He did so formally and in writing, if not in the first person. His long, self-defense response was drawn up by his eldest son, Monsignor Pietro Filippo (with corrections by Cardinal Sforza Pallavicino), and covers all categories of objection raised against the Colonnade project. But tellingly it begins with the issue of the project as a form of poor relief on the part of a compassionate pontiff. Bernini's apologia opens with a full volley of Baroque rhetoric, rising to the very spheres of heaven, like the ceiling or cupola of so many a Roman church:

> In view of his merit, Cardinal Fabio Chigi seemed destined above all others to occupy the throne of Peter when indeed in the year 1655 the unceasing

prayers of the Church and the acclamation of the people gave birth to an Alexander [a reference to Alexander the Great, as is made explicit later in the text]. From the heights of his office this most pious prince did not lose sight of the children who lay subject to his greatness. Nor did he allow himself to be beguiled by that majesty, which, being so close to heaven and the angels, lifts him far away from earth and from humankind. Instead, with his merciful glance, he both saw and contemplated their widespread miseries and prepared himself to bring them succor. He was mindful of the fact of how, as Fabio Chigi, he had edified others through his example; he now, as Alexander, had to bring warmth to them through his actions, for he is a Prince and therefore is like the sun that with its rays not only illuminates but also warms.

[After describing Alexander's initial distribution of "vast quantities of gold" in direct almsgiving to the poor, he continues:] Carried away by the full inspiration of charity, our most generous Prince well realized that to simply open up for the common good the treasuries of the Church was to in fact instill sloth and to encourage vice. . . . He therefore repressed that flame of charity, not to extinguish it, but in order to disseminate it more widely for the good of his subjects. He thus decided to undertake the building of this great structure.

This same memorandum ends with the famous and much-quoted passage in which Bernini describes the *concetto*, the symbolic poetic idea behind the oval shape of the expansive Colonnade. Its circular form, Bernini (through the pen of his son Pietro Filippo) explains, is beautiful inasmuch as it is geometrically perfect in itself and most pleasing to the eye. But more than that, the shape is here most appropriate, "for, since the Church of St. Peter is, as it were, the mother of all others, it must have a portico that indeed expresses the fact that she, with maternally open arms, receives Catholics to confirm them in their faith, heretics to reunite them with the church, and infidels to illuminate them into the true faith."[3]

Together with the pope, the entire committee of the Fabbrica of St. Peter's was theoretically involved in the business of the design and construction of the Colonnade. In reality, only a few members actively participated in the day-to-day technicalities of the process, interacting, dialoguing, and debating with the official architect, Bernini. Unhappily for Bernini, among

the latter was his old nemesis, Father Virgilio Spada, papal architectural advisor. We last encountered Spada at the time of the traumatizing (to Bernini, that is) demolition of the two bell towers of St. Peter's in 1646–47. Bernini had put the blame on Spada for that last-minute, inexplicably extreme decision on the part of Pope Innocent X. Ten years later, he was evidently still seething in resentment over the fact when the new Colonnade project was initiated. This we deduce from Spada's already-mentioned letter of 1658, *Sopra doglianʒe fatte dal Cavalier Bernino* (Regarding complaints made by the Cavalier Bernini), formally responding to grievances raised against him by Bernini to an unnamed third party. That in the new Chigi pontificate the much-resented Spada continued to serve on the Fabbrica, and in general maintained all his considerable behind-the-scenes power as papal confidante, is further reminder that Bernini did not hold dominant artistic sway over Pope Alexander VII. For his part, Bernini would have wanted Spada banished from the papal court. Instead, in the papal diary, Spada appears with more frequency than Bernini, as the pope consulted with him nearly weekly on matters of financial and organizational administration, a pattern ending only with Spada's death in 1662.

As was inevitable, the two clashed. Spada had the audacity to raise what were to Bernini obnoxious objections to the architect's proposed design. The objections may have been entirely courteous and well reasoned in their presentation, but Bernini did not take them graciously. He never took criticism graciously from anyone he considered inferior in talent to him—in other words, almost everyone in the world. But even more so in the case of Spada, an old, certified enemy and protector of Bernini's rival, Borromini. Bernini at some point in 1658 exploded, pouring out his anger at Spada to an anonymous mutual acquaintance. That individual relayed Bernini's laments to Spada who, taken by complete surprise, at first thought, as he says, that it was all a joke. However, upon reflection, probably knowing and fearing the effects of Bernini's paranoia, Spada felt moved to write a detailed rebuttal, namely the letter *Sopra doglianʒe fatte dal Cavalier Bernino*. We cannot know the truth about Spada's feelings toward Bernini and his actions for or against our artist, but the fact that he took the trouble to respond—in an entirely serene, gracious, dispassionate fashion—and attempt to calm the waters between him and Bernini would appear to speak well of the man. As Spada points out in his letter, true, he had found fault with some of Bernini's work, including the preliminary Colonnade design,

but "from the fact that I had taken the liberty of criticizing certain works of his, it seems to me that one can conclude that the praise I gave to the rest was not out of false adulation." Spada comes out sounding like an entirely reasonable man.

Time and space do not allow us to go into the further details of Spada's rebuttal of Bernini's charges against him, but one cannot help but be curious about a final point Spada raises at the end of his letter. He mentions having found "great and patent" irregularities in the financial accounts of the Fabbrica, irregularities for which Bernini, as *architetto di San Pietro* and director of the Colonnade project, had ultimate responsibility. We know from other sources that Spada raised these concerns on several other occasions, directly implicating Bernini. But we know of no official investigation of Bernini on this front, and to date no documentation has surfaced proving the artist guilty of any financial wrongdoing in his role as architect of St. Peter's— or any other role for that matter. Nonetheless, the charge stayed with Bernini till the end of his life: a Roman *avviso* dated November 30, 1680, that is, just two days after his death, claims that the final bequests made by Bernini to the pope and various cardinals were "fatti politicamente," done for political motives. What motives? To purchase their silence should an auditing of his books find criminal discrepancies, the *avviso* goes on to claim.

An earlier anonymous news bulletin (*avviso*) of May 25, 1680 (therefore, while Bernini was alive and healthy), had, in fact, announced this audit of the artist's bookkeeping as a reality already decided by Pope Innocent XI. This review was prompted, the *avviso* reports, by the discovery of a gross discrepancy of 800,000 scudi in the financial accounts relating to the Colonnade project. The papal treasury had allegedly been billed—it was Bernini's job to verify and confirm all billing—for 1,500,00 scudi, whereas only 700,000 in actual expenses could be verified. Again, in the end nothing damaging came of all this for Bernini's reputation or bank account. But the Spada letter and this May 1680 *avviso* remind us that even this form of hostile static—charges of financial corruption—surrounded Bernini in his vulnerable role as executive director of such massive, complicated, and costly public works. Even more disturbingly, they remind us that even though he was never convicted of fiscal wrongdoing, there was, nonetheless, something in Bernini's character and manner of conducting his business that would not allow people to believe that he was above suspicion in matters of cooking the books.

With so many building and embellishment projects going on, *Roma alessandrina*, the Rome of Alexander VII, was one big, open construction site. It was noisy, uncomfortable, and even dangerous. This made daily life extremely unpleasant, especially for most of its ordinary, nonpatrician residents, who spent a great deal of their daily existence outdoors and immersed in the crowded, stinking, cacophonous chaos of the city's streets and other public spaces. So complained an eyewitness to all this, Lorenzo Pizzati, an unemployed but quite intelligent courtier and observer of the Roman scene. In a long, meticulously detailed plea sent in writing to Pope Alexander, Lorenzo movingly describes the city's ills from the point of view of not the privileged elite but rather the great masses of people. At the same time, he makes many reasonable (and quite modern) suggestions for more enlightened urban planning.[4]

One of Lorenzo's commonsense suggestions is that the pope invest in improvements of immediate, practical, universal benefit like more rigorously and rationally organized garbage collection. I am sure the Roman populace would have cheered in unison for that proposal. Another was that no new building projects be undertaken until the old ones had been fully completed so as to eliminate the chaos and inconvenience of so many active construction sites. Above all, "what is most needed among all these churches, convents, monasteries, colleges [that is, residences for seminarians and lay students of the religious orders], hospitals, confraternities, palaces and squares . . . [is] modest housing at fair rental." One hears the very same complaint from Romans to this very day: the present writer once saw "Più case, meno chiese!" (More homes, fewer churches!) prominently scrawled in graffiti on the majestic column in front of Santa Maria Maggiore. If the pontiff ever received or read Lorenzo's letter, he paid no attention. He forged frenetically onward, as before, with his "magnificent" plans. Death was always too close behind, and Alexander had much more sublime accomplishments to achieve than state-of-the-art garbage collection. Yet Lorenzo spoke for a legion of his contemporaries, and one could well understand their disappointment and lingering resentment of the pope—and by extension of Bernini, who aided and abetted him—when their pleas went unheeded.[5]

Public resentment over Pope Alexander's architectural spending sprees was all the more aggravated by the lavish amounts of money he showered upon his cardinal nephew, as many a pope had done before him, in

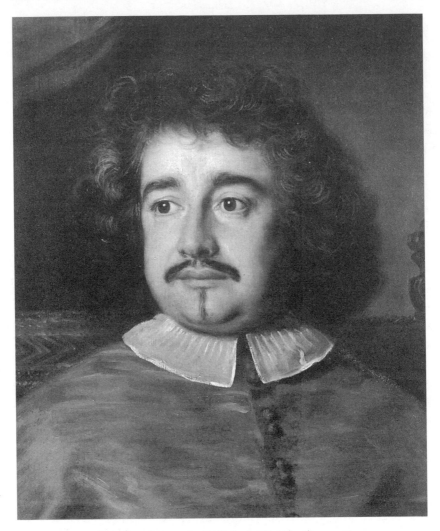

FIG. 23 ⟶ Jacob Ferdinand Voet, *Cardinal Flavio Chigi* (detail), ca. 1660, Ariccia, Palazzo Chigi, inv. 467.

traditional nepotistic fashion. The nephew in question was the notorious Flavio Chigi (fig. 23). Among the cardinal nephews of Baroque Rome Flavio ranks second only to Scipione Borghese for the scandalous conduct of his personal life, as was well known to the Roman population. It was the decadently self-indulgent lifestyle of Cardinal Flavio, financed by the papal treasury, that, for example, fueled the incandescent anger of Queen

Christina's letter against papal nepotism, sent to Cardinal Azzolino in September 1666:

> Is it not a shame and a disgrace to see millions from the treasures of the Church supporting the luxury and the licentious tastes of veritable nobodies who from time to time glut their appetites on the blood and sweat of the poor, who exhaust the Church and her state in order to nurture dogs, horses, pederasts, ruffians, and other types of scum?

In one of his diplomatic dispatches, Ferdinando Raggi, Roman agent of the republic of Genoa, reports that Alexander well knows that his nephew is "mightily afflicted by venereal compulsions," which is why the pontiff willingly finances Flavio's other, more harmless though still costly pleasures like hunting, hoping that they will distract him from the allurements of the flesh.

Despite all this popular resentment, Bernini's Colonnade project nonetheless got earnestly underway. But the ink had hardly dried on the papal orders for that one project, when Alexander started making the first moves on his next great project for Bernini, the "Chair of Saint Peter," in Latin, the Cathedra Petri. This project would kill two birds with one stone. One, it would provide a new, appropriately majestic setting for the wood-and-ivory relic then believed the actual throne of the first pope, Peter the Apostle. And, two, it would fill in with sumptuous embellishment the empty, dead space of the basilica's apse where the chair was to be transferred. Neither the pope nor the Fabbrica nor Bernini seemed to mind that respected scholars like Fioravante Martinelli had already raised significant doubts about the chair's authenticity, doubts now amply confirmed by modern scientific analysis that dates the throne to many centuries after Peter's death. Turning a deaf ear to such inconvenient truths, the pope, the Fabbrica, and the artist moved forward. No one, however, deluded himself into thinking that this would be a quick—or inexpensive—project. Ten years elapsed between the time the Fabbrica formally ordered (on March 3, 1656) the transfer of the relic from the baptismal chapel near the basilica's entrance to its visual apex, the apse, and the inauguration (on January 17, 1666) of Bernini's spectacular altar monument, which, like the Baldacchino, is in gilded bronze and of colossal dimensions.

The completion of this complex, technically arduous monument, which tried Bernini's patience to no end, must have been an especially gratifying moment for him. He had finally fulfilled the second portion of the solemn prophecy made in his boyhood by the legendary master Annibale Carracci: "Believe you me, there is to come one day some prodigious genius who, in the center of this basilica and at its far end, will create two great structures befitting the vastness of this temple." Those two structures turned out to be Bernini's Baldacchino and his Cathedra Petri. There is compelling evidence that already when executing his Baldacchino in the 1620s, Bernini had conceived the general contours of the design of the much later Cathedra Petri. In New York's Morgan Library there survives a large drawing, dated 1626–29, showing the full-scale wooden test model of the Baldacchino in place above the main altar. Behind the Baldacchino one clearly sees the outline of Bernini's early design for the Cathedra, with the chair held aloft by the church Fathers against a sunburst *gloria* of Paradise. If the evidence of this drawing is to be trusted, one can only conclude that already during the reign of Urban VIII, Bernini (and the pope) had begun to think about placing the chair-relic in the apse and to conceive of its setting essentially as it was to later come to fruition under Alexander VII. But it may be that Bernini had been thinking of that apse since even earlier, that is, ever since he had first heard Annibale's prophecy in his boyhood.

By 1666, the year in which the Cathedra Petri was inaugurated (though still lacking finishing touches), Bernini was at least three years into yet another colossal project. This was the Scala Regia, "the Royal Staircase," within the papal administrative and residential headquarters at the Vatican, called the Palazzo Apostolico. (The Palazzo Apostolico is the rather plain building—in truth, a complex of amalgamated edifices—immediately behind the right arm of the Colonnade, from which popes today usually address crowds in the piazza below.) Bernini's new project entailed the complete rebuilding and thorough embellishment of the ceremonially—and geographically—important staircase. Important because it leads distinguished papal guests from the principal ground-floor entrance of the palazzo, known as the *Portone di Bronzo* (the Bronze Portal) to the audience hall on the floor above, the *Sala Regia*, "Royal Hall." (At the staircase's base, facing the side entry to the atrium of St. Peter's, Bernini's colossal statue of the *Vision of Constantine*, would later be installed.) Strangely, there is no record of when this grand new project was either first discussed or officially

approved by the pope or the Fabbrica di San Pietro. Construction on the staircase began in April or May 1663 and so, Bernini's design, it is surmised, must have come to maturity in late 1662.

The old staircase was intricately enmeshed in the support structures of the very fabric of the Palazzo Apostolico, and the design of its replacement had to reconcile many physical constraints and ceremonial necessities. Of this incredibly challenging task Bernini would later remark that "this had been the most daring project he had ever undertaken; and that if, before working on the stairway, he had ever read a description by someone else of what it entailed, he would never have believed it." It was the architectural equivalent of open-heart surgery, performed on a feeble, aged patient. For once there is not the least bit of exaggeration in Bernini's or Domenico's description of the challenges, both technical and aesthetic, that our artist successfully overcame in this project. One of the big problems was the narrow and irregularly shaped space in which the staircase was inserted: the artist brilliantly overcame this in typical Baroque fashion, employing a series of clever architectural optical illusions. Again, in contemplating the superbly majestic and supremely functional final product, Bernini must have experienced a sweet feeling of satisfaction and vindication. After the disaster of the bell towers, he had proven his competence as an architect in masterful fashion and in the most trying of circumstances.[6]

For those who still might not be sufficiently impressed with the breathtaking scope of Bernini's activities within the eleven-year span of the Chigi pontificate, there is more to report. In addition to all the works already mentioned dating to these years, our artist was involved in a host of many other "smaller" projects. In the years 1655–67, he designed and carved two complete statues (*Daniel and the Lion, Habakkuk and the Angel*) for the Chigi Chapel in Santa Maria del Popolo, the historic and strategically important church adjacent to the northern gate to the city. Under Bernini's direction and design, moreover, the same church was completely overhauled inside and out under Alexander VII. Bernini also redesigned that same city gate, the Porta del Popolo, in time for the formal entrance of Queen Christina of Sweden, whose arrival in town in December 1655 kept him quite busy on other fronts, as we shall shortly see.

Alexander also wanted to give the rest of Piazza del Popolo a facelift. As part of the slowly coalescing redesign of the sprawling, aesthetically haphazard but ceremonially important piazza, Bernini was charged by the

pope with the initial task of investigating the ownership of the land on which eventually the two "twin" (or nearly twin) churches of Santa Maria di Montesanto and Santa Maria dei Miracoli were built. The design and construction history of the twin churches is protracted and complicated. Even though the official architects were Carlo Rainaldi and Carlo Fontana, Bernini still had some say in the design of at least one of those churches. This must have been, for Bernini, a bittersweet responsibility, since the project was using recycled materials from his demolished bell towers at St. Peter's, as Carlo Fontana points out in his *Tempio Vaticano*. In another part of town, Bernini also oversaw design and construction of the new wing of the Quirinal Palace, the drearily monotonous—especially after its subsequent lengthening—*Manica lunga* ("Long sleeve"). Within the same papal palace, Bernini was also given the task of constructing the stately Gallery of Alexander VII, a work whose connection to Bernini is not well known even among those overzealous Bernini enthusiasts who are quick to ascribe anything Baroque to the artist's hand. The gallery, by the way, is the third of Bernini's architectural projects—the Church of Santa Bibiana and the Palazzo Barberini are the other two—featuring frescoed decoration by his rival, Pietro da Cortona. Despite the chronic friction between them, the two men, while on the premises of the papal palace, were on their gentlemanly best behavior. After all, they were within earshot of the pope himself, who had chosen to live and work at the Quirinal and not the Vatican.

In this same year as the Quirinal gallery project, 1656, Bernini even found the time—and stamina—to accept a commission from Cardinal Antonio Barberini in Paris. The commission was for a full-sized statue of the Virgin and Child for the Carmelite Church of St. Joseph in Paris on the Rue de Vaugirard, where it remains today. Of this graceful and tender seated group of mother and child, Bernini did the complete design and *bozzetto*, that is, the detailed, three-dimensional model, subsequently used by sculptor Antonio Raggi to carve the finished product. Also in 1656, for the overseers of the Cathedral of Milan who were deciding the design of its facade, Bernini provided a professional opinion paper, his second on the same topic (the first dates to 1652). For patrons even farther north, Bernini offered professional consultation for the design of the country residence of the House of Savoy at Mirafiori, thirteen miles southwest of Turin. Back in Rome at the Vatican Palace, in addition to executing many papal portraits in various media (marble, bronze, oil on canvas), Bernini supplied designs

for various commemorative papal medals, crucifixes, and candlesticks for St. Peter's. More noteworthy, he was responsible for modifications to the ceremonial reception space, the Sala Ducale (Ducal Hall) providing a cleverly embellished connection with the adjacent Sala Regia (Royal Hall). The foregoing inventory is far from complete. We must add Bernini's various "ephemeral" works, that is to say, those temporary floats, arches, and decorative backdrops in stucco, linen, and wood, built to commemorate important milestones (births, marriages, deaths, canonizations, etc.) in the lives of royalty, popes, and saints. Furthermore, in the midst of all these endeavors came major interruptions, as we shall soon see, in the form of the arrival of that whirlwind from the North, the newly converted Christina of Sweden, a bubonic plague epidemic, and (as is described in the next chapter) a long-term diplomatic crisis involving the pope and King Louis XIV of France, into which poor Bernini was dragged as helpless pawn.[7]

Fortunately for the pope and Bernini's other patrons, one of the undisputed talents of our artist was multitasking on the grandest of scales. Bernini and his huge workshop successfully tackled all these overlapping projects, large and small, without calamity or irreversible setback on any front, despite the enormous material and aesthetic challenges and the customary amount of interpersonal conflict. There were no more repeats of the bell tower affair, that is, no more humiliating failures—at least not in Rome (Bernini's Louvre design and equestrian statue of Louis XIV, as we shall see in the next chapter, were well-publicized failures, at least in the eyes of their patron, the French king). Bernini's incredible store of mental and physical energy made this possible. But crucial as well were his managerial skills, which allowed him to organize and control a massive, extraordinarily busy and potentially unwieldy workshop. Those skills, one might note, came only from sheer instinct and trial-and-error experience, for there were no MBA programs to be had and no specialized apprenticeships in the domain of workshop management. And we can be sure that within his workshop he exercised his authority with the "princely" governing style and spirit of the day, that is, dictatorial and absolute. "The patient man is worth more than the strong," says the Book of Proverbs (16:32), and Bernini also had that virtue in abundance, for abundant were the opportunities in his life for the testing and honing of his patience and perseverance.

Above all, Bernini accomplished all that he did because of sheer optimism. Optimism is not a quality usually associated with Bernini. We never

see him smiling in any of the numerous self-portraits or the portraits of him executed by others over the course of his lifetime, with the sole exception of the one painted in 1622 by Ottavio Leoni. Quite the contrary: Bernini usually appears in his portraits as brooding, worried, uncertain, if not insecure. Bernini's optimism was not the serene, sunny, cheerful outlook on life that we usually associate with the term. His temperament may have been fiery, but it was not "sunny." He did not view life or his fellow humans through anything even remotely approaching rose-colored glasses—we need not look beyond the plot summaries of his many biting satirical comedies to be convinced of that. Rather, his optimism consisted in a fervent, deep-seated belief that God was "on his side," that his ultimate patron, his real sponsor and the effective guarantor of his success, was God. Hence he could do all. That this was Bernini's pious belief is implicit in Domenico's biography with its various references to the quiet working of Divine Providence on Bernini's behalf from his earliest days. It is explicit in Bernini's own utterances as recorded in Chantelou's diary on more than one occasion:

> The Cavaliere replied that God was the author of his success. . . . God had come to his deliverance. . . . Bernini had been astonished how well he had succeeded [in sculpting the Louis XIV bust]. I [Chantelou] replied that it was the great care that he took with his work. He said that was true, but there must be something else as well, meaning the grace of God, to which he ascribes everything.

This conviction of God's continual assistance fueled and fired up Bernini, allowing him to persevere on those many occasions when hostile voices, interior and exterior, were predicting disaster or counseling surrender in the face of seemingly insurmountable obstacles. In the last years of Bernini's life, however, the wheel of his fortune would seem to be making, slowly but surely, with one blow after another, a 180-degree turn against him. At that point the artist would have much reason to suspect that God had changed his mind, deciding that Bernini had had his share of grand victories. But that's the topic for our last chapter.

Back in the Chigi pontificate, there were still victories to be had. And one of the those victories came in the form of the friendship and protection of an extraordinary Scandinavian woman—extraordinarily talented, extraordinarily controversial, and, to her Roman ecclesiastical hosts, extraor-

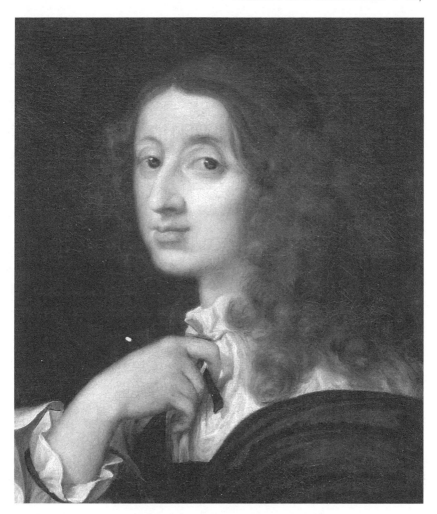

FIG. 24 ➻ Sebastien Bourdon, *Queen Christina of Sweden* (detail), ca. 1652, private collection. Photo: Erich Lessing/Art Resource, NY.

dinarily exasperating—Queen Christina of Sweden (fig. 24). Recently converted to Roman Catholicism from Lutheranism, Christina, the "Minerva of the North" and "Queen of the Amazons," had decided to make Rome her permanent residence. Once she arrived there in December 1655—it is no exaggeration to claim—the city was no longer the same. Nor was Bernini's life. Hardly rested from her long journey from Stockholm to Rome, one of the first *virtuosi* she summoned to her presence was Bernini. Already well apprised of Bernini's talent and accomplishments, the queen was eager

to honor him with public expressions of her esteem and to reward him with her unfaltering protection.

The nature and sincerity of Queen Christina's religious faith were and are often questioned, but there is no question that she worshipped devotedly at the altar of Art. And in her personal pantheon of great artists Bernini occupied a most prominent niche. Though the queen was strapped for cash most of the time and could commission no major works of art, her protection was, nonetheless, worth a great deal. In 1670–71, for example, that protection helped rescue Bernini and his family during a particularly dark hour of need in the aftermath of Luigi's sodomitic crime. Several years later, in order to help bolster Bernini's reputation, Christina willingly lent her royal name to an editorial hoax perpetrated by the artist's family. We will arrive at these episodes in due time in the last chapter of this book, but for the moment let us zoom in on December 20, 1655, the moment of Christina's first arrival in Rome. It is a Monday evening, two hours after sundown, and Pope Alexander is eagerly awaiting her in the Palazzo Apostolico at the Vatican.

"She's a Hermaphrodite, They Say"

One hopes that someone had warned His Holiness in advance. Warned him so that when the long-anticipated moment finally arrived, he would not be caught off guard and betray with some involuntary change of facial expression his true reaction to the person he was meeting for the first time in his life. The person in question was, of course, Queen Christina of Sweden. The long-awaited moment was the first face-to-face encounter between the newly converted monarch and the Roman pontiff, her new spiritual father. Pope Alexander had been personally involved in the planning of her long, sumptuously staged triumphal journey to Rome. "Pope Alexander has had no other thought in this period than that of honoring the Queen of Sweden," a Roman *avviso* pointed out. Alexander ended up spending the enormous sum of 100,000 scudi, several million dollars in today's currency, in order to give the queen a journey worthy of her status, not only as monarch (the terms of abdication preserved her royal title with some of its rights and privileges), but also as the papacy's trophy convert. After all, she was former ruler of a powerful Protestant nation, only child of Catholicism's great nemesis in the Thirty Years' War, King Gustavus

Adolphus, and signatory of the infernal Treaties of Westphalia, and she had come "to submit to Rome." It was, on paper, a great PR coup for the Roman Catholic Church. But it was one that had been and would continue to be exceedingly expensive until the queen, finally, much later in life (after Bernini's death), settled her finances. Furthermore, there must have been times when Alexander wondered whether the "prize" had been worth it. As PR icon, the unconventional, freethinking, impulsive, and psychologically unstable Christina was to prove of exceedingly ambivalent value, to say the least. She may have come to Rome, but she submitted to no authority and to no orthodoxy.

On the evening of December 20, 1655, as far as first visual impressions were concerned, what was there to especially warn the pope about? Again, as in the case of poor Pope Innocent X, it was her looks—not only her face, but also her entire misbegotten physical appearance. By most honest accounts, printed or painted, Christina was, to put it bluntly, ugly. Although it is impolite to refer to the issue, we are here obliged to do so because in Baroque Italy—again, a society defined by its cult of beauty, especially in the case of women—physical appearance counted for a great deal. True, Christina was not ugly in any plain, run-of-the-mill sort of way. As befitting her queenly stature, she was, instead, "magnificently, awe-inspiringly ugly" (to borrow Henry James's description of female novelist George Eliot). Her looks commanded attention. The lack of sweet, tender, even-featured charm was true of not only her face but the rest of her short, seemingly hunchbacked, inelegant body as well. And she did not help matters by dressing in a drab, disheveled manner, wearing an oversized man's wig, and covering her face with too much powder dusted over too much cream. Apparently none of the patrician Roman ladies had offered to assist her in a makeover. And even if they had, she, always the maverick, would have resolutely refused. But in the estimation of her contemporaries, even worse than all her fashion offenses was the fact that she looked, sounded, and moved about in her body not like a woman, but like a man. Or rather, like a disturbing physical mixture of both: "By many persons it was reported as a fact that she was a hermaphrodite, even if she professed to being a woman," testifies Roman diarist Gigli, and his testimony is amply confirmed by other eyewitnesses. Another reporter of the Roman scene who had gotten a close look at Christina summarizes his assessment of the queen's much-discussed person on the same note: "In short, in creating her, Nature had initially

sketched her out as a man, but then finished her off as a woman." Men in those days may have encouraged women to be "manly" in their virtue, but they wanted them to look reassuringly and unambiguously like women on the outside.

Yes, there was little of the truly feminine in Christina. And there was little of the truly majestic in her physical presence, except perhaps her lively, intelligent eyes, which took in the world with penetrating acuity. They were also "full of fire," as we are told by one observer who had gotten close enough to the queen to notice this feature. The same, as we heard, was true of Bernini's eyes. What energy there must have been when Christina's fiery glance met that of Bernini. Did they recognize the fire within each other? We are told that, making her way to her first papal audience on that evening of December 20, the queen immediately identified Bernini amid the dense crowd of spectators lining the corridors and antechambers of the papal palace, even though she had never see him before:

> As if already having imagined for herself his facial features, she pointed to him and promptly declared: "That is Bernini." Both Cardinal Giovanni Carlo de' Medici and Cardinal Friedrich, Landgrave of Hessen replied, "Yes, that is indeed he," whereupon the queen summoned Bernini to her presence. Satisfying for the moment her desire to communicate to him some expression of her esteem, she compelled him to pay her a visit that very same evening.

Once again, a good story, but probably not true. This "instant recognition" phenomenon was a stock theme of literature back then in which one illustrious personage instantly recognizes another of the same exalted stature whom he or she has never seen before in person simply on the basis of the unmistakable greatness exuding from his (or her) being. In any event, their first encounter marked the beginning, if not of a friendship in any real, psychologically authentic, reciprocally self-revealing way, then certainly of an affectionate, mutually profitable association that lasted until death. Affectionate, that is, at least on Christina's part. As usual we have no idea how, in the silence of his heart, Bernini truly felt about the queen. He certainly welcomed, valued, and did not hesitate to make use of her public support, but did he really trust or respect the unpredictable, capricious woman? At that stage in his life Bernini was completely conventional in his

piety, morality, and philosophy of life, especially with regard to women. The contrarian Christina was anything but that.[8]

Nonetheless, as we are told by Domenico, their "initial encounter, together with the high regard for the Cavaliere that had already occupied her royal mind, gave rise to a most special predilection on the queen's part for Bernini. For the remaining twenty-five years of his life, Bernini ranked among the very foremost in the queen's mind as far as the objects of her esteem were concerned, so much so that she was wont to say, 'Whoever does not esteem Bernini, is not worthy of esteem himself.'" In a 1679 letter to the Venetian diplomat Angelo Morosini, Christina expressed in equally strong terms her affectionate allegiance toward Bernini: "I have so much esteem for the person of the aforementioned Bernini that I embrace with joy all opportunities that present themselves for showing my favor to a man who has made himself the greatest and most illustrious of his profession of all time."

As formal, public recognition of that esteem, Christina, like Popes Urban and Alexander, even deigned to pay personal visits to the artist in his home studio, doing so on four separate occasions. On the occasion of her first visit (on February 20, 1656), she found Bernini still dressed in his coarse, dusty work clothes—a deliberate move on the artist's part. Instead of being insulted, Christina understood Bernini's true intent and was moved to touch Bernini's clothes as if they were some miraculous relic:

> Bernini, who was at that moment absorbed in his work, received her, dressed just as he was, wearing the clothes of his profession, even though he had had the time to change into something different. To those who had advised him to change his clothing, the artist replied that "he had no attire more appropriate with which to receive a queen wishing to visit an artist, than this coarse, rough garb, which was indeed proper to that talent that had elevated him to the status of artist in the estimation of the world." The sublime mind of that great lady was able to penetrate the significance of this gesture on Bernini's part and not only did her opinion of him consequently rise all the more, she, as a further demonstration of her esteem, actually touched the garment with her own hands.

Possessing a large art collection of her own (an indecent amount of which was, in reality, war booty, especially from poor Prague), Christina

was quite knowledgeable about art history and connoisseurship. This was a genuine talent for which Bernini praised her to Chantelou in Paris. In discussing, however, ancient Roman art with the queen, the astute Bernini, we can bet, must have refrained from any reference to the fact that one of the famed Borghese antiquities he had restored for Cardinal Scipione was that of the *Hermaphrodite*. Christina was not known for a self-deprecating sense of humor and was well aware, like Bernini, of the gossip about her ambiguous sexual apparatus. Another common ground between Bernini and Christina was their love for theater; that must have also been a frequent topic of their conversation. There is no record of Christina's having attended one of the comedies written and produced by the artist himself. However, in the late 1670s as a further sign of her protection of the Bernini family interests, she did favor Bernini's prelate son, Monsignor Pietro Filippo, an amateur playwright, with her presence at more than one of his own productions.

Not surprisingly, Bernini had been early on caught up in the frenetic preparations for the queen's arrival in Rome. To begin with, Alexander had him remodel and embellish Porta del Popolo, the northern city gate through which she was to formally enter Rome. (His original design was somewhat altered when the gate was widened in the late nineteenth century.) Bernini was also given the task of refurbishing the queen's temporary apartment at the Vatican in the so-called Torre dei Venti (Tower of the winds), originally built as an astronomical observatory. As part of the refurbishment, Bernini made sure that the inscription below the fresco depicting the north wind was whitewashed over: "Ab Aquilone pandetur omne malum" ("All manner of evil is disseminated by the north wind"). That warning was explicitly intended as a reference to Protestant Northern Europe, from which Christina had just descended. Allowing the queen to reside in the strictly homosocial world of the papal complex, by the way, represented an enormous departure from tradition and a singular display of honor to her person. Women—those troublemaking "Daughters of Eve"—were kept far away from the Palazzo Apostolico and its precincts. Donna Olimpia had been the previous notable exception to this antifeminist rule of decorum, and her behavior did nothing to encourage relaxation of the traditional rule after she was gone.

The pope had also decided that another formal gift on his part to the queen was to be a new coach. It was, naturally, Bernini who designed the

exquisite vehicle in silver and turquoise. Nothing survives of this gift-on-
wheels, unfortunately, whether by way of actual remnants, preparatory
drawings, or finished engravings. But memory of the coach lives on today,
for it furnished the occasion for both queen and artist to display their re-
nowned quick-wittedness. On Tuesday morning, December 21 (the day
after her arrival in Rome), Christina was inspecting the papal gift-coach
just before the start of a personal tour of the papal art collection to be con-
ducted by Bernini. Hearing Count Raimondo Montecuccoli inform the
queen that it was Bernini who had been responsible for its design, our artist
modestly quipped: "If you see anything defective in it, it came from me."
To which Christina, with equal wit, quickly retorted: "Then in that case
there is nothing at all from you in this coach."

Since her finances were extremely precarious after her abdication and
during the years that Bernini was still alive, Christina was in no position
to afford a major work of art from his hands. The only commission from
Christina to Bernini of which we have notice was a large, ornamental mir-
ror, depicting the winged figure of Time in the act of lifting the drapery
that hangs over the reflective glass. Many people were able to admire Ber-
nini's mirror, as the queen had installed it in her *sala dei quadri*, her picture
gallery. Yet no documentation survives explaining the origins of this com-
mission, and as a result its message remains a puzzle. (Bernini's drawing of
it is today in the Queen's Collection at Windsor Castle, but the mirror itself
disappeared sometime after 1740.) Traditionally such iconography, espe-
cially when, as here, associated with both a mirror and a woman, would
have been understood as a moral reminder of the *vanitas* theme, that is, of
the fleeting nature of the woman's beauty and her other earthly pleasures.
In Christina's case, that would have been a cruel and grotesque sort of
joke. Instead, a recent persuasive thesis suggests that the theme of the mir-
ror is that of "Truth revealed by Time," relating to the nasty aftermath of
Christina's rather savage execution of her equerry, Marquis Gian Rinaldo
Monaldesco, a public relations disaster for the queen. The story merits our
attention.

In 1657 while Christina and her court were on an extended visit to
France, Monaldesco had betrayed to the Spanish the queen's secret plot
(aided by the French) to occupy the throne of Naples, then a possession of
Spain. Confessing to his betrayal, the marquis was summarily executed at
Christina's order, without any form of judicial review, despite the terrorized

courtier's tearful pleas for mercy. News of the shocking event, as recorded by an eyewitness and sensationalized by the many Christina haters of the continent, quickly spread throughout a horrified Europe. Christina's already questionable reputation was severely compromised. The queen attempted to defend her action and correct the record with her own account of the affair, but to only mixed results. Many still considered her a monster, and upon returning to Rome, she was met with a cold reception from the pope, who saw the episode as an eruption of her Nordic "barbarian" roots. Bernini's mirror, thus, would express her hope or confidence that in the end she would be vindicated. Where have we heard this before? In Bernini's own life, in the 1640s, in the aftermath of his failed bell towers at St. Peter's, a failure that severely damaged his own reputation, the gravity of the situation having been sensationalized by his enemies. It was then, as we saw, that Bernini carved for himself the consolatory statue of *Truth Revealed by Time*. So, perhaps it was Bernini himself who suggested this reassuring philosophical theme for the queen's monumental mirror. Otherwise, as an object of mere practical utility, the mirror, especially such a large one, does not seem like something in which Christina would invest much money. She was not the type of woman to spend much time admiring herself in front of a mirror.

As for Bernini, he returned to the "Truth and Time" theme on yet a third occasion, in modified form, when designing the tomb of Pope Alexander VII in St. Peter's Basilica. There, in addition to the usual depictions of the Christian virtues, Bernini placed a personification of truth, an addition that departed from the usual conventions of funereal iconography. Why this unusual choice? It was meant as a reminder, according to another persuasive theory, that the much-condemned and gossiped-about Alexander—the pope who had bankrupted the treasury through his architectural extravagances while bankrolling the debaucheries of his nephew Flavio—would one day be vindicated by the uncovering of the truth of his virtue. Be that as it may, if one looks closely at the facial features of Bernini's Truth, one finds that, likewise contrary to all custom, the female is no classic, idealized, refined beauty at all. Her nose is decidedly oversized, her eyes conspicuously bulging, and her chin, firm and well-defined but in a manly way. Look at an honest painted or engraved portrait of Christina of Sweden and you will find the same features. Did the queen serve, directly

or indirectly, as Bernini's model, we wonder? Was this one further way of honoring his queenly patron, who was also a figure closely associated with Alexander's pontificate? (If so, this would not be the only time that Bernini had done such a thing: recall that the artist had given the features of his lover, Costanza Bonarelli, to the representation of Charity on the tomb of Pope Urban VIII.) On Alexander's tomb, further inspecting the statue of Truth, one discovers that her foot rests upon a globe, and more specifically, upon Christina's native Scandinavia. Just a coincidence? Or is Bernini offering us a clue as to the identity of his female model?[9]

In addition to her monumental mirror, we know—from both an inventory of Christina's possessions and the travel diary of a Swedish visitor to Rome, architect Nicodemus Tessin—that by the end of her life the queen owned several other works by Bernini. Unfortunately, all these objects today are either completely untraced or cannot be identified with certainty. They include two paintings, a marble bust of a female figure, and several drawings. Some, if not all, of the drawings came as gifts directly from Bernini—for some years during Pope Alexander's pontificate, Christina was one of the recipients of the artist's annual gifts of an original drawing by him, as Bernini himself mentioned to his friend Chantelou in Paris. Shortly before his death in 1680, to thank her for her patronage and to ensure that it would continue after he was no longer around to protect his reputation and his family's interests, Bernini tried to give the queen an even more precious gift, likewise the work of his own hand. The gift in question was a large marble bust, his final work of sculpture, depicting Christ the Savior seen in the act of imparting his blessing. Even though it was technically a "gift" freely given, in those days the unspoken social code required Christina to reciprocate the gesture in some appropriate, that is, financially proportionate fashion. However, the cash-challenged Christina was in no position to do so. Therefore, we are told, "she elected to refuse [the *Savior* bust] rather than be untrue to her royal beneficence, since it was impossible for her to properly compensate Bernini for its value."

In the end, Christina, nonetheless, got the statue—Bernini left it as a special bequest to her at his death (it is not mentioned in his formal will, however). Christina's most recent biographer has claimed: "It was a great irony, too [that Bernini gave the Savior bust to the queen], for Christina disliked this sculpture almost as much as she had disliked the pope

[Innocent XI]." Unfortunately the biographer does not cite the source of this information. But the claim is fully plausible in view of what an earlier and entirely sympathetic biographer of the queen has written about her religious views. Christina left a large body of personal reflections on the subject of her faith, and that faith, it seems, was a "Christianity without Christ":

> Christina was skeptical about the Incarnation of the Son of God: she always avoided mentioning Christ, or the Incarnation, or the Redemption. In Quietism [a form of "minimalist" spirituality promoted by the Spaniard Miguel de Molinos in vogue in Rome in the 1670s] she found exactly what she had hitherto sought in vain, a genuinely Christian way of life that disregarded all the things she found so distasteful: pious gestures, pious exercises, a too ecclesiastical mentality and perhaps even the Second Person of the Trinity. This heterodoxy was neither consistent nor deliberate. But her total silence on the subject of Jesus Christ in her religious writings is hard to explain otherwise.

So, we now wonder: had Christina, in fact, refused Bernini's gift also because of theological, not only financial, reasons? It would be entirely like her passionately opinionated self. In any event, we have here another reminder that Christina, as "trophy convert" and icon of triumphal Roman Catholicism, proved to be quite an ambivalent, contradictory, and often embarrassing entity. A Christian without Christ! This is the convert on whom the pope had spent 100,000 scudi to bring to Rome? Despite the religious chasm between them, Bernini, so completely and simplistically conventional in his own piety, seems, by all accounts, to have gotten along fine with the queen. Did mutual self-interest allow them to overlook the theological differences between them? Or did art bridge the gap for them? Whatever the truth of their relationship, during his final sickness, we are told, Bernini begged Christina's prayers on his behalf. He begged her intercession, he wrote, because "he believed that great lady had a special language with which to make herself understood by the Lord God, just as in turn with her God made use of a language that only she was capable of understanding." Was he speaking sincerely or could he not set aside his life-long habit of courtly flattery even on his deathbed? Bernini offers no specifics about that "language," but clearly it was one that he did not speak.[10]

Bubonic Plague, Yet Again

Between Christina's first decision to emigrate to Rome (in 1651) and her actual arrival there, four years had elapsed. Many annoying obstacles had gotten in the queen's way, delaying her long-desired departure from cold, colorless, dour, and too-Protestant Sweden. One of the lesser known but in fact significant obstacles came in the form of another woman: the imperious Donna Olimpia. There could be only one *prima donna* in Rome, and as long as Olimpia was in residence, Christina would not set foot in the city. (We have this from a most authoritative source, Jesuit Cardinal Sforza Pallavicino's biography of his friend, Pope Alexander VII.) Finally in July 1655, after the death of her brother-in-law, Pope Innocent X, and threatened by a public trial for theft from the papal treasury, Olimpia quietly left Rome, retreating to her feudal estate near Viterbo, San Martino al Cimino. It was now safe for Christina to enter Rome and succeed La Pimpaccia as unofficial queen of the city. But Christina had barely settled in her new home when she decided to depart, doing so on July 19, 1656, for what was to be a two-year absence. She needed to go north, she said, to settle her finances. However, there was another factor inspiring the queen to make a hasty departure from Rome: bubonic plague.

As at numerous other times in Rome's well-recorded history, bubonic plague hit the city yet again in the summer of 1656. It arrived in early June from Naples, where thousands were dying daily. This latest outbreak of 1656–57 went down in history as one of the great pandemics of all times across the continent. Fortunately, it was also one of the last. In Italy, the chaotically governed Naples lost three-fifths of its population. Rome fared better, thanks to quick, well-organized civic response and a precautionary exodus from the city of about 20,000 of its residents. Nonetheless, Rome lost 14,473 of the 100,000 remaining behind, according to Girolamo Gastaldi, Alexander VII's ad hoc commissioner of health, who later published an abundantly illustrated, detailed account of the city's official plague response.

We have another fascinating eyewitness account of the 1656 plague in Rome from Sforza Pallavicino, who includes a long digression on the subject in that same biography of Alexander VII. In reporting his plague mortality statistics, by the way, His Eminence Cardinal Pallavicino notes, with an air of patrician satisfaction, that "almost all these deaths were from the

ordinary masses, with few civil heads and not one illustrious head having been lost." In other words, no human being of real worth died from the plague in Rome, just nameless poor slobs. (Bernini, by the way, shared in the prevailing undemocratic view of humanity; consider, for example, his remark recorded in Chantelou's diary: "The better one's birth, the more capable one was of the higher virtues, which are rarely to be found among the common people.") One of the "common people" had in fact been the initial carrier of the infection into Rome, as Pallavicino and all other sources of the time report, a Neapolitan fisherman staying in a public house near the Church of San Crisogono in Trastevere. Once his death was certified as bubonic plague by the medical authorities, the decision was made to quarantine immediately all of Trastevere, for swift and strict isolation of infected districts and homes, they well knew, was the only effective defense once the contagion had breached the city walls. Literally overnight, on June 23, the entire neighborhood was physically sealed off with a hastily constructed wooden wall, its bewildered, terrified residents cut off from all commerce with the outer world.

One cannot have a proper understanding of the effective tenor of seventeenth-century Italian life and of the ordinary mindset of the Italians alive at that time—including Gian Lorenzo Bernini—without taking into account the awful, inescapable reality of recurrent epidemic disease of all types, of which bubonic plague was perhaps the most feared. In fact, Casa Bernini was struck by plague in the same outbreak in October 1656. For the nearly four centuries since the first "modern" pandemic of 1347–48, the plague struck so often and in so many localities in Europe (especially Italy with its several international ports) that when the inhabitants of any given town or city were not actually living through an active outbreak of plague, they were anxiously awaiting and preparing for its certain return, knowing that there was little they could do to protect themselves in those preantibiotic days. Geographical distance was of small comfort. Knowing how porous was the blanket of protection between them and plague and how rapid the disease's migratory ability, the Genoese or Bolognese, for example, would have had every reason to tremble when they heard of pestilence even in far-off Palermo, Sicily.

After centuries of experience with the plague, early modern Italians had arrived at the conclusion that despite all the pills, poultices, and potions offered by the doctors, pharmacists, superstitious healers, and practitioners

of folkloric medicine, the only sure form of protection against the plague was to remove oneself from sources of the contagion, that is, to flee possibly infected people, objects, homes, and towns. Those who could not or chose not to flee (like Bernini and his family) faced constant anxiety about falling victim to the dread disease. It was the silent, invisible, mysterious Enemy seemingly omnipresent, ready to strike anyone at any given moment. All an unfortunate person had to do was breathe in a single infected draught of air or touch an infected item or surface of any sort, including the holy water founts in churches (these were soon drained for the duration). Those who remained in the city also faced the sight and smell of bonfires burning in every district to purge the air of contagion, homes sealed up by the public health commission as sites of infection or suspected infection, and the cadavers of plague victims being hauled away in carts by convicts or slaves. (Yes, slavery did legally exist in the Papal States, especially on the papal galleys, the popes being fully aware and tolerant of its existence; the numbers of the slaves were small, however, and essentially restricted to non-Christian war captives.) Articles of daily use, including letters and packages coming through the mail, were routinely disinfected with smoke, vinegar, or sulfur. All activities involving the gathering of people into close quarters were prohibited, including religious functions, especially Rome's beloved processions. The city gates were shut, interaction with the external world kept to a minimum.

As for scientific remedies, it was all well and good, said the learned churchmen in numerous sermons and theological treatises, to attempt to identify what were called the "natural causes" of plague. But in reality that was of no value, because ultimately the effective cause of plague was spiritual, not physical: it was human sinfulness, which provoked the "just wrath" of God. And as the Bible teaches, plague is one of God's preferred mechanisms of punishment—or, rather, "revenge," as our ecclesiastical sources term it, in fidelity to biblical vocabulary. Returning to his pulpit at the papal court during the Lent season of 1657, at the end of a nine-month plague epidemic, Bernini's Jesuit friend Gian Paolo Oliva begins his first sermon to the pope and cardinals thus:

> After so many funerals accompanied by so many tears, we can now believe that Divine Wrath, placated by the prayers of the priests and dissipated by the contrition of the people, has finally said in Rome to the Angel who

avenges the outrages committed against Him what Christ in Gethsemane said to Peter . . . : "Put your sword back in its place." . . . Yet even though the Angel's sword has at the moment been pulled back from its extermination of Rome, it has not been thrown away into the Tiber: instead, it has simply been returned to its sheath, only to come out again with a fury, even more insatiable and implacable, aimed at our destruction if to our misfortune we fall into sin once again, as before or worse than before.[11]

In his own response to the plague, Bernini, the good orthodox Catholic, would have fully accepted the church's consistent teaching. Obliged by his papal commissions to remain in Rome, he, too, would have also lived through the just-described psychological and material circumstances in which the residents of Rome found themselves trapped for nine months. Though our sources do not speak of his emotional state during this siege, Bernini had every reason to feel especially vulnerable. Not only was he an "old man" of fifty-eight, he had also just gotten over a prolonged case of debilitating *febbri terzane doppie*, double tertian fevers, only weeks before the arrival of the plague. Then, in the autumn of 1656, what was feared became reality: plague struck the Bernini family. The artist's younger, unmarried brother, Domenico, aged forty-two, succumbed to the disease on October 29. He had drawn up his will only the day before, naming his sister-in-law, Bernini's wife, Caterina Tezio, his universal heir. There had almost been a second death by plague in the Bernini family, according to Roman diarist Carlo Cartari, but a miracle intervened:

> I heard that before the death of Bernini's brother, another brother, his second one [Luigi], returned home one night with an excruciating headache and fever and went right to bed. A bubo [a swollen lymph gland, symptom of bubonic plague] was found on him and as a result the entire household was thrown into great distress. His sister-in-law [Caterina, Bernini's wife], from a certain distance, offered him some of the special bread of Saint Nicholas of Tolentine, telling him that to eat it with sincere faith and prayers to the saint. He did so, first placing some of the bread on the infected part of his body. From that moment on, they say, his illness diminished and he later was entirely cured of it. A formal inquiry by the Church was going to be undertaken of this miracle.

Since plague had struck Casa Bernini, the family's home and everyone in it would have been placed under absolute quarantine. No home or institution, no matter how august, was exempt from this measure. The Cartari diary tells us that at one point even Cardinal Francesco Barberini's Palazzo della Cancelleria, the Jesuit Collegio Romano, and the residence of Prince Pamphilj were placed under official quarantine because of plague deaths among staff members therein. That fact would have been publicly announced by a large placard attached to their front doors bearing the simple but unwelcome word, "SANITÀ," literally, "HEALTH," referring to the Public Board of Health, who ordered the quarantine.

Bernini himself, however, was not at home when this medical disaster struck his family. A state of epidemic was formally declared by city officials in June, and probably shortly thereafter Bernini had been sequestered for his safety by Pope Alexander in the well cordoned-off papal palace on the Quirinal Hill. The highest of the seven hills of Rome, the Quirinal, still sparsely populated and dominated by the open green space of private parks and lush gardens, enjoyed a healthier air than the rest of the lower-lying city. Along with Pietro da Cortona and several other artists upon whom Pope Alexander depended for the realization of his great plans for the rebuilding of Rome, Bernini apparently spent the duration of the epidemic there. In these months, he was kept busy working on plans for his papal commissions—recall that the St. Peter's Colonnade project had gotten underway in August 1656—and assisting in remodeling work on the Quirinal Palace itself. Among the sequestered artists, unfortunately, was not Bernini's faithful assistant, painter Guido Ubaldo Abbatini, who died of plague in September. Yet another victim of the same plague was Donna Olimpia Maidalchini, who died alone, uncared for, and unmourned, at her estate outside Viterbo, San Martino al Cimino. She thought she was safe in her marble palace, but the Silent Enemy, with his winged feet, had pursued her even up there in her isolated splendor. How ironically fit that she whom many had repeatedly cursed as a plague upon Rome should herself die of the plague.

Having been gripped in anxiety for many months, Romans resumed their usual lives once this latest wave of terror had passed and was declared by the medical authorities as being officially over in August 1657. The plague ended up carrying away only one member of the extended

Bernini family, the aforementioned brother of the artist, Domenico. Daughter Francesca Giuditta, as already recorded, died one year after Domenico's death, in August 1658, but not of plague. (August, by the way, seems to have been a particularly deadly month in Rome in this century; Romans, including popes and cardinals, dropped like flies during the dog days of August.) Soon after Domenico's death, however, another boy joined the Bernini family, to take his place, also named Domenico in his late uncle's honor. Yet anxiety attended that birth as well. The church record tells us that the infant was baptized on the very day of his birth (August 3, 1657) for it was feared he would not survive long. As it turned out, Domenico, Jr.—our future biographer Domenico—was to live to the age of sixty-six, a respectable demographic achievement for those days.

On a more mundane front, in this same period (in 1658 to be precise), Bernini expanded his home on the Via della Mercede, spending in the process as much money as he had spent to purchase it in the first place, just over 7,000 scudi. As Bernini explained to his French audience while in Paris designing Louis XIV's new Louvre, "So true it is that buildings are portraits of the spirit of princes"—but the same held for princely artists as well.[12]

A JEWEL FOR THE JESUITS

Looking south from the papal palace on the Quirinale where he was waiting out the plague epidemic, Bernini would have had a good view of the Jesuit novitiate of Sant'Andrea, just across the straight but narrow Via Pia (today's Via del Quirinale). Little did he know—or did he already have some inkling?—that he would soon be caught up in the architectural schemes of the Jesuit fathers there. The enviably large, well-situated complex included extensive gardens, several fountains, residences for the Jesuit novices and professed fathers, an infirmary, and two churches, the early Christian basilica of San Vitale (still surviving, with its main entrance, much below street grade, on today's Via Nazionale) and the medieval Church of Sant'Andrea. The latter cold, dark, musty structure served as the domestic chapel. In addition to the unhealthy status of its interior, by the third decade of the seventeenth century, Sant'Andrea had become too small for the Jesuits' needs, and therefore the decision was made to replace it with a completely new church. Bernini may have been aware that in 1647 his rival Borromini had been engaged by one prospective patron, Cardinal Francesco Adriano

Ceva (Urban VIII's one-time private secretary), to design a "grand and sumptuous church." But the reigning pope, Innocent X, refused permission since he did not want a big new structure looming over and competing with his own property across the street.

Fortunately, Innocent's successor, Alexander VII, was of a different mind, perhaps wanting to use the proposed new church as an annex to the worship space available at the papal palace. Ironically, this time around—it is now the summer of 1658—the patron who came forth with an offer to finance the building program was the nephew of the same obstructionist Pope Innocent, Prince Camillo Pamphilj. Camillo was the son of Donna Olimpia Maidalchini—it was not, by the way, a happy mother-son relationship—whom we have had already had occasion to meet in this story. Not surprisingly Alexander called on his man Bernini to serve as architect for the project. Bernini seems to have immediately accepted the pope's proposal, apparently even before either he or Alexander had consulted the Jesuits themselves. Did Bernini relish the prospect of taking on yet another project that had been formerly given to his rival Borromini and that was located just down the block from Borromini's acclaimed Church of San Carlino?

As for their part, the Jesuits seem to have had no problem with the pope's choice of architect, especially once he announced that he would do the entire job for free. Bernini had never done any architectural work for the order, nor, for that matter, any large-scale artistic work of any kind. By 1658 his Jesuit-related work amounted to just three items: the funerary bust of Roberto Bellarmino of the early 1620s, a frontispiece (*David Slaying the Lion*) for the Jesuit-sponsored edition of 1631 of Urban VIII's poetry, and some unidentified contributions to ephemeral decorations at the Jesuit order's 1640 centenary celebrations at the Collegio Romano. Nonetheless, Bernini was well known to them, thanks not only to his general reputation but also to his nonartistic contacts with the order. If Domenico's biography is to be believed, Bernini had regularly participated in religious devotions at the Jesuit mother Church of the Gesù since the 1640s, in particular, those of the "Happy Death" (Bona Mors). In the course of his lifetime Bernini had also interacted with various members of the order in papal and other circles. During Bernini's lifetime the Jesuits were at the apex of their activity and influence in Rome; it would have been nearly impossible to have avoided them. Nor would Bernini have wanted to: he was always attracted to big wielders of power of any ilk.

FIG. 25 ⊷ *Gian Paolo Oliva, S.J.*, contemporary
engraving, published in Alfred Hamy, ed., *Galerie illustrée
de la Compagnie de Jésus*, vol. 6 (Paris, 1893), pl. 9.
Photo: Author.

Among the Jesuits of Bernini's acquaintance were two prominent pub-
lic authorities, both residing at Sant'Andrea itself, both playing impor-
tant roles in the 1658 church project, and both familiar to us at this point,
preacher Gian Paolo Oliva (fig. 25) and scholar Sforza Pallavicino (fig. 26).
One cannot stroll for long amid the chronicles of late Baroque Rome with-
out encountering repeatedly the figures of Oliva and Pallavicino. The
patrician man of letters Pallavicino (whose first name is indeed Sforza, not
Pietro as often erroneously given) had just been named cardinal by Pope
Alexander in April 1657. Exactly ten years later Bernini's new Church of
Sant'Andrea was Pallavicino's burial place (tomb designed by Mattia de'
Rossi, but approved by Bernini), just as even later it would be for Oliva
in 1681. Celebrity preacher of Rome since 1629 and to the Roman court
since 1651, Oliva was, like Pallavicino, one of the pope's closest advisors.
Though both Jesuits had been present and active on the Roman scene for

FIG. 26 ➤➤ G. L. Bernini, *Cardinal Sforza Pallavicino*, 1666. Yale University Art Gallery, New Haven. Photo: Yale University Art Gallery / Art Resource, NY.

decades (Bernini probably first met Pallavicino in the mid-1620s within the Barberini cultural circle), the effective beginnings of their friendship with Bernini dates to these same years of Alexander's pontificate, that is, the late 1650s. As patrons, protectors, and political-spiritual consultants, both loomed large in the artist's subsequent life, if more behind, than in front of, the scenes.

In his day Oliva was famous for his elegant, stately, erudite sermons—today we might find them pompous and stodgy, at times ludicrously so. Even more important, Oliva was known and admired in his role as the politically astute general of the Jesuit Order (1661–81). He craftily steered the vast ship of that international organization—loved by some, detested by others, including many Catholics—through the stormy diplomatic and theological waters of late seventeenth-century Europe. Today, outside of Jesuit circles, his name, if known at all, is most cited for the decisive role he played as head of the order in commissioning the elaborate Baroque decoration of the Jesuit churches in Rome. We have Oliva to thank for commissioning those beautiful, awe-inspiring, *trompe l'oeil* ("fool the eye") ceiling frescos for the Roman churches of the Gesù and Sant'Ignazio, which today cause tourists to wrench their necks upward in perilous, painful attempts to capture a proper view of the glorious celestial scenes hanging over their heads at great heights and over great expanses of the church interiors. (In one sermon, however, Oliva deplores the fact that visitors to Rome show enthusiastic aesthetic pleasure for the art contained in its churches but little knowledge of, interest in, or devotion toward the sacred subjects and teachings depicted by those works of art.) Oliva and Bernini's appreciation of the devotional and propagandistic power of theatrically staged religious art might have been grounds enough for a friendship between the two men, for not all within the Jesuit order or even the Catholic Church agreed that churches should be so elaborately decorated and at such expense. Against such opposition, it was Oliva who provided further, authoritative theological defense of the activity by which Bernini was making, and hoped to go on making, his living.

At the mother Church of the Gesù, the frescoes of the cupola and vault of the nave commissioned by Oliva were executed by a young artist, Giovanni Battista Gaulli. In competing for the job, Gaulli had the advantage of coming from Oliva's native city of Genoa, no small consideration in Baroque Rome. (The nickname by which Gaulli is still known today, Bacic-

cio or Baciccia, is Genoese dialect for his baptismal name, Giovanni Battista.) More important, Gaulli also had the advantage of enjoying Bernini's warm, genuine support. It was Bernini who helped secure this prestigious commission for the inexperienced Gaulli. Bernini went so far as to personally guarantee the quality of the work and accordingly supplied his protégé with ideas and some of the actual designs for these challenging compositions. Unfortunately, even with Bernini's help, the final results did not please everyone. According to the anonymous Roman *avvisi* of the day, Gaulli's frescoes were met with a fair amount of criticism when unveiled (the cupola in 1675; the nave vault in 1679). In the case of the cupola fresco, *The Vision of Heaven*, attributing its "many defects" to the stinginess of the Jesuits in hiring so young a painter, one sarcastic critic singled out the depiction of God the Father therein as particularly unsuccessful: "The Almighty Father appears to be all out of sorts; he's in this state, they say, because he sees the world in so much turmoil—and Saint Peter is pointing out to Him the source of that turmoil: it is Saint Ignatius together with that Society of his [the Jesuit order]." Because Bernini's contribution to the project was a matter of common knowledge, this lack of success on Gaulli's part reflected badly on him as well.

For Oliva personally, as far as we know, Bernini produced only two works of art, both of them drawings as frontispieces for the preacher's publications. In his sermons Oliva, in turn, cites various works by Bernini, such as his Fountain of the Four Rivers in Piazza Navona and the Baldacchino and the Cathedra Petri in St. Peter's. But curiously the preacher never mentions Bernini's name in connection with any one of the artistic marvels he signals out for his audience's appreciation. We find the same curious silence in Sforza Pallavicino's long biography of Alexander VII.

In addition to the absence of Bernini's name, another paradox that surfaces from a reading of Oliva's sermons is the fact that their fiercely conservative, moralizing author spends much energy denouncing both secular theater—especially Carnival comedies—and, as we already heard, sensual art as potent enticements to sin and therefore grave dangers to the salvation of one's soul. Taken literally, as Oliva certainly meant them, such condemnations would have included in their target Bernini's own theater and at least some of his art—perhaps not his *Saint Teresa in Ecstasy* but certainly the bare-breasted buxom personifications of Charity in the De Sylva Chapel in Sant'Isidoro and on Pope Alexander's tomb in St. Peter's, as well as his

even more fully exposed statue of Truth, which greeted all visitors to the Bernini studio located in his home on the Via della Mercede. (The *Charity* on Alexander's tomb was covered up by orders of the even more puritanical Pope Innocent XI shortly after its completion). We wonder what Bernini and Oliva had to say to each other on the subject of theater and sensuality in art. Or did they diplomatically avoid those issues?

Nonetheless, Oliva earns a special place of recognition within any Bernini biography for his role in finally convincing the greatly reluctant, fearful artist to accept King Louis XIV's invitation to Paris, despite the dangers and doubts, of all sorts, attached to that invitation. Chantelou's diary records Bernini's public acknowledgement to his French hosts of Oliva's role in getting him there, as well as the artist's words of praise for the Jesuit's spiritually edifying sermons. Bernini also happens to mention, with pride, that some remarks he once made (about how "the nobility of the [artistic] idea is suppressed by the slavery of imitation") pleased the erudite Oliva so much that he "made a note of them and used them in his sermons." In Domenico's biography, in turn, we hear Oliva praising Bernini's great theological acumen—so great, confessed Oliva, that "in discussing spiritual matters with the Cavaliere, he (Oliva) felt obliged to carefully prepare himself, just as if he were going to a doctoral thesis defense." It was, in other words, another mutual admiration society.[13]

In 1660 Sforza Pallavicino, too, had asked Bernini for a frontispiece for one of his books, the *History of the Council of Trent*, a monumental work of papal apology upon which most of his enduring memory as church historian today rests. But the overcommitted Bernini was obliged to say no. Six years later, however, Pallavicino received an even more precious gift from Bernini: his own portrait—of the cardinal, that is—a drawing in red chalk, which managed to survive the centuries (fig. 26) and is now in the Yale University Art Gallery. In it we see an almost painfully thin, withered but wise prelate with somewhat disturbingly large, dark eyes, just one year before his death. Another splendid gift to the cardinal from Bernini was a duplicate of the larger-than-life-size crucifix commissioned by the pope as a gift for King Philip IV of Spain in the mid-1650s and now at the Escorial.

Bernini made the gift of the Crucifix to Pallavicino while in Paris, to thank the prelate for looking after the interests of his family during his absence, in particular for mentoring his son, Monsignor Pietro Filippo, who was being groomed for greater things in the Roman curia. Not just greater

things, we might mention, but the greatest of things, the papacy: in Paris Bernini at one point boasted to Chantelou that his son "was a man fit to become pope," and we can be sure both father and son were aiming that high. Thanks to his father, Pietro Filippo ended up receiving several prestigious benefices and sinecures—as well as a real job in the papal bureaucracy with real responsibilities—but, for better or worse for the destiny of the Holy Roman Church, he never became pope. In fact, he never even made it to the cardinalate. Even Bernini's wealth and connections could not overcome the obstacle of Pietro Filippo's mediocrity. Failure to get a Bernini into the College of Cardinals was a defeat for the entire clan, for that represented one of the surest means of long-term upward mobility for any family. No wonder the Bernini clan slid slowly but surely into oblivion after the artist's death. Yet we must give credit to Pallavicino for trying his best—or at least he appeared to—to facilitate Pietro Filippo's ascent up the ecclesiastical ladder. In an April 1665 letter to the French foreign minister, Hugues de Lionne, Pallavicino refers to his mentoring of Pietro Filippo, while boasting that the young man's artist-father "truly has very few friends whom he trusts as much as he does me. As for me, loving every form of talent, I am most partial toward this glorious artist."

No survey of the Jesuit presence in Bernini's life would be complete without mention of two other well-known priest-scholars of the Society of Jesus with whom our artist has some sort of rapport, even though we don't know many details. Both men were scientists: Athanasius Kircher and Niccolò Zucchi. Kircher was in his day applauded and revered as a universal genius, a kind of "Mr. Wizard" who could answer any of your questions about the natural world and its history. In the late 1640s Kircher served as scholarly consultant on Bernini's Fountain of the Four Rivers project, thanks to his knowledge of Egyptology (especially hieroglyphics, which he erroneously professed to have deciphered) and geology. His contribution to Bernini's design was not insignificant for, as Ingrid Rowland has pointed out, "the very form of [Bernini's] fountain reflects Kircher's concept of geology; he believed that mountain ranges stood hollow over vast underground reservoirs in which all the rivers of the world had their origins. Bernini's design of a hollow mountain is therefore . . . an expression of the latest in scientific thinking."

In honor of Pope Innocent's new fountain, Kircher published in 1650 his *Obeliscus Pamphilius* (the Pamphilj obelisk), an erudite, if often fanciful,

treatise revealing fascinating Egyptian lore and supposed theological "secrets." The centerpiece of the Fountain of the Four Rivers, as you will recall, is an ancient obelisk covered with exotic hieroglyphs. Part of Kircher's contribution to the *concetto*, or symbolic, erudite meaning of Bernini's fountain, again according to Rowland, was to endow it, in effect, with "a sexual edge." That is to say, as the Jesuit taught in print and would have explained to Bernini, the ancient Egyptians believed that a kind of cosmic, divine sperm—what Kircher called "a certain universal seminal power"— continually rained down upon the earth, traveling on the rays of the sun. As icons of solar rays, obelisks, including that in Piazza Navona, thus served to attract this life-giving "solar spermatic power" to the planet. We don't know how Bernini reacted to this theory, and there is no explicit sexual imagery in his design, even though today we might tend to read the very shape of a tall, erect obelisk as phallic (whereas the Egyptians intended it to represent a ray of the sun). But knowing him, we can be sure he was not displeased by the thought.

Another of Baroque Rome's brilliant scientists was the saintly Niccolò Zucchi, nowadays all but forgotten. Yet fortunate is he, because he can be entered on our list of "Jesuit Writers for Whom Bernini Supplied Frontispieces." The book in question was Zucchi's study of light and vision, the *Optica philosophica*, the first volume of which was published in 1652. Though a scholarly work mixing highly technical physical science and philosophy, Zucchi's *Optica* was in fact directly relevant to Bernini's art. In creating his works of art, sculptural or architectural, Bernini was always exceptionally aware of the crucial importance of light—specifically, the proper manipulation of its source, its angle, and its intensity—for the final, successful effect of the work in question. This is especially true in his chapel designs, noteworthy for their cleverly staged theatrical lighting. In fact, in the 1990s in the course of a thorough restoration of the most famous of all Bernini chapels, the Cornaro Chapel featuring his *Saint Teresa in Ecstasy*, a special lens was discovered implanted in the fabric of the building and clearly original to the chapel's design. The lens was crafted and positioned in such a way that when the sun reaches its zenith on the saint's feast day, October 15, Teresa's statue is flooded with golden light. The use of such special lenses to control the direction of reflected light are among the many subjects treated in Zucchi's work and it is likely that working on the Cornaro Chapel in the late 1640s and early 1650s Bernini had gotten the

idea for his own lens from Padre Zucchi, in advance of the publication of his volume.[14]

With so many Jesuits in his life, one would expect Bernini's own spirituality and devotional habits to be thoroughly permeated by Jesuit principles and a distinctly Jesuit "way of proceeding," to use a favorite Jesuit turn of phrase. Instead, there proves to be little that is patently Jesuit in what we know of the articulation and practice of Bernini's faith. His faith, like his art, drew from all fonts of inspiration and tended to be, in its essence, as conventional as it was eclectic. Moreover, and contrary to what is often claimed, there is no evidence that Bernini ever did the "Spiritual Exercises" of Saint Ignatius, either in the full (thirty-day) or abbreviated (eight-day) version of that famous guided retreat regimen. The most overtly Jesuit element of Bernini's faith life was his participation in the devotions of the "Good Death" at the Gesù.

But it is time to return to the new Jesuit Church of Sant'Andrea al Quirinale, which we left behind, pages ago, in only its initial stages of planning by Bernini. Though a small church, Sant'Andrea proved to be yet another drawn-out project for the artist. (Again, poor Bernini had few opportunities for instant gratification in his professional life.) The initial design was prepared in the late summer of 1658 and the first stone laid on November 3 of that same year. It was consecrated on November 11, 1670, and by 1672 was essentially complete except for the side chapels, which did not get finished until early in the next century. Looking at the magnificent final product—harmoniously and organically unified in all its components, inside and out—one would not know that its design had evolved continually and its construction stretched out over so long a period of time. Modern descriptions of this small but charming oval church inevitably make use of words like "gem," "jewel," and "jewel box," and such comparisons are entirely warranted. It is by consensus the apex of Bernini's church architecture, just as it had been acclaimed by contemporaries upon its inauguration in 1670. And more amazing, not only did Bernini in the end succeed in satisfying his patrons and the general public, he even satisfied himself. This his son Domenico knew from his personal experience:

It was this same church that, one day, Bernini's son—he who is writing the present book—entered to make an act of devotion and inside came upon his father, the Cavaliere, withdrawn by himself in a corner. In a state of genuine

satisfaction, the Cavaliere was gazing admiringly upon all the parts of that small temple. His son respectfully asked him, "What was he doing there, silent and all alone?" The Cavaliere replied: "My son, it is only from this one work of architecture that I derive some particular gratification in the depths of my heart, and often, seeking respite from my labors, I come here in order to derive consolation in this work of mine." This was a novel sentiment for the Cavaliere, since he was never able to be truly satisfied with any of the numerous works he created, believing that they all fell very short of that beauty that he knew and conceived within his mind."

The theme of the great artist being perpetually dissatisfied with his work is a stock item in Renaissance art biography, but we can readily believe it to have been fully true in Bernini's case. As for the specific episode recounted by Domenico, it is likely to have occurred in the years 1671–73 when the biographer was himself a resident at Sant'Andrea during his two years as a Jesuit novice (in the end he decided a Jesuit vocation was not for him). The encounter may even have taken place, more specifically, in mid-July 1673 when, immediately following the death of his wife on the twelfth of that month, Bernini withdrew in spiritual retreat for a few days at Sant'Andrea.[15]

FINAL ACT OF THE BERNINI-BORROMINI RIVALRY

It is a reassuring sign about the quality of the relationship between husband and wife that Bernini felt the need to go into retreat after Caterina's death, one of the rare times in his life that he voluntarily put aside his labors. What was not rare for Bernini, especially in the 1670s, was the sad experience of witnessing the deaths of family members and friends, some of whom were much younger than he. This was the unfortunate consequence of living as long as he did in those demographically perilous years. At the same time, however, this meant that Bernini had the satisfaction—however much he might piously try to suppress the feeling—of outliving his opponents, such as Father Virgilio Spada, who died in December 1662, leaving Bernini to complete his Colonnade project with greater peace and autonomy. Bernini also outlived by far his greatest rivals in sculpture, François Duquesnoy (d. 1643) and Alessandro Algardi (d. 1654), and when on May 16, 1669, his formidable rival in architecture, Pietro da Cortona, passed from this life,

Bernini remained as uncontested king on the crowded mountain of Roman architects. Again, if only despite himself, our artist must have experienced some degree of relief and satisfaction upon hearing of these permanent departures from the scene. Earlier however, at the news in August 1667 of the death of another archrival, Francesco Borromini, Bernini, we would like to believe, took no satisfaction whatsoever, for Borromini's last days and death were heart-wrenchingly pathetic.

After the conclusion of the bell tower affair in 1646, though each would have certainly been aware of the activities of the other, Bernini and Borromini did not have much occasion for direct interaction, professionally or socially. With the end of the reign of Innocent X came also the beginning of the slow downward spiral of Borromini's fortunes. He well understood that under Innocent's successor, the ardently pro-Bernini Alexander, his chances for big papal commissions were slim. He had to content himself with completing the commissions he had already received. True, he completed two of them to much enduring acclaim, the university Church of Sant'Ivo alla Sapienza and the new wing of the Collegio di Propaganda Fide, the headquarters of the church's overseas missionary operations. But thanks to his increasingly belligerent and eccentric ways, Borromini ended up getting himself fired from two other prestigious projects, the restoration of the Lateran Basilica and the construction of the Pamphilj family Church of Sant'Agnese in Agone. It must have galled Borromini to no end in December 1666 when the direction of the latter project was given (though only for a short while) to Bernini, and then again in June 1667 when yet another old friend of Bernini's, Giulio Rospigliosi, ascended to the papal throne as Clement IX. In July of the same year, the commission for the tomb of the pope whom the Pamphilj-protected Borromini had always considered "his," Innocent X, also went, heart-wrenchingly for Borromini, to Bernini.

Shortly thereafter, Borromini's mental state declined rapidly and soon arrived at the breaking point. On August 2, an hour or so before dawn, the desperately depressed Borromini attempted suicide by throwing himself upon his sword. Death came slowly from the resultant wound on the evening of the next day. Borromini was conscious and talking (to his sole house servant) till the very end. He had few friends and no family to mourn him except one nephew, Bernardo Castelli. And you, Bernini? When the news was brought to you, what was your reaction? What were your

feelings? Assuredly not satisfaction, not vindication, not relief. Whatever your faults, as even your most staunch opponents would admit, it is impossible to imagine you deriving any pleasure from the misfortune of others, especially tragically fatal ones such as this. We are certain that you felt only sadness and quickly offered up a sincere prayer for the eternal repose of the soul of a luckless rival.[16]

A ROMAN ARTIST IN KING LOUIS'S COURT

<div style="text-align:center">

[CHAPTER 5]

</div>

BERNINI BECOMES A POLITICAL PAWN

"I don't know what game it is that we are playing. Your Excellency holds his cards up so high, that one can learn nothing. Therefore, impelled by impatience, I am revealing my own cards." So wrote Cardinal Antonio Barberini from Paris to Bernini in Rome on October 27, 1662. The cardinal was in the French capital for another extended stay, this time not as an exile as in 1645 fleeing from the wrath of Innocent X, but as official papal representative. He had been sent earlier that year to deliver Alexander VII's gift for the newly born heir of King Louis XIV and his wife, Maria Teresa of Spain. (What do you give a royal baby who already has everything? Swaddling clothes personally blessed by the pope.) During that visit, in order to further ingratiate himself with King Louis, Antonio decided to resurrect the idea of getting Bernini to come to Paris to work for the French court. The twenty-four-year-old, supremely self-confident Louis, the "Sun King," had just assumed personal rule of the nation upon the

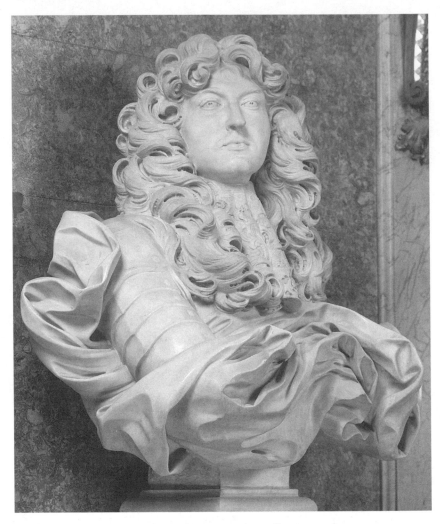

FIG. 27 ↠ G. L. Bernini, *King Louis XIV*, 1665, Versailles, France.
Photo: Réunion des Musées Nationaux/Art Resource, NY.

death (in March 1661) of his all-powerful chief minister, Cardinal Mazarin, and was the fast-rising star of the European political firmament (fig. 27). The ambitious "miracle child" of Louis XIII and Anne of Austria was poised to rise incontestably to the very top, as indeed he did in just a few short years. But in addition to fighting and winning endless wars, in order to confirm, advertise, and enhance his public status, Louis needed to fill his capital, and his whole country, with awe-inspiring works of art and archi-

tecture, publicizing and glorifying his name as munificent patron. Again, it was art as political propaganda, or, to use a nicer term, "public relations," the tried-and-true strategy of all power wielders in the Age of Absolutism. For awe-inspiring artistic propaganda—or public relations, if you will—Bernini, "Image Maker of the Popes," was one of the very best in Europe, and Cardinal Antonio would procure his services for the French king.

Or so he thought. By that October, Cardinal Antonio, Bernini's long-time Barberini patron, was utterly frustrated by the artist's politely evasive responses to his inquiries. So he bluntly confronted him, dispensing with the usual hyperpolite, verbosely indirect rhetoric of Baroque letter writing. As for Bernini, not saying "No" while not saying "Yes," he had played this same game of cagey diplomacy before with the late Cardinal Mazarin, who had died unsuccessful in his numerous attempts to lure the artist to Paris beginning in the 1640s. One cannot blame Bernini for being evasive. True, as the pope's architect in Rome, he was an extremely big fish in an extremely big pond. But as he had already painfully experienced for himself in the mid-1640s, the wheel of fortune could suddenly change direction. The situation in Rome could once again turn hostile for him overnight—especially once the sickly Alexander died—and he might need a suitable place of safe, well-paying refuge for himself and his large family. Under the circumstances, the court of "The Most Christian King" (as the French kings were traditionally styled, with no irony intended) would do well. Therefore, it was better not to close definitively that Parisian door being held open for him by Cardinal Antonio.

Furthermore, to any request of a powerful patron, even an old, ostensibly affectionate one like Cardinal Antonio, it was always dangerously impolitic to deliver an outright "No." The affection of a patron could turn mighty quickly to punitive rage when their clients disappointed them. This was the infamous "Fallen Favorite" syndrome of courtly life, all too well known to Bernini, as it had been to Shakespeare when composing his English court tragedies. Yet things in Rome would have to become intolerable, even life-threatening, to get Bernini, that resolute homebody, to leave. As Pope Urban had reminded him at the time of the last French campaign to lure him to Paris, Bernini "had been made for Rome and Rome made for him." Bernini was stubbornly of the same mind and resisted this latest volley from beyond the Alps, despite the considerable quantity of gold coins held up in front of his eyes by the French.

In the end, as his son Domenico says, "it took nothing less than a war to wrench Bernini away from Rome." The war was between France and the papacy, and in it Bernini eventually found himself a helpless political pawn in a deadly, high-stakes, international power struggle whose outcome the whole continent was watching. Ready to take his place as premier sovereign of the West, Louis was in those days flexing his arrogant muscles all over Europe, deliberately provoking the other powers into diplomatic and military showdowns. He expected to exit victorious, and indeed he did in those early years of his reign.

In 1661 in London during a public procession to mark the arrival of the new Swedish envoy, the coaches of the Spanish and French ambassadors became unexpectedly embattled in a conflict over precedence: namely, whose coach had right of way when in parade? The conflict immediately turned violent. The French ambassador's coach was knocked over, his horses killed, and his humiliated entourage sent running off like scared rats for safety. Why the violence? As everyone understood, deciding such a ceremonial detail was tantamount to asking which country was more powerful, Spain or France? Even though France had scored a major victory over Spain in the 1659 Peace of the Pyrenees, she still had a ways to go in making Spain—and the rest of the world—understand that Spain was now a second-rate power—second, that is, to France. This London clash-of-coaches was exactly the kind of showdown Louis XIV sought in order to send out this message. Rattling his sword, Louis seized the opportunity and escalated the London episode into a dramatic international affair. The details need not detain us; suffice it to know that in the end France won this battle of precedence, even publicizing her victory with the issue of a commemorative bronze medal.

It was the papacy's turn next to be humiliated by France on the international stage. The Catholic Church's effective political and diplomatic clout had been in steady decline since the 1648 Peace of Westphalia, and everybody knew it. Westphalia had, yes, put an end to the catastrophic Thirty Years' War between Catholics and Protestants, but at the same time it represented a shameful defeat for the Catholic Church. In hammering out the terms of peace, papal demands had been ignored, especially by two of the major Catholic players, France and the Holy Roman Empire. Later, in 1659, when it came time to negotiate the Peace of the Pyrenees with Spain, France (in the person of pope-hating Prime Minister Cardinal Maza-

rin) made sure that the papacy was excluded from the negotiations, thus ignoring the pope's traditional role as peacemaker between Catholic powers. As a further insult, Mazarin made sure the pope and his representatives were kept in the dark about the entire process itself. Totally left out of the picture, a much-surprised pope found out about the treaty, like everyone else, only after it was a done deal. What seemed clear before—ever since Mazarin's repeated provocations of Innocent X and grand betrayal of the Catholic cause in 1648—was now abundantly clear: France was no friend of the papacy and would pursue her national self-interests, at no matter what cost to the papacy and the church. She would even maintain friendly relations with the Muslim Turkish court, to the point of aiding and abetting its attack on Vienna, capital of the Hapsburgs, who, although Catholic, were enemies of France.

Tensions between France and the papacy, therefore, were already high when on a hot August night in 1662 an armed skirmish erupted on the streets of Rome pitting the pope's Corsican Guards against the soldiers of the French ambassador, the Duc de Créqui, who was then living (as French ambassadors still do today) in the Palazzo Farnese. The ambassador's wife, just at that moment returning home by carriage from her evening church devotions, was caught in the terrifying exchange of fire between the two parties. She escaped harm—by fleeing to Francophile Cardinal Rinaldo d'Este's residence—but one of her pages was shot dead. Even though this incident was just as grave as, if not graver than, the London clash-of-coaches, it would not have spiraled into the international uproar that it did, had Louis XIV not been intent on seizing another opportunity to humiliate a rival and assert his supremacy on the European stage. Claiming that Alexander had deliberately provoked the incident, France eventually demanded a long list of reparations from the pontiff. Those reparations struck the pope close to home: they included banishment from Rome of the pope's brother, Don Mario Chigi (superintendent of the papal guards) and the erection of a large public monument in the center of Rome—known as the "Pyramid of Shame"—to publicize papal culpability and contrition. When the pope's contrition was slow in coming, Louis sent his troops to seize the papal territory of Avignon, which they did, and to march onto the Italian peninsula toward Rome itself, which they likewise did.

With the French army heading his way, Pope Alexander was forced to submit, completely and abjectly, to all of France's terms, signing the Treaty

of Pisa on February 12, 1664. The Pyramid of Shame was duly erected—with the possible collaboration of Bernini's architectural assistant, Mattia de' Rossi—near the barracks of the Corsican Guards, not far from the Palazzo Farnese. The French court once again publicized and immortalized this "monumental" victory with the issuance of another exquisitely cast bronze medal. (The pyramid was demolished in June 1668, four years after its erection, following Pope Clement IX's concessions to King Louis regarding the right of royal nomination of certain bishops and abbots.) At this juncture in his biography of our artist, Bernini's son Domenico makes a dramatic claim: "At the peace negotiations, it was secretly agreed that the pope would concede permission to the Cavalier Bernini to go to France and remain there for at least three months in the service of His Majesty. On this one point the king so insisted with Cardinal Flavio Chigi (who had gone to Paris with the title of papal legate in fulfillment of the terms of the peace concordat), that he demanded oral confirmation of this detail directly from the cardinal's mouth." In other words: See how important Bernini was? So important that he even figured into the highest levels of political negotiation between two of the august powers of Europe.

However, thus far no confirmation of Domenico's claim has been found anywhere in the documentation, not even in the gossipy but usually well-informed *avvisi di Roma*. The pope's official—and patently reluctant—permission to release his prized possession, Bernini, to King Louis did not come until over a year later, on April 23, 1665 (Domenico prints the full text of the letter, though incorrectly dating it April 27). Had the pope agreed through his legate in Pisa in February 1664, and amid such dramatically decisive political circumstances, to lend out "his" Bernini, the artist would have had little or no choice in the matter. Instead, as long as the pope himself was unwilling to concede this victory to Louis—Alexander, as did all of Europe, knew the supreme symbolic value of this tug-of-war over Bernini—the artist continued to play hard to get. And he did so until April 21, 1665, when, according to a letter by Cardinal Sforza Pallavicino, the pope finally conceded the game to Louis and delivered a firm, direct order to Bernini: "We beg you with great insistence to satisfy the King's request." Making the artist appear less of a pawn and more of a free agent, Domenico's biography instead leads us to believe that the pope had not forced or given his permission to Bernini until Bernini himself came forward to say that he had agreed, of his own accord, to go to Paris.[1]

The entirely tentative tone of the surviving correspondence between Paris and Rome in the months preceding Bernini's departure would indicate that there was genuine doubt on both sides as to the outcome of negotiations with the artist and the papal court. The doubt was great enough for the French court to put pressure on VIPs in Rome, such as the two Jesuits, Sforza Pallavicino and Gian Paolo Oliva, to persuade Bernini to accept Louis's offer. Likewise arguing against Domenico's claim is the competition among Roman architects for new Louvre designs initiated by the French court in April 1664, Bernini being only one of four architects asked to submit plans to the contest. However, on the other hand, the existence among Bernini's personal papers (now at the Bibliothèque nationale, Paris) of a translated copy of the August 30, 1662, letter from Louis XIV to Alexander VII regarding the king's reaction to the Créqui affair would in fact lead one to suspect that Bernini somehow was involved in this diplomatic affair, for why else would he have come to posses a copy of official correspondence between two heads of state?

The signing of the Peace of Pisa treaty in February had, nonetheless, emboldened the French court to, shortly thereafter, take the next step and write directly to the pope's architect. The task fell to Louis's superintendent of buildings, arts and manufacturing, Jean-Baptist Colbert, who functioned, in effect, as a kind of minister of fine arts (fig. 28). In a culture in which, as we have seen, the arts played a crucial political role, Colbert exerted much influence in his position as superintendent of buildings. But it was just one of several offices that Louis eventually invested upon Colbert, his chief minister, the most powerful of the advisors who sat on the royal council. Colbert's effective power was such that he answered only to the king. On March 9, 1664, Colbert sent by special royal courier the following letter to Bernini:

Signor Cavaliere, the exceptional creations of your spirit, which earn for you the admiration of the entire world and of which my master, the King, has perfect knowledge, are such that he could not allow himself to finish construction of his superb and magnificent palace of the Louvre, without submitting the designs for examination by the eyes of so excellent a man as yourself and thereof receive your opinion. Accordingly he commanded that I write you these lines in order to entreat you most earnestly on his behalf to spare some of the time you are devoting, with so great glory, to the

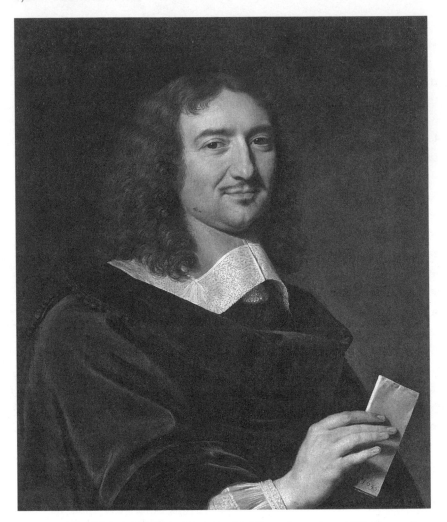

FIG. 28 ➤➤ *Philippe de Champaigne Jean-Baptist Colbert*, oil on canvas, 1665, Metropolitan Museum of Art.

embellishment of the premier city of the world, and examine the plans that will be delivered to you by Signor Abate Elpidio Benedetti.

Regarding the latter plans, His Majesty would desire that you not only communicate your opinion of them, but that you would also be willing to set down on paper some of those admirable conceptions that spring so readily from you and of which you have given so much demonstration. His Majesty also desires that you give full credence to all that which the aforementioned Signor Abate will communicate to you on behalf of the King regarding this

matter; hence, if it please you, I entrust the remainder of this communication to him. And please rest assured, through these few lines, that I am truly

Your Most Humble and Most Observant Servant,

Colbert

In entreating Bernini to supply a design for the new Louvre, the letter mentions nothing of Bernini's coming to Paris. But both parties well knew that in order for a significant, complex work of architecture such as this to be properly executed, the designing architect would have to supervise the actual work on the spot, at least in its initial phases. The project in question, by the way, did not entail construction from scratch of an entirely "new Louvre" but rather completion of the major additional portion (today known as the Cour Carrée, "Square Court") that had already been initiated and slowly advanced by Louis XIV's predecessors. What remained to be done—and what Bernini was asked to design—was the important fourth and final wing of that four-sided building, even though the earlier portions might be subject to transformation in the process. Bernini's facade (facing east and the still standing Church of Saint-Germain l'Auxerrois) was to be the principal entrance to the royal palace. Bernini was, therefore, charged with creating one of the ceremonially most conspicuous public "faces" of Louis's reign. Louis fully understood (as we already heard Bernini remark, repeating a political-architectural commonplace of the time) that "buildings are portraits of the spirit of princes."

Colbert's letter reached Bernini on April 20, and the artist quickly responded. With a letter of May 4, having secured papal permission to do so, he accepted the task. Soon thereafter, by mid-June, he produced a design. The design reached Paris on July 25, and even before it arrived at its destination, Bernini had been rewarded with the costly and dazzling gift of a small painted portrait of King Louis, surrounded by forty diamonds. Inflating the figures as is his habit, Domenico says the gift was worth 8,000 scudi, whereas Baldinucci says it was worth "only" 3,000. In any case, it was a gift fit for a prince. Whatever Bernini may have felt about the portrait itself as a work of art or its sitter as a political leader or human being, he would have, of course, welcomed such a "reward." (The vulgar word "payment" is never used to describe the sublime Bernini's compensation from equally sublime princes.) Jewelry was always a useful, readily liquidated form of

remuneration, even though the artist preferred the gold and silver of hard cash, as he had told the agent of Duke Francesco d'Este when discussing possible "rewards" for his portrait bust. Louis's gift has not survived, unfortunately (one of Bernini's daughters-in-law decades later dismantled it to recycle the diamonds into a piece of jewelry for herself), but a similar object sent by Louis to another Italian, art biographer Carlo Cesare Malvasia, can today be seen in a museum in Bologna.

What Colbert's letter of March 1644 did not mention was that the same invitation was, in fact, being sent at the same time to three other architects in Rome—Pietro da Cortona, Carlo Rainaldi, and a certain Candiani. (Strangely enough, though presumably talented enough to be given this honor by the French court, Candiani is otherwise completely undocumented in the history of architecture.) Led to believe this was a personal commission to him alone, Bernini was being blindsided. And to add insult to injury, not only was he being put into a competition, he was also being placed in the same class as men he considered his inferiors—since deep down, or perhaps not so deep down, Bernini considered all other architects his inferior. He did not find out about the competition until several months later, in October 1664, and when he did, he was, to put it mildly, not happy. Had he known of the competition he would never have touched this commission, he bitterly complained to Colbert's Roman agent, Elpidio Benedetti. In vain, Bernini tried to deny what he knew everyone firmly believed: it was not that he considered himself above everyone else. On the contrary, he protested, "he considered himself the least among all in his profession." By that same October, Bernini had another, equally disturbing motive for agitation over this commission: except for a brief note from Colbert in July acknowledging receipt of his design, the artist had heard nothing from the Parisian court by way of response to his creation. Was it a case of "No news is good news"? wondered the artist.

No, in this case, no news was bad news. The delay in the French response was due not only to the fact that both Minister Colbert and King Louis were extremely busy men, governing a nation and plotting the creation of an empire. There was a second reason as well. Carefully examining Bernini's design, the judicious Colbert found many things wrong with it on all fronts. Once he had shared his reservations with the king, he laid out his criticism in precise detail in what turned out to be a long memorandum for Bernini. This, understandably, took time. The objections were eventually

communicated to the court's agent in Rome, Benedetti. However, well acquainted with Bernini's easily offended sense of personal honor and violent temper, the fearful Benedetti did not want to be the one to have sit down with the artist and spell out to him all of Colbert's numerous and grave objections. That unpleasant task, instead, fell to Cardinal Flavio Chigi. It was decided that once the cardinal returned to Rome from his diplomatic mission to Paris—he had been sent there to formally extend papal apologies for the Corsican Guard incident as dictated by the Treaty of Pisa—Chigi, as a more authoritative and more familiar personage, would be the bearer of the bad news to Bernini.

As predicted, Bernini exploded in anger, not in Cardinal Chigi's presence (offending the cardinal nephew would have had terrible consequences for the artist), but in that of French ambassador Créqui. Créqui, naturally, reported the explosion back to Colbert, who thereby got his first taste of Bernini the temperamental superstar. Eventually, Bernini calmed down and was persuaded to prepare a second design. In doing so, however, he expressed his certainty that French architects would never permit a foreigner to design a French royal residence. Bernini's feeling was, unfortunately, prophetic. In the end—and the end came in July 1667 when the Bernini Louvre project was formally canceled by Colbert—the Italian artist prepared a total of five designs, all surviving today in form of drawings and engravings.

Despite all his revisions and despite repeated, detailed feedback from Colbert, Bernini never succeeded in meeting the expectations of his French patrons. Bernini's design was always found seriously wanting, but not on the level of aesthetics—aesthetics are never mentioned in any of Colbert's (or his agent Elpidio Benedetti's) surviving memos to or regarding Bernini. Bernini's designs certainly conveyed the necessary royal *magnificentia*. As far as we know from the surviving documentation—and despite what one frequently reads in the Bernini literature—his French patrons never criticized the aesthetic style of Bernini's plans as being, for example, "too Roman" or "too Baroque" or "too flamboyant." No, his plans were found seriously wanting, instead, on the just as important level of the physical security and comfort of those who had to occupy the residence: the king, his family, and his court. (Cost and construction time were also major concerns.) In his critiques, Colbert is above all concerned about practical issues like climate (cold, heat, wind, humidity), personal safety, noise, and the

size and disposition of rooms, hallways, staircases, and other elements like kitchens and courtyards. If the external, that is, aesthetic, look of Bernini's Louvre plans changed over time, it was as a result of his responding to these sorts of practical internal considerations, not artistic, stylistic complaints.

Bernini's failure to respond to these necessities, as well as the effective opposition of a cabal of resentful French architects, eventually killed the project. But lo and behold, once Bernini was no longer part of the picture, the new Louvre was quickly designed, approved, and built by a team of French architects, with results that are, it must be admitted, majestically elegant and classically French. (Bernini's Louvre plans, though unexecuted, did not die to the world: they were engraved and circulated throughout Europe, where they influenced the design of many a stately royal building, from Sweden to Spain.) Colbert claimed in 1667 that the cancellation was simply due to the prohibitive expense of money and time, especially since France was about to enter a long, costly war. But no one has ever been convinced by that explanation, at least not as the full story. An even more puzzling question is why Bernini's project was ever allowed to advance as far as it did in the face of Colbert's abiding and entirely justifiable reservations. Despite these reservations, Colbert encouraged and paid for Mattia de' Rossi's return to Paris in spring 1666 to spend an entire year creating a full, three-dimensional (and very expensive) wood and stucco model of Bernini's building design.

As Bernini well knew, the fundamental mandate of any architect, as taught by the great ancient master, Vitruvius, was to produce a building of "venustas, firmitas, utilitas," that is, attractiveness, stability, and usefulness. Yet in Paris Bernini behaved as if preoccupation with *utilitas*, that is, mundane practicalities like security and creature comforts—including the location of latrines—were either beneath the dignity of an architect or simply had to take second place to aesthetics. He was an artist, not a mere tradesman, he seemed to think. In Bernini's own estimation, instead, it was pure jealousy that killed his project, on the part of not only the French architectural cabal but also Colbert. Colbert, according to Bernini's conspiracy theory, did not want to see his place of honor as royal architectural advisor usurped by the Italian artist, who seemed to be charming his way into King Louis's good graces and personal favor. Given the vicious struggle for power and status in the zero-sum, self-enclosed world of a royal court, it was all but inevitable that not long after Bernini got to Paris, the sparks

would begin to fly between the artist and the equally strong-willed Colbert. But that is getting way ahead of our story. We first have to get Bernini out of Rome, across the Alps, and into the city of Paris.[2]

OVER THE ALPS IN A SEDAN CHAIR

The road ended abruptly at the foot of the mountains, and to cross to the other side heading northwest to France, you had to take the ancient but unpaved trail over the Mont Cenis Pass, first traversed in pre-Roman times by the Celts. The crossing could be done either on foot, or astride an obliging mule, or, at best, in a small, wobbly sedan chair, entrusting your life to the strength and dexterity of specialized local porters who had been providing this grueling service for centuries. Since the twelfth century, Mont Cenis had been the principal Alpine route from Italy to France. (Actually, until 1860 you were in the independent Duchy of Savoy on either of the two immediate sides of the mountain.) However, at 6,827 feet (2,083 meters), the pass was still treacherous five centuries later and the descent was no easier than the ascent. And in the pre–Romantic Era days, there were no dreamy, poetic notions in circulation about the sublimity and grandeur of these awesomely wild, untamed colossals of the natural landscape—the Alps—to help transform the harrowing experience into an uplifting (physically and emotionally), lyrical thrill. It was hard to romanticize what was a forbidding, often dangerous physical barrier between you and your destination. These vast wastelands—populated, they said, by ferocious animals and a grotesque subspecies of humanity—inspired dread, horror, and gloom. Their existence was also a philosophical conundrum: monstrously chaotic, harshly contoured, and "useless" mountain ranges seemed so out of place within God's orderly, purposeful, and aesthetically pleasing universe.

Yet, philosophical puzzles aside and despite danger and inconvenience, each year many people needed to cross the Alps for whatever reason and, as a result, the Mont Cenis Pass received a constant stream of traffic. Some of that traffic even made history, as when Hannibal and his elephants crossed in 218 BCE (or so legend has it), and later, in 312 CE, when Constantine the Great descended into Italy toward Rome for what was to be his fateful victory over Maxentius at the Milvian Bridge. It took the diminutive but determined Napoleon to finally construct a modern highway over the pass, which opened in 1810. Several decades later, Mont Cenis was definitively

FIG. 29 →→ A sample of Bernini's handwriting; postscript of a letter written in Bologna by Mattia de' Rossi then traveling with Bernini to Paris, May 5, 1665, Bibliothèque Nationale, Paris. Ms. italien 2083, p. 57. The text translates: "I send my affectionate greetings to all, in particular to my dear Monsignor [i.e., his eldest son, Pietro Filippo], who, I hope, is remembering me at Mass, which is most important of all. Please send my regards to Signor Lotti, in whom I have great hopes. In the name of Jesus and Mary. + Gio. Lorenzo Berninij." It is not known what favor or service Bernini expected from Giovanni Lotti (d. 1688), a poet-librettist-scholar of considerable reputation and extensive social connections who worked variously for the Barberini, Rospigliosi, and Colonna families, as well as for Queen Christina of Sweden.

conquered with the inauguration in 1871 of the nearly nine-mile Fréjus Tunnel. The tunnel pierces clean through the heart of the mountain that had daunted, if not terrified, so many travelers, including Bernini in that May of 1665 (fig. 29).

Chances are that it was precisely at this moment in his long journey from Rome to Paris, coming to a halt at the foot of the Alps and contemplating the ascent ahead of him, that Bernini exclaimed to himself, as Italians are wont to do in such situations: "Chi me l'ha fatto fare?!" How did I let myself be talked into this?! Who would blame him if he had also thrown in a few curse words. But mostly he prayed, to be sure. Perhaps he also recalled the words of his spiritual advisor, the revered Father Oliva, whom he had sought out in those anxious, indecisive days in April leading up to his and the pope's final surrender to French coercion. Oliva had told him in no uncertain terms: he must agree to "enter into the service of so great a monarch," Louis XIV, "even if an angel were to come down beforehand announcing that he would lose his life upon the Alps." The good Jesuit is much praised in the Bernini literature for getting Bernini to Paris. How-

ever, one wonders if it occurred to Bernini, as it did to his later biographer Filippo Baldinucci, that Father Oliva's unconditional advice was not completely disinterested. The Jesuit order was in those days maneuvering its way—successfully so—to a position of religious domination within the new king's government, and within his own moral conscience (as difficult as it is for us today to believe that Louis's policy decisions reflected sincere, moral conscience). Since his 1654 coronation and until his death in 1715, Louis's official personal "confessors" were all Jesuits (Fathers Annat, Ferrier, La Chaise, and Le Tellier). To consolidate and maintain this place of privilege and influence, Oliva, "father general" of his order, was always eager to find ways to further ingratiate himself with the monarch, for the Jesuits had many fierce enemies in and outside the ecclesiastical establishment.

But, one might here object, could Bernini not have saved himself some anguish and taken the shorter sea route, across the Mediterranean from Civitavecchia to Southern France, thus avoiding the Alps? For Bernini and many others, however, that prospect was even less appetizing: death by shipwreck was always a possibility, for the Mediterranean was by no means immune to dangerously stormy weather. Equally possible was seizure by marauding infidel pirates who perpetually stalked that busy sea and usually returned home with a host of Christian captives whom they held prisoner until ransom was paid. That is, in fact, what happened in 1674 to a young French architectural student, Augustin-Charles d'Aviler (also known as Daviler), whose acquaintance Bernini later made in Rome during the Frenchman's residence at the French Academy (1676–79). En route from Marseille to Genoa, d'Aviler's ship was overrun by Algerian pirates, and the unfortunate youth spent the next sixteen months a prisoner in Tunis.[3]

Actually, up until now, the journey from Rome had not been so bad, all things considered. The artist had a temporary flare-up of his "usual kidney pain" at Siena and just before Bologna, at the last minute, he and his entourage had to improvise lodgings at a monastery, since there was no more room at their intended resting place, an inn uninvitingly named the Scarica l'Asino, the Donkey Discharge. But they never had to fend for themselves: the king had sent a royal courier, a certain Monsieur Mancini, and a quartermaster to oversee the transport of the Bernini party from Rome to Paris. More important, the monarch also sent in advance a hefty pile of cash—30,000 livres—to pay for a comfortable journey from start to finish.

Louis's "artistic" victory over Pope Alexander was, by the way, to cost him dearly in sheer monetary terms. The expense of Bernini's travel and Parisian stay in the end amounted to over 100,000 livres, an astronomical sum by any reckoning. Yet this was simply one of the many astronomical sums spent by Louis on his self-aggrandizing artistic projects (above all, Versailles) and his incessant wars, while 80 percent of the French population went poorly housed, poorly clothed, and poorly fed—when they weren't actually starving. No wonder there was a revolution.

"Seized away rather than freely released," as Domenico says, Bernini had left Rome on April 25, 1665, and arrived in Paris a little over a month later on June 2. His traveling companions (in addition to the aforementioned courier and quartermaster) were his seventeen-year-old son, the apprentice-sculptor Paolo Valentino; his long-term, faithful majordomo, Cosimo Scarlatti; his principal assistants in matters of architecture and sculpture, respectively, Mattia de' Rossi and Giulio Cartari; an otherwise unknown interpreter identified in French documentation as "Barbaret" (Barbaretto in Italian?); and two other unnamed servants. The party was undoubtedly well armed, given the omnipresent brigands on the road, known from the paintings of the Roman *Bamboccianti*, the illustrators of scenes of everyday life, especially of low-lifes. Brigands are just one of the reasons why all Rome, we are told, had wept at the artist's departure, fearing that they "would lose him completely either to the dangers of that long journey or to the enticements which that powerful monarch would offer him in order to keep him permanently in his service."

At every resting stop in Italy and France, Bernini was treated like royalty, which, one can be sure, he did not mind. Another source of pleasure, no doubt, was that he finally got to see with his own eyes many of the famed masterpieces of art and architecture in the cities and towns along his route. Unfortunately, next to nothing is recorded of his spontaneous reactions to what he saw, a great loss to art history. (In Florence, we know that he, not surprisingly, "praised to the skies" Giambologna's celebrated statue of *The Rape of the Sabines*, and in Siena was eager to see all the works of the Sienese painter Ventura Salimbeni, but that's about all we know of Bernini's personal responses to works of art while traveling to Paris.) Bernini's route took him, among the principal stations, through Viterbo, Bolsena, Siena, Florence, Bologna, Milan, and Turin; then, after the Alps, to Chambéry (then part of Savoy, not France), before arriving at the first town in France,

Pont-de-Beauvoisin, eventually followed by Lyon, the party's first major stop in French territory. In Italy, the local lords—including the Grand Duke of Tuscany, Ferdinand II; and Duke of Savoy, Carlo Emanuele II—came out to personally greet Bernini and offer the hospitality of their homes and coaches. People of lesser stature—including an extraordinary number of nobility in Turin—lined the streets and squares in order to catch a glimpse of the superstar. "It was as if an elephant were traveling around," Bernini quipped about the excited response of the curious crowds to his passage through Italy. Live elephants were, needless to say, an exceedingly rare sight in those days in Italy, though Bernini himself would have had the opportunity of seeing the animal for himself at least twice in his life when pachyderms came visiting Rome in 1630 and 1655 and performed for their spectators for a fee.

On May 22 Bernini and company arrived in Lyon, the second-largest city in France on the banks of the busy Rhône River, where they spent the night. From there onward the party's progress was more rapid and even more comfortable, thanks to the easier geography of France and the arrival of extra staff from the royal household—the *maître d'hôtel*, a chef, and several other specialized servants dispatched by Louis to meet the artist's every need en route. At a certain point one of the royal attendants was even sent off to a nearby town to fetch some ice so that Bernini would have cool drinks at his disposal. Though less than forty-eight hours long, Bernini's stay at Lyon was memorable. He was formally welcomed by the assembled ranks of the civic officials, nobility, and representatives of every guild, with numerous eloquent orations, estimable gifts, and even more numerous personal visits to Bernini once he settled in the patrician lodgings reserved for him by the city's fathers. As the local archbishop remarked of the artist's reception there, "This is a completely extraordinary honor, one that the city of Lyon reserves only for princes of the blood."

However, soon the continual flow of visitors paying their respects at his residence became too much for Bernini. Not wanting to commit a breach of etiquette by simply closing the door to any of his well-wishers, Bernini resorted, as he often did, to theater: he made use of an amusing theatrical ruse, a trick of switched identities often seen in popular comedy, including his own. He dressed up his majordomo Cosimo Scarlatti—of similar age, physical appearance, and *gravitas*—in his own clothing, including all the regalia of his knightly rank, and had this fake Bernini greet local visitors in

his place. Life imitates art. The ever mischievous Bernini must have thoroughly enjoyed this theatrical deception successfully deployed upon yet another unsuspecting audience. Did any of the Lyonnais ever find out?

From Lyon, Bernini and his company headed northwest to Roanne, where they transferred from coach to boat to ascend the Loire River until the town of Briare. There the king's only sibling, the flamboyant Duke of Orléans (known simply as "Monsieur"), had placed his own princely coaches at Bernini's disposal, and in these more stately conveyances the party proceeded north by land. They passed through Châtillon-sur-Loing, Montargis, Fontainebleau, and Essonnes, before arriving at Juvisy, less than ten miles south of Paris. They reached Juvisy early in the day on Tuesday, June 2, 1665. At Juvisy another change of coaches occurred—this time Bernini got to ride in the coach of Minister Colbert's brother, Charles-François. There also took place at that juncture the first official encounter between Bernini and a personal representative of the king, that is, an aristocratic representative, not a mere courier or quartermaster as had been the case thus far.[4]

The man in question was Paul Fréart de Chantelou. Chantelou was a member of the royal household, a man of minor nobility but whose various responsibilities in court (especially his role as steward) afforded him frequent, direct contact with the king. This gave him within the court an enviable position of privilege. Chantelou spoke and wrote excellent Italian, having spent time in Rome on a couple of extended visits on royal art-collecting business. He also had a deep knowledge of the arts, like his author-brother, Roland Fréart de Chambray, who translated into French Leonardo's *Treatise on Painting* and authored a fundamental reference work of architectural theory, *A Parallel of Ancient Architecture with the Modern*, a copy of which Bernini received as a gift during his stay in Paris.

In addition to being the first bearer of Louis's formal greetings to the king's newly arrived Italian guest, Chantelou was assigned to serve as Bernini's daily companion, interpreter, diplomatic mediator, and tour guide during his entire stay in Paris. Luckily for both Bernini and Chantelou, a rapport of apparently genuine trust and affection developed between the two men, enduring (at least by correspondence) beyond their few months together (they were never to meet again in person once Bernini left Paris on October 20). This friendship was quite an achievement, especially on the part of Chantelou, who was frequently caught in the crossfire between

Bernini and various members of the court, from Colbert down. Luckily for posterity, Chantelou kept a detailed journal of what he saw, heard, and did during his time with Bernini, published in English as *Diary of the Cavaliere Bernini's Visit to France*. The diary is filled with wonderfully intimate and entertainingly mundane details about Bernini's character, behavior, mannerisms, utterances, and experiences, some of which we shall sample later in this chapter.

On the occasion of this first meeting at Juvisy, however, Chantelou had the pleasure of Bernini's undivided attention only for a short while. After traveling north for three miles, they were intercepted by the nuncio (papal ambassador) to France, Monsignor Carlo Roberti de Vittorij, who had come out to meet Bernini, together with other members of the French court. Yet another change of coaches and conversation partners for Bernini. Fortunately, Bernini, entirely used to being in the company of august personages, was never intimidated by folks of this stock and certainly never at a loss for words. In the late afternoon of the same day they finally arrived in Paris, where Bernini and party were immediately lodged in the Hôtel de Frontenac within the precincts of the Louvre. After two months, Bernini was moved a bit further away from the distractions of the royal palace, to, somewhat ironically, the Palais Mazarin. This was the sumptuous residence of the late Cardinal Mazarin, who had attempted, as we saw, to lure Bernini to Paris with generous commissions, including the expansion and renovation of his own palace now being used as guest quarters by the artist. Was Bernini ever able to sleep serenely in the cardinal's home, still filled with his possessions and his memory, if not his spirit as well? Though a sensitive art-lover and patron, Mazarin was also a hated scoundrel in the eyes of many of his contemporaries, as he was for much of posterity. At one point Bernini diplomatically hinted at this ambiguous reputation, expressing his own reservations about the state of the late cardinal's soul:

> The Cavaliere repeated some reflections which he said often occurred to him in the Palais Mazarin—how little it profits a man to have built great palaces, possessed vast wealth and high favors; it might have been better for the Cardinal had he thought about having good quarters where he is now. Father _____, a Dominican and a papal preacher said . . . those who were Christians and refused to give up their sinful ways should be put in the madhouse.[5]

"Speak to Me of Nothing Small!"

The first encounter between Bernini and the man who held the keys to Louis's kingdom, the daunting Jean-Baptiste Colbert, took place later that same day, June 2. Sometime before leaving Rome, Bernini had assuredly been well apprised of the personality and reputation of Louis's extremely capable and extremely loyal second-in-command and the person to whom he would be directly reporting while in Paris. As one historian has summarized his reputation, "Jean-Baptiste Colbert enjoyed little popularity among his contemporaries and even today remains eminently unattractive." Of all the biographical details of Colbert's life, one of the most vivid was the image on the minister's blazon, his heraldic mascot: a grass snake. Though this detail of his family's coat of arms was merely a linguistic reference (the name "Colbert" supposedly derived from the Latin word for such a reptile, *coluber*), it was not exactly an image that would predispose one to liking or trusting the person bearing such an association. *Nomina sunt consequentia rerum* was an ancient and still current belief, that is to say, there is an intimate connection between the things of this world (including people) and their names. Bernini must have pondered that thought with some dread as he prepared to meet and play the usual political game of court with Minister "Snake." Among the actual nicknames given to Colbert at court, there was *Le Nord*, "The North," devised by Madame de Sévigné because of the minister's formidably frosty, aloof, businesslike-to-a-fault manner.

Nonetheless, the first meeting between Louis's cold "snake" and Rome's fiery "monster of genius" was completely cordial and totally lacking in formal ceremony, almost amusingly so. Bernini happened to be lying in bed taking a nap when Colbert unexpectedly came calling. Colbert had rushed over as soon as he received word of the artist's arrival, as an expression of honor and respect for Bernini. But the even greater expression of honor and respect was the fact that Colbert refused to let Bernini get out of bed. And so Colbert delivered his fine formal words of official greeting to a supine and probably still drowsy and slightly unkempt Bernini. No one, Italian or French, would have missed the diplomatic significance of so great a compliment on Colbert's part. Another great compliment paid Bernini on this occasion was Colbert's announcement that the king was extremely impatient to meet him and wanted to do so as soon as possible. So, just two days later, early on the morning of Thursday, June 4, Colbert came to fetch

Bernini, his son Paolo, and his architectural assistant, Mattia de' Rossi, and took them to meet the king at the royal castle of Saint-Germain-en-laye, some twelve miles northwest of Paris.

Very little remains today of the original splendor of the castle and gardens of Saint-Germain-en-laye, but when Bernini first saw them they were impressive indeed. Saint-Germain, a royal estate since the twelfth century, was the king's preferred residence in those years before the building of his beloved official residence and place of business, Versailles. Ironically, King Louis, by choice, was never to occupy the Louvre, despite the money he poured into what was planned as the Parisian home of the royal court. Paris, he decided, was not sufficiently safe or clean for his comfort. In the course of his stay at the French court, Bernini would thus be obliged to drive out to Saint-Germain on several occasions in order to meet with the king to discuss the Louvre project and sketch him for his portrait bust. Like the first meeting between Colbert and Bernini two days earlier, this one between the artist and the king took place in a bedroom, King Louis's. But to be sure, the king was fully awake, fully dressed, and fully prepared to greet his Italian guest with all due pomp and circumstance. Despite the formality of the occasion, Domenico claims that Louis's impatience to set his eyes on Bernini was so great that it overwhelmed His Majesty's normally acute sense of royal decorum:

> Unable to endure the delay in seeing him, the king simply peeked his head out from behind a doorway; curious to see where Bernini was and what he looked like, his eyes scanned the room searching for the artist amidst that multitude of knights. Bernini, for his part, having noticed that bit of movement from behind the aforementioned doorway, turned his eyes in that direction and immediately remarked, "That's the king." The Maréchal de Turenne expressed his amazement that Bernini was able to recognize Louis since he had never seen him before that moment; to which the Cavaliere replied that he "had recognized in that face, at his very first glance of it, a greatness and a majesty that could belong to no one else but a great king."

Chantelou's diary, not surprisingly, makes no mention of this unregal detail of the king's eagerness to satisfy his curiosity. Instead, it is confirmed for us by eyewitness Mattia de' Rossi, who wrote a letter to Monsignor Pietro Filippo Bernini in Rome describing this first encounter: "The King,

anxious to see the Signor Cavaliere, appeared from behind a door and looked at the Cavaliere, laughed, and then withdrew inside again." Mattia does not explain, however, why the king laughed. Nervousness? Amusement at the sight of the real, flesh-and-blood Bernini?

As for Bernini's "instant recognition" of Louis from the sheer "greatness" exuding from his very person, this is, in fact, simply a commonplace of the day about great personages: they always recognize each other at first sight, on the principle that "it takes one to know one." But in this case, the truth was otherwise. Not because Louis was not impressive in his physical appearance. Hortense Mancini, sister of Louis's first lover, Marie Mancini (both of them Cardinal Mazarin's favored nieces) says in her memoirs that even as a teenager playing among friends, Louis could be unmistakably and intimidatingly regal without even trying: "Although he lived among us with marvelous kindness, there has always been something so serious, so solid, and frankly, so majestic in all his manners that he could not help inspiring awe in us, even without intending to." No, Domenico's claim is untrue for the simple fact that Bernini already knew what the king looked like. Our biographer forgets that he had told us in the previous chapter that Louis XIV had sent Bernini just a few months earlier a bejeweled painted portrait of himself to reward him for his labors on the first Louvre design. From this, and the assuredly many other representations of the king to be seen in Rome, the artist was already well acquainted with the king's distinctive likeness.

Upon finally meeting, both king and artist were impressed, or at least publicly avowed to be impressed, with each other. Chantelou tells us that Bernini behaved "with complete self-confidence" even in the presence of such majesty. The artist repeated to Louis, undoubtedly in more flowery and flattering language, what he had told Colbert about the reasons that had persuaded him to make the long, difficult journey to Paris, namely, that "he had heard on all sides that the King was a great prince with a great heart and a great intelligence, as well as the greatest gentleman in his kingdom" and hence, it was the greatest of honors to serve so sublime a monarch. Mattia de' Rossi's long letter to Rome of June 5 assures us that Bernini, in effect, had the king from the first hello:

Signor Cavaliere always knows how to give truly beautiful, well composed speeches, but that morning it was apparent that the grace of God was help-

ing him in an extra special way, for not a word left his mouth that did not fill the king with admiration. The king at one point turned towards the members of his court and exclaimed: "Yes, indeed, I well now know that this is fully the man that I had imagined for myself." This declaration of the king's was so powerful in its expression of esteem that the court remained stunned and satisfied, considering it a veritable oracle.[6]

Further praise was regularly exchanged between Louis and Bernini during their subsequent meetings. Theirs was a mutual admiration society, or so it seemed on the surface. (One scholar has, instead, argued that if we look closely at the evidence, underneath all the constant hyperbolic expression of affectionate esteem and exquisite politeness lies not mutual admiration but, rather, mutual disdain between king and artist.) Describing Louis's demeanor toward Bernini in a later letter to Rome, Mattia claims that the king spoke to and jested with Bernini in a very familiar manner "as if he were his best friend," and, to the astonishment of all, even asked Bernini's pardon for having to miss appointments, something unheard of in a king's interaction with an inferior. And, as they were expected to do, Louis's well-trained, groveling courtiers took their cue from the king. Soon, as Domenico reports, believably in this case, "the leading knights and most eminent ladies of Paris were running to him at every hour; and throughout that city, they spoke of nothing else but the Cavaliere. Whereby Bernini wrote in a spirit of amusement to his great friend, Cardinal Pallavicino, that 'There was no other fashion in Paris than the Cavalier Bernini.'" Yet Bernini was troubled from the start by all this adulation. As he himself confessed, he wondered whether he could "adequately live up to the exalted image" the king had formed of him. Moreover, with his long experience of court life, Bernini well knew that sooner or later jealousy would transform the applause and hospitality of the French courtiers into poisonous, vindictive opposition. He was correct on all accounts.

Meeting Louis for the first time, Bernini, of course, addressed the specific matter that had brought him to his court, the Louvre. He assured the king that he would design a royal residence far more magnificent than all those he had seen en route from Rome to Paris. Then turning to the crowd of courtiers surrounding the monarch—the cream of the crop had been invited for the occasion—Bernini, with calculated dramatic flair, added by way of emphatic admonishment: "Speak to me of nothing small!"

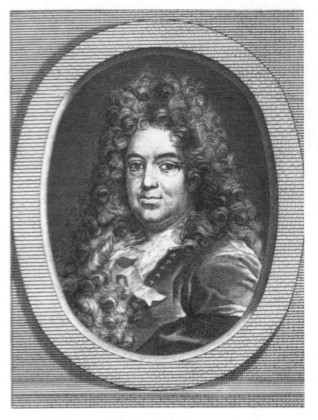

FIG. 30 ⤞ *Charles Perrault*, contemporary engraving.

Summing up the artistic vision of his lifetime, these words could have well served as Bernini's epitaph. But as far as his Louvre project is concerned, they ring with bitter irony, for it was precisely the excessive, costly, but inefficient grandiosity of Bernini's design that helped damn the project. Nonetheless, for the moment, the speech impressed the audience. Among the eyewitnesses was Charles Perrault (fig. 30), trusted personal assistant to Colbert in matters of art and architecture. Perrault was soon to become a leading member of the French cabal organized to defeat Bernini at court. Though his lasting literary fame rests in his collection of fairy tales (*Cinderella*, *Little Red Riding Hood*, *Puss in Boots*, etc.), Perrault has also left us his *Memoirs* containing several, entertainingly spicy pages about, or rather, against Bernini. Some of the latter negative appraisal may be exaggerated,

but it serves as a good corrective to the mass of fawning glorification that one finds in Domenico and Baldinucci. But in his *Memoirs*, even Perrault, with all his hatred for Bernini, had to grudgingly admit the Italian artist's star quality:

> He was slightly below average height [this was fortunate, since Louis himself was only 5'4"], but with a pleasing appearance and a bold manner. His advanced age and great reputation gave him even more confidence. He had a lively, sparkling wit, and a great talent for making himself shine in company; he was a good speaker, with a full stock of sayings, parables, anecdotes, and witticisms which he used in most of his remarks, not deigning to give a simple answer to a question.

This squares with what we find in the description of a much friendlier source, Chantelou:

> Bernini is a man of medium height but well proportioned and rather thin. His temperament is all fire. His face resembles an eagle's, particularly the eyes. He has thick eyebrows and a lofty forehead, slightly sunk in the middle and raised over the eyes. He is rather bald but what hair he has is white and frizzy. . . . He is very vigorous for his age and walks as firmly as if he were only thirty or forty. I consider his character to be one of the finest formed by nature, for without having studied he has nearly all the advantages with which learning can endow a man. Further he has a good memory, a quick and lively imagination, and his judgment seems perspicacious and sound. He is an excellent talker with quite an individual talent for expressing things with word, look, and gesture, so as to make them as pleasing as the brushes of the greatest painters can do. This is no doubt the reason why his comedies have been so successful.[7]

Once the initial formalities were over, Bernini and Mattia immediately settled down to work on the Louvre design. Say what you want about Bernini, but he was a hard, conscientious worker who never stinted in his labors on behalf of his patrons, at least not the highest paying ones. Of course, he now had greater incentive: the sooner he finished the Louvre project, the earlier he could return home. Bernini would have to come up with a detailed final design on paper, to Colbert's and the king's satisfaction;

this would then have to be transformed into a three-dimensional wood and stucco model, before construction could begin in earnest. But even before any of that occurred, to hasten the process, Colbert had master masons of Bernini's choosing brought from Rome to Paris to instruct and guide the French laborers on Italian construction techniques. (The latter ended up failing in the much-colder French climate, to the glee of the native stonemasons.) Though the design was far from finalized, shortly before Bernini's departure, a formal, elaborate laying-of-the-foundation-stone ceremony took place, with the king, Colbert, and Bernini in attendance, a special commemorative medal having been struck for the occasion. All this for a project beset by grave, enduring reservations on the part of Colbert, reservations that, we can be sure, he communicated to the king. As is well known about Louis's governing style from the time of his coronation onward, he made a point of keeping scrupulously informed on all issues, even small details, and delegated very few important decisions to any of his ministers, no matter what the subject.

On June 11 Bernini complained privately to Chantelou that he had heard from various sources that the king wanted him to sculpt his portrait in marble, but a formal commission had not yet arrived. Chantelou confirmed the rumor, and the royal order was soon forthcoming (on June 20), delivered by the king himself, in the most gracious, deferential terms, as Mattia de' Rossi wrote back to the folks in Rome. Yet, even before leaving Rome Bernini had suspected such a request would be made of him, which is why he had brought along with him to Paris his closest, most talented assistant in matters of sculpture, Giulio Cartari. And once in Paris, even before receiving the commission, he had asked for modeling clay to start the long, difficult process. Bernini never truly enjoyed doing portrait busts, even when he had the convenience of having his sitter right in front of him. It was the most challenging of artistic tasks, that of rendering the true likeness of a living, breathing human being, in all his or her color and spirit, through the medium of cold, colorless, hard stone. Why, even the great Michelangelo refused to do portraits, Bernini pointed out, self-defensively, to his French hosts. Nonetheless, Bernini proceeded undaunted, and in the end produced a bust that captured in a palpably realistic, lively manner two seemingly contradictory realities at the same time: not only Louis the man with less than perfect facial features (his nose, for instance), but also at the same time, and more important, Louis the idealized, more-than-human ab-

solute monarch. "In this kind of head one must bring out the qualities of the hero as well as make a good likeness," Bernini explained. He even added a few hairs under the king's lip, further explaining that "a freshly shaven appearance lasts only two or three hours, so that for the greater part of the time there is hair on the face; one must endeavor to represent people as they are generally." If the king did not like that scrupulous degree of realism, he did not say so outright.

Not that Louis intended Bernini's portrait to enjoy any exclusivity as the official representation of the king at this stage of his life. French sculptor Jean Warin, another portraitist of extraordinary talent, was also commissioned to do a marble bust of Louis XIV at this same time, while Bernini was still in Paris. (Louis spent enormous amounts of his time being sketched for official portraits in all genres throughout his reign.) And Bernini's bust does have one defect, noticed then as now. In response to complaints that he had shown the king with his forehead uncharacteristically exposed, the artist went back to his nearly complete bust and carved a single, flat curl in the center of the forehead. "The cutting of this curl, of course, meant that the upper part of the forehead receded into a slightly deeper level of the stone, so that now the bumps [over the eyes, already overemphasized] stand out even more prominently." Nonetheless, if he noticed, Louis never said anything, and thereafter his Bernini bust was treated with nothing less than royal respect.[8]

BERNINI WEEPS

Other members of the royal family and the court added to Bernini's workload by seeking designs and consultations on their own pet projects. It became a source of annoyance for the artist, not so much because of the additional labor, but because invariably, as he complained to Chantelou on July 28, his advice and designs were nearly all ignored. The Queen Mother, Anne of Austria, pressed the reluctant Bernini for a design for the main altar of her votive church, the stately Val-de-Grâce, then in the final stages of interior decoration: "And is it possible, Signor Cavaliere, that in my church there is to be no design of yours?" she demanded to know. (The church in question was her expression of thanks for the long-awaited "miraculous" birth of her first son, Louis, who, as Bernini was certain to have heard through the rumor mill, was widely believed to have been fathered by

Cardinal Mazarin, not Anne's reputedly homosexual husband, Louis XIII.)
Bernini, to his credit, diplomatically tried to evade the commission, know-
ing that his intrusion into a project already begun by local artists would be
fiercely resented. It was. The main altar that one sees in the church today,
with its elaborate Baroque canopy, is extremely Berniniesque, being yet
another close cousin to his Baldacchino, as we find also in Louis's Church
of the Invalides. But it is not the design that Bernini prepared for Queen
Mother Anne. Bernini's design is lost, but is known in its general contours
thanks to one of Mattia's letters from Paris to Rome. Domenico claims that
Bernini's design "brought no ordinary consolation to that great princess,"
but in fact Anne was not satisfied with what Bernini had proposed. Perhaps
Anne's "consolation" was, in reality, that of discovering that French archi-
tects could produce more satisfying work than Bernini.

While in Paris Bernini also labored on another work that was not his
own but of his own free choice: a small, oval, deep relief of the Christ Child
(pensively playing with the kind of nails with which he would be even-
tually crucified, a gruesome Baroque conceit). This *Christ Child* was be-
gun by his fledgling sculptor-son Paolo, intended as a gift to Louis's wife,
Henrietta Anne (daughter of Charles I and Henrietta Maria of England).
It survives today, on display in the Italian Sculpture gallery of the Louvre,
bearing only Paolo's name as author but, in fact, as Chantelou's diary re-
veals, his father gave so many "touches" to the marble relief that the name
of Gian Lorenzo Bernini should be added to its label. Wisely, Paolo later
gave up sculpture altogether, having produced next to nothing. There was
no incentive to continue in a profession for which he had as little interest as
talent once the sizeable inheritance from his multimillionaire father's estate
afforded him the life of a gentleman of leisure.

Despite the company of his son and several other familiar faces from
home, Bernini confessed to Chantelou that in Paris "his evenings here were
melancholy; in Rome, when he had worked all day, his wife and children
entertained him in the evening." Strange to say, be it by choice or other-
wise, Bernini seems to have had no "night life" in Paris. We read of no Pa-
risian dinner parties or other soirées attended by or offered in honor of the
visiting Italian celebrity, not even by his official hosts. It could be perhaps
that Chantelou simply did not deem such entertainment worthy of note in
his diary, but this seems unlikely, since such events would be important
displays of social and political power that warranted their being recorded

for posterity. In any case, in all our extant sources, the aforementioned confession of melancholy is a rare moment for Bernini of personal self-revelation and emotional vulnerability.

But we encounter another, more heart-wrenching one later in Chantelou's diary. On September 14 Bernini received a letter from his Jesuit friend in Rome, Father Niccolò Zucchi, bearing intimations of bad news: "It distressed him terribly, for he inferred from it that either his wife was dead or her life despaired of. He was so affected that he wept copiously." Bernini drifted in and out of a state of depression for several days until further letters from Rome arrived. While confirming the fact of his wife's near-fatal illness, they happily announced that she had made a miraculous recovery: "He was so overjoyed and said that he was quite sure his pulse must be beating very fast." The next night Bernini had a dream that, he declared, further confirmed the fact of Caterina's recovery, and that put his fears fully to rest. Though painful for Bernini, the episode gives us some indication that our fundamentally self-absorbed artist had perhaps come to truly love the woman whom he had "purchased" for his bride some twenty-six years earlier, marrying Caterina without knowing her at all as a person. It is too bad, as we have seen, that the final comment on the relationship between Bernini and his wife would be the disparaging remarks he makes against her in his last will and testament of 1680, seeking to overturn the provisions she had stipulated in her own will for a more equitable inheritance for her daughters.

The tears that Bernini shed in Paris for his wife were probably mixed with many for himself. It was a kind of bursting of the dam that had been slowly accumulating pressure ever since he had been roped into submission by the French king in April. Deep in his heart, Bernini never reconciled himself to the fact of being a political pawn, despite all the rationalization and spiritualization of what was for him an emotionally brutal act of coercion. At the advanced age of sixty-seven, he had to face the fatigue and dangers of trans-Alpine travel, leaving behind in a precarious state of incompletion monumental commissions, namely, the Colonnade and the Cathedra of St. Peter's. No wonder Bernini was, in effect, in one long, uninterrupted bad mood from the moment he arrived in Paris, criticizing the French and their culture at every occasion possible. And this from a man whom the biographers celebrate for his unflagging sense of diplomacy, modesty, and what the Italians call *delicatezza*, psychological sensitivity,

when confronted with difficult social situations. When it was not possible, for example, as Domenico boasts, for Bernini to speak well of the work of another artist, Bernini preferred to keep silent or tactfully say something that had the effect of saying nothing, rather than criticizing. Instead, in Paris, Bernini seems to have forgotten this rule of his. The anger and resentment he felt but could never openly express about his Parisian imprisonment, temporary but nonetheless intolerable, was instead channeled into near-chronic, grouchy, arrogant criticism of the art and architecture of Paris, and the character and customs of the French.[9]

Bernini's nonstop criticism of all things French did not escape the attention of his hosts. This included King Louis, who, in fact, hardly missed a thing that was said or done at his court. Perrault reports in his *Memoirs*: "It did not take the King long to notice that Bernini praised few things, and he said so to the Abbé Francesco Butti, who was a great admirer of the Cavaliere." Perrault's claim is confirmed by another source. In his dispatch dated June 19, 1665, the Duke of Modena's agent at Louis's court and royal theatrical architect Carlo Vigarani writes that the king told him that he did not want Bernini invited to the upcoming festival at Versailles "because the king had understood Bernini, after just a half-hour of conversation with him, to be a man predisposed to finding nothing well done in France." Even Chantelou confesses: "Then the King said of Bernini, 'He praises very little here.'" And beneath this one brief, curt utterance of the king's probably lay a deep well of unspoken annoyance.

Colbert was of similar mind. Hearing that Bernini had actually liked the Poussin paintings in Chantelou's collection, Colbert remarked sourly: "I'm glad that he had finally praised something in France!" As for the rest of the French painters, in Bernini's estimation, they all had a "petty, miserable, niggly style," while all French artistic style was in general "poor and feeble." When on one occasion Chantelou began to defend Bernini by pointing out that he was, after all, a man of extraordinary talent (and, therefore, that talent should forgive a multitude of sins), Colbert cut him short with an exasperated, "Yes, this is true, but I wish he would spare others a little." Bernini did not spare even the city of Paris itself. Chantelou had taken Bernini up to some high promontory (perhaps the towers of Notre Dame Cathedral) to have him admire the city from above. But Bernini was not impressed. Paris, Bernini complained, with its crowded mass of drab, utilitarian chimneys, resembled nothing but an ugly card-

ing comb, unlike the elegant, exhilarating panorama of his beloved Rome, which gave, instead, a "superb impression of grandeur," as any proper royal capital should.

Bernini managed to let slip from his mouth some criticism even of the king himself. Despite his much-repeated praise for the royal brain, Bernini thought Louis poorly educated and said so in what was in effect a public conversation. In his youth, observed Bernini, Louis had been "kept down" by Mazarin and given "no opportunities for learning" by the cardinal; instead of now compensating for that past intellectual deprivation, Louis did not surround himself with learned men whose knowledge and experience he could be absorbing. (Though impolitic, Bernini's remarks about Louis were not entirely off the mark: the king cared far more about war, sex, food, horses, and dance than books or ideas.) On another public occasion, given a guided tour of the royal apartments, Bernini casually remarked that some of the rooms were "designed to the taste of the ladies." Bernini should have known better and kept quiet.

The artist's ill-advised remark was duly noted by unsympathetic eyewitnesses and repeated in exaggerated form throughout the court. Chantelou was later asked by a courtier to confirm or deny the charge that Bernini was in effect calling into question Louis's masculinity. This was not a good thing to question in the case of a monarch who was attempting to terrorize his European opponents into submission by the projection of monstrously powerful macho image. Chantelou duly came to Bernini's defense on this occasion, but decided to pass on a gentle word of admonishment to Bernini through his Italian compatriot, the Abbé Butti, namely, that he should quit denigrating and start praising what he was being shown by his French hosts. As for Bernini's remark about the feminine décor of Louis's chambers, one can't help but wonder if he was in fact, if only unconsciously, questioning the king's sexuality. Bernini certainly must have heard the rumors about Louis's father, Louis XIII, while the sexual orientation of his flamboyantly gay brother, Philippe, the Duke of Orléans, was a matter of public knowledge. Maybe he thought it ran in the French royal family, despite the reports of Louis's voracious appetite for women?[10]

When he was not working on his commissioned tasks, Bernini was frequently escorted around Paris and environs, being shown its public buildings and monuments, churches, and private residences. Many of his reactions and evaluations are recorded in Chantelou's diary. But again,

unfortunately, he saw little to his true liking and did not hesitate to say so bluntly. Perhaps predictably, the Luxembourg Palace, the most Italianate of Paris's edifices, which Bernini visited on June 11, pleased him the most and unqualifiedly so. Strangely enough, Chantelou does not record what Bernini said of the famous Marie de' Medici cycle of paintings done by Peter Paul Rubens; we presume he did see them inside the palace. On September 13, Bernini traveled to and praised as "most beautiful and elegant," Versailles, which in those days was a much more modest estate with respect to what it became by the end of Louis's reign. He visited Notre Dame Cathedral on at least one occasion for personal devotions (on August 15, the great summer feast of the Assumption of Mary), but we don't know his opinion of what he saw inside or outside the cathedral. We do know that Gothic architecture was not at all loved by the Baroque. In the Baroque artistic vocabulary, "Gothic" was, in fact, a synonym for bizarre, ugly, irrational, and deformed. We see this in Bernini's famous critique of the architecture of his rival Borromini: "Borromini had strayed so far from what he learned in Bernini's school and from the good designer he used to be and had, instead, adopted the Gothic style, rather than that of ancient Rome and the fine modern manner."

As far as we know, Bernini did not visit Fontainebleau or any of the great outlying chateaus, like Vaux-le-Vicomte. In addition to the art he saw in churches and the royal residences, he got to see several private collections of ancient art, modern painting, and drawings. He was also invited to formally address (on September 5) the Academy of Painting and Sculpture. The subject of his discourse was the training of young artists. Bernini was asked by Colbert to commit his remarks to paper, but if he ever did so, the document has been lost. Despite finding little to praise in the art he saw in Paris—beyond the works by Guido Reni and Nicolas Poussin he came across—Bernini obviously enjoyed looking at art (especially painting) and discussing, with great expertise, technical matters of style and attribution. It is of comfort to know that even then telling an original Raphael or Titian from a copy was a challenge for connoisseurs and a problem for collectors.

Another pastime for Bernini during his days at Louis's court was the meeting of illustrious personages not only from France but from other parts of Europe. Louis XIV's Paris, one of the vital cultural centers of the Western world, was a popular, if not necessary, destination point for lu-

minaries from all over the continent, from the world of politics, science, and the arts. Space does not allow even a partial list of Bernini's encounters with the glitterati of France and the rest of Europe while in Paris, but one can hardly keep from mentioning at least one encounter that, though brief and probably immediately forgotten by Bernini, represents, "with hindsight," as one scholar has claimed, "one of the most momentous in the history of seventeenth-century architecture—the man destined to be England's greatest exponent of the Baroque in a face-to-face encounter with the most famous Baroque architect in Europe." We speak, of course, of Christopher Wren, then thirty-three years of age and completely untested in the practice of architecture. Wren, who had heard through the grapevine about Bernini's expected trip to Paris well in advance of its occurrence, had arranged to travel there at the same time for an extended study trip in the hopes of meeting the Italian artist. Socially well connected, he crossed the Channel at the end of June in the entourage of Queen Henrietta Maria herself. For months he had anxiously anticipated his meeting with the great Bernini, which finally took place in early or mid-August. Alas, it was not what he had hoped for, as he described in his own words: "Bernini's design of the Louvre I would have given my Skin for, but the old reserv'd Italian gave me but a few Minutes View; it was five little Designs in Paper, for which he hath received as many thousand Pistoles; I had only time to copy it in my Fancy and Memory."

One has the sense that Bernini neither actively sought out these encounters with glitterati nor particularly enjoyed them, even in the case of personages of far greater renown or social connection than the young Wren. In his spare time, he preferred to visit churches. And that is what he did, not only for their art but also for his own private devotion. There may be some debate about the state of the artist's personal faith in his earlier years, but clearly, by the age of sixty-seven, Bernini had become a sincerely believing, devoutly practicing Catholic. One vignette is worth a thousand words: "On leaving the audience with the King," Chantelou records, "we went into the chapel where the Cavaliere remained a long time in prayer, from time to time kissing the floor." In his Paris evenings he continued his Roman habit of reading from "devotional books" and engaging in private prayer. Chantelou also records the artist's numerous moments of spiritual conversation and theological reflection. Suffice it to say that through all of it, Bernini's brand of Roman Catholicism comes across as completely and

prosaically orthodox, despite the thoroughly "modern" Baroque artistic cloak with which he expressed it in his works of art.

On a less exalted level, again thanks to Chantelou's meticulous diary, we also get to peek into the more private, mundane world of Bernini, and catch glimpses of the uncensored, more spontaneous Bernini, to a degree unmatched by any other primary source. Bernini and his "official biographers" Domenico and Baldinucci would be greatly displeased by the indelicate moments or unheroic details recorded by Chantelou for posterity. Bernini's bouts of diarrhea; his near-fainting spell; his badly inflamed tongue caused by a broken tooth; his search for decent eyeglasses. There is also that moment of slight uncouthness on Bernini's part that we had occasion to mention in discussing the artist's love of sweets: As a parting gift, Chantelou's wife presented Bernini with a basket of sweetmeats and patties: "I'm the gourmand; I only get good things," the Cavaliere said with a smile, and straightaway began to eat the sweets. On the subject of Bernini's eating habits, we learn this further detail from Chantelou: "He said that he disliked eating anywhere but home, in case he ate too much and felt ill and also because of the waste of time involved in sitting down to an elaborate meal." On the same subject of food, we learn the revealing detail that access to the kitchen that prepared Bernini's food was constantly under surveillance by his staff. This we learn from Mattia de' Rossi, writing to Monsignor Pietro Bernini: "For meals, Cosimo [Bernini's majordomo] supervises the kitchen at all times, morning and night, so that it is impossible for a living soul to enter and thus Your Lordship can rest absolutely assured on this account." The kitchen guarded against whom? Against those who would wish to poison the Cavaliere, of course. By the end of his Parisian stay, there were, I daresay, any number of people entertaining such an idea.[11]

"A PLAGUE TAKE THAT BASTARD!"

"As soon as we were alone together, Bernini shut all the doors and told me in a rage that he now wished to leave, that they were making fun of him, that Monsieur Colbert treated him like a small boy; he took up whole meetings with long and useless discussions on privies and water pipes; . . . he understood nothing at all; he was a real dickhead." The poison in Bernini's life in Paris, as far as he was concerned, came in the form of minister Colbert and his chronic dissatisfaction with Bernini's Louvre design, despite the

numerous revisions the artist had made even before leaving Rome. There it was, October 18, just two days before Bernini's planned departure, and Colbert had presented yet another long list of necessary revisions, setting Bernini's fuse off yet again. And Bernini was not exaggerating; Colbert's concern with privies was real (and entirely legitimate) as we read in his instructions to the Italian artist:

> It is necessary to pay careful attention to the question of the facility of discharge of excrement; the privies must be placed in convenient locations, so that their stench will never invade the apartments or other interior spaces of the Louvre; at each floor the discharge of excrement must be easily managed. This issue must be considered one of the most important of all and on which the health of the royal family depends.

During this latest encounter Bernini had enough self-control to stifle his fury while the minister was present, but once he left the room, the artist exploded and began the tirade just quoted. He concluded by threatening to leave Paris right then and there, without saying a word to anyone, including the king. That, of course, would have been a monumental breach of etiquette and a shocking insult to Louis XIV.

In Bernini's estimation, Colbert was an ignoramus when it came to art and architecture and should not have been interfering in the creativity of a great artist (like himself). Furthermore, Bernini was convinced that Colbert was jealous of the growing rapport between Bernini and Louis XIV. Therefore, he was attempting to undermine Bernini's success by belittling his work and by deliberately standing in the way between him and the king, the two geniuses who loved and truly understood each other. For Colbert, the problem was, instead, Bernini's outrageous arrogance and his narcissistic refusal to admit the defects of his designs, defects that were the direct result of his ignoring the abundant, clear, and precise instructions given him by Colbert on behalf of the king. The more time passed, the more tensions grew between Bernini and Colbert, but neither man breached courtly etiquette by uttering in public one word of hostility to the other. On the surface, it was all so polite, with much respectful bowing of heads and exchanging of sweet, benign smiles. . . . While behind closed doors the truth came out of how Bernini felt about Colbert and how Colbert felt about Bernini. For the latter, we turn to the *Memoirs* of Charles Perrault, who

served as Colbert's personal assistant on the Louvre project and therefore was frequently an eyewitness to private encounters between the minister and the artist, and the aftermaths of those encounters.

At first, Perrault confesses, he was deceived by Colbert's "remarkably respectful" outward demeanor with regard with Bernini. Then, he said, "something happened which opened my eyes to this dissimulation, and made me see what kind of world is the Court." That "something" was another meeting between Colbert and Bernini to discuss specific details of the latest Louvre design. The king was to spend millions on a new palace, Minister Colbert politely explained to the Italian artist, and yet, the way things stood, he would end up with a bedchamber entirely too small for all the ceremonial needs incumbent upon that important space. Bernini was probably perplexed, if not shocked, by how much of Louis's so-called private life had been ritualized into well-attended public ceremony in his bedchamber. Be that as it may, Bernini needed to attend to this matter even though changing the size or position of one room could have a domino effect on the entire layout of the palace. His genius would rise to the occasion. And how it did, Perrault describes for us in detail:

> Three days later he came to the meeting . . . and brought a design which he held pressed against his stomach. . . . [H]e said he was convinced that the angel which presides over the happiness of France had inspired him, and that he sincerely knew himself to be incapable of discovering on his own a thing so beautiful, so great, and so fortuitous as the idea which had come to his thoughts. "*Io sono entrato*," he pursued, "*in pensiero profondo*" [I immersed myself into the deepest of thought]. He said these words with as much gravity as if he had descended to the depths of hell. Finally, after a long speech that would have tried the patience of the most self-restrained of men, he showed his design with the same respect with which one would reveal *il vero ritratto di vero crucifixo* [the true likeness of the crucified Jesus Christ]. This profound thought was nothing more than a bit of paper glued on to another drawing of the pavilion of the Louvre, on which he had marked four windows in yellow, instead of the three that were in the former design and already in the building.

Colbert reacted then and there with nothing but words of great admiration and hearty approval of Bernini's ingenious emendation. Perrault, instead,

was "bursting with indignation at seeing such boasting," especially since he, like anyone else in the room, could see that this one change could not be effected without razing the entire pavilion, if not more of the existing structure. King Louis had made clear that one of the nonnegotiables of the Louvre completion project was that the earlier structures be preserved. This prohibition was, above all, for symbolic reasons, to illustrate and publicize in architecture "the myth of dynastic kingship, according to which the reign of Louis represented a culmination of generations of divinely ordained rule." Unlike his master, Perrault could not restrain himself and whispered to Colbert his alarmed reactions to Bernini's proposal. The paranoid Bernini insisted on being told what Perrault had said, but upon hearing it, simply dismissed it as nonsense and Perrault himself as another presumptuous ignoramus.

In response, Colbert readily expressed his full agreement with Bernini and assured him that Perrault's impertinent remarks would be ignored. Poor Perrault was soundly and publicly humiliated (we can feel sorry for him at least on this occasion). Once the meeting was over and Bernini had departed the scene, the mortified Perrault raced to Colbert to humbly offer his apologies for having dared to point out a defect in Bernini's proposal. He was totally unprepared for the minister's response: " 'Do you think,' he told me angrily, full of indignation, 'that I don't see it as well as you do? A plague take that bastard, who thinks he can pull his tricks on us.' " Perrault's sadder-but-wiser reflection on the experience: "I was astonished, and at the same time I praised God for making me see so clearly what kind of dissimulation one is forced to practice when one is at court."

Bernini, however, was not finished with Perrault and his impudence. Since he could not confront Colbert himself, Bernini instead used his closest personal assistant, Perrault, as a safer target for his anger against the minister. On another occasion, during the public display of Bernini's Louvre designs on October 6, Perrault again made the foolish mistake of raising a question about some of their details. Again, Bernini went berserk: "The Cavaliere, who had heard me ask this question, became suddenly furious, and said to me the most outrageous things imaginable, including among other things that I wasn't worthy of scraping off the soles of his shoes." Perrault attempted to reason with Bernini, "sincerely and respectfully," but the Cavaliere just increased the volume of his indignant shouting: "A man such as I! whom the Pope treats graciously, and for whom he

had great regard, that I should be treated thus! I will complain to the King, even if it should cost me my life: I want to leave tomorrow and be gone. I don't know why I don't take the hammer to this bust [the portrait bust of Louis XIV there in Bernini's studio], after being so scorned. I will go to Monsieur the papal nuncio."

Bernini's just-quoted speech comes from Perrault's memoirs, but, lest anyone doubt its accuracy, Chantelou's diary confirms the episode and the speech itself, in all essential detail, including the threat by the momentarily crazed Bernini to smash his bust of Louis XIV. Perrault adds the damning observation that Bernini's own assistant, Mattia de' Rossi, had himself attempted to point out the same defects to his master several times, but Bernini dismissed him just as arrogantly: "He [Bernini] always answered me [Mattia] by saying that it was not my place to think about it, and that he brought me only to draw and carry out his ideas." Bernini's wrath, however, calmed down by the next day. According to Chantelou's version of the story, the artist decided to dismiss the matter after understanding from his talk with the papal nuncio that it would be impolitic to pursue retribution and thus risk making a further bad impression, especially when his departure was so imminent. Moreover, of his own accord, in the course of the previous night, the pious Bernini "had laid his resentment at the foot of the Cross." Perrault's explanation of Bernini's change of heart is, not surprisingly, different and cynical—Bernini did not want to risk losing any or all of his expected parting gift from Louis (which turned out to be 3,000 gold louis) by creating the uproar he had threatened. So, what was, in truth, the effective calming agent? The Cross or the gold?

By October 6 Bernini's departure from Paris was imminent, because on the preceding day, what was in effect the formal "unveiling" to King Louis of his finished portrait bust had taken place. Bernini's Louvre design was as complete as it needed to be. (Upon Colbert's insistence, Mattia de' Rossi was to return to Paris the following year to settle the details and construct the three-dimensional model in wood and stucco, as he indeed did.) So there was nothing more to keep Bernini from returning home. According to Chantelou, after delivering his final flowery speech communicating his praise of and gratitude toward Louis, "the greatest of all kings," Bernini burst into uncontrollable tears and had to withdraw from the room. Louis, in turn, "behaved in the most kindly way in the world," assuring Bernini

that "if he had only understood his language, he [the king] would . . . say many things that should make him very happy" and express his affection for the artist. However, this final lovefest notwithstanding, it is revealing that neither on this nor any other day leading up to Bernini's actual departure (October 20) was there repetition, orally or in writing, of the much-earlier, intense encouragement on Colbert and the king's part that Bernini agree to come back and work full-time for the French court. By that point, the French court had had enough of Bernini, and he of it. Colbert just loaded him up with gold coins and the promise of an annual royal pension, no strings attached, and sent him home.[12]

The Long, Troubled Aftermath

The anti-Bernini mischief-makers in Louis's court were busy till the very end of the artist's days in Paris. Moreover, they made sure that grief followed Bernini all the way home and then some. The artist first learned of the latest batch of Parisian-brewed trouble when he arrived in Lyon on October 30: there he found an anxious letter from Chantelou awaiting him. Bernini's enemies in the court, the letter warned, had spread the rumor that the artist was not satisfied with the king's parting gifts to him and had expressed that dissatisfaction openly in his last hours at court. In effect, Bernini, they claimed, had called the king stingy, unworthy of the title of "magnificent" due a true prince. This would have ranked among the grossest of insults to a monarch, and Bernini, as an international celebrity, was in the position to publicize this shameful report at every court en route back home and to all ears in the Roman court, including those of the pope and foreign ambassadors. Moreover, the rumor had immediately reached the ears of the king himself, who gave full credence to it. And who could blame Louis for doing so, after the four months of nonstop complaining and belittling that Bernini had done about everything he had seen in Paris? In fact, there is reason to believe that Bernini had left himself vulnerable to this slander, because, apart from the months of criticizing everything French, the artist, in his farewell speech to Colbert, apparently had neglected to acknowledge the king's generosity. This was an incredibly thoughtless and most unfortunate lapse of courtesy on Bernini's part. Deliberate or otherwise on Bernini's part, this silence was subsequently used against him and with a great deal of success by his enemies.

In his letter Chantelou urgently advised Bernini to immediately do all he could to deny and counteract the rumor, first of all, by writing personal letters to Colbert and Foreign Minister de Lionne. Putting on the mask of a calm public face in the midst of this latest attack, Bernini duly wrote the letters and had other authoritative personages do likewise on his behalf. Among them was Father Oliva, whose word counted for something at the French court. Oliva wrote to Minister de Lionne that back in Rome, Bernini had truly become a busy, loud "Trumpet of the Most Christian King," that is to say, had been broadcasting his praise of Louis's greatness and generosity far and wide. Among the dramatic statements that Bernini famously made to prove his awe of the "magnificence" of the royal gifts and rewards was the following: "I can affirm that my labors were remunerated more in just six months in Paris, than in six years in Rome." Music to the ears of Louis, no doubt. But how did Pope Alexander feel, when that same statement reached His Holiness's own ears (as we know it did from his diary)? In any event, Bernini seems to have weathered this ministorm, for we soon have a gracious letter from Colbert to Bernini, thanking him for his kind words about the king and looking forward to a continuing prosperous relationship between the artist and the French court. But that was not to be.

Domenico's biography reports that, responding to the slander spread about him in Paris, Bernini proclaimed that he would prove his gratitude to the king, above all, by fulfilling the promise he made while at court, namely, to sculpt a grandiose, colossal equestrian statue of Louis. As far as early modern monarchs were concerned, there was probably no more impressive a public monument, and therefore no more powerful an "image-maker" than one's portrait, in full battle armor, preferably classical Roman, seated majestically upon an enormous, muscular horse of combat. Bernini's *Louis Equestrian* statue did get done eventually, but the history of this work is fraught with much confusion, ambivalence, and ambiguity from beginning to end. And more significantly, in the eyes of its patron, King Louis, it was an utter failure.

Neither Chantelou's diary nor any other source records any formal commission to Bernini for the equestrian monument while he was in Paris. Chantelou gives us only two vague, fleeting references to the possibility of such a statue. In the official records and correspondence of the French

government, the subject of the equestrian statue didn't come up until a full two years after Bernini's departure from Paris: in a letter to the artist dated December 2, 1667, Colbert finally and formally asked Bernini to undertake the execution of the *Louis XIV Equestrian*. In reply, Bernini agreed to do the statue, even though he must have been still felt the stinging wound of the abrupt cancellation of his Louvre project communicated by Colbert in July of that same year. Why, after this insult and with no further mention of additional compensation, he would take on this huge labor at that point has kept scholars in debate for years. His royal pension was not dependent upon his doing the statue. No stipulations, in fact, were attached to that pension, as far as we know, even though long after its bestowal, an exasperated Colbert, in a letter to Bernini of March 11, 1667, claimed that the artist was receiving his royal pension in compensation for his guardianship of the newly founded French Academy in Rome. The reason for Colbert's exasperation is that despite his promise to lend support to the Academy, Bernini had simply ignored it.

Contrary to the impression created by Domenico's biography, the equestrian statue was far from a priority in Bernini's mind when he returned home on December 3, 1665. And once he did agree to undertake the commission finally in 1667, he was in no hurry to begin work. In fact, he did not begin until sometime in 1670. Even then it was at a lackluster pace, so much so that Colbert had to constantly send letters to Rome, both to Bernini and the French Crown's contacts there, to get the artist moving on his promised labor. The irregularity of his royal pension may have had something to do with Bernini's procrastination: if they did not pay, he would not work. It may have been also a case of passive aggression on his part, in response to the cancellation of his Louvre project. Strangely enough, even though it was costing them a fortune, until the finished work reached Paris years later, Bernini's French patrons didn't even know what it looked like.

Bernini never sent the normally expected presentation drawing or preliminary model for the court's approval, even after Louis's treasurer paid the whopping sum of 20,166 livres for the massive block of marble. Not even a written description was sent from Rome to Paris.

Furthermore, all communication between Bernini and Colbert or any other court representative ceased, mysteriously, for several years beginning

in November 1673. Yet, despite this silence, in 1674, seemingly out of the blue, the king authorized the issuance of a fine bronze medal in Bernini's honor, featuring a most flattering portrait of the artist by royal medalist Charles-Jean-François Chéron. This gesture would certainly seem to indicate continuing good feelings toward the artist, at least on Louis's part. Or did Louis have some other, more self-serving motivation for this surprising gesture? (Exalting Bernini meant at the same time exalting his royal patron, Louis.) Unfortunately, we can't know Louis's (or Colbert's) mind on the matter, since no documentation relating to this royal commission survives, except for the medal itself.

In 1677, Bernini announced that the *Louis Equestrian* was complete. Was he surprised when he received absolutely no reply from the French court, not even an acknowledgement of receipt of his letter? The court was perhaps engaging in its own passive aggression. He had made them wait, and now they would make him wait. Whatever its motivation, Paris's silence lasted until December 1683, when the statue was finally sent for by Colbert's successor, the Marquis de Louvois, right after Colbert's death. Poor Bernini himself had died in November 1680 not knowing what destiny awaited his mighty colossus. It took almost two years for the statue to make its way to Paris—at one point its Mediterranean passage was delayed because both the Spanish and the pro-Spanish Genoese had threatened to "kidnap" it, in order to embarrass the French king. After so much time, labor, and expense to produce and ship it to Paris, the *Louis Equestrian* proved to be an utter flop once it was unveiled in the French capital in March 1685. Several sources report the same thing: the king found the work so repulsive and so badly executed that he wanted to have it destroyed. Minister Louvois, who had spent so much money to ship the statue to Paris, lamented in a letter, "The equestrian statue of the king by the Cavalier Bernini is so hideous that there is no chance that once the king sees it, he will allow it to remain in its current state."

What specifically in the statue provoked such royal horror is nowhere identified. Modern scholars conjecture that it was the benign, unmanly smile on Louis's face or the too flamboyantly Baroque style of the design. Again, the documents are either silent on the issue, or, rather, point generically to the overall mediocrity of the design and workmanship (the execution itself, in fact, was largely done by students at the French Academy in Rome). The ever malicious but here perhaps truthful Perrault reports:

FIG. 31 ➤➤ Twentieth-century copy after G. L. Bernini, *Louis XIV Equestrian* (reworked as *Marcus Curtius*), Louvre, Paris. Photo: Author.

It was found to be so hateful that the King had it removed from the spot where it was placed and had the head taken off, which had been intended to resemble him, and Monsieur Girardon put on a new head modeled in the classical style. No one has ever been able to find out why Bernini had so little success with this work: some said age had greatly enfeebled him, while others claimed that the chagrin of having his [Louvre] designs rejected had led him to take this revenge.

As Perrault and others tell us, Louis was in the end persuaded to spare the statue and banish it instead to Versailles. There it was moved around a couple of times but always on public, and not necessarily inconspicuous, display. Eventually (sometime in 1687) it was transformed by sculptor Girardon with some strategic recarving—the head, in fact, was not replaced wholesale—into a classical scene, that of the hero *Marcus Curtius Riding into the Fiery Abyss* (fig. 31). Ironically, this transformation was to later save the statue from the antiroyalist destruction of the French Revolution. The final irony of the destiny of this statue was its selection by architect I. M.

Pei as the crowning and sole sculptural ornament to Pei's much-acclaimed remodeling (1985–89) of the main entrance to the Louvre Museum, next to its magnificent glass pyramid. The statue placed there is in reality only a copy in lead, but the name "Le Bernin" (as he is known in France) is displayed prominently on the pedestal as its sole creator. Three hundred years after his ignominious defeat, Bernini had this small, symbolic, but nonetheless prominent vindication upon French soil.[13]

"MY STAR WILL LOSE
ITS ASCENDANCY"

CHAPTER 6

A BRIEF SIGH OF RELIEF

Bernini must have breathed a deep sigh of relief as he departed from Louis's court on October 20, 1665. Good riddance to all of them—with the exception, of course, of the kind and loyal Chantelou. Bernini simply shook the Parisian dust off his feet and never looked back. That is to say, he resumed being the same man he was before. He picked up his life in Rome exactly where he had left it in April, not skipping a beat. Meeting Bernini just two days after his return to Rome, the pope's brother, Don Mario Chigi, wrote to Prince Mattias de' Medici, governor of Siena, claiming that Bernini "seems to me to have become completely French." But to what was Don Mario referring? His clothes? His manner of speech? Perhaps to the exaggeratedly effusive words of praise of Louis that Bernini was obliged to broadcast to counteract the damaging rumors about his ingratitude toward the king. Instead, all other indications are that Bernini's five months in France did not change him at all, artistically or otherwise. Despite or

precisely because of all that he had witnessed first hand in France, the trip served only to confirm in him his personal artistic vision and native cultural values, as well as his antipathy toward the French. A thoroughly Roman artist he left Rome, and a thoroughly Roman artist he returned.

Yet, whatever relief he felt in leaving Paris behind could not have lasted long. Even before arriving at Lyon ten days later and learning about the slander campaign brewing against him in the capital, Bernini had much to think about on his return journey, especially about what awaited him back in Rome. Presumably his family was healthy and thriving, since letters from home had communicated nothing further to worry about since Caterina's recovery. But he had left monumental works unfinished, above all, the Cathedra Petri, the "Chair of Saint Peter." He told his Parisian hosts that "he would have it in mind every minute of his journey" back to Rome. The Colonnade of St. Peter's Square was also in a state of incompletion, as was the Scala Regia, although it was only stucco work that remained to be done on the latter project. How had they fared in his absence, under his brother Luigi's direction? Adding to the stress of unfinished tasks was the unspoken race against death: would Bernini make it back home safe and sound and with sufficient energy? And even more worryingly: would the sickly Alexander survive long enough to see these hugely expensive projects to their conclusion? If he were to die, so might the financing and so might what remained to be done of these works. There was no guarantee that Alexander's successor would be willing to continue to risk financial ruin for what some in the curia and many in the Roman population considered unnecessary extravagance.

Bernini reentered Rome on Thursday afternoon, December 3, 1665, his jubilant family having gone out in coaches to greet him at the outskirts of the city. (His oldest son, Pietro Filippo, had actually gone up to Florence to await his father's arrival there ten days earlier.) Once home, the artist hit the ground running. On December 4 he paid his respects to the pope and then went immediately back to work. In the course of the next two years, as it turned out, his fears proved unfounded. All three of these great "Alexandrine" projects were brought to happy completion and to general applause before Pope Alexander breathed his last on May 22, 1667. In the case of the Colonnade, just a small portion of one of its "arms" and the joyful array of gesticulating statues crowning its top had to be finished under Alexander's successors. Bernini had further planned to close off the east-

ernmost point of Piazza San Pietro with the eventual addition of some form of a so-called *terzo braccio*, or "third arm," placed, that is, at the point where the oval met the dark maze of narrow medieval streets coming up from the river (replaced in the 1930s by Mussolini's single, broad, straight Via della Conciliazione). By impeding full sight of the piazza and the basilica until the last minute, this "third arm" was to provide visitors to St. Peter's with an exhilarating "squeeze and release" experience: after making their way through dark, narrow streets, unsuspecting visitors, upon passing through the Colonnade, would suddenly find themselves in the huge, wide-open, light-filled "theater"—to use that much-beloved Baroque term—of St. Peter's Square. They were to feel at once transported to a different, higher realm of reality. After Alexander's death, Bernini held out hope through two more pontificates that some form of this addendum would finally be constructed as planned, until 1679, when the austere Pope Innocent XI, the last pope of Bernini's lifetime, resolutely blocked the project. Innocent had other priorities beyond that of delighting tourists.

With the election of Clement IX on June 20, 1667, in effect, began the final chapter of Bernini's life. Extending past Clement IX's pontificate, it was to be a long last chapter—thirteen years long—and in the end Bernini would go out quietly. To be sure, in these last years the artist scored further genuine accomplishments and received much applause till practically the very end. But the accomplishments were of ever smaller dimension and the applause increasingly incapable of drowning out the rising volume of criticism, anger, and outright hatred. And amid all this adversity, once Clement IX died (in December 1669), the last two of the eight popes of Bernini's professional career, Clement X and Innocent XI, would be of no help to him, nor wanted to be. The glorious age of the "magnificent" Baroque papacy was effectively over, especially as far as monumental projects of art and architecture, and, therefore Bernini, were concerned. It was a question, above all, of money and the urgency of new priorities, especially that of repelling the threatened Turkish invasion of Europe.

Yes, in 1667 the cardinals had elected another sensitive man of refined culture, Giulio Rospigliosi (fig. 32). In addition to being a capable and trustworthy ecclesiastical servant, Rospigliosi was also a genuinely accomplished poet-playwright. He was, furthermore, an old friend of Bernini's from the Barberini days; the two had worked together on theatrical productions, and in 1668 Bernini produced another one for Casa Rospigliosi

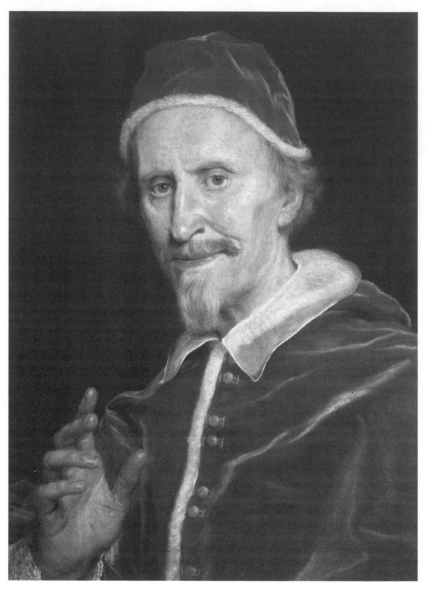

FIG. 32 ➻ Giovan Battista Gaulli ("Il Baciccio") *Pope Clement IX*. Rome, Galleria Nazionale d'Arte Antica.

at Carnival time, with a script by the pope written in his youthful days. As pope, the amiable Rospigliosi proved to be generally loved by the people but otherwise unremarkable. Perhaps the sheer brevity of his pontificate— two years, five months—is to blame for this undistinguished record. We are told, in any event, that Clement himself did not expect a long pontificate, not because he was terribly old (he was sixty-seven) or terribly sickly. No, instead, as the Venetian ambassador reports, the astrologer who had correctly predicted the significant milestones in his earlier life (his post as papal nuncio and his rise to the cardinalate) had also predicted that he would one day become pope but that his reign would be short. The astrologer in question was identified as "*Abbate* Affetti (*sic*), formerly a confidante of Pope Urban's," presumably referring to Giovanni degli Effetti, better known as scholar and art collector. The astrologers, again! Remove them from the history of Baroque Rome and you will have lost sight of a large population of effective influence wielders and opinion makers of the age, their behind-the-scenes, shadowy status notwithstanding.

Bernini, too, knew something of his own ultimate destiny. When in Paris, responding to praise of his works by his French companions, the artist had made a remarkable pronouncement: "He owed all his reputation," he said in a confident but matter-of-fact way, "to his star, which caused him to be famous in his lifetime; that when he died its ascendancy would no longer be active and his reputation would decline or fail very suddenly." Bernini's companions, as far as we know, did not question this startling remark, but we ourselves cannot keep from doing so: How did Bernini know this "fact" about his future? Why was he so sure of it? And why did he express himself in the peculiar "stellar" way that he did? The answer, again, is most likely astrology. Bernini was probably not using merely metaphorical language, but rather the technical and then quite familiar terms of astrology, immediately recognizable to the refined French courtiers in his company at that moment. In France as in Italy, even the most pious made regular recourse to astrology. To cite just one famous and well-publicized instance involving King Louis XIV himself: in 1638 upon the birth of the long-awaited male heir, his mother, Anne of Austria, had the same maverick Dominican friar consulted by Pope Urban VIII, Tommaso Campanella, draw up the newborn's astrological chart.

Bernini used specifically astrological terms—rather than some piously Christian reference to the will of God—to describe his future probably

because he himself had consulted an astrologer on occasion. Does this really surprise us? Even popes had done so, most notoriously, Urban VIII. One such occasion might, in fact, have been in January 1627, when Bernini is documented as availing himself of the bibliographic services of the learned monk, Reverend Orazio Morandi, well-known abbot of the Roman monastery of Santa Prassede and former superior general of the Benedictine order of Vallombrosa. Bernini appears in the abbot's written records as having borrowed two books from his extensive library, an Italian translation of Titus Livy's *History of Rome* and Boccaccio's *Genealogy of the Gods*. But was the artist there just to borrow books? In addition to being a generous lender of books, Father Morandi was also, as everyone knew, a much-consulted, expert astrologer, one of the best in the city. Unfortunately for Morandi, in 1630 he let his expertise go to his head and was foolhardy enough to predict (wrongly in this case) the imminent death of Pope Urban VIII. Urban was not amused and had him thrown into the Tor di Nona prison, where he died awaiting trial in November of that same year. Many Romans, including our diarist, Giacinto Gigli, suspected that the priest had in fact been poisoned. Why poisoned? To protect the reputation of many high-ranking members of the Roman curia: Morandi had too much incriminating information about the private lives of prelates.

The two books that Bernini borrowed from Morandi were not especially difficult to find in bookshops or elsewhere, nor were they particularly expensive. Even then Bernini was wealthy enough to purchase them for himself or could have easily consulted them in the well-stocked library of his ever-obliging patrons of the moment, the Barberini. Why did he, instead, go to Morandi? Simply because the Santa Prassede library was closest to his home at Santa Maria Maggiore? Instead, the book-borrowing might have been a convenient cover for what was really an astrological consultation. Like the ban of artificial birth control today among married Catholics, long-standing ecclesiastical prohibitions against astrology were simply ignored by the population (even by Pope Urban, who himself had renewed such prohibitions). Of course, for prudence's sake no one publicly advertised the fact of his noncompliance. If the consultation between Bernini and Morandi—or any other astrologer—did take place, there is no surviving evidence of it, beyond that one remark by Bernini about his lucky "star." However, as a reminder of the widespread nature of this practice at the time, even in Casa Bernini, we find among the Bernini family documenta-

tion at the Bibliothèque nationale in Paris several astrological charts and related commentary belonging to Bernini's prelate son, Monsignor Pietro Filippo. Monsignor Pietro regularly consulted astrologers in the course of his adulthood, above all for medical reasons (a common motivation back then) and carefully preserved his charts for posterity.

Bernini's astrological prophecy recorded in Chantelou's diary dated the collapse of his reputation to some time after his death. This proved to be the case. Quickly in the new century, the eighteenth, the Baroque, and Bernini along with it, suffered a terrible decline in popularity and esteem as aesthetic tastes shifted dramatically away from that theatrical, emotional, highly embellished style to the static simplicity, cool sobriety, and academic purity of the neoclassical. Sculptor Antonio Canova (1757–1822) ultimately became the new hero among modern artists. The most vociferous and most dogmatic of the neoclassicists denounced the Baroque style in general and the work of its leading exponent Bernini in particular as intellectually vacuous, morally decadent, psychologically unhealthy, and repulsively ugly. The decline lasted well over two centuries. It was only in the mid-twentieth century that Bernini and his Baroque contemporaries, Caravaggio premier among them, were rehabilitated. By now, the early twenty-first century, the prevailing taste of the art-loving public has completed its shift, fully and dramatically, in favor of the Baroque.[1]

THE STONING OF CASA BERNINI

In 1665, when he made that gloomy pronouncement about the future of his reputation, Bernini may have believed that the stars would at least allow him a graceful, if not glorious, last chapter of life and an honorable exit. However, starting in the year 1670 and intensifying in the next three years, there was reason for him to suspect that perhaps that was not to be the case, that perhaps the painful waning of his public stature might unfold before his very eyes, while he was still very much alive. Between 1670 and 1673—but in some ways continuing to the year of his death—there were an increasing number of disturbing signs that he was losing ground professionally, and perhaps permanently so. Some of the signs were impersonal, affecting him only indirectly: for example, Rome and the politically castrated, financially exhausted papacy were clearly ceding hegemony to Paris and the French monarchy. But others were more personal and more direct: attacks against

his name and his very person and a rapid series of crushing setbacks in his personal life and his public career.

Bernini was used to attacks, even vicious ones, and disappointing reversals of fortune in both his private and professional lives. But beginning in 1670, the nature and intensity of those attacks and reversals changed, leaving Bernini by 1673 to wonder whether his lifelong luck might be running out and whether he might no longer be capable of neutralizing the hostility of rivals or dodging the fatal blows of fortune, as he had done so cleverly in the past. Certainly as he aged and his physical body weakened, he could not have felt the same confidence and optimism of his more youthful years. And, again, once Clement IX died in 1669 there were no more friendly popes to protect and exalt him. Similarly, in the College of Cardinals, there were fewer powerful, old, reliable friends: Sforza Pallavicino departed this world in 1667, Antonio Barberini in 1671, Rinaldo d'Este in 1672, and Francesco Barberini in 1679. Fortunately, to fill some of the void, Bernini now had Cardinal Decio Azzolino (Queen Christina's counselor and "companion") and Cardinal Pietro Ottoboni, who would become, after Bernini's death, Pope Alexander VIII.

The first disturbing events to shake, if not shock, Bernini in this period occurred shortly after the new year in 1670. In Rome it was yet another season of *Sede vacante*, that precarious, violence-filled interlude between the death of one pope and the election of another. In this case, it was between the two Clements, IX and X. During this *Sede vacante*, as in the past, in the absence of the papal head of government, all manner of civic disorder erupted, including the settling of old debts and the exacting of revenge by acts of extreme violence, even to the point of homicide. Bernini had lived through this chaotic change of government several times before, but without the threat of violence to himself, as far as we know. This time was different. As we learn from an *avviso di Roma* dated January 4, within a short period of time, the person and property of Bernini were the direct targets of hate-filled hostility in a most physical manner. On the first occasion, the windows of his home were smashed by angry stone-throwers, while, on the second, his coach was forcibly detained and searched by several armed men of ill intention toward the Cavaliere. Fortunately Bernini happened not to be in the coach at the time of this aggression and survived this particular round of *Sede vacante* unharmed, if not unshaken. Although the extant documentation gives no motive for these attacks on Bernini, it is likely no mere

coincidence that this news about Bernini is delivered in the *avviso* together with similar news of violent physical assault by several armed men upon a certain Abbate del Gallo (identified as *Maestro di Camera*, chief chamberlain, of papal niece Donna Caterina Rospigliosi), presumably, as the anonymous *avviso* reporter speculates, because of the "hatred" provoked in certain men of rank (*diversi cavalieri*) by the cleric's arrogance. Had some act of arrogance on Bernini's part also provoked this attempt on his own life? We shall see in a moment.

As for the stoning of Bernini's home, that might strike us today simply as a passing nuisance and nothing more. Instead, within the social code of honor of Baroque Rome, it was, in fact, well understood by its perpetrators, its victim, and all eyewitnesses, as a dead-serious, ritualized act of revenge, intended to bring public shame upon the proprietor of the house. Usually accompanied by much loud insult-hurling and other boisterous shouting, the phenomenon was common in seventeenth-century Italy. Historian Elizabeth Cohen has recently coined a special term for it: "house scorning." As victims of house scorning, Bernini and his family could have only felt anger and humiliation, especially since they well knew that news of the assault would spread quickly throughout the gossip-loving city. Moreover, occurring in quick succession to the attempted attack on his person (in the coach episode), it was more than just humiliating, it was frightening as well. Someone was out to get Bernini. Frightening or humiliating, the attack on Bernini's home and the attempted attack on his person—which failed only because he happened not to be in his coach—were also unprecedented. What had Bernini done to deserve this?

One answer, in a word, could be: everything. That is to say, the motivating force behind these attacks could simply be that thick, pervasive, toxic cloud of anti-Bernini feeling that had accumulated over five decades and was now materializing into acts of violence against his very person. This was part of the price he paid for his longevity. There was much reason for hatred of the artist at that point: his continual grabbing of many of the most lucrative and most prestigious commissions in Rome, his inescapable influence—political and aesthetic—on the artistic profession in Rome, his arrogant treatment of competitors and rivals, his enormous financial wealth—in a word, everything he had done and accomplished in Rome. But there may have also been a more recent precipitating cause. In the summer of 1669 Clement IX decided to make provisions for his tomb

monument. It was to be placed not in St. Peter's, but in the basilica of Santa
Maria Maggiore, where he had long served as canon. He furthermore de-
cided that next to his tomb would be placed that of his benefactor and pre-
decessor, Alexander VII. Bernini had already received from Alexander the
commission for his tomb; Clement further entrusted to the artist the de-
sign of his own tomb and a proper architectural setting for both of them
in the ancient Marian basilica. By the end of the summer, Bernini's design
was ready. It was fittingly and sumptuously monumental. Unfortunately,
Bernini's design was also astronomically costly, and worse, entailed the
destruction of ancient mosaics in the basilica's tribune, which had to be
expanded and remodeled to accommodate the new tombs. The pope, none-
theless, gave his permission to go forward. Ground was broken in early
September 1669, with the ceremonial laying of the foundation stone at the
end of the same month. Shortly thereafter began the dismantling of the
mosaics.

It soon became apparent, however, that the only persons in Rome
happy with what was happening at Santa Maria Maggiore were Bernini
and the pope, and, we assume, Bernini's son, Monsignor Pietro Filippo,
a canon of the same basilica (a position he held thanks to his father). Ev-
eryone else was thoroughly rankled. The remaining canons of the ba-
silica were unhappy over the destruction of the revered mosaics, as were
the Roman people. Everyone was likewise furious over the expense—yet
another ruinously extravagant Bernini project in the midst of famine and
hardship. The pope's relatives were particularly enraged: if (as was likely)
the pope died before all the work was finished, they would be financially
responsible for completing the project, and they simply did not have that
kind of money—it was still too early in Clement's reign for them to have
had the time to enrich themselves at the expense of the church's treasury
in the manner of the Borghese, Barberini, Pamphilj, and Chigi. Bernini's
proposal had calculated the total cost of the project at 100,000 scudi; yet
by early November, just two months into the construction, word had got-
ten around that 60,000 had already been spent on the foundations alone.
How? Where? When? People demanded an answer. Recently discovered
documentation shows that 60k figure to have been grossly exaggerated,
but nonetheless, people believed it at the time. Given the exorbitant costs
of Bernini's earlier papal projects, they had no trouble believing that he had
burned through so much cash in so little time.

The vehement anti-Bernini chatter rose to high volume. One *avviso* reported that the Rospigliosi family, "with no small amount of resentment," believed that Bernini had tricked the pope into this ruinous venture. Another *avviso*, denouncing Bernini as a sleazy "operator," described the pope as "incandescently angry" at Bernini over the expense. According to the same source, one of the cardinals cited the authority of ancient Roman architect Vitruvius (who held architects personally responsible when their projects failed) and demanded repayment from Bernini or else the exacting of capital punishment upon the allegedly felonious artist. Yet another *avviso* described an angry encounter between the artist and Cardinals Rospigliosi and Barberini (presumably Francesco), who were demanding financial accountability. This unpleasant meeting supposedly ended with Cardinal Barberini abruptly dismissing Bernini, calling him a "scoundrel" to his face. There is no doubt some exaggeration in these reports, but probably not much, given what was at stake: a huge sum of money in a time of general misery and what was seen by many as irreversible damage to one of Rome's most beloved basilicas.

Resolution of the controversy, however, had to await the next pontificate, because on December 9, 1669, the sixty-nine-year-old Clement IX came to the end of his days. The astrologers had gotten it right again: his pontificate was short, just as predicted. The civil disorder and violence of *Sede vacante* followed predictably thereafter, this time hitting Bernini at home with the stoning of his palazzo on Via della Mercede and the assault upon his coach. Clement IX, it was widely reported, died of a broken heart: the cause, the disastrous defeat in early September of the Christian military forces at the hands of the Turks on the island of Crete, the last remnant of Venice's once-substantial empire in the Mediterranean and Middle East. Clement had invested heart and soul— and vast amounts of money—into this expedition. For him, to lose Crete (or Candia, as it was then called, after the name of its capital city) was to lose Christianity's war against the "infidels" who, the pope and his contemporaries feared, were aiming to overrun Europe and wipe out its civilization. To organize the defense of Candia, Clement had had to twist the arms and grease the palms of the various leaders of Catholic Europe, for, although they shared the same religion, they were frequently at war with each other. They finally agreed to the expedition and amassed an impressively large fleet, but their lack of solidarity ultimately doomed the enterprise.

France, in particular, was a troublesome partner for the pope. Louis XIV was unenthusiastic about the pope's rallying cry against the infidels. The king had, in fact, always maintained friendly relations with the Turks because such an alliance gave him a further card to play in his own war against the Hapsburgs. He would rather consort, at least diplomatically and commercially, with Turkish Muslims than Hapsburg Catholics. But in the end, thanks to various papal concessions made to France, Louis was persuaded to be part of the expedition. Papal apologist Domenico Bernini notes with pride that the pope sent to Louis "an exquisite standard bearing an image of the Cross under which, as the papal ensign, the king wished his troops to wage this war." The pope's gift was a splendidly wrought scarlet banner bearing the inscription *Dissipentur omnes inimici eius* (Let all his enemies be scattered). However, it was not piety that compelled Louis to raise this banner, rather than the French flag, on the French commander's ship, it was political dissimulation: he did not want to publicize the fact of French participation in this war against the Turkish empire, since he had never broken off diplomatic relations with it, nor had any intentions of doing so.

The French naval commander whose duty it was to lead the campaign was François de Vendôme, Duke of Beaufort, one of the illegitimate grandsons of French King Henri IV. An at times uncouth and not entirely savory character, the Duke of Beaufort was also thoroughly incompetent in his roles as admiral of France and grand master of navigation, positions which he had secured simply as a matter of succession from his father, their previous, and hardly more competent, incumbent. It was probably not with great regret that Louis learned of the admiral's death at Candia on June 25 attempting to break through the fierce Turkish siege of the city. Certainly Louis's secretary of the navy, Jean-Baptiste Colbert, did not mourn Beaufort's demise, for it removed one of the last obstacles to the minister's plan for the building of a truly modern and efficient French navy.

Another winner in this episode was the family of the famous Maréchal de Turenne, that is, Henri de La Tour d'Auvergne, vicomte de Turenne. Maréchal-général of the camps and armies of the king, Turenne was one of the great military heroes not only of Louis's reign but also of all French history (he is one of the few generals to be buried in the company of Napoleon in the Invalides). As even Domenico makes a point of noting in his biography of Bernini, a conspicuous part of the purchase price exacted by

King Louis from Pope Clement for French participation in this 1669 Candia expedition was the cardinal's hat given to Turenne's young nephew and ward, Emmanuel Theódose de la Tour d'Auvergne, who thereafter became known as the Cardinal de Bouillon. Often a thorn in the side of the monarchy, Bouillon is one of the more colorful, if least beloved or admirable members of late Baroque College of Cardinals.

That "color" begins with his intimate, fifty-year friendship, established in childhood, with the notorious, self-confessed transvestite, the Abbé François Timoléon de Choisy, who was likewise childhood playmate of Louis XIV's homosexual brother, Philippe, Duke of Orléans. "Since childhood, the cardinal and I had been accustomed to knowing, and, do I dare say it, to loving each other," declares with pride Choisy, known, in his transvestite days, as "Madame de Sancy." That Bouillon shared the same "unmentionable vice" is confirmed by the uncensored, brutally honest *Memoirs* of his younger contemporary at the French court, the Duc de Saint-Simon. Saint-Simon also adds, "There was nothing ecclesiastical or Christian about the cardinal's life, except what could serve his vanity. His pride was surpassed only by that of Lucifer. The conduct of his personal life was morally abominable, and he did nothing to hide that fact." Bouillon died in 1715 and was buried in Bernini's Church of Sant'Andrea al Quirinale. Since his self-exile to Rome in 1712, the cash-strapped and discredited cardinal had found inexpensive lodgings and a warm welcome by the Jesuits (his partners in intrigue, claims Saint-Simon) at the Sant'Andrea novitiate. The cardinal's choice of burial sites had nothing to do with Bernini, of course, but our artist and he may have crossed paths in Rome during Bouillon's travels there for the conclaves of 1669–70 and 1676.[2]

Colbert may not have shed a tear over Beaufort's death, but Pope Clement certainly did, abundantly and publicly. According to reports from the papal court, Clement grieved the duke's death more profoundly and more openly than that of his own young nephew, Tommaso Rospigliosi, who died of fever in early August of that same year. Pope Clement understood that the death of the French commander gravely undermined the chances for success of Candia and with it, the anti-Turkish campaign. In fact, as a result of Beaufort's death, the French withdrew from the expedition, and this soon led the Christians to surrender the island to the Turks on September 6. The enemy had secured yet another major victory and, in the fearfully overwrought imaginations of the Romans, were one step closer to the

doors of Rome. The Romans could all too easily imagine yet another sack of their city. After all, had it not happened so many other times in history?

Burdened by this costly and humiliating defeat and haunted by such dreadful scenarios of future Turkish incursions, Clement suffered a stroke several weeks later, at the end of October. Another, more severe stroke in late November brought him to his death on December 9. Clement IX's successor, the eighty-year-old Emilio Altieri, was elected on April 29, taking the name of Clement X (fig. 33). Though a decent man and faithful servant of the church, Altieri was no poet, no humanist, and no friend of Bernini's. Despite the fact that, born and raised in Rome, he had spent almost his entire life and career in the city, Altieri had somehow managed to resist the pull into the Bernini orbit. By June, the pontiff had temporarily suspended work on the new Santa Maria Maggiore tribune. In August, he went so far as to fire Bernini from the job, replacing him with the much-younger but talented rival, Carlo Rainaldi. Rainaldi proposed and executed a far less costly but also far less engaging design, completely lacking in the "wow factor" of the Bernini brand: you get what you pay for. Rainaldi's new apse ended up costing 34,176 scudi, whereas Bernini's suspended construction had consumed in less than a year 13,128 scudi.

An *avviso* of August 23, 1670, reported that Bernini was in a "state of despair" over his shameful dismissal from the Santa Maria Maggiore job. He counted himself lucky, however, for he escaped having to repay from his own pocket some of the expense of the already executed foundations, as representatives of the Roman people were threatening to legally force him to do. News of this threat had been reported in another *avviso* earlier that month. That same *avviso* also tells us that the civic authorities of Rome, the "Popolo Romano," denounced Bernini as "the one who instigates popes into useless expenditures in these calamitous times," advising him to be content "with getting rich from his statues without trying to rob [the papal treasury] through building projects." Grave charges and hostile words indeed. Nonetheless, it is difficult to imagine that the mature, pious Bernini, as the August 23 *avviso* claims, was truly in a "state of despair" over his dismissal—just as we cannot imagine him contemplating suicide in 1667 over the cancellation of his Louvre project, as the local gossips had said at the time, according to one of Christina of Sweden's letters in which she flatly denies the rumor. Nonetheless, Bernini's dismissal from the tribune job, the brutally bad press, and the ill will that had been stirred up against

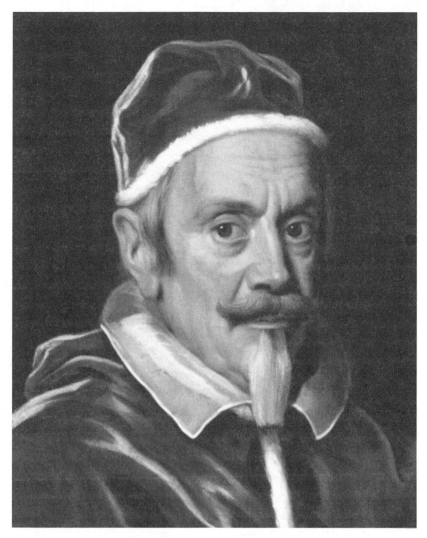

FIG. 33 ➢ Giovan Battista Gaulli ("Il Baciccio"), *Pope Clement X*. Florence, Uffizi Gallery.

him especially among once-friendly cardinals must have been exceedingly bitter pills for him to swallow.

Bernini tried to court the favor of Pope Clement and the Altieri family by agreeing to sculpt an equestrian portrait of papal nephew Don Gasparo for the courtyard of Palazzo Altieri. The attempt failed miserably: apparently our artist promised too much too soon, while accepting a cash

advance for his work. In visiting the family residence in October 1670, the pope was extremely disappointed not to find any evidence of the promised statue and scolded Bernini publicly to his face. In response to Bernini's humble excuses, the pope quipped wittily but sarcastically with a biting reference to the artist's other equestrian project that then also seemed doomed to failure: "Well, Cavalier Bernini, we do believe that if we have to depend on your horses neither will the King of France come to Rome, nor my nephew go to Paris." After that we hear nothing further of the project.[3]

In the 1640s during the crisis in his career provoked by the failed bell towers at St. Peter's, Bernini had retreated within himself, or more specifically, within his art. Now, after the collapse of his Santa Maria Maggiore apse project, he did the same. As a dispatch from the Roman agent of the Court of Savoy reported in August 1670, the Cavaliere was busy executing a work of art that would display to the world "his incomparable *virtù*." The latter word, *virtù*, in this context could mean either "virtue" or "talent," but in either case, the meaning is clear: Bernini's art would vindicate, as well as comfort, him. In the 1640s he had responded to crisis with the carving of his statue of *Truth Revealed by Time*. On this occasion, the older and more pious Bernini did not produce another life-size, buck-naked, coyly smiling woman, or anything remotely like it. Instead, he produced a drawing, which he immediately had engraved for distribution in the form of inexpensive prints. He also had it copied in oil on canvas. The subject of the composition, usually called *The Blood of Christ* (*Il sangue di Cristo*), represents High Baroque iconography at its goriest extreme, so revelatory of Bernini's turbulent emotional state at the time. Let us hear his son Domenico's description of it:

He had, for his personal devotion, reproduced as both an engraving and a painting, a wonderful drawing that depicted Jesus Christ on the cross with a sea of blood at its base, the blood gushing copiously from his most holy wounds. Therein one also sees the Most Blessed Virgin in the act of offering her son to the Eternal Father, who appears above, his arms extended, moved to tender compassion by so piteous a scene. And "In this sea," Bernini used to say, "all his sins were drowned and could not otherwise be found by Divine Justice than amidst the blood of Jesus Christ; Jesus' blood would have either caused these sins to change color or else, through its merit, would have obtained mercy for them." His trust in this was so deep that he used to

refer to the Most Holy Humanity of Christ as the "*Cloak of Sinners*." He all the more trusted that he would not be struck by divine vengeance since the latter, before reaching him, would necessarily have to pass through this garment; hence, in order not to pierce the innocence of that cloak, God would, instead, forgive him his sin.

The *Blood of Christ* composition derives from a vision of the Florentine nun Maria Maddalena de' Pazzi, a cloistered Carmelite like Teresa of Avila, who died in 1607 and had been canonized only in the previous year, 1669 (Bernini designed the commemorative medal for her canonization). The relatively short time between her death and her canonization testifies to the great popularity of the saint and her dramatic brand of mystical spirituality. The fact that some of her most clamorous miracles involved the healing of her moribund nun-companions by licking their putrefying wounds and sucking the pus from their sores might nowadays represent a bit of a stumbling block to a proper appreciation of the saint's spiritual qualities. They did not to Bernini or his Roman Catholic contemporaries. The gorier the saint's wondrous deeds, the more heroic her or his virtues seemed.

The gruesome *Blood of Christ* drawing is not only revelatory of Bernini's state of mind at the time, it is also an excellent illustration of one of the central, distinctive articles of the Christian faith, then as now: salvation through Jesus Christ. For the benefit of non-Christian readers, a quick explication of church doctrine is here in order. God the Father, angry for millennia over the disobedience of Adam and Eve (the "Fall") condemned to hell for eternity all their progeny (with a few exceptions) until the coming of the Messiah in human form, in the person of God's son Jesus Christ: this was the "Incarnation." Jesus finally placated the wrath of God the Father—"placating divine wrath" is the very vocabulary used by centuries of completely mainstream Christian theologians and spiritual writers—by the blood sacrifice of his death on the cross, the "Redemption."

The Virgin Mary's privileged role as intermediary in this process is a specifically Roman Catholic addition to the doctrine, highlighted in Bernini's composition. Moreover, Jesus's sacrifice, "his blood," serves its appeasing-protective function for all repented sins committed even after his crucifixion, for the sins of mankind continue to provoke "divine vengeance." The seeking of vengeance was not considered incompatible with the idea of the deity: in the *Dies irae*, "Day of Wrath," one of the most

popular of all Catholic Latin hymns since the Middle Ages, heard by Bernini at many a Lenten and funeral service, God is famously invoked as the *juste judex ultionis*, "the just judge of vengeance." Nonetheless, thanks to the sacrifice of Jesus and the intersession of Mary, Bernini would have some degree of confidence about the consequences of his own sin. Yet, let us note, despite the "satisfaction" for sin brought about by Christ's sacrifice, divine justice still requires the punishment of humanity by immediate, corporal means such as famine, war, and plague of every sort. This was the literal belief of Bernini and his contemporaries. Not to understand the belief in this dynamic of sin, salvation, and redemption is not to understand significant aspects of the artist's life and work, for it inevitably had many ramifications and manifestations in the psychology of Roman Catholics and in the dynamics of daily life, too numerous to spell out here.[4]

SODOMY BEHIND THE STATUE(S)

We do not know whether Bernini's adversaries were as impressed by the artist's "incomparable *virtù*" displayed in his *Sangue di Cristo* design as the artist had hoped. Though circulated in the form of an engraving, it seems not to have inspired much reaction, at least as far as we can tell from surviving documentation. His Oratorian priest nephew Francesco Marchese did include the engraving, full-size, in his work of popular spirituality, *Unica speranza del peccatore* (The sinner's only hope) of 1670, which would have assured its further dissemination.

Several months after his August 1670 dismissal from the Santa Maria Maggiore project, preparing for the official inauguration at the Vatican of his finally completed colossal equestrian statue, the *Vision of Constantine*, Bernini may have been hoping to further nullify the bad press generated over the Santa Maria Maggiore debacle with an even more dazzling display of his *virtù*. Instead, he was sadly disappointed. The statue of Emperor Constantine, depicted in thunderstruck reaction to a heavenly vision above, was formally inaugurated on November 1, 1670. The reaction was mixed, and for Bernini at that juncture in his career, the fact of mixed reviews was almost as undesirable as uniformly bad reviews. He needed an unqualified, universal, crowd-pleasing success. Many criticized the statue for both the unrealistic aspects of its composition and its supposedly less than masterly

workmanship. In fact, such criticism had started circulating even before the formal inauguration.

The bad press this time was not restricted to informal conversation or brief references in the *avvisi di Roma*. Some Bernini-hating critic decided to spell out and publicize what he saw as the numerous defects of the Constantine in a detailed, vitriolic treatise, *Del Costantino del Cav. re Bernini* (Regarding Cav. Bernini's Constantine), condemning not only the statue but also its maker. This first treatise inspired and provided the ammunition for yet another equally anonymous and equally vitriolic attack, *Il Costantino messo alla berlina* (Constantine brought to the pillory). The latter pamphlet is full of pedantic nitpicking and cheap shots not just about this latest statue but about several of Bernini's earlier works, rubbing salt in old wounds like the failed bell tower project and the "cracks in the cupola" charges against Bernini. The anonymous author concludes with a "benevolent" suggestion for our artist: "Truly out of charity would I advise the Cavalier Bernini to avoid forever as an unfortunate arena the Church of St. Peter's where on the rocks of both architecture and sculpture he has always been shipwrecked."

Did Bernini read his reviews? Did any of his friends or relatives dare tell him what was being spread about his *Constantine* and about him personally? Even if Bernini had full knowledge of these various bad reports, they would soon represent in his mind no more than mere firecrackers in contrast to the huge bomb that exploded in the artist's life just about a month later, in December 1670. Again ground zero was his *Constantine* in the Vatican. Let us listen to the first known public report of the catastrophe that struck Casa Bernini in that month:

> Without reflecting upon the Civil Laws of Constantine the Great, several of which order the severe punishment of Gomorrhans with fire and stone, the brother of the Cavalier Bernini has committed this sin within the enclosure around and in the presence of the statue of the said Constantine (recently erected, as reported, in St. Peter's). In doing so, he inflicted extensive physical violence on the poor victim, who suffered sixteen fractures as well. The Treasury was ordered to confiscate the possessions of the perpetrator, since he himself has already fled to Naples for safety. In any case, this Champion [Gian Lorenzo Bernini] is seeking to take care of the matter by paying out

the sum of twenty-six thousand scudi to the aforementioned Treasury and two thousand to the boy's father. Cardinal Albizzi, who is the boy's godfather, is raising hell over this crime, seeking punishment of the guilty party; the cardinal has promised to pursue formal criminal charges against him.

"This sin"—its name was considered too horrible to even mention—was sodomy. Luigi Bernini—sixty years old—had violently raped a young man—identified as *un putto*, a boy—somewhere in the immediate vicinity of his brother's *Constantine* (presumably behind some privacy-affording temporary fencing) within the sacred precincts of the holiest shrine of Catholic Christendom. (The precise date of Luigi's crime is not known, but it must have taken place in early December, since Cardinal Rinaldo d'Este, living in Modena, had already been informed of the news by the thirteenth of that month by his Roman agent.) The crime in itself, rape, was horrendous enough, but it is hard to imagine a worse set of attendant circumstances, including the fact that victim's godfather was no less than the distinguished senior cardinal, Francesco Albizzi. Luigi must have simply been crazed by sexual frenzy to have committed so outrageous a crime, under such circumstances, knowing full well the consequences, legal and personal. As was traditional in Europe and as last repromulgated in 1580 by Pope Gregory XIII's *Statuta almae urbis Romae* (book 2, article 49), the punishment was death: "Let anyone committing the unspeakable crime of sodomy be burnt at the stake with fire in such a way that he dies; in these cases, the Curia is obligated *ex officio* to investigate the circumstances of the crime." On a personal level, Luigi risked complete ostracizing not only from his peers but also and above all from his family, including his pious older brother, whose destiny had been closely intertwined with his own since childhood.

Wouldn't we like to have been a fly on the wall when poor Bernini, already afflicted by bad news of his own, received the dread word about Luigi? Did he hear it from his brother himself? Or did the terrified Luigi not stick around Rome long enough to confess the truth directly to his brother? The memory of Gian Lorenzo's fit of fratricidal rage in April 1638 over their common mistress Costanza Bonarelli must have been seared into his consciousness.

Many thoughts undoubtedly raced through Bernini's head in those first moments of stunned disbelief, but one thought that did not cross his mind

was that Luigi was gay or homosexual. We can be sure of this, for not only did those terms not exist, the concept itself did not exist and would not exist until the late nineteenth century, namely, that of homosexuality as an involuntary, psychologically constituted, perhaps genetically determined orientation of a person's fundamental identity and erotic attraction. Moreover, the very concept of "sexual orientation" did not exist. It was for all premodern generations of Christians simply one further manifestation of the universal infection of lust plaguing humanity since the Fall of Adam and Eve, engaged in by persons whom we would call today heterosexuals. That is to say, anybody, male or female, young or old, could be and was tempted by Satan into the sin of sodomy. Today we might raise a whole series of questions about Luigi's sexual orientation and his activity, but for his brother Gian Lorenzo, his family, the church, and all of his contemporaries, the picture was simple; horror-inspiring to be sure, but conceptually simple.

Although sodomy was called the "sin against nature" by the preachers, it was a sin that came rather naturally and on a fairly widespread scale in early modern Italy. Scholars have only recently begun to study sodomy in Baroque Rome, but a survey of just one of the three tribunals with jurisdiction over that crime uncovered 114 trials in the period 1601–66, and these were just the formally prosecuted cases. For the French, Spanish, and English, sodomy was the stereotypical vice of the Italians. The Italians, in turn, saw it as the vice, above all, of the Florentines. Bernini would have been well aware of the sodomitic reputations of the artists Donatello, Botticelli, and Leonardo da Vinci, just as he would have been well aware of the gossip about the great Michelangelo himself. Michelangelo's poetry contains some of the most moving, passionate expressions of male same-sex love, especially his verse addressed to the handsome young Tommaso de' Cavalieri. And his contemporaries understood it exactly as such: a man expressing his erotic (however much spiritualized and "Socraticized") love for another man. This is why, when publishing his uncle's love poems in 1623 (dedicating the edition to Cardinal Maffeo Barberini), Michelangelo Buonarroti the Younger felt compelled to select and edit them carefully (for example, he changed the pronouns and other gender references from male to female) to prevent further damaging gossip.

Princes and other men of power like Cardinal Scipione Borghese, Philippe the Duke of Orléans (Louis XIV's brother), or King James I of

England could with impunity let word of their homosexual love circulate in public. They could even act on it, but not lesser mortals. Lesser mortals in this case included artists. Bernini would have been mindful of the fate of Jérôme Duquesnoy the Younger, the artist-brother of his one-time rival in sculpture, François. In 1654 Jérôme was executed by strangling in Ghent for raping several of his workshop assistants and models. In Rome in 1670 Luigi could meet the same end if Gian Lorenzo did not act immediately. Like it or not, it was up to him as head of the clan to clean up the mess. At the same time, he knew that he could not continue his own work without his brother's expertise, especially in matters of engineering. Bernini had to prevent any trial from taking place and obtain a special papal pardon so that his brother could return home, recover his confiscated possessions, and resume his life, more or less as before. Everyone in Rome fully expected the resourceful Bernini to succeed in his goal, as this dispatch from Rome to the court of Modena reported: "Regarding the aforementioned Luigi Bernini, the prevailing belief is that justice will not be served with respect to the charges that have been publicized against him; this is because his brother has an abundance of money, connections, and brains and will manage to navigate successfully these ill winds and find a remedy for any damage done to the reputation of his family."[5]

The question for Bernini now was: Whom to turn to? Which of his high-placed connections would be most effective in these circumstances? A crime of this extreme kind would require intervention of an equally extreme kind. The answer: Christina, Queen of Sweden. Who better than she, the most powerful woman in Rome, second in diplomatic rank only to the pope himself? Furthermore, if what they said about her own sexuality were true, she would certainly be far less morally judgmental about Luigi's crime. Lover of *virtuosi* and of Bernini in particular, Queen Christina immediately agreed to help the artist. We do not know what Bernini promised her in return, most likely some work of his hand; she may not have in fact accepted anything, just as years later she did not accept a still-grateful Bernini's gift to her of his bust of the Savior. With all due ceremony and formality, Christina paid royal visits to Pope Clement (and apparently the victim's godfather-cardinal as well) and succeeded in preventing a trial from taking place: "The Queen forcefully persuaded the pope that this was a matter to be dealt with in the context of private confession and not the

courts." A great victory for Luigi and Gian Lorenzo. The victory was further consolidated by a payment of a fine of 18,000 scudi, as well as a "gift" to the father's son of 2,000 scudi.

Bernini's victory left a bitter taste in the mouth of the Romans, as we learn from this indignant *avviso* of the time:

> The Queen of Sweden . . . went to see the Pope from whom she was able to obtain the grace of putting a stop to any legal measures against the brother of Cavalier Bernini, guilty of having violated a boy in front of the statue of Constantine, as reported, in St. Peter's. This was granted despite the tirades on the part of [papal nephew] Cardinal Altieri against the criminal, who was on the verge of having his possessions confiscated. However, nowadays sodomy is no longer the little snack of just the Florentines but rather has spread to all parts and is a dish especially loved by princes. The sodomites of Rome in particular have their great protectors and defenders, since this is a tasty dish enjoyed in Rome by the upper and lower classes alike.

The fact of general tolerance in Rome of sodomy, including what was called *bardascismo* (prostitution involving young men or boys) is also lamented in Gregorio Leti's 1668 satire of the papacy, *Il puttanismo romano* (The whoredom of Rome). In Leti's racy dialogue, politically astute prostitutes of Rome gather together after the death of Alexander VII to discuss the scandals of his reign and the upcoming conclave. Thoroughly cynical, they refuse to believe that the cardinals will have the courage to elect a pope who will rid the papal court of its sexual immorality. Why such cynicism?

> Don't you know that the sin of sodomy provokes far less uproar than that of fornication with female prostitutes? That's the reason why those more self-righteous prelates and those cardinals who have greater pretensions to the papal throne, turn their faces in disgust whenever they see a poor, young whore attending Mass or a most excellent courtesan going for a ride in some ambassador's carriage—they react as if they were seeing the horned devil himself, even, very often, making the sign of the cross on themselves at the sight. Yet, in their own bedrooms, they enjoy themselves for entire days and nights with some cute little boy or some young rough trade. . . And the young boy keeps his mouth shut about what is done to him in order

to protect the reputation of the cardinals and bishops, who, in turn, make display of their disdain for women, in order not to create a scandal for the faith, while cavorting with boys.

No wonder Bernini harbored faith that he would find allies within the court of Rome to settle the mess that Luigi had made so that they could all resume life as before, as if nothing had ever happened.

However, it turned out that blocking the trial and securing the release of Luigi's confiscated assets proved to be the easy part. The remainder of the task, full pardon of Luigi with his return from exile and a restoration of his various positions at the Vatican, proved much harder. It was also excruciatingly long in coming. Swallowing his pride, Bernini at regular intervals had to literally throw himself at Pope Clement's feet and abjectly beg on his brother's behalf. Mere words were, of course, not enough, and this Bernini understood without having to be told. Bernini had to deliver to the papal family a whole series of marble statues, free of charge, over the course of four years. At the time of each new delivery, Bernini would renew his begging and Pope Clement would offer some words of hope for the pardon. The cynical among us would say that the pope was deliberately stringing Bernini along to squeeze more free art out of him, since the Altieri were then busy expanding and embellishing their family's grand palazzo near the Church of the Gesù. Others might, instead, point out that granting a pardon too soon would have caused great public scandal, since popular sentiment against Luigi was still too vehemently negative. (Some of that sentiment was humorous at the same time; the aforementioned anti-Bernini treatise, *Constantine Brought to the Pillory*, manages to get in this sarcastic jab: "There are not lacking those, however, who excuse [the fact that Bernini gave Constantine a shaggy beard] by saying were he smooth-shaven, he would not be safe from Luigi, Bernini's brother.") In the end, we are not exactly sure when the papal pardon was granted, as there is no documentation describing it; it most likely came during the Jubilee year of 1675, a time when such special indulgences were routinely and plentifully granted. In the interim, Luigi remained safely outside the Papal States. Even once he returned to Rome, however, he did not resume residence at the Casa Bernini on "Ransom Street" (Via della Mercede) until 1679, according to the annual Easter census lists.

Since they were meant to serve as mere garden ornaments, the statues delivered free of charge to Pope Clement were most likely executed by Bernini's assistants and not the master himself, who may not even have designed all of them. They were the routine production of early modern sculpture workshops, Adam and Eve, the Four Seasons, and a group of ancient Roman emperors. If Bernini were to get the big pardon he sought, he would have come up with something big, really big, in return. Fortunately the opportunity soon presented itself. On January 28, 1671, the pope beatified a holy woman of recent Roman history, Ludovica Albertoni (1473–1533), a member of the lay Franciscan order of the Penitenti. (More accurately, the pope officially ratified the title of *beata*, "blessed," that had long ago been bestowed upon Ludovica by popular acclaim.) Then as now, beatification was the last step before attaining canonization as a duly enrolled saint of the Catholic Church. Known as the "mother of the poor" for her works of charity, the Blessed Ludovica was also one of those miracle-working, levitating, ecstasy-experiencing female ascetics like Teresa of Avila, whose extreme brand of sanctity was so attractive to Baroque Catholicism. Ludovica enjoyed a large popular cult in Rome especially among housewives and matrons, for she herself had been a wife and mother before her widowhood and entrance into religious life. Bernini's wife, Caterina, was one of the many Roman matrons who prayed and lit votive candles in the tiny chapel where Ludovica's memory was honored in the Church of San Francesco a Ripa in Trastevere. A small but eloquent indication of Caterina's personal attachment to that church is the fact that her last will was dictated there, in the residence of its Franciscan friars, some of whom she appointed as executors of that will.

Ludovica's ecclesiastical status remained stagnant until the pontificate of Clement X, or more specifically, until the nephewless Clement X adopted as his legal nephew Cardinal Paluzzo Paluzzi Altieri degli Albertoni. Cardinal Paluzzo was Ludovica's great-great-grandson, and having helped secure her beatification, he decided to upgrade her image and renown by commissioning a biography and embellishing the locus of her cult, the aforementioned and now newly renamed Altieri Chapel in Trastevere. Cardinal Paluzzo's motives were not purely pious. Nothing like having a saint, or an almost-saint, in the family to enhance one's socioeconomic status in society. But Ludovica had to be properly marketed, especially if

she were to make it to the finish line—canonization—in timely fashion. In late 1673 or early 1674, Cardinal Paluzzo set a competition in motion among the artists of Rome for the design of a new, refurbished chapel in which the Blessed Ludovica would play a more prominent role in the form of a large marble statue. Bernini won, promising to do the work free of charge, supposedly, as a Roman *avviso* reported on February 17, 1674, on the condition that brother Luigi be recalled from exile. Bernini may not have been so blatant in his explicit terms, but we can be sure that he and the cardinal understood each other without having to spell things out verbally: *Una mano lava l'altra*, one hand washes the other.

Bernini's incredibly fertile creative imagination and phenomenal physical energy did not fail the seventy-six-year-old in this time of desperate need. He finished the statue in just over six months' time. The artist also redesigned the rest of the small chapel, calling upon one of his favorite painter-disciples of the period, Giovanni Battista Gaulli, "Il Baciccio," to create the large, tender, and richly colored altarpiece of Saint Ann, the Virgin Mary, and Christ Child. Like the Saint Teresa (Cornaro) Chapel in Santa Maria della Vittoria, though on a much more modest scale, the result is a superb blending of all component elements—sculpture, painting, fresco, stucco decoration, and specially manipulated natural lighting—into one organically unified and visually stirring whole, another example of Bernini's famous *bel composto*.

Then as now, the attention of visitors, or better, spectators, was and is captured by the gleaming white marble statue of the recumbent Ludovica depicted in the spasmodic throes of ecstasy, her body almost lost amid an excited, tousled mass of drapery. (Is she dying, as Domenico's biography says she is? Or just experiencing, like Teresa, her mystical nuptial union with Christ? Or both at the same time?) Again, as in his *Saint Teresa*, Bernini set aside the inconvenient historical truth in depicting his Ludovica with soft, supple, wrinkle-free skin on her perfectly featured face and graceful, almost plump hands (fig. 34). The real Ludovica, through endless fasting and other forms of extreme physical self-mortification, had rather quickly in her religious career reduced her tormented body to a state of desiccated emaciation. So we can imagine what she looked like at her death at age sixty. But who can blame Bernini? Better to look upon an unblemished, well-fed, Baroque beauty rolling in waves of orgasmic ecstasy than a hungry-looking, battered corpse. Nonetheless, everyone today knows the

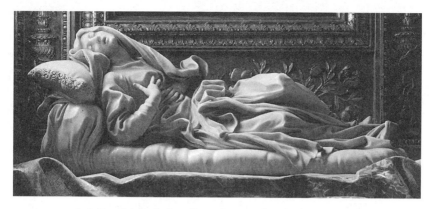

FIG. 34 ➻ G. L. Bernini, *Ludovica Albertoni*, 1674, Church of San Francesco a Ripa, Rome. Photo: Scala/Art Resource, NY.

sordid Bernini family secret that had remained buried in the archives for centuries until its rediscovery by art historian Valentino Martinelli in 1959: behind this gleaming white, spiritually poignant statue hides an ugly crime, Luigi's sodomitic rape. No wonder poor Ludovica is in such agitation, one is almost tempted to say.[6]

"That Dragon Vomiting Poison in Every Direction"

On January 17, 1675, the Blessed Ludovica's remains were solemnly reinterred in the Altieri Chapel, which meant that Bernini's labors must have come to completion by then. All indications are that his finished product was met with the entire satisfaction of cardinal nephew Paluzzo Altieri. As an unmistakable public sign of his newly found pleasure with Bernini, Cardinal Paluzzo deigned to attend the February 25, 1675, performance of Pietro Filippo Bernini's comedy at Casa Bernini, bringing along with him a large entourage of noble personages to further publicize the message. Queen Christina and her courtiers were also in attendance, so Bernini must have been a happy man that evening.

True, he was paid nothing at all for his work on the Altieri Chapel, but to have brother Luigi finally and fully pardoned by the pope—as we assume occurred as result—would have been compensation enough. As a further sign of Bernini's newly established good relations with the pope and his family, the artist's eldest son, Monsignor Pietro Filippo, was granted soon

thereafter yet another income-generating office within the papal curia, that of secretary of the Congregation for Water and Roads (*Congregazione delle acque e strade*), which had responsibility over the roads, bridges, and aqueducts of the Papal State. Again, Bernini had reason to be happy. Apart from the revenue it entailed, this further foothold within the papal administration could only advance his son's passage up toward the rank of cardinal, and from there—dared he hope?—to the throne of Saint Peter. (In the end, that never happened: Pietro Filippo died a mere *monsignore*; were he not Bernini's son, he would hardly be remembered at all by posterity.) As usual, Bernini's good fortune did not fail to inspire, in turn, public sarcasm and humor at his expense. In reporting the securing by Bernini of this salaried sinecure for his son, the Roman agent of the Duke of Modena compared the artist to Moses striking his rod against the rock and causing water to flow forth—the rock being, of course, Bernini's sculpted marble, and the water, this new job within the papal congregation.

Any moments of happiness Bernini may have experienced in these early years of the last decade of his life could only have been temporary and certainly incapable of obliterating the larger woes besetting him. In this period of life, we can imagine him praying with an acute degree of personal identification before the image of Our Lady of Sorrows, the *Mater Dolorosa*, that is, the grieving Mary of the Good Friday Passion processions: her face streaming with tears, her hands tightly clasped in grief, and her exposed heart pierced with seven swords. In 1672 another sword was thrust into Bernini's heart, another major blow to his professional reputation: the publication of Giovanni Pietro Bellori's collection of artist biographies, the *Vite de' pittori, scultori et architetti moderni* (Lives of the modern painters, sculptors and architects). Bellori had all the credentials—education, intellect, experience, publication record, and employment—as one of the most authoritative, influential, and, thus powerful art critics and theorists of late seventeenth-century Rome. When Bellori spoke—or wrote—people paid attention. He, furthermore, had prestigious pulpits from which to preach: as of 1670 he was Clement X's commissioner for antiquities, and in the following year he was elected *principe*, rector, of the Accademia di San Luca, the Roman artists' academy. In the late 1670s the versatile *erudito* (scholar) Bellori joined Queen Christina's court, serving as her librarian and antiquarian.

As far as the 1672 *Vite de' pittori, scultori et architetti moderni* and Bernini are concerned, the troubling matter is not what Bellori said therein about Bernini, but that he said nothing at all. That is, in this lineup of the most prominent artists of his times, Bellori completely excludes Bernini. He includes (though criticizes) even the universally unloved maverick Caravaggio, but excludes the great and powerful Bernini. How dare he? But more important, why? The reason has everything to do with the neoclassicizing prejudices of Bellori's ideology of art, although, given Bernini's behavior, our artist may have also given Bellori reason to dislike him personally. In Bellori's estimation, Bernini's brand of extravagant Baroque had strayed too far from the purity of classical antiquity and its idealizing version of nature and hence perfect beauty. Therefore, Bernini merited no niche in the gallery of modern artistic greatness. Bellori's classicizing orthodoxy was then winning, and would continue to win, many adherents even after his death in 1690. It was Bellori who in large measure helped sow the seeds of the neoclassical movement that would blossom and overtake the landscape of art theory and practice in the following century. In their triumph, the keepers of neoclassical orthodoxy would sweep Bernini under the carpet in complete disdain and keep him there for over two centuries. Although we have no documentation describing his reaction to Bellori's work, Bernini would surely have been both infuriated and saddened to be seventy-four years old, patronized by one pope after another and the king of France, and have his numerous accomplishments, indeed, his entire existence, ignored in what professed to be the latest word on who's who in contemporary art.

Not long after the publication of Bellori's work, another collection of artists' lives began to circulate in Rome in manuscript form, Giovanni Battista Passeri's much more inclusive *Vite de' pittori, scultori ed architetti che hanno lavorato in Roma, morti dal 1641 fino al 1673* (Lives of the painters, sculptors, and architects who worked in Rome and died between 1641 and 1673). Yet again it was a sword in Bernini's heart. Though of lesser intellectual status than Bellori, Passeri still enjoyed enough of a respectable public reputation to gain a wide audience for his writings. There is no separate *vita* of Bernini in Passeri's work, since, as its title declares, the collection is restricted to artists who died in the period 1641–73. Nonetheless, the sharp-tongued Passeri has much to say about Bernini in the form of random remarks scattered throughout the entire work, and some of it is

stingingly negative. Most notoriously, at one point, Passeri applies to our artist a most uncomplimentary image that was destined to have a long life in the memory of posterity, just as it must have immediately caught the attention of his delighted enemies, whom we can easily imagine gleefully repeating it throughout the city and beyond. For Passeri, Bernini, with his fierce and jealous protection of his professional turf and privileges, was no less than "that dragon custodian who kept watch over the gardens of the Hesperides . . . and who vomited poison in every direction, constantly carpeting with the sharpest of thorns the path that led to the possession of the most desirable favors." Everyone back then would have immediately understood the unflattering reference to classical mythology, that is, to the ferocious, repulsive beast that stood guard over the golden apples of the goddess Juno and that was eventually slain by Hercules in the eleventh of his twelve famous labors. Bernini had been called many nasty things in his life, but this would have certainly been counted by the artist as one of the worst, for, if anything, Bernini saw himself as a heroic, divinely endowed Hercules, not as a slimy dragon fated to be vanquished. Finally, like Bellori's *Vite* (dedicated to French Chief Minister Colbert), Passeri's work would have further annoyed our artist for the fact of having a French dedicatee, this time Louis XIV himself. It was another galling, if not depressing, reminder that Rome was losing its cultural leadership to the France. And if Rome declined, so would Bernini, for, as he well understood, their destinies were intimately intertwined.

Passeri's "dragon" slam against Bernini occurs in his *vita* of painter Guido Ubaldo Abbatini, a member of the Bernini workshop. In the same *vita*, Passeri gives voice to what was probably the complaint of many an overworked Bernini disciple and student: their employment under Bernini felt at times like entrapment or exploitation. (Of course, in the days before modern trade unions and strict laws protecting workers' rights, employment in most fields was exploitation.) Passeri specifically points to the punishing schedule of Bernini's annual theatrical productions in which the master's assistants were obliged to participate both on stage and off, but given the often frenetic productivity of the Bernini workshop, the complaint was probably applicable to all aspects and seasons of their employment and training under the fire-driven Bernini. The fact that he treated himself even more harshly than he did others, however, did not necessarily make life any less unpleasant for his oppressed subordinates, who had

to silently and passively endure their boss's type A personality. In his art Bernini may have been famous for his *tenerezza*, tenderness, but not in his personnel management style.[7]

Abbatini is just one of many painters who, working under Bernini's close guidance and at times according to his designs, produced canvases and frescos that were integral components of the master's larger multimedia works such as churches and chapels. For his talent and independent accomplishments, Giovanni Battista Gaulli of Genoa, "Il Baciccio" or "Baciccia" (1639–1709) stands out far above and beyond these *pittori berniniani*, "Berninian painters," as they have been called. A great deal of his fame rests today on the monumental frescoes he executed in the 1670s for the cupola and vault of the mother church of the Jesuit order in Rome, the Gesù. These vast, illusionistic works of light and color open up endless ineffable vistas of the heavens to the mouth-dropping delight of the thousands of neck-strained tourists who visit the church each year. Not only did Bernini secure this prestigious commission for Gaulli (the Jesuit superior general at the time was his good friend, Gian Paolo Oliva), he also supplied his young protégé with some of the designs incorporated therein. Gaulli signed his first contract with Father Oliva in 1671. In the following year as a sign of respect and gratitude to his master, he asked Bernini to serve as godfather to his newly born son, whom he named, Lorenzo, after the artist. Only those raised in traditional Mediterranean Catholic cultures can fully appreciate the emotional and social significance of that gesture (which remained potent until fairly recent times): in accepting the invitation, Bernini was, in effect, welcoming Gaulli and his son into his own extended family.

Little known even among the experts is the fact that, unfortunately, at their respective unveilings, in 1675 and 1679, both the frescoes of the cupola and vault were not at all greeted with a universally favorable public reception. The Roman *avviso* announcing on April 20, 1675, the unveiling of the cupola frescoes reports that their design was by the Cavalier Bernini and their execution by "some Florentine [*sic*] by the name of Bacicci [*sic*]," and that neither the *invenzione* (design) of the former nor the handiwork of the latter were much praised by the Roman *virtuosi*. Another *avviso* of the same date criticizes the Jesuits for hiring a "not much esteemed young painter" just to save some money, with the result being a cupola fresco filled with defects. (This is the same *avviso* that gave us that stinging but funny anti-Jesuit sarcasm cited earlier about God Almighty being seen in the cupola

in quite a perturbed state because of the chaos in the world sown by Saint Ignatius and his Jesuit order.) The reviews of the vault frescoes in August 1679 were also disappointingly mixed. Before letting in the general public, the Jesuits invited a large group of cardinals, painters, sculptors, and architects to view—and hopefully provide advance praise for—the almost finished ceiling. Instead, "all of them concluded that it would be beautiful if the painted scenes had been less disorderly and executed by a different hand." In other words, you would have to start from scratch to correct this mess. Yes, an *avviso* writer says in his December 23, 1679, bulletin, Queen Christina did praise the new ceiling decoration, "but what else could she do?" it cynically points out. True, as a slightly later *avviso* (January 6, 1680) reports, there were those who considered the newly embellished ceiling as a whole, which included large areas of gilding and many decorative embellishments (angels, festoons, banderoles, and putti) in white stucco, to be "one of the most beautiful and sumptuous marvels of Rome." However, as the same *avviso* qualified, "as far as the painting in itself is concerned, it has not been able to escape the censure of the critics."

Poor Baciccio, to hear something like this after years of back-breaking labor. But poor Bernini as well. Everyone was aware of his role in the advancement of Baciccio's career especially at the Gesù, and thus Baciccio's failure was, to some extent, Bernini's as well. The same guilt-by-association phenomenon had applied earlier, in November 1671, at the unveiling of the tomb monument to Pope Clement IX in Santa Maria Maggiore. Though he had originally been given the commission, Bernini ended up playing no direct role in its design or execution (it was the work of several artists who had collaborated with Bernini on other projects). Still, as an *avviso* reports, the unveiling of this Bernini-inspired monument "brought derision to Cavalier Bernini, who thinks he's another Phidias and Praxiteles," two of the most celebrated sculptors of antiquity. Not what Bernini wanted to hear in this, the worst decade of his life.

It is not surprising to hear that Bernini fell gravely ill twice in these first woe-filled years of the 1670s. As we learn from a letter to Colbert from the French ambassador in Rome, in July 1672 Bernini experienced a brief but violent, near-mortal illness. Like most illness in premodern times, Bernini's case was undiagnosed, but we are told that the artist was "attacked by a continual fever and bouts of diarrhea." By September of the same year, the state of health of his wife, Caterina, must have also been cause of genuine

concern, to the point of motivating her to draw up her last will and testament at the end of that same month. We do not know what ailed Caterina in those days, but we do know that she died ten months later on July 12, 1673, at the age of fifty-six. She had been married for thirty-four years; her youngest child (Domenico) was sixteen years old at the time. We have already discussed what is known or can be reasonably speculated about the nature of the relationship between Caterina and Bernini. Whatever the nature of their relationship, Caterina no doubt had had more than her fair share of patient, quiet suffering and compromise in light of her husband's fiery, narcissistic temperament and high-strung, if not chaotic emotional life. Perhaps easier for her to handle were the more normal demands of raising nine children and running an extensive household that included in-laws, numerous servants, and her husband's workshop assistants. In her absence, we wonder, who took over the management of that huge household?

As so often in the case of the artist's private life, silence prevails in the extant documentation on the subject of Bernini's intimate emotions at the death of his wife. What we do know is that Bernini did his mourning in private, away from even his own home and family. As we heard earlier, taking a servant with him (probably his long-term majordomo, Cosimo), the artist spent a few days in retreat at the Jesuit house of Sant'Andrea on the Quirinal hill across from the papal palace. His choice of refuge is not surprising. Again, his newly finished Church of Sant'Andrea was, and is, the jewel of Bernini's architectural crown. It had the distinction of being the sole work of his to meet with his complete and abiding satisfaction. We like to think that it was during these days of mourning just after Caterina's death that his son Domenico happened to come across his father alone in silent but contented reverie in "his" church, drawing solace from the rich but harmonious beauty of its proportions, light, and ornamentation.

How the death of his wife changed Bernini we have no way of knowing or even guessing. But the next grave illness—as we learn from another French dispatch—to strike him in the following month (August 1673) might have been a direct result of his grief. Yet another result of Caterina's death may have been the decision by her youngest son, Domenico, to abandon his Jesuit vocation that same summer, before the pronouncing of his solemn perpetual vows on the Feast of the Assumption (August 15) as traditional in the Society of Jesus. Bernini must have been truly disappointed: a Jesuit in the family was a matter of prestige and would have been

a nice way of solidifying the long-term partnership between Casa Bernini and the Society of Jesus. In his disappointment, Bernini may have sent Domenico to live and study outside Rome, for in the annual Easter census lists Domenico's name remains absent from the family residence until 1681, the year after his father's death. We also know from other documentation that Domenico was not in Rome at the time of his father's death. Yet at the same time there is nothing in Bernini's last will and testament to suggest that father and son were in any state of estrangement.[8]

QUEEN CHRISTINA LENDS HER NAME TO A HOAX

By late 1673 Bernini's reputation had suffered too many blows for the artist and his family to sit idly by. Would more people jump on the anti-Bernini bandwagon? Would the growing onslaught lead to a complete demolition of his artistic legacy? Would the damaging vicissitudes of his last decade cancel out the glory of the preceding seven? Would Bernini die a broken, humiliated man? Yes, there were some bright spots, some major artistic successes, on the landscape of Bernini's professional life in these years (as we shall see below), but they seemed incapable of neutralizing the relentless opposition and silencing the vicious chatter. The future seemed menacing.

Thus, a plot was hatched in Via della Mercede. It would call for a bit of dishonesty on the part of the Bernini clan and their accomplices, but, as yet another Italian proverb counseled, *A mali estremi, estremi rimedi,* Desperate times call for desperate measures. We don't know whose idea it was first—eldest son Pietro Filippo is the only name we find in the related documentation—but it could have come from Bernini himself. We likewise don't know how long it took to fully coalesce within their minds—the first documented traces of it date to early January 1674—but ultimately the plan came to be this: working secretly behind the scenes, the family would commission (that is, pay for) an unabashedly celebratory and perhaps even illustrated, full-length biography of the artist to be written by some respected scholar who was favorable to the artist but not a part of his known circle of disciples or clients. The author would work with ample editorial "assistance" from the family, if not from Bernini himself, and the final product would be published under the fictional patronage of some suitably high-ranking member of the Roman glitterati, to whom the work would also be dedicated. Contrary to the conventional dynamics of patronage,

this Bernini bio patron would lend his or her august name to the venture without having to contribute a scudo to the cost of the enterprise and without having had any role at all in its genesis.

In short it was an "official," family-financed piece of public relations masquerading as an independent, erudite biography. Bernini himself, we note, is nowhere to be seen in any of the extant documentation (extending from 1674 to 1682) as an active, front-stage participant in this project. But certainly some form of contribution on his part to this initiative is not to be excluded. How could he—who for his entire life had maintained an anxious, direct, imperious control over all his affairs, professional and domestic—keep silent and passive in this matter? After all, he was living in the same house as his would-be biographers, Pietro Filippo and his brothers. There is, in fact, nothing in the documentation to confirm Bernini's exclusion from this enterprise, as perhaps its behind-the-scenes instigator and orchestrator, who was careful, however, to leave no direct paper trail pointing to his role.

In the end, the author chosen to write the biography was Filippo Baldinucci, distinguished art connoisseur of the grand ducal court of Tuscany, who had the advantage of being a "foreigner," that is, not from Rome, but Florence, and not tainted as a Bernini sycophant. The pseudo patron who lent her name to this literary hoax was none other than Her Royal Highness Queen Christina of Sweden, duly publicized as having first commissioned the biography. Again, in Rome Christina ranked second only to the pope, and therefore the Bernini family had scored a great victory in having her name attached to the work. The mischievous Christina probably enjoyed being part of such a ruse; and, in the bargain, she also acquired, free of charge, the credit of being the prime mover behind yet another notable cultural achievement. Although Baldinucci carried out his own interviews and research, the resultant volume, *The Life of the Cavalier Gian Lorenzo Bernini Sculptor, Architect, and Painter*, incorporated extensive amounts of verbatim text supplied by Domenico Bernini and probably some from his older brother, Pietro Filippo. (Domenico's text, in turn, was in large part based upon the reminiscences of Bernini himself, and as a result, both Baldinucci and Domenico's biographies are, to some degree, autobiographies.) The initial goal was to publish Baldinucci's volume while Bernini was still alive, but that was not to be: the biography left the presses in Florence in March or April 1682, some sixteen months after the artist's

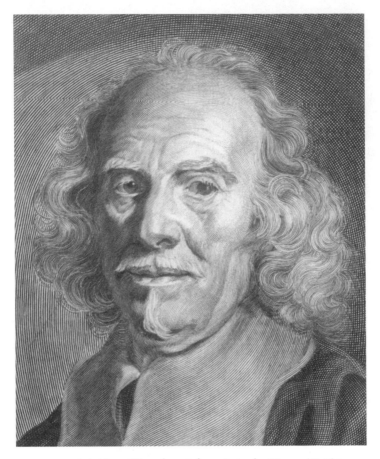

FIG. 35 ⤞ Arnold van Westerhout (after painting by Giovanni Battista Gaulli), *Gian Lorenzo Bernini* (detail), 1680. Author's collection.

death, with none of the originally planned engravings except for a portrait of the now deceased subject (fig. 35). Domenico ended up publishing his own text in 1713, but since he, of course, could not expose the hoax behind Baldinucci's biography and his family's role in that hoax, Domenico's own biography came to be seen as a plagiarism, instead of what it was in reality, Baldinucci's prototype.

Though nowhere in the documentation is there mention of the Bernini clan's motivation in publishing the biography, it could have only been in response to the exceedingly bad press their father was then receiving. Yet it seems that they were not the first to conceive the idea of a biography. A Roman *avviso* dated December 9, 1673, reports without further elabora-

tion that "a certain abbé and dear friend" of the Cavaliere was writing his life. Scholars are largely in agreement that the cleric biographer in question is the Abbé Pierre Cureau de La Chambre (1641–93), a member of some standing of the French court and Parisian intellectual milieu. La Chambre's friendship with Bernini dated back to the artist's return trip from Paris to Rome in October 1665. The then young man, obviously well connected socially, had succeeded in gaining permission to accompany Bernini on his return trip from Paris to Rome. He remained in residence in Rome for a year, continuing his frequent and friendly contact with Bernini during that period. La Chambre's announced biography never came to be, but as of January 1685 he was still intending to write it, for he discusses it in his discourse delivered that month before the French Academy entitled "Préface pour servir à l'histoire de la vie et des ouvrages du Cavalier Bernin" (Preface to serve toward the history of the life and works of the Cavalier Bernini), a kind of prospectus for his work-in-progress on the Italian artist.

Several months later, the "Préface" was issued in print, together with a revised version of La Chambre's 1681 eulogy of the artist, the "Éloge de M. le Cavalier Bernin." If the Bernini sons had not heard it already from other channels—letters between Paris and Rome could take as little as one week to arrive by special courier, and therefore there was a ready exchange of information between the two capitals—the published account would have informed them, to their great dismay, that the French abbé intended in his biography to describe Bernini just as he was, a fallible human being, warts and all, not suppressing even "what was reproached in him by his enemies and by those envious of him." It was not merely filial piety that would have made Pietro Filippo and his siblings bemoan the news of a text that promised to publicize to the world the less-than-flattering aspects of the artist's personality. It was also the painfully acute awareness that, even if fundamentally favorable to the artist, such a narrative would inevitably contribute fuel to the anti-Bernini fires that were raging in Rome during the last decade of the artist's life. With friends like La Chambre, who needed enemies?

It is, therefore, tempting to see La Chambre as the anonymous target of Baldinucci's vitriolic condemnation inserted in the "Statement of the Author" at the conclusion of his *Life of Bernini*, attacking an unnamed author, whom he characterizes as "some poisonous spider, born in filth and nourished by garbage," supposedly intent upon writing a scandalous,

tell-all *vita* of Bernini. However, the thoroughly antagonistic intent of this
rumored biography and the specification (if true, and not simply a stra-
tegic falsehood) that the unfriendly, would-be biographer did not want
"to commit his own name to print" would seem to exclude La Chambre
as Baldinucci's target. The French abbé was, after all, a sincere, proven
admirer of Bernini's who had always made no secret of his intentions of
writing a biography and would not seem to deserve such a scathing attack.
In any case, the exceedingly bitter tone of Baldinucci's protestation is an
important reminder of the hostile environment (hostile to Bernini, that is)
in which the Florentine's biography—and that of Domenico—came to be.
In the impassioned polemics of the Roman Baroque art world, lots of ver-
bal "poison" was "vomited" in all directions, but especially in the direction
of Bernini.[9]

AN OCCASIONAL ROUND OF APPLAUSE

We have made more than one reference above to the fact that in the midst
of all the gloom and doom of Bernini's last years, there were, nonethe-
less, some luminous, gratifying moments, in terms of professional and per-
sonal achievements. It is time to acknowledge at least the most notable of
them. Let us begin with one of the most spectacular and the most unquali-
fied successes of his life as architect, the completion of the Jesuit Church
of Sant'Andrea al Quirinale. Years of labor on this small elliptical jewel,
fortunately still in excellent condition today, came to happy termination
in 1670 upon completion of its essential interior decoration. Entering the
church, or rather, ecclesiastical theater, one is greeted by a chorus of swirl-
ing angels and playful putti in white stucco hovering within a sumptuous,
multicolored stone setting dominated by the warm red-and-cream hues of
the precious Cottonello marble. All this frames the central spectacle of the
main altar, the dramatic martyrdom and glorious apotheosis of Saint An-
drew, who rises to heaven before our very eyes. An *avviso* of November
22, 1670, announcing the completion of the project judged it "a success of
complete perfection, lovely and noble, by any reckoning one of the most
beautiful buildings that the Cavalier Bernini has ever created." We have al-
ready heard of Bernini's own complete satisfaction with this one product of
his artistic imagination. Always a man of exquisite aesthetic taste, Cardinal
Sforza Pallavicino did well in choosing it as his final resting place. What the

austere Counter-Reformation reformer, Saint Ignatius of Loyola, founder of the Jesuit Order, would have felt about this lavish piece of real estate, is another story.

Nearly one year later, on November 7, 1671, four years of labor came to a ceremonial end on another of Bernini's much-applauded and much-beloved works, the refurbishment of the ancient Ponte Sant'Angelo, leading to the castle of that name (formerly Emperor Hadrian's tomb) and, beyond, to the sacred precincts of the Vatican. Since it was at the time, and for long thereafter, one of only two bridges spanning the Tiber within the city limits (and the one closest to the densely populated city center), the Ponte Sant'Angelo was a most vital element of Roman life, practical and ceremonial. On that November day, Pope Clement X, with an impressive retinue of cardinals and prelates, as well as Bernini and his assistants, crossed the bridge in solemn procession to inaugurate the newly designed thoroughfare. The entire renovation entailed a whole complex of challenging architectural and engineering tasks, all successfully executed by the artist, the full scope of which only a few specialists are aware today. It is likewise easy to take for granted the genial novelty of one of Bernini's innovations upon the bridge's aesthetic design: the opening of its parapets with wide iron grilles so as to afford a more ready and gratifying view of the Tiber River.

From his stay in Paris, we recall Bernini's self-confessed delight and solace in contemplating the movement of flowing waters. His son Domenico adds: "It was a very familiar saying of his that 'the good architect, when working on fountains or any project involving water, should always ensure an unobstructed view of the water, whether the latter be cascading or flowing by. Since the sight of water is extremely pleasurable to our eyes, to block or diminish that sight is to deprive such a work of its most delightful quality.'" However, today most of our attention, I daresay, is absorbed by the ten solemnly elegant angels placed upon the bridge by Bernini to preside over it and guide pilgrims to St. Peter's. In their day as in our own, these majestically expressive sculptures were and are considered things of exquisite beauty. But not so during that centuries-long interval (especially in the Victorian period) of neoclassical disdain for the overtheatrical and oversensual art of the Baroque, and therefore of Bernini. Emblematic of this wholesale dismissal of our artist is the description of Bernini's Ponte Sant'Angelo's angels given in one of the most popular guidebooks to Rome

of the nineteenth and early twentieth centuries, Augustus J. C. Hare's *Walks in Rome* (twenty-two editions between 1871 and 1925): "Bernini's Breezy Maniacs." Bernini's angels had entirely too much emotion and sensuality for those stiff-upper-lipped Victorians.

The Ponte Sant'Angelo bridge project marks the end of Bernini's large-scale interventions upon the public fabric of the Roman cityscape. It closes a long and glorious era, though some of the big "urban renewal" projects of Rome that were to come even in the anti-Bernini days of the neoclassical eighteenth century still bear his unmistakable if indirect influence: the Trevi Fountain is the most notable example. On the other side of the bridge, within St. Peter's Basilica, an even longer era of Bernini's artistic intervention was also coming to an end, and successfully so in the 1670s, with the completion of two further projects, the Altar of the Blessed Sacrament Chapel (1674) and the Tomb of Alexander VII (1678). As we saw, Bernini's career in St. Peter's had begun fifty years earlier in 1624 when he, with no architectural training to speak of, was engaged by Pope Urban VIII to create a new, permanent metal canopy over the main altar, which turned out to be that daring new structure now known as the Baldacchino. It was the first of a long list of his embellishments, large and small, of the basilica, only some of which we have had occasion to note in the previous pages. That list is so long that one could dare say that St. Peter's as visitors experience it today is as much the work of Bernini as it is of Michelangelo and Bramante or any other architect or artist contributing to its design and embellishment. According to Bernini's son Monsignor Pietro Filippo, "Alexander VII once said that if one were to remove from St. Peter's everything that had been made by the Cavalier Bernini, that temple would be stripped bare." The witty statement is no exaggeration, for included among Bernini's contributions to the outfitting of basilica is (as few know) the design of the great, multicolored and elaborately patterned expanse of the pavement and walls of the long nave. No wonder Bernini appears so tired, and even frazzled, in the last known self-portrait, done circa 1678 (fig. 36).

Outside the papal precincts, yet another of Bernini's noteworthy accomplishments of the final decade of life (in 1674) was his contribution to the remodeled Galleria in the Colonna family's Roman residence. One of the latest archival discoveries, Bernini's intervention, it seems, turned that vast room, originally designed by second-rate Roman architect Antonio del Grande, into a truly majestic, princely space that was the envy of

FIG. 36 ⤞ G. L. Bernini, *Self-Portrait*, ca. 1678, Royal Collection, Windsor Castle, Inv. 5539. The last known self-portrait.

all patrician families. The Galleria is also world famous as the prototype for similar structures of its genre around Europe: it is the inspiration for the Hall of Mirrors in Versailles and the Court Library in Vienna. Another reminder of the fact that if you scratch the surface almost anywhere in Baroque Europe, more often than you expect you are likely to find Bernini in some shape or form.

Though the Colonna were one of the most prominent and most ancient of Roman families, Bernini had, surprisingly, done very little work for them prior to this decade. This may in part be due to the Colonna's strong Spanish and antipapal politics, sentiments not shared by our artist. In any event, Bernini's effective, sustained relationship with the family dates only to the years 1674–80. Better late than never for Bernini to forge an indelible link between his name and that of yet another legendary Roman patrician family. This must have been a source of particular satisfaction for Bernini, who had probably courted the Colonna favor (specifically, its reigning family head, Lorenzo Onofrio) in view of the severe decline of his reputation in other quarters. Despite the great wealth of the Colonna, there is no indication in surviving records that the artist received any substantial payment for his Galleria consultation (or other smaller tasks), dramatically incisive though his ideas might have been. This should not surprise us: in those crisis years of the 1670s, Bernini needed the goodwill of powerful allies like Colonna much more than he needed their cash. He probably would have been happy to work for Lorenzo Onofrio for no money at all, just as he had done for the papal family, the Altieri.

In 1676 the Bernini name was again paired with that of the Colonna on the occasion of a musical drama, *La donna ancora è fedele* (The woman is still faithful), staged by the Bernini family for the Carnival season in the "salone nuovo" of Palazzo Rucellai on the Corso, already the venue of earlier Bernini comedies. The production was dedicated to Lorenzo Onofrio Colonna (who likely financed the publication of the libretto written by Pietro Filippo Bernini) but was the collective work of the Bernini brothers, not (or not only) Gian Lorenzo. Maintaining this precious, conspicuous social connection, the Bernini family Carnival play of the following year, 1677, could publicly boast of being offered "under the protection of" Lorenzo Onofrio. (That "protection" may have been needed, since the reigning Pope Innocent XI had placed strict bans against the theater.) As for the 1676 play, the amusing irony, by the way, of such a subject (a faith-

ful woman) being dedicated to Lorenzo Onofrio would not have been lost on any of the Romans in attendance: in the summer of 1672, to the great scandal and malicious entertainment of Rome, Colonna's trophy wife, the celebrated French beauty Marie Mancini—niece of Cardinal Jules Mazarin and celebrated first love of the young Louis XIV—had in undisguised disgust run away from her husband, publicly humiliating him in doing so and never to return despite years of well-advertised bargaining on his part.

Speaking of Roman patricians, the Bernini family itself was slowly making its way toward that status—patrician status—in these same years. It would fully and officially reach that goal only in 1746 when Pope Benedict XIV authorized the addition of their name to the "Golden Book" of Roman noble families. Nonetheless, during this decade of woe, in 1672 Bernini's daughter Dorotea happily helped further the aristocratization of the family by marrying the Neapolitan nobleman Antonio de Filippo. Not only did Bernini thus acquire some further trappings of aristocracy, he also gained a son-in-law whom he actually came to like: in his last will and testament, Bernini bequeathed a painting of his to Antonio, calling him "my most dear and old friend and son-in-law." These are rare words of explicit, genuine affection coming from Bernini. The two other Bernini daughters who were not sent to convents also helped the family's climb up the social ladder by marrying into aristocracy: Angelica married a count, Giovanni Battista Landi of Velletri, while Maria Maddalena married a marquis, Giovanni Francesco Luccatelli of Bologna. However, in the eyes of their Roman contemporaries no less a sign of the family's upward social climb, in those days before indoor plumbing, was the enviable fact that in 1672 Bernini was granted authorization to draw water from the public water supply to feed a private fountain built on his own property in Via della Mercede. The family had indeed arrived, having joined the ranks of the hydraulically privileged.

We have already mentioned in the previous chapter another of the great honors received by Bernini in the 1670s, the celebratory medal commissioned by Louis XIV in 1674 in honor of our artist. The medal, a work of art in itself, bears on one side a most flattering, elegant, well-wrought portrait of our artist in profile: Though seventy-six years old, Bernini, wrapped in a voluminous aristocratic mantle, still appears robustly and vibrantly alive, his piercing, eagle-eyed glance undiminished by age or the adversities of the decade. Bernini was to thank the artist, François Chéron,

by supplying him with a personal letter of recommendation addressed to Colbert when the young Frenchman left Rome and returned to Paris in October of that year. Bernini's portrait figured as well in yet another honor in 1674: Cardinal Leopoldo de' Medici acquired Bernini's self-portrait of circa 1630 from the artist himself (for 56 scudi, through his agent in Rome). The cardinal wanted the painting for the Medici collection of artist self-portraits. That collection, including the Bernini portrait, is still intact today and open to the public in the Uffizi Gallery in Florence (fig. 8). In May of that year Leopoldo's Roman agent, Paolo Falconieri, wrote to the cardinal to inform him of the thrilling acquisition: "Today Ciro delivered to me a most singular object, the most beautiful thing one can imagine for the Portrait Cabinet." As Falconieri reminded his patron, the portrait was a precious rarity, for Bernini "as you know, has painted next to nothing." Bernini could thus boast of yet another of his works in the famed art collection of the grand ducal family of Tuscany. In his June 30, 1674, letter to Cardinal Leopoldo, the same Medici agent, however, has left us with a less than flattering detail about his financial negotiation with Bernini: in order to induce the Bernini to sell his jealously guarded treasure at a decent price, Falconieri says that he used a sure-fire method: he held up the cold cash right before the artist's eyes.

The "Ciro" mentioned in Falconieri's letter of May 1674, by the way, is Ciro Ferri, a painter of talent all but forgotten today but who enjoyed a distinguished reputation in Rome at the time. For Bernini, Ferri's name may have been tainted by the fact of his having spent many years in the workshop of Bernini's enemy, Pietro da Cortona. It was probably Ferri who gave finishing touches (to the clothing and background) of this Bernini portrait sold to Leopoldo de' Medici. Ferri, too, has left us a less than flattering characterization of Bernini in a letter written to Florentine scientist-diplomat Lorenzo Magalotti, dating to the time of Bernini's two brief visits to Florence on his way to and from Paris in 1665. Referring to a conversation in Florence between sculptor Ferdinando Tacca and Bernini to which Magalotti was an eyewitness, Ferri remarks: "The fact that Tacca babbled a lot of nonsense, I can easily believe, because Bernini is a scoundrel and would have enticed him into such singing and coaxed him into sputtering thousands of stupidities." Despite the malicious jab at Bernini, in the same letter Ferri eagerly beseeches his correspondent to find out "in all truth" what Bernini had to say about his (Ferri's) own paintings. Bernini

may have been a scoundrel, but his professional opinion still counted, even among those who had little love for him.[10]

"Cover Those Breasts!"

Well, perhaps His Holiness Pope Innocent XI did not express himself in precisely those words, but that's what he was thinking, and that's what in May 1678 he ordered done to Bernini's recently completed tomb of Pope Alexander VII in St. Peter's Basilica: "Cover those breasts!" He was referring to the figure of Truth in the right foreground. Bernini intended her to be bare-breasted, her nudity being symbolic of the candid nature of that virtue. Bernini, of course, humbly obeyed Innocent's order, but as for how he truly felt about his new spiritual father, a simple, hastily sketched caricature of the pontiff—one of the most mercilessly disparaging of all his surviving caricatures—says it all: it depicts His Holiness, sporting a comically unregal papal miter, knees drawn up in bed, weakly gesticulating with one skeletal hand, looking like a ridiculous dried-up bug (fig. 37). One presumes the pope is in bed because of illness: is this some wishful thinking on the part of Bernini, who perhaps had hoped to outlive the current pontiff? After all, he had outlived Innocent's seven predecessors.

But that was not to be. Innocent survived Bernini by nine years. He was Bernini's last—and worst—pope. Though he had great concern for the poor and sought in vain to abolish the nepotism of the curia, he was disagreeably puritanical, detested the theater, and was a penny-pincher, except where war against the Turks (and, reportedly, secret loans to the Protestant William of Orange) was concerned: three major strikes against him in Bernini's eyes. The austere Lombard Benedetto Odescalchi, born 1611, had been elected on September 21, 1676, just two months after the death of Clement X (yet another of the Baroque popes, by the way, to die during the dog days of the late Roman summer; Odescalchi would follow suit, dying in August 1689). It was fortunate that his background—the Odescalchi were an upper-middle-class family of merchants and bankers—had prepared him to deal with things financial, because one of the major challenges of his pontificate was the disastrous shape of the papal treasury. With a debt of more than 50 million scudi, the papacy was tottering on the verge of bankruptcy, and it thus fell to Innocent to tighten the buckle to an extreme unmatched in recent memory. Therefore, we must admit,

FIG. 37 ⇢ G. L. Bernini, *Caricature of Pope Innocent XI*, 1676–80. Museum der bildenden Künste, Leipzig. Photo: Bildarchiv Preussischer Kulturbesitz/Art Resource, NY. Photo: Ursula Gerstenberger.

Innocent's penny-pinching ways were justified, even if unpopular. To his credit, though, he didn't dismiss Bernini from any of his salaried Vatican jobs, as he did the two "Architects of the Papal Palace," Carlo Fontana and Giovanni Antonio de' Rossi, in March 1678.

However, the resolute Innocent said "no" to so many things—including art projects and social pleasures—that he was nicknamed Papa Minga, "Pope No-No," in his native Lombard dialect. Even Queen Christina allowed herself to refer to His Holiness in a similarly disrespectful manner, for the pope had incurred Her theater-loving Majesty's great disdain by the severe restrictions he placed on theatrical performances, including during the beloved Carnival season. Christina's "letters and notes are full of ironic phrases about Innocent," so much so that at one point she was gravely warned to cease speaking so critically of the pope lest she jeopardize her position in Rome. Not moved by Christina's opinion on matters of theater or civic morality, Papa Minga even abolished the entire Carnival season for the years 1684, 1688, and 1689. As for other forms of art, as we saw, it was Innocent XI who prohibited any further progress in the realization of Bernini's plans for the "third arm" of his Colonnade. He also refused to

allow the Jesuits to spend their gift of 30,000 scudi from a Spanish bequest to build a more sumptuous main altar at the Gesù: these are not times for such vanity, scolded the pope. The anonymous *avviso* writer who brings us this news cannot help but point out, "The altar project would have kept one hundred artists employed for at least three years." No wonder, as another *avviso* of September 1678 reports, artists were abandoning Rome in droves: there were so many of them they looked like troops in retreat, fleeing the "present financial straits of this city." As a result, it was not a pontificate of any great projects for Bernini: no money, no art.

For the war against the Turks, however, there was plenty of money— Innocent spent millions of scudi to help finance the European battle against the "infidels" as he vigorously rallied the Catholic princes to the cause. Unlike poor Clement IX, he would not die of heartbreak over a further defeat of Christendom. On the contrary, he lived to see the great victory of 1683 when Polish King John Sobieski routed the enemy from their siege of Vienna. Nonetheless, it would still take four more decades for the Turks to be expelled from the rest of Eastern Europe and for the Turkish threat, which had terrorized the imagination of Europe for centuries, to be effectively over. In his struggles against the very much antipapal and power-hungry Louis XIV, the "Most Christian King" of France, Innocent came out the loser. Louis's alliance with the Catholic king of England, James II, eventually put Pope Innocent in an outrageously paradoxical straitjacket of pragmatic politics: in 1688 he, the head of the Catholic Church, was obliged to lend public support (and apparently also the secret support of cash) to William of Orange, the Protestant enemy of the Catholic king of England, in order to place an effective check on the monstrously imperialistic designs of the king of Catholic France. Innocent's strategy got him nowhere. The conquest of England and the assumption of its throne by William of Orange failed to put an end to Louis's successful power-grabbing ways, but it did put a definitive end to any remaining hope that the papacy may have had for the restoration of Catholicism in England.[11]

When his attention was not on the Turkish or French threat abroad, Innocent, at home, was waging war against another of Catholicism's long-feared and irrationally demonized traditional enemies: sex. And as from the time of the earliest Christian theologians and moralists like Tertullian, women and their immodest dress were one of the targets of his moralizing campaign. Pope Innocent sought to ban from the city the latest French

feminine fashion, which showed entirely too much flesh of the arms, neck, and, worse, chest. The sight of naked flesh was the number-one temptation to the sin of lust, and that is why, an *avviso* tells us, Pope Innocent personally intervened at the female monastery of Santa Cecilia "in order to avoid scandals that were being caused among the nuns by the sight of the half-naked men working as grave-diggers" in their vicinity. The exposure of naked flesh in works of art was equally intolerable for Innocent. Hence, the "cover-up" was ordered not only on Bernini's tomb of Alexander in St. Peter's but also on a painting of the Madonna by the "divine" Guido Reni in the Quirinal Palace. Not even immodest art in private residences belonging to laymen escaped Innocent's eyes: the pontiff let it be known to Prince Borghese that he was no longer to display those "lewd paintings that are in the ground-floor apartment of his Gallery in order not to provoke lust in those who visit his art collection."

Pope Innocent would surely have had a fit had he visited Bernini's De Sylva Chapel in the convent Church of Sant'Isidoro not far from the Villa Borghese, which then as now was in the hands of the Irish Franciscans. Bernini designed this family chapel as a favor to some distinguished Portuguese neighbors of his in the years 1662–64. The space is exceeding narrow, and as a result, any priest celebrating Mass at its altar is practically cheek by jowl with the ornate memorial plaques on either side. The plaques' conventional iconography includes female nudes personifying Truth and Charity, and in the case of Charity, not only is this sensually beautiful, full-figured, seductively smiling young maiden bare-breasted, she is also cupping her abundant breasts with her two hands, causing them to protrude further, in the generous act of offering her milk to all lovers of that virtue. Really, Bernini, what were you thinking? In a convent church belonging to Irish Franciscan priests and brothers? Again, are you going to hide behind the words of Saint Paul: "To the pure of heart, everything is pure"? Yet, as far as we know, no one in Bernini's day complained, not even during Innocent XI's puritanical reign. In fact, Bernini's Truth and Charity escaped the bondage of "modesty dresses" all the way until the nineteenth century. Recently, in the 1990s in the process of restoring Bernini's chapel, the heavy black bronze coverings were removed from the plaques, and once again Charity, in all her gleaming whiteness, is able to share the milk of her turgid breasts unimpeded.

Unlike his campaign against immorality, Pope Innocent's poor-relief efforts were more welcome and more needed, even if shortsighted (namely, he treated the problem with alms, rather than identifying the real root of poverty in the structural injustices of the economic system). Throughout the seventeenth century, in the midst of all the dramatic artistic, architectural, and engineering improvements made to the city by the popes, the reality of endemic poverty remained constant in Rome. The largest portion of the population still lived their lives poorly fed, poorly clothed, and poorly housed. To relieve the problem of the huge numbers of the homeless wandering the streets of Rome, the pope decided to turn the grand but empty papal palace at the Lateran into a hospice for the poor. In November 1676, Innocent commissioned Bernini to come up with a design for this transformation.

Nothing came of these plans, but, as one historian has suggested, Bernini's final work of sculpture, the half-length marble bust of *The Savior* (also known as the *Salvator Mundi*), may have been initially conceived as an adornment of the new hospice, perhaps at its entrance. Bernini's *Savior* is not just a generic image of Jesus; its specific iconography relates to a depiction of Christ closely associated with an ancient confraternity attached to the Lateran devoted to service to the poor and sick. Furthermore, its over-life-size dimensions would suggest a public destination, especially if we reckon into the calculations the tall, extremely elaborate pedestal designed for it by Bernini, which survives in the form of a preparatory drawing. The whole grand ensemble would have reached a height of ten feet. In explaining the origins of the *Savior* bust, Bernini's son Domenico, however, simply repeats a conventional rhetorical commonplace of artists' biographies to the effect that the pious Bernini wanted to crown his life with a work summarizing the entirety of his art and faith. If that was its goal, Bernini's *Savior* missed the mark. Whatever their merits, neither of the two versions of the bust (in the Chrysler Museum of Virginia and in San Sebastiano fuori le Mura in Roma) currently competing for the title of "Bernini's original," can possibly fill such a hyperbolic bill.[12]

"The Cupola Is Falling (Again)!"

In 1680, the last year of his life, an old ghost came to haunt Bernini yet again. It was a big ghost, as big as the cupola of St. Peter's. It would make

his final months exceedingly bitter, and probably even hastened his death. As we saw, in the mid-1630s, shortly after the completion of his embellishment of the four piers of St. Peter's (the huge pillars holding up the cupola), a crack had been noticed in the masonry of the cupola. Immediately people began to shout out in hysterics, "The cupola is falling!" and "Bernini is to blame!" In 1636 someone (perhaps the cranky Ferrante Carli?) put the charges in writing and sent the report to the pope and the Reverenda Fabbrica di San Pietro, but apparently none of the latter individuals were convinced by the charges. No official investigation was held and the case was thus closed. Closed, that is, as far as the pope and Fabbrica were concerned. The rumors and fears never completely went away. They even surfaced—with alarming descriptions of the state of disrepair of the basilica—in a digression within a 1668 work on atheism written by Filippo Maria Bonini, a prominent member of Cardinal Antonio Barberini's circle.

In April 1680 for reasons we are not quite sure of, the same alarm about the instability of the cupola was sounded again and this time with such anxiety-raising force that the pope (Innocent XI) was moved to investigate the matter. In September Innocent turned to one of the three official *misuratori* ("measurement takers") of the Fabbrica, the Dominican friar and architect Giuseppe Paglia, to investigate. Paglia conducted a thorough on-site investigation and presented a scathingly blunt report to the pope that confirmed all the disturbing rumors, including that of the suspected presence of a stream of running water in the crypts and the dangerous accumulation of rainwater in the cupola. This is not what the pope or Bernini wanted to hear. (Paglia's report, however, is so exaggeratedly damning and so inaccurate throughout that one suspects it was simply an act of vengeance by yet another jealous, angry architect who had been forced for years to work in Bernini's omnipresent shadow in Rome.) The pope then asked the treasurer general of the Fabbrica to convene a committee of expert architects who would meet with Paglia to discuss his findings and then go investigate the matter on their own with an eye to either confirming or refuting Paglia's report. The pope would accept their judgment as definitive.

As Bernini waited nervously by, the committee of architects appointed by Pope Innocent conducted its own investigation of the stability of the cupola (their findings are appended to the end of Baldinucci's biography of Bernini, copied verbatim from Mattia de' Rossi). In the end, point by point the committee refuted Paglia's findings and was able to deliver a reassuring

final report to the woefully vexed pontiff, who had been wondering why "it would have to be during Our reign that all these calamities are taking place for which We then have to find a remedy." There was no danger of a cupola collapse. There was nothing fundamentally wrong with the cupola or any other portion of St. Peter's. No one, by the way, seems to have been troubled by the fact that the papal committee was heavily stacked in favor of Bernini: it included Bernini's right-hand-man, Mattia de' Rossi, as well as Mattia's uncle, Giovanni Antonio de' Rossi. Nonetheless, the substantial body of unimpeachable historical and technical evidence—visual and textual—gathered by the investigators does convincingly clear Bernini of all blame.

As in 1636, Bernini was vindicated; he would again be vindicated in 1694 by the massive historical-technical description of the construction of St. Peter's, *Il Tempio Vaticano* by Carlo Fontana, and yet again in the eighteenth century when questions about the stability of the cupola arose yet another time. So it was a happy ending to this long, troubling story for Bernini. He had been the target of malicious whispering about his supposed architectural incompetence since 1636. Now the voices were silenced. But Bernini's joy was short-lived. Bernini died on November 28, 1680, of complications following a major stroke. Roman diarist and Bernini family friend Carlo Cartari tells us that the artist had first suffered the stroke two weeks earlier on Friday, November 15. That places us just a short time from the day (November 12) when the papal committee finished its investigative work and would have informed Bernini of his exoneration. Had the good news simply been too much for Bernini?[13]

Not with a Bang, but a Whimper

Neither Domenico nor Baldinucci makes a connection between the conclusion of the cupola affair and the onset of Bernini's final illness. Instead, they place the blame on the artist's overexertion on yet another arduous papal project, the repair of the elegant but structurally compromised Palazzo della Cancelleria (the Chancery). Built in the fifteenth century and gleaming white thanks to marble facing plundered from ancient monuments, the Cancelleria is one of the few examples of Renaissance architecture in Rome. Domenico presents Bernini's acceptance of this, his last papal commission, as a manifestation of his deep devotion to his profession and the papacy:

"To his children who begged him not to expose himself in his declining years to so much danger and strain, he, with determined spirit, responded: 'This, and nothing less than this, is what the gravity of this situation, proper service to the pope, and my personal reputation all require; and I wish to give each its due, even at the cost of my own life.'"

The venerable Cancelleria had been for many years during Bernini's lifetime the home of his friend and patron, Cardinal Francesco Barberini, who at the time of his death on December 10, 1679, had long served as "vice chancellor of the Holy Roman Church." In fact, an *avviso* dated April 13, 1680, describing the imminent danger of collapse of a portion of the Cancelleria, blames the late cardinal for having ignored the grave problem and caused the current crisis. The only other document that has come to light concerning this project is the actual repair order written by Pope Innocent XI on May 15, 1680; therefore, Bernini's involvement, we presume, dates to the summer and probably also fall of 1680. Like Domenico, Baldinucci describes with heightened drama the many challenges facing Bernini in this task: "Every day new difficulties of the gravest sort were discovered." In the end, as Baldinucci reports with proud emphasis, Bernini finished the repair job with complete success and to great applause from the city of Rome. Why the emphasis on a project that many contemporaries didn't even notice and that has hardly left a dent in the historical record? We are justified in imagining the hidden agenda lurking here in the biographies. Behold, they are suggesting, at the very time that Bernini's competence as an architect was being humiliatingly challenged in the public arena over his interventions in St. Peter's Basilica (the renewed cracks-in-the-cupola charges), the pope still entrusted this mighty architectural task to the eighty-two-year-old artist. Why hadn't he chosen instead of one of the many other and younger masters in Rome? Because there were none better.

It was a success—the elegant Cancelleria still stands upright today—but it was Bernini's final one. Or better, it was his final *public* one, for that repair job was not his final challenge. Dying was. Domenico devotes an entire chapter to Bernini's final illness and death, which one nowadays might find strange in the biography of an artist. What does all of that have to do with his art? Again, the goal of official biographers Domenico and Baldinucci was to prove Bernini was not only a great artist, but also a great human being—"UN GRAND'HUOMO" are the concluding words of Domenico's biography, printed in capital letters. This meant, above all, that he was

a devout, upright Catholic. And to prove that, an account of his departure from this world was essential. It is virtually a universal trait of traditional Catholic hagiography (the literature of the lives of the saints) to include a detailed description of the saints' preparation for death and of their death itself, for it was believed that the manner of their passing was directly revelatory of the moral quality of their soul on earth and future destiny in eternity. As even the rather unorthodox Queen Christina of Sweden, in completely orthodox fashion, explains in one of her "Maxims": "Our true worth and our blessedness depend wholly on the last moment of our life: all the rest vanishes like smoke that disperses and is scattered by the wind. But in this last terrible or happy moment, God lets us know what we were and shall remain for all eternity, before the whole universe and in God's own sight." Needless to say, according to his son, Bernini's death was exemplary in every way—courageous, serene, and impeccably pious. So much so that at the end of this chapter, one almost feels the urge to call out in pious supplication, "Saint Gian Lorenzo, pray for us!"

Domenico also uses this opportunity to summarize the most important features of his father's personal theology and pious practices. Two items stand out: the emphatic descriptions of Bernini's absolute trust in God's mercy and his extraordinarily generous almsgiving. These are not surprising virtues in the case of a good, pious seventeenth-century Christian, or any believer for that matter. However, the emphasis they here receive tempts the more cynical among us to want to read between the lines. Doth Bernini protest too much? Do we have here an unwitting reflection of the artist's fearful, guilty conscience for the sins of his past life? Especially the sexual license of his premarital days and the at times callous egotism—and, perhaps, avarice—with which he pursued fame and fortune? Did Bernini feel that he in fact had done much in his past life by way of moral misbehavior so that he now, about to face the divine judgment, needed to reassure himself by insisting emphatically on God's superabundant mercy? Bernini was no moral monster, to be sure, but neither had he been a saint. And as we read in the biographies even of "complete saints," abiding doubts over one's salvation after death haunted Christians far more virtuous and pious than Bernini.

Such doubts, such gnawing mental torment, were hard to escape. After all, the churches and chapels were filled with fearfully vivid depictions of the Final Judgment and of hell. Michelangelo's rendition in the Sistine Chapel

is just one of hundreds in Christian Europe. The fierce Old Testament God who demands justice and revenge was never eliminated from Christian doctrine, despite Jesus's preaching of a God of love. Furthermore, the church still believed, as church father Saint Augustine had taught, that in the end the number of the damned would be far larger than that of the saved: this was the never-repudiated notion of the so-called *massa damnata*. Thus, well might have the dying Bernini quaked in the silent recesses of his conscience while he publicly protested his absolute trust in God's mercy and in the efficacy of the blood sacrifice of Jesus Christ.

As if all this theology were not enough to make the approach of death a terrifying experience, there was also the further firm Christian belief of the "final test" to be endured at the moment of death. All of Bernini's preparation for death, as described by Domenico, represents, in fact, a preparation for this "test." But exactly what test? By whom? Even for devout believers who had lived their entire lives in utter probity, the moment of death brought with it a final and potentially fierce test, because, according to the popular (and then fully orthodox Catholic) belief, at the moment of death the devil made his last attempt to win over the soul of the dying person through a series of vigorous temptations so as to be able to add that soul to his company in hell. A whole lifetime of virtue and sincere belief could be vanquished by the devil in one final moment of weakness. This belief is expressed, for example, in the Barberini musical drama of 1634, *Il Sant'Alessio*, with a script by Giulio Rospigliosi (Pope Clement IX), in which (act 2, scene 8) the Devil prepares for his assault on the dying Alessio: "Alexis is preparing his heart for death; in this last combat, then, let not my daring plan fall short in cunning or force, for a soul, up to its very last moment, remains exposed to danger. Ah, if only, in the tearing of the bodily veil, in that irreparable instant on which depends an eternity of torment, on which depends an eternity of happiness, I could steal him eternally from Heaven!" Even closer to home, Bernini's mother, Angelica Galante, in her last will and testament, echoes the same belief: "I supplicate all the saints to assist me in the hour of my death and defend me from the snares of the Demon." Even more graphically, Oratorian preacher Stefano Pepe's *Le battaglie de gli agonizzanti* (The battles of the dying), describes in over three hundred pages the "demonic temptations in the hour of one's final agony."

Fortunately, the dying Bernini had the assistance of one of the great experts in Roman on the "art of dying," Father Francesco Marchese, who

happened to be his own nephew. Son of Beatrice Bernini, Marchese had made a reputation by writing popular books of practical spirituality for the laity, including one on the art of dying. As mentioned, Marchese used his uncle's composition *The Blood of Christ* (*Il sangue di Cristo*) as frontispiece to his book, *Unica speranza del peccatore* (The sinner's only hope) of 1670. During Bernini's final days, that same image, Domenico tells us, served as the artist's exclusive visual point of meditation, having been installed on some sort of altar which he had set up in his bedroom. Bernini's obsessive preparatory work with Marchese even entailed coming up with a new sign language: "Anticipating that, as usually happens with the dying, he might be deprived of his speech in those last days of life and thus suffer the distress of those who cannot make themselves understood, the Cavaliere devised with Father Marchese a special way of communicating at that stage even without the use of speech." Again, since the demonic test was awaiting him, it was important for Bernini to remain in communication with his confessor, who would hopefully guide him safely through the snares of the devil.

Domenico would have us believe that in his final days, Bernini's thoughts were focused entirely on death, the test, the Hereafter, and nothing else. Yes, he took the time (two hours before dying) to impart his final blessing on his children, but apart from that, he had supposedly already "checked out" on life with its concerns and attachments. Yet, surely, in between his moments of pious, otherworldly reflection, Bernini turned his thoughts back to earth. How could he not keep from reviewing the many years of his long, momentous life, private and public? On what, we would love to know, did he most dwell? What did he most regret? Of what was he most proud? What would he have done differently? Whom or what would he miss the most from his earthly existence? Unfortunately, we will never know the answers to such questions. Bernini, his children, and Father Marchese his confessor, all took that information with them to the grave.[14]

Naturally, Bernini's illness and death also provided the dignitaries of Rome and elsewhere with an opportunity of further expressing their esteem for the artist. Personal notes were written to the family; visits made to the house; and tears shed over the prospect of losing Bernini forever. Pope Innocent sent his personal apostolic blessing, a great social honor and privilege, as well as further spiritual armament against the final assaults of the devil. But the most conspicuous presence at Casa Bernini during the

artist's last days—at least in the form of her delegate, Cardinal Decio Az-
zolino—was Queen Christina of Sweden: "Cardinal Azzolino honored the
Cavaliere several times with personal visits during these last days and one
evening Bernini requested of Azzolino that 'In his name the Cardinal beg
Her Majesty the Queen to offer up an act of love to God on his behalf, since
he believed that that great lady had a special language with which to make
herself understood by the Lord God, just as in turn with her God made use
of a language that only she was capable of understanding.'"

Referring to Christina's reputation as an irreverent, freewheeling free-
thinker, Bernini's first modern biographer, Stanislao Fraschetti, mocked
the artist's request of Christina as a ridiculous and meaningless piece of
flattery: of all the people in Rome, the Holy City, from whom to ask for
prayers on one's deathbed! The complex, enigmatic, and erratic Christina
will probably always elude attempts to define her views according to neat,
simple categories. Yet, despite the queen's popular reputation as a cyni-
cal libertine and psychologically unstable personality, there are signs that
in her last years she had in fact formed for herself some kind of genuine
personal faith built upon a mature, authentic, even mystical spirituality,
though, to be sure, one that did not necessarily coincide in all elements with
official Roman Catholic orthodoxy. Unless he was engaging in courtly flat-
tery, Bernini may have understood this, and hence his dying request to the
queen.

During Bernini's two weeks of gradual detachment from life, his doc-
tors—a trio bearing the comically Baroque names of Tiracolla, Truglia,
and Buttafoco—attempted the usual remedies of bloodletting and leeches
on their patient. But to no avail. According to a notation of the public no-
tary found on his will, Bernini breathed his last on Thursday, November
28, at "around the sixth hour" of the day, that is to say, the sixth hour after
sunset. (Time in Italy was then reckoned according to a division of the
day into twenty-four hours commencing at sunset.) Bernini had finalized
his will ten days earlier. In it he says only this about funeral services: "I
leave up to my aforementioned heirs the [details of my] funeral; however I
remind them that, for the poor souls of the deceased, suffrages in the form
of Masses and prayer are more necessary than the external appearances of
funeral ceremonies."

Strangely enough for the case of so eminent a citizen as Bernini, details
about his funeral and Rome's immediate postmortem mourning of his loss

are scant. Baldinucci assures us, however, that the family gave their father a suitably grand funeral in the Basilica of Santa Maria Maggiore. Though most recently the site of a bitter professional and personal defeat (the failed apse project of 1669), that ancient basilica, where Monsignor Pietro Filippo served as canon, had been intimately associated with the Bernini family since 1606 when father Pietro had been called to Rome to work on the Pauline Chapel therein. It also contained the family's funeral vault. For Bernini's wake and funeral, the church was decked out with ornamental banners from ceiling to floor, with sixty torchbearers surrounding the body. Yes, people were counting the number of torches: descriptions of funerals in Baroque Rome often specify the number of torches in attendance, for this was a conspicuous gauge of the socioeconomic importance of the deceased. Sixty is, to be sure, a very respectable number. But Monsignor Pietro Filippo at his own funeral in May 1698 would outshine his father, as it were, with a total of eighty torches.

The funeral mass, sung by a choir, was delayed by a day because of the crowds of people who wished to pay their last respects to the artist at the wake on the twenty-ninth. At the conclusion of the mass, the usual distribution of free candles and other alms took place. This practice was long customary at Roman funerals: what better way to emphasize the generosity of the deceased while also attracting large numbers of "mourners" at the ceremony? Yet, again strangely enough, nothing is said in the sparse surviving documentation about other important details of the ceremony: Which priest or prelate presided over the liturgy? Who from the ranks of the Roman elite attended the ceremony? And just as important, which preacher delivered the sermon-eulogy in Bernini's honor? In Baroque Rome, every significant occasion, religious or civil, especially the death of a local, beloved luminary, was accompanied and memorialized in the form of a sermon or oration from a distinguished preacher or professor of eloquence, the text frequently being published as a volume unto itself. Why is there only silence in the record on these details in the case of Bernini's funeral? Was it because there was nothing especially remarkable or distinguished of which to speak? If there had been, why did no one make an effort to record it better for posterity?

Nonetheless, as Domenico assures us, "universal was the mourning in the city of Rome for the loss of this man, well aware that she had been further endowed with great majesty by means of his untiring labors. Within

the academies, Bernini, as in life, so in death, was the subject of many bril-
liant literary compositions." But where are these "many brilliant literary
compositions"? To date, none has been found in the archives. After his
death, there were only two published eulogies, and they came, ironically,
not from Rome but from Paris: the first in the January 1681 issue of the pop-
ular courtly journal, *Le Mercure galant* (written by its editor, Jean Donneau
de Visé, who did not know Bernini personally), and the second in the
February 24, 1681, issue of the more prestigious *Journal des savans*, written
by his friend, the Abbé Pierre Cureau de La Chambre.

Instead, what have survived are the malicious *avvisi* written about Ber-
nini once news of his postmortem benefactions had gotten around the city.
The *avvisi* claim that these last, special gifts of works of art by him or from
his collection—to Pope Innocent, Queen Christina, and three powerful
cardinals—were politically motivated, *fatti politicamente*. Of course they
were, as were all gifts in the ever self-interested world of the Roman court.
Certainly in making them, Bernini hoped to secure the recipients' continu-
ing protection of his family. More specifically, however, one of the *avvisi*
makes the claim that the bequests were for the benefit of "others" (plural)
of Bernini's family (his brother Luigi, for example?) guilty of unnamed
crimes: "Cavalier Bernini has bequeathed, among other singular gifts,
a painting of Our Savior to the pope and a statue of the same subject to
the Queen of Sweden, so that the former might make his son, Monsignor
[Pietro Filippo] a cardinal, and the latter might protect others of his family
who have traveled unto the path of evil." No less ominously, another *avviso*
states that the gifts were made in order to purchase the silence of those in
authority in light of a possible incriminating audit of Bernini's books. The
latter, we assume, is a reference to the accounts relating to Bernini's various
projects for the Fabbrica of St. Peter's Basilica. As we saw earlier, already
in the early 1660s, Father Virgilio Spada had denounced glaring irregulari-
ties in Bernini's bookkeeping. However, in 1680 as before, nothing came
of these charges. Sad to say, nonetheless, Bernini left this world with this
cloud of suspicion hanging over his name.[15]

But the gossip mills of Rome were even busier on another topic con-
cerning Bernini's money. Everyone wanted to know: how much was he
really worth? It was common knowledge that Bernini was fabulously
wealthy, but exactly how much did that wealth amount to? Unfortunately,
no official reckoning of the monetary value of Bernini's estate at the time of

his death was made public. That remained a closely guarded family secret. The diary of family friend Carlo Cartari mentions the rumor that Bernini's estate "adds up to 600,000 scudi or more," while another anonymous Roman *avviso* claimed it was "above 300,000 scudi." Yet another intermediate figure was reported to Queen Christina, whose shocked response has become famous in Bernini lore: "The following day, taking advantage of the opportunity offered by the pope's presentation of a gift to her, Queen Christina asked His Holiness's servant, 'What are they saying about the estate left by Cavalier Bernini?' 'He left,' the servant replied, 'about 400,000 scudi.' To that the queen remarked, 'I would be ashamed if he had been in my service and had left so little.'" Christina's feigned surprise was sarcasm, however, against the reigning Pope Innocent XI, for whom she bore little affection.

By any account, Bernini died a multimillionaire (even the lowest estimate of 300,000 scudi represents roughly twelve million dollars in today's money). All his generous almsgiving made hardly dent in his vast wealth. In his formal will, Bernini left his entire estate to his sons. Among the smaller legacies, he made provision for a wedding dowry of 25 scudi a year for an impoverished maiden (that would cover about two or three months' rent in a decent working-class apartment at the time). Curiously, in case of the extinction of the Bernini family line, he stipulates that one entity alone, the "Archconfraternity of the Most Holy Annunciation at the Church of Santa Maria della Minerva in Rome" (and not the papacy or the Fabbrica of St. Peter's or even Santa Maria Maggiore) is to become his universal heir. The most conspicuous public service of this old, prestigious confraternity was the annual distribution of dowries, again, to impoverished maidens on March 25, feast of the Annunciation. Bernini apparently had a special concern for the maidens, presumably because he well knew how morally vulnerable unmarried girls were in the city of Rome teeming with so many dangerously libidinous males like himself. Bernini also stipulated in his will that a detailed inventory of his possessions in the Via della Mercede was to be taken immediately after his death (and every twenty-five years thereafter), and these instructions were carried out in 1681, 1706, and 1731. The three inventories have survived and are precious windows onto the domestic life of Bernini and his family, especially the first one, taken just weeks after the artist's death. Although many works of art (painting and sculpture) are listed, frustratingly none of them bears an artist's name or

even some vague indication of dating like "modern work" or "work of antiquity." Presumably a great deal is the work of Bernini himself, but not all—and wouldn't we like to know the identities of especially those large paintings that the inventory describes as being "of good hand" or "of very good hand"? If it is true that an inventory of one's possessions is a mirror of one's heart and mind, what is noteworthy here is Bernini's apparently scant interest in books: none at all are mentioned, not even in the description of the contents of the "studio where Cavalier Bernini of happy memory used to study," and despite the minute attention paid to lists of pots and pans and tables and chairs.

Perhaps the greatest irony attached to Bernini's death and immediate postmortem reputation is that he, who so excelled in the creation of splendid funerary tributes to deceased luminaries in the form of both temporary catafalques and permanent marble-and-bronze tombs, should have none for himself. His remains were simply deposited in the Bernini family crypt in Santa Maria Maggiore, with no fanfare or special marking. That crypt had been granted to his father Pietro in 1625 by the basilica's canons. It is today identified by merely a nondescript, flat marble slab on the pavement of the basilica, to the right of the sanctuary, adjacent to the sanctuary balustrade (fig. 38). The coat of arms and inscription presently seen on it—"Nobilis familia Bernini hic resurrectionem expectat" (The noble Bernini family here awaits the resurrection)—date to after 1746 when Pope Benedict XIV conferred the status of nobility upon the Bernini family. Excavations in 1931 of the ill-kept interior of the crypt uncovered no traces of Bernini's remains except for a fragment of his Cavaliere's sword, now in the basilica's archive. Bernini, it seems, had momentarily given some thought to the idea of his own tomb monument earlier in life. There survives a sketchy drawing, dated circa 1670, for such a monument done by one of his close painter-collaborators, Ludovico Gimignani. It has also been suggested that the striking, well-wrought, terracotta portrait bust of the eagle-eyed Bernini at just that age, now located in St. Petersburg, may also relate to this never-executed funeral monument.[16]

But Bernini never pursued the idea of creating or having created for him a properly elaborate and celebratory tomb monument. Perhaps the aged artist was in reality too humble for that. But even more revelatory is the fact that once he was dead, no one else pursued the idea either. Ever. No one at any time made a move to memorialize him by means of a tomb of

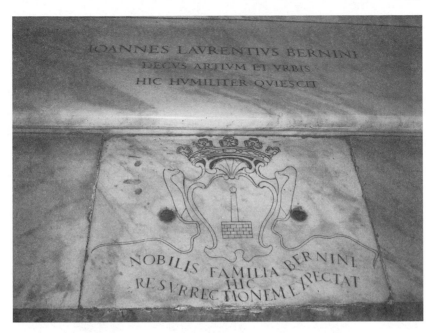

FIG. 38 ➤➤ Bernini Family Tomb, Santa Maria Maggiore, Rome. Photo: Author.

his own, a plaque on the Capitoline, or a bust in the Pantheon alongside those of Raphael and Annibale Carracci. (In 1898 a historical marker was finally affixed to Bernini's home on the Via della Mercede [fig. 39], noting the building as his place of residence.) What strikes us more in the descriptions of his last days, his death, and his postmortem tribute is what is missing rather than what is effectively there. Was there simply too much anti-Bernini feeling still in the air for anything beyond what was contained in the few, quickly passing days of mourning? Had Bernini lived too long and outstayed his welcome? What a contrast, for example, with the case of Michelangelo, over whose very cadaver the cities of Rome and Florence fought and whose grand tomb monument in Santa Croce has long been the destination of endless generations of admirers. Despite all the hyperbolic claims—asserted, not proven—by Domenico about the great outpouring of homage and mourning for Bernini in December 1680 and immediately thereafter, objectively examining the documented facts, one has the sense that Bernini, the "Michelangelo of his age," went out, not with a bang, but a whimper.

FIG. 39 ➤➤ Memorial plaque, 1898, on the facade of Bernini's home in Via della Mercede, Rome. Photo: Author.

Yet, having dared to say that, we can almost hear his indignant son Domenico rising furiously from the grave to scold and challenge us: "You seek his monument?" in thundering tones he demands to know. "You seek a mere marble tomb? A single, puny plaque? A lone portrait bust to contain the memory of so colossal a genius? Do you jest?" Instead, grandly sweeping his arm across the magnificent panorama of the city of Rome, from the Vatican to the Villa Borghese, he invites us with haughty but justifiable pride: "If you seek his monument, just look around you!"

NOTES

For abbreviations used in the notes, see page xxi above.

MONEY, WAGES, AND COST OF LIVING IN BAROQUE ROME
1. After arriving at my estimate, I came across the March 20, 2008, article by
Malcolm Moore in the British newspaper the *Telegraph*, on an episode of inter-
national intrigue involving the supposed loan of 150,000 scudi by the Odescalchi,
the banking family of the future Pope Innocent XI, to the Protestant William
of Orange (www.telegraph.co.uk/news/worldnews/1582334/Vatican-forced-
us-out-of-Italy-claim-authors.html). Without describing the metrics behind this
currency conversion, the article describes that amount in scudi as representing
3.5 million British pounds. At the 2008 exchange rate, this equaled 7 million US
dollars. By that same calculation, therefore, 1 million US dollars equaled (in 2008)
21,430 scudi, or 28,570 scudi at the 2010 exchange rate, figures that reassuringly
approach my own.

CHAPTER ONE
1. All translations, except those taken from English-language secondary
sources, are mine. The basic (well-known, undisputed) facts and fundamental bib-
liography relating to Bernini's life and works not given here in either text or notes
can be readily found in the well-indexed Mormando, 2011 (my critical edition of
Domenico's biography of his father), which on many topics also provides further
data and sources.

Pietro and Angelica's wedding documents and death certificates: Mormando,
2011, 270nn7–8. Contemporary advice on choosing a wife: Piccolomini, 481–83,
492–94, recommending that men marry at thirty and choose wives between

eighteen and twenty-two. Rarity of twelve-year-old brides in early modern Italy: Cohen and Cohen, 202. In Rome in 1650 the average age of marriage between citizens (in the case of first marriages) stood at 26.7 for men and 19.8 for women (Sonnino, 1999, 792).

2. Agnese as wife of Ciampelli and her death: Mormando, 2011, 282n37. Names and birthdates of Bernini's siblings: Mormando, 2011, 269n6.

3. Bernini's explanation of his two names: Chantelou, Aug. 10, f.111, e.109. His parents' marriage contract spells the family name as "Barnini" (Fagiolo dell'Arco, 2002, 200). Origins of Bernini family name: Del Panta, 112–13.

4. "Seventh Elegy," *Duino Elegies*: Rilke, 61. Angelica's portrait in 1681 inventory: Martinelli, 1996, 256. Pietro's mother in 1609: Mormando, 2011, 270n6. Pietro as "mediocre artist": Howard Hibbard and Irma Jaffe, quoted by Mormando, 2011, 270n7. Mormando, 2011, 270n7 for Baglione's and Passeri's praise of Pietro; Pietro as greatest exponent of Mannerist sculpture (Francesco Petrucci); and "all expectations of what a historical relief" (Steven F. Ostrow).

5. Pietro Filippo's biographical sketch: Mormando, 2011, appendix 1. Editorial history of the biographies by Baldinucci and Domenico Bernini, see chapter 6 below.

6. "Understood that the only worthy teacher": Domenico, 5. "Passing himself off to posterity" and "It is difficult being the son": Zeri, 96 and 95. "One of the first things I remember": Chantelou, June 6, f.47, e.15–16. Pietro is identified as "sculptor to His Holiness Urban VIII" in his death certificate: Fagiolo dell'Arco, 2001, 353. "Amidst many graces and much happiness": Baglione, in Mormando, 2011, 270n7.

7. "Paradise inhabited by demons": Croce. Descriptions of Naples and Neapolitans: Astarita, 86–188; Gardiner; Porter; Selwyn. "Malignant, bad and full of treasons": Selwyn, 26, quoting a fifteenth-century commentator. "Narrow, dark, melancholy": Astarita, 163, quoting a 1533 description by the Spanish viceroy. Annunziata statistics: Astarita, 167. "See Naples and Die": Goethe, 189, repeating an Italian saying, "Vedi Napoli e poi muori." "Certain extremely expressive gestures": Cureau de La Chambre, *Éloge du Cavalier Bernin*, in Montanari, 1999, 125. Bernini's love of fruit: Domenico, 177.

8. Quotations about Bernini's childhood in this paragraph: Domenico, 2–3. Bernini as "Michelangelo of his age": Domenico, 9. Mormando, 2011, 271n9, for Martinelli and Passeri on Bernini as Neapolitan; Leoni and Rouhier engravings; and Bernini's Roman citizenship. Bernini on list of Neapolitan artists: Baldinucci, 1974–75, 6:363.

9. Mormando, 2011, 58 (and nn. 135 and 136) for "How, by sheer force of his intellect" (Domenico); Alexander's tutoring of Bernini; "without having studied" (Chantelou); and "man without letters" (Franco Borsi). For refutation of the

claim that the postmortem inventory of Luigi Bernini's book collection actually represents the library of his brother, Gian Lorenzo, see Mormando, 2011, 263n137.

10. Date of the family's move to Rome: Mormando, 2011, 275n3. "Pietro was keenly desirous": Domenico, 6. Contarini's description of Rome: Barozzi and Berchet, 200. "Premier city of the world": Colbert in Domenico, 117. Relevant passage from Nicholas's "Testament" is quoted in chapter 3 below. 1606 Roman census: Cerasoli, 174. Ranking of Rome among Italian cites: Sonnino, 1998, 94. List of Tiber floods compiled from Aldrete, 244; Segarra Lagunes, 76–80; and Gigli (Index, s.v., "inondazioni"). Europe's Little Ice Age: Heiken et al., 75. 1598 flood plaque on Minerva facade: Lansford, 399. Socioeconomic divisions of seventeenth-century Italy and its poverty rate: Sella, 75 and 79; and Fiorani, 1979, 99–103; and 1980, 121–23, 128–29. Distraught Roman mother's suicide: Gigli, 537. Decline of the Italian economy: Sella, 23. *Pagnotta* and bread supply: Reinhardt, 1997, 212–14. Innocent's encounter with Roman mob: Gigli, 507.

11. Bernini's food remuneration for Piazza Navona job: Fagiolo dell'Arco, 2001, 105. Bernini's eating habits and the fruit diet for cholerics: Mormando, 2011, 422–23n32.

Abandoned baby statistics in Rome: Schiavoni, 538. Rome census: Cerasoli (174 for 1606). Centini and "his prostitute": De Paola, 184. Centini was known as "Il Cardinale d'Ascoli," after his birthplace; in Latin, "de Ausculo" or "Ausculus." Crime of Centini's nephew: Spada, 5–6 (n. 25 for child ritual murder); and Rietbergen, 2006, 349–60. Nun hanged for poisoning (Aug. 24, 1669): Rossi/ *Avvisi*, 17 (1939): 509. Executions as popular entertainment: Varriano, 78. Piarist sexual abuse scandal: Liebreich.

12. "Had in tender youth reached": Domenico, 10. Pietro's *Assumption* and *Coronation* commissions: Mormando, 2011, 274n22 and 276n6. His 1614 land grant: Kessler, 442–43, doc. 119. 1625 burial vault concession to Pietro and search in the 1930s of Bernini tomb: Mormando, 2011, 421n29. Move to the Santa Marta house, move to Via della Mercede, popularity of Bernini's neighborhood among artists, and the distinction held by the Bernini and Cortona residences: Mormando, 2011, 318n14. De Sylva's rental of the Bernini house: Negro, 17. Palazzo Bernini on Via del Corso: Sestieri, 13–14; and Forti, 196. Plaque inscription in Via della Mercede: Fraschetti, 432. Francesco Bernini as sculptor: Mormando, 2011, 400n17. Bernini's training with Cigoli: Mormando, 2011, 282n37. "He had already begun working": Domenico, 10. *Goat Amalthea* as Bernini's earliest documented work: Mormando, 2011, 277n13.

13. "The Cavaliere told Colbert" and "He said that at six years": Chantelou, Aug. 5, f.106, e.102; and Oct. 6, f.228, e.260. Bernini's claim about carving two heads for his father's reliefs: Mormando, 2011, 276n6. Three quotations from Domenico ("Monster of genius"; "From then on he was universally"; "It is not

to be believed"): 19, 9, 12–13. "Let me be for I am in love" and "It is not easy to describe": Baldinucci, i.139, e.72; and i.142, e.76. Pietro's withholding of approval: Pietro Filippo Bernini's *Vita Brevis* in Mormando, 2011, 239; Domenico, 5; and Baldinucci, i.75, e.10. Bernini and Salimbeni: Mormando, 2011, 380n4. Maffeo Barberini's providential entry and other quotations in this paragraph: Domenico, 11–12. "The wise man will indeed": Guarini, 88. Dissimulation in early modern Europe: Snyder.

14. "I beg you to dissimulate": Chantelou, f.408n1. Tasso on dissimulation: Zatti, 195–215. Ducci in Luigi's library: Mormando, 2011, 262n132. Christina's maxim: Åkerman, 34; for that maxim as a commonplace: Accetto, 19n1. "Being a secret and hidden animal": Snyder, xiv, quoting Louis d'Orléans. "Orators, courtiers, and those who know": Snyder, 28–29. Three quotations from Domenico ("He was so adept"; "Bernini used to say"; "However, when it was not"): 6, 57, 31. "Art should be disguised": Chantelou, Aug. 2, f.103, e.99. Polemics over Cigoli's cupola fresco: Mormando, 2011, 300n36.

15. "He loves me so much": Testi, 1:433. "Damn me if you can" and "Come now, shall I tell": Bernini, *Impresario*, in Beecher and Ciavolella, 99 and 88. "Whoever were to examine" and *Saint Lawrence*: Domenico, 14 and 15.

16. "This saint seems to exact": Rice, 192–93. Innocent XI caricature: see fig. 37. Aldobrandini *Sebastian* and first payment directly to Bernini: Mormando, 2011, 284n41. First appearance of Bernini's name in legal contract: Mormando, 2011, 280n23. Bernini's admittance into sculptors' guild: Lavin, 1968a, 236. Maffeo's letter regarding Michelangelo's unfinished statue: Mormando, 2011, 277n10.

17. "Brilliant series [that] contains": Hibbard, 45. "Any sculptor who looks at Bernini's *Apollo*": Peter Rockwell, quoted by Cole, 55. Cardinal Scipione's lament: Domenico, 19.

18. Use of specialist sculptors, "most astounding metamorphosis," and Finelli's relationship with Bernini: Montagu, 104–7. Conflict between Bernini and Mattia: Mormando, 2011, 372n18. "I do not mind that he": Burbaum, 279. "Was perhaps the only": Domenico, 114.

19. "Utterly given over to pleasures": Barozzi and Berchet, 158. Scipione's character and career: Pastor, 25:55–64; D'Onofrio, 1967, 199–206; Coliva; Hill, 1998 and 2001; Faber; Reinhardt, 1984; and Collins, 2006. His mule ride during flood: Coliva, 400. Scipione's revenue: Reinhardt, 1984, 40–98. "Extermination of the greatness" and 1614 bribe: De Paola, 192.

20. Giacomo Antonio Marta: De Paola. Marta's June 1612 and Jan. 1615 reports: De Paola, 61–62 and 207. Pignatelli (1578–1623): Coliva, 413, esp. 413nn184 and 189, from which the quotations about him; Cardella, 6:216–18. "Why is everyone so surprised?": Rendina, 2007, 146; Dall'Orto, 1997, 61–62; and Dall'Orto, 2001, 61. "The cardinal prince was quite enthralled": Domenico,

8. Male homosexual rape in Baroque Rome: Baldassari. "As you know only": Infelise, 217. "As far as the personal interests": Lupis, 290.

21. "A certain coming closer": Baldinucci, i.78, e.12. "Hearing someone remark that": Domenico, 16. "This Spaniard paid him": Chantelou, Aug. 17, f.123–24, e.125–26. "A milestone in the history" and "A possible 'labor of love'": Hibbard, 89. Domenico's account of the Scipione busts: Domenico, 10–11. "It is in imitation": Domenico, 30.

22. "With such a piercing look" and "Rather stern by nature": Domenico, 177 (both). "His face resembles": Chantelou, June 6, f.46, e.14. Bernini's self-portraits: Mormando, 2011, 294n12. Bernini's poor health until age forty: Baldinucci, i.138, e.72. Bernini's fiery nature: Chantelou, June 6, f.46, e.14.

23. Paul V died a virgin: Gigli, 80. "However, his fears were": Domenico, 21–22. Bernini as *Cavaliere*: Mormando, 2011, 290n3. Ludovisi "threatens Borghese one day": Coliva, 420n191. Barberini's poisoning: Gigli, 131, 132.

CHAPTER TWO

1. Maffeo's scorekeeping: Harper, 217. "Pretty-beard Urban": Rendina, 1991, 191. "Pope is a most expert astrologer": Testi, 1:500. "Pope Urban regulates his life": Rietbergen, 2006, 372–73 (Urban and astrology, 336–75). Lorestino's prophecy: *Sincero racconto*, 336–37. Maffeo's reaction to Crescenzi's remark and donning of wig and beard: *Sincero racconto*, 365 and 367.

2. Cecchini's cross-examination by Urban: Cecchini, ff.184r–189r. "Fell ill and was in great danger": Gigli, 341. 1625 honors for Marino: Rossi/*Avvisi*, 16 (1938): 298. "Capable of illustrious and glorious," "On the very same day," and "Urban made it clear": Domenico, 24 (first two quotations) and 25. "Word of the scheduled papal appearance": Domenico, 35–36.

3. Jobs given to Bernini by Urban: Fraschetti, 41 and 129; and Borsi, 1986, 106, under "1623" (curator of the papal art collection). "What Bernini didn't himself produce": Leopoldo Cicognara (d. 1834), quoted by Bacchi, 42. "Our evening drive was rather short": Chantelou, July 31, f.100, e.94. Bernini's order from Urban to study painting: Domenico, 26 and 37. "He should really have been a painter": Chantelou, Oct. 6, f.228, e.259. Estimated 150 Bernini canvases: Domenico, 26.

4. Painting simply as Bernini pastime: Baldinucci, i.140–41, e.74. Bernini's difficulties with complex narrative compositions: Montanari, 2007, 55–70. Bernini's complaint about princes and Roman fortifications: Chantelou, June 7, f.50, e.20–21. Bernini's collection of art: see his 1681 postmortem inventory in Martinelli, 1996, 253–60; to which must be added five paintings omitted in 1681 but included in the next inventory of 1706: BALQ, 113 ("Seconda Stanza contiqua alla sudetta"). Bernini's *Four Seasons* by Dughet: Boisclair, 54–55 and cats.

179–82; and "Vita di Gasparo Dughet pittor romano detto Gasparo Poussin," in Baldinucci, 1974–75, 5:303.

5. Becoming an architect in the seventeenth century without formal training: Marder, 1998, 20. "The pope already knew": and "His eyes [were] likewise black": Domenico, 37–38 and 177. "I shit blood": Chantelou, Sept. 20, f.195, e.216. Bernini's nomination as architect of St. Peter's: Rossi/*Avvisi*, 15 (1937): 182. Bernini's 1630 nomination as *principe* of San Luca, service as instructor there, and Barberini's Accademia del Disegno: Mormando, 2011, 310n20 (*principe*) and 293n7 (instructor and Barberini academy). Bernini's suspicion over Finelli-Cortona relationship: Santi, 481–82. "Both of them are the most insatiable": Merz, 241. "That dragon custodian": Passeri, 242–43.

6. Bernini's unkept promises to Borromini: Burbaum, 279. "Had robbed him": Domenico, 76. Borromini-Bernini conflict: Mormando, 2011, 301–2nn43, 44. Bernini's secret deal with Agostino Radi: Passeri, 385 ("Vita di Borromini"). Bernini's 1632 recommendation for Borromini: Wittkower, 1975, 159; and Connors, 2000, 11. Oct. 1661 report to Duke of Savoy: Mormando, 2011, 340n4. "The Cavaliere intervened": Chantelou, Oct. 20, f.282, e.326.

7. Ciampelli's criticism of Bernini's Baldacchino: Mormando, 2011, 311n25. Stripping of the Pantheon bronze: Mormando, 2011, 306–7nn12–13. Author of pasquinade, "Quod non fecerunt": Mormando, 2011, 307n13. "He thus recommended": Domenico, 39–40. Bernini's respect for Pantheon: Mormando, 2011, 307n12. Bernini's aborted display fountain at Trevi: Pinto, 40–49 (42 for the popular protest).

8. Allegations by Bellori and Passeri regarding Bernini's undermining of Duquesnoy: Lavin, 1968b, 26n124. "It is said that this excellent sculptor": Evelyn, 1:191. Duquesnoy's complaint as recorded by Sandrart: Lavin, 1968b, 39n174. Reference to Bolgi in Bernini papers in Paris: Mormando, 2011, 314n37. Bolgi portrait in Bernini's home (per family inventory): Martinelli, 1996, 256. Mochi's "ingratitude": Domenico, 112. June 22, 1658, entry in Alexander's diary: Mormando, 2011, 314n38. "Why, from the big crack": I am paraphrasing Pascoli, 2:416 ("Vita di Mochi").

9. Cupola charges: Domenico, 43–44 and 167–68. Bernini's 1680 exoneration: see chapter 6 below. Mormando, 2011, 312n27, for the following: Mantovani's reports about Carli, Carli's career and alarmist rumors, anonymous 1636 memorandum about the cupola peril, Bernini's planned 1637 Carnival comedy, and suppression of the Collegio Capranica satire. "Issue of architectural competence": Marder, 2008, 433. "Behold the evils that are caused": Bonini, 473.

10. *Patria potestas* and legal right to castrate sons: Uberti, 40–41 (Uberti was a jurist). Husband's right to imprison his wife: Fornili, 248, doc. 4. Borghese daughter suicide: Paita, 104–5, dating the event to the beginning of the eighteenth

century, but with no further details. Her father is presumably Marcantonio III (1660–1729). 1635 Alaleona scandal: Gigli, 270.

11. Girolama the witch: Pallavicino, 1839–40, 272–77; Gigli, 779–80. Child pedagogy of Baroque Europe: Ago (287–88 for dangers of "excessive fondness" toward children). Ursuline convent of SS. Rufina e Seconda: Piazza, 345–50; Bonanni, 2:103. Chantelou's diary contains an endearing reference to one of Bernini's two daughters in that convent: Paolo Bernini, explaining his father's reluctance to move to Paris, mentions, "There was only one thing that worried him, that one of his daughters, whom he loved dearly, was a nun in a convent where, however, no vows were taken; he did not wish to leave her behind" (Chantelou, Sept. 7, f.166, e.179). It is not clear to which of his two daughters this refers, Agnese or Cecilia, both still alive when Bernini was in Paris. "All his life, Bernini showed an excessive respect": Gould, 1958, 173. "Already rich, was always acquisitive": Hibbard, 114–15. "To be sure, Bernini adored money": Wittkower, 1961, 498.

12. The Bernini family real estate at Santa Maria Maggiore is included in their 1706 inventory: BALQ, 122. The precise date of the move to Santa Marta is nowhere documented.

13. All quotations referring to Bernini's illness and response to it (including the papal visit): Domenico, 47–50. *Giulebbe gemmato*: Mormando, 2011, 317n10. Alexander's two visits (June 19, 1662, and June 5, 1663) to Bernini's home: Mormando, 2011, 362nn11 and 15. Queen Christina's visits: Mormando, 2011, 361–62n7 (her only documented visit dates to Feb. 20, 1656. Clement IX's visit (July 28, 1668): Mormando, 2011, 405n12. Bernini's attendance at "Good Death" devotions at the Gesù: Domenico, 171. "Good Death" sodality: Piazza, 684–87 (687 for "pious use of the discipline"); and Mormando, 2011, 416n7.

14. March 1638 as most likely date for end of Bernini-Costanza love affair and attempted murder of Luigi: D'Onofrio, 1967, 132. Costanza Bonarelli and all known details of her affair with Bernini: McPhee; and Mormando, 2011, 294–95nn13–15. Matteo Bonarelli (whose last name in sources is also given as Bonucelli): McPhee, 325–27; 325 for his last will. Italian text of Angelica's letter: D'Onofrio, 1967, 132. Urban's exoneration of Bernini: Domenico, 27. Roman husbands' pimping their wives: Storey, 147–49. Bonarelli's *Visitation* relief for Bernini's Siri Chapel: Pavone, 278. Pope Paul V's attitude toward artists: Chantelou, f.26 (introduction by Stanić, quoting Malvasia's *Felsina pittrice*).

15. Costanza's daughter, Olimpia, and her gift to the Convertite: McPhee, 325 and 333. Bernini's marriage (including Urban's role), wife, and children: Domenico, 51–53; Mormando, 2011, 318–19nn16 and 17. Bernini's repugnance at suggestion of marriage: Baldinucci, i.85, e.20. Sexual intercourse as medically necessary: Storey, 61–62; and Dooley, 80. "Although it may be that up": Baldinucci, i.134, e.68. "Turning then to Monsieur": Chantelou, July 23, f.85, e.72–73. "For

both its tenderness": Domenico, 42. Any discussion of Bernini's personal faith and practice of devotional life must have as its preamble this word of caution: we have absolutely no reliable, nonpartisan (i.e., not coming from Bernini, his family or "authorized" biographers) documentation on the topic until 1665, when Chantelou began writing his diary, which contains many references to Bernini's piety: see Mormando, 2011, 60–66.

16. Gift of the Costanza bust to Cardinal de' Medici: *Marmi vivi*, 329. Bernini-Costanza double portrait (in 1681 inventory): Martinelli, 1996, 255 (the "mezza Testa di Donna" presumably refers to Costanza). Costanza as Charity in Urban's tomb: Munoz; Bauer, 53 (contemporary report). "Bernini remained so mortified": Fraschetti, 104; D'Onofrio, 1967, 130.

Sources of information about Bernini's marriage, his wife and her family, see previous note. "The kind of woman he desired": Domenico, 51. Size and social significance of dowries in Baroque Italy: Ago, 285. "Declared that he intended to treat": Fraschetti, 104, also source for detail of the secrecy and amount of Caterina's dowry. "In the end a woman's pride": Chantelou, Sept. 23, f.198, e.220. "He took his future wife to his house": D'Onofrio, 1967, 137–38. Angelica's will: Martinelli, 1996, 252–53, docs. 3 and 4. Disparaging reference to Caterina's will and "mia prima figlia dilettissima" in Bernini's will: BALQ, 61.

17. Bernini's retreat at Sant'Andrea al Quirinale after wife's death: Mormando, 2011, 255n78. Bernini's lament about melancholy evenings in Paris: Chantelou, July 23, f.86, e.75. Distress over his wife's illness: Chantelou, Sept. 12, f.175–76, e.191–92; Sept. 14, f.180, e.197; and Sept. 20, f.194, 215–16.

Bernini's children (names, dates of birth and death): Mormando, 2011, 319–20nn20–22. Bernini's lobbying on behalf of his sons and on the need to actively lobby princes for favors: Mormando, 2011, 248n12. 1680 *avviso* claiming that Bernini left a bequest to Pope Innocent XI so that his son might be named cardinal: Rossi/*Avvisi*, 19 (1941): 491. References in Chantelou's diary to Bernini's "touching up" Paolo's sculpture: Mormando, 2011, 380n2. "One of the famous writers": Giuseppe Lancisi, in Mormando, 2011, 248n13.

Extinction of the Bernini family name (sources disagree over Prospero's date of death) and subsequent continuation of the family through adopted daughter Concetta Caterina Galletti (married into Giocondi family): Visconti, 3:877; D'Onofrio, 1986, 418n31; Sestieri, 13–14; Forti (descendant through Concetta); and Petrucci, 394.

18. For the reference in Alexander's diary to the Bernini family "operetta" and "This evening they will perform": Mormando, 2011, 427n5. "He used to say that if he": Domenico, 178. The *Mercure* assures us that Bernini "wrote very fine verse": Mormando, 2011, 243. The text of Bernini's sole surviving, untitled comedy, known in English as *The Impresario* (and in Italian as *Fontana di Trevi*) has been

published several times; edition cited is Beecher and Ciavolella. "Ingenuity and design constitute": Beecher and Ciavolella, 102. "And Bernini used to say": Domenico, 57; 53–57 for Domenico's account of his father's comedies; in Baldinucci: i.94, e.29 (whence the reference to stage machinery) and i.149–51, e.83–85.

"I have him up the ass all night": Hammond, 250 ("L'ho nel culo tutta la notte, che mi lascia il giorno"), also cited by Wolfe, 2007, 263–64n63, giving further details, including those regarding Cardinal Pamphilj. Original source is Goulas, 2:118 (the well-informed Nicolas Goulas, 1603–83, was an intimate member— "Gentilhomme ordinaire de la chambre"—of the court of Gaston, Duc d'Orléans, brother of King Louis XIII). Some, like Hammond, might be quick to dismiss the remark as a mere conventional insult of the period (which it may well have been), but there are no grounds for ruling out the possibility—given what we know of the private lives of Roman clerics—of homosexual behavior in this case. Gualtieri's service to Antonio and rumors about his death: Rossi, 308–14; and Goulas, 2:118. Antonio Barberini's personality and career: Pecchiai, 189–213 (189–200 for his corrupt ways and morally compromised friends and servants); Loskoutoff; Spada, 133n81; Wolfe, 1998; 2007 (253 and 256 for his ruthlessness and narcissism); 2008 (113 for the outraged protests over his nomination as cardinal); and 2010 (271 for the quotation about the scandalous behavior of his household; 276 for his favoring of Pasqualini; 276 and 290n128, for Leonora Baroni). Homophobic attacks in Paris against Mazarin, Antonio Barberini, and Pasqualini: Olson, 124–25.

19. Bernini's 1675 comedy: Martinelli, 1959, 215. "It is the work of Bernini": Evelyn, 189–90. Bernini's discussions of his plays: Chantelou, e.353, Index, under "Bernini, Gian Lorenzo: comedies." "Sometimes it took an entire month": Baldinucci, i.149–50, e.83. His poor oppressed workshop students "in chains": Passeri, 243 ("Vita di Abbatini"). Hypothesis about Bernini's theater and the *affetti*: Mormando, 2011, 56 and 321n27, citing Tomaso Montanari. Oliva's antitheater campaign: Taviani, 241–59; also below, chap. 4. "Nuns came to physical blows": Gigli, 521. Bernini and the *commedia ridicolosa*: Mormando, 2011, 322n32. "Bernini's clever remarks": Domenico, 54. Bernini's mocking of Cardinal de Borja, his 1646 play for Donna Olimpia, and "It was a miracle": Mormando, 2011, 323n34. Roman Carnival: Ademollo (10 for race of Jews and hunchbacks); and Clementi; Zucchi's diatribe against Carnival: Neri, 668. Race of the Jews in Alexander's diary: Morello, 328, under Feb. 3, 1660. Jews and the barrel "game" at Monte Testaccio: Dusmet Lante della Rovere, 21. Innocent XI's cancellation of Carnival: Pastor, 32:29–30. Plague deaths in the Roman ghetto: Pallavicino, 1837, 34.

20. "Recent, persuasive new interpretation" of *The Impresario*: Perrini, ix–xxxviii. Death caused by Bernini's theatrical conflagration: Domenico, 56; and Perrault, 65. 1640 Oratorian rental property episode: Russo.

21. "You were made for Rome": Domenico, 71. Bernini as guest of Prince Paolo Giordano Orsini: Benocci, 24. Trips to Rieti and Palo: Aloisi, 26 (25–35 for his Santa Barbara chapel); and Fraschetti, 423. Bernini, Charles I, and Henrietta Maria: Domenico, 64–66 (65 for Charles's letter); Mormando, 2011, 333–35nn4–14. Henrietta Maria's presence at French court during Bernini's stay there: Chantelou, f.392, letter by Mattia de' Rossi of July 24, 1665 (neither Mattia nor Chantelou mentions a meeting between Bernini and Henrietta). Competition among the "greatest potentates" of Europe over Bernini: Domenico, 2 and 64. "Bernini did not work for just anyone": Domenico, 67. Baker bust: Domenico, 66–67 (67 for "just as King Charles did, and not a penny less"); Mormando, 2011, 335nn15–16 (n. 16, Bernini's explanation to Stone of why he accepted the Baker commission). "Guilty of an audacious act": Ronald Lightbrown, quoted in Mormando, 2011, 335n15.

22. Bernini's bust of Richelieu: Mormando, 336–36nn17–24. "Openly contemptuous of the Spanish": Perrault, 72. Complete list of all known Bernini works for Spanish patrons or recipients: Mormando, 2011, 286n48. Philip IV statue and crucifix-gift to him: Mormando, 2011, 286n48, and 332n1. Two Carpio gifts for Charles II: Mormando, 2011, 286n48. Gift of the Bernini self-portrait to Carpio and other Bernini works in Carpio's 1682 inventory: Mormando, 2011, 296–97n19 (including Carpio biography).

23. Bernini's work on Chair of Saint Peter chapel (1630–37): Mormando, 2011, 369n3. "If one were to remove": Mormando, 2011, 240. Elizabeth of Portugal canonization: Fagiolo dell'Arco, 1997, 255–58. Bernini's floral displays: Fagiolo dell'Arco, 2001, 81 and 309.

Bernini and the bell tower affair: Mormando, 2011, 330–32nn17–23. "A few days later a third" (Gigli) and *avviso* of Sept. 28, 1641: Mormando, 2011, 332n22. 1642 interruption of the bell tower work due to War of Castro: Mormando, 2011, 332n23, citing Sarah McPhee. Summary of maledictions against Urban VIII and Ameyden quotation: Nussdorfer, 246. "When I have sat among their learned men": Milton, 25. "The pope could easily ruin me": Chantelou, Oct. 18, f.269, e.312. "It is a lesser evil to be a bad Catholic" and "So high did the acuity of his genius": Domenico, 32 and 171. Mob violence against the statue and stucco image of Urban VIII: Gigli, 426; and Nussdorfer, 234. Mazarin's attempts to lure Bernini to Paris: Mormando, 2011, 337–38nn27–29.

CHAPTER THREE

1. "That it was ridiculous to elect": Coville, 30, citing Gregorio Leti; see also Venetian ambassador's dispatch in Barozzi and Berchet, 88, for Innocent's physical appearance and irascible character. Brivio's discourse on ugliness: Rossi/*Avvisi*, 16 (1938): 298. "If Pamphilj the new pope it turns out to be": dell'Arco, 151.

Flight of the disguised Barberini: Rossi, 1936 (303 for Antonio dressed as *carbonaio*); Pastor, 30:52–53; and Pecchiai. "Placed his government in the hands": Herman, 284. Pimpa and *Olim pia, nunc impia*: Rendina, 1991, 199–200 and 203. "It was simply a disgrace" and "It was public rumor": Gigli, 527. Olimpia and Pope Innocent in Venetian ambassador's dispatch: Barozzi and Berchet, 88.

2. "People speak ill of Bernini": Domenico, 73. Bell tower affair and Bernini: Chap. 2n23 above. Borromini's alarmist charges: Domenico, 77. Text of Spada's *Sopra doglianʒe fatte dal Cavalier Bernino*: del Pesco, 67–69. "A certain minister of his": Domenico, 79. Mormando, 2011, 343n20 for Bernini's bribes to Donna Olimpia and Camillo Pamphilj; Bernini's financial accountability in Modenese report and Cartari diary; and cost of the bell towers as per the *Tempio Vaticano*. "The city of Rome mourned": Domenico, 79. "Somewhat like a Beaux-Arts train station": Collins, 2004, 128.

3. "The Cavaliere, the subject": Domenico, 80. Bernini's "steadfastness," "resoluteness," and "absolute control": Baldinucci, i.100, e.34–35. The self-portraits (none securely dated) in the Galleria Borghese, Prado, and Uffizi: *Regista*, cats. 6, 10, and 11, respectively. Deaths of Angelica and Vincenzo: Fagiolo dell'Arco, 2001, 357 and 364. A search of the documentation relating to the Bona Mors sodality in the Jesuit archives in Rome (Borgo Santo Spirito) found Bernini's name nowhere in membership lists. Statue of *Truth* (including attempted sale to Mazarin): Mormando, 2011, 344–45n24. Preparatory drawing of *Truth* in Leipzig: Lavin, 1981, 101n14. Sexual significance of body language (i.e., legs) in profane art: e.g., Bayer, 206 (discussion of the "slung leg" motif). "It was a saying current in Rome": Chantelou, Aug. 23, f.136, e.142, also for Bernini's description of the statue. Reference to *Truth* in Bernini's last will: BALQ, 71–72.

4. "If you want to see what": Chantelou, Oct. 9, f.239, e.274. Bernini's Cornaro Chapel and *Teresa in Ecstasy*: Mormando, 2011, 346nn33–35. Cost of the chapel: Barcham, 822; payments to Bernini for statue and other items: Napoleone, 184 and 185. "Cavalier Bernini received and continues": Rossi/*Avvisi* 16 (1938): 528. "Work of perfect beauty": Passeri, 245 ("Vita di Abbatini") "This is the least bad work": Domenico, 83. Bernini as "supreme trickster": Beecher.

5. "Most astounding peep show": Schama, 2006, 78. "Dragged that most pure Virgin": Bauer, 53. "Depicted in the act of rising": Connors and Rice, 132. Mascardi's oration on Teresa: Mascardi, 98–110; 106–8 for his remarks here paraphrased. Song of Songs and Baroque erotic imagery: Graziano, 187–204. Oliva's commentary on the Song of Songs: Oliva, 1677. Council of Trent's decree on cult of saints and sacred images: Jedin, 1967, 145–47, 151–53; and 1975, 164–66, 180. My thanks to John W. O'Malley for the Jedin reference.

6. Clement VIII's policing of church art and the proposed licensing of artists: Beggiao (72n13, for removal of paintings and crucifix cover-up; appendix 4, 106,

for the edict). Paleotti and the question of nudity in religious art: Mormando, 1999, 117–18; *Grove Art Online*, under "Paleotti, Gabriele"; Borromeo, in index under "Nudity." Oliva's Luigi Gonzaga sermon: Oliva, 1712, 1:316–23 (no. 27, "Nella vigilia del Beato Luigi"); for his Filippo Neri sermon: Oliva, 1670, "Predica in lode di S. Filippo," 691–725 (ss. 409–31), esp. 707–9 (ss. 419–20). "I know of a man who, while contemplating": Bernardino, in Mormando, 1999, 117–18. "Glory of Paradise shining with tremendous brightness": Weil, 227, quoting a contemporary *avviso*. "The only people who understand": Christine Smith and Joseph O'Connor, trans., in Mormando, 2011, 267n8.

7. "One of the most sweeping and extravagant": Wittkower, 1981, cat. 50, 269. Bernini's 1672 water conduit concession: Fagiolo dell'Arco, 2001, 275. Fountain of the Four Rivers: Domenico, 85–91 (86–87 for the quotations); Mormando, 2011, 347–50nn5–20. Innocent's downgrading of status of Barberini Trevi Fountain: Pinto, 49, 51. Borromini's claim about having won the fountain commission for his design: Mormando, 2011, 348n6. Role of Donna Olimpia and third-party contemporary commentary on the fountain competition: Mormando, 2011, 348n7. Text of Innocent's July 1648 order to Torregiani: D'Onofrio, 1986, 424n36.

8. Bernini's water trick on Innocent: Domenico, 89–91. "He was never able to be": Domenico, 109. "Command that these stones" and "We don't want obelisks": Gigli, 534. "One marvels not a little": Baldinucci, i.104, e.38. "When the crowd saw": Domenico, 92. Severe weather of Aug. 1653 and the 1654 earthquake: Gigli, 687, 688, and 709–10.

9. "Once a week Innocent desired": Domenico, 87. Payment of 3,000 scudi to Bernini for the fountain: Fraschetti, 191. Olimpia's attempt to make Bernini's brother a Lateran canon: Lavin, 1998, 65, doc. 41*. Fountain of the Moor: Butterfield. Early history of *Constantine* commission: Mormando, 2011, 351–52n26. "Man with enormous aspirations": *Encyclopaedia Britannica Online*, under: "Este, House of: Decline of Power." "Bernini works only as a favor": Lavin, 1998, 57, doc. 4. Payment of 3,000 scudi to Bernini (who "has enough jewels and silver") for bust: Lavin, 1998, 70, doc. 67. Bernini's letter of Oct. 1651 to Duke Francesco: Lavin, 1998, 65, doc. 43.

10. "Substantiate the impression": Jarrard, 2002, 409. Bernini's visits to the Villa d'Este and his work on its fountains: Domenico, 99, 162. Rinaldo's career in Rome and interactions with Bernini: Jarrard, 2002 and 2003. "The bellicose cardinal was accustomed": Conforti, 66. "Worthy prince of most affable manner" and "that sublime genius": Domenico, 99 and 162. Clash between Rinaldo and El Almirante de Castilla: Gigli, 466–72; Coville, 123–26, 210; Jarrard, 2003, 175n20; and Conforti, 59–60. Rinaldo's clash with Don Mario Chigi: Conforti, 66. Corsican Guard affair and its consequences: see chap. 5 below; Rinaldo's role and recompense in the affair: Conforti, 66–67; and Jarrard, 2003, 178. Proposed

imprisonment of Rinaldo: *Mémoires de Monsieur le Cardinal Reynaud d'Este*, 2:118 (anonymous, but authored by a long-term member of Rinaldo's inner court circle).

11. Deaths of Paolo Tezio and Dorotea Bernini: Fraschetti, 104; and Fagiolo dell'Arco, 2001, 365. *Febbre maligna* of 1649: Gigli, 558–59; its identification as typhoid: Schiavoni, 538. Olimpiuccia's marriage: Herman, 322–27. Mascambruno affair: Gigli, 645–49; Ciampi, 154–64; and Herman, 302–8. Francesco Barberini's reception by Innocent in 1648: Mormando, 2007n125. Public fight between Cardinals Antonio Barberini and Giovanni Battista Pamphilj: Wolfe, 2010, 285n57.

12. *Zelo domus Dei* text: Feldkamp, 293–305 (302 for passage quoted); *Zelo domus* printed as broadside: *Enciclopedia dei Papi*, 3:329–30. Antagonism between Mazarin and Innocent: Coville. France's "lion's share" and headquartering with the Protestants: Buckley, 83 and 87. Donna Olimpia's seizing of papal possessions and cash and "Since the ninth century": Herman, 355–56. "I'm just a poor widow": Gigli, 731. Donna Olimpia's final act of revenge upon Innocent: Herman, 368–70. First meeting between Bernini and the newly returned Chigi: Domenico, 94.

CHAPTER FOUR

1. "Now here, indeed, does a new order": Domenico, 99. Sant'Andrea al Quirinale and Christina's mirror: see below in this chapter. For the Louvre, see chap. 5. De Sylva chapel: Negro. Work at Santo Spirito in Sassia: Fagiolo dell'Arco and Fagiolo, cat. 193 (hospital); and Merz (sacristy). Torre del Mangia clock, Siena: Frangenberg. Life expectancy in Europe: Livi Bacci, 61.

2. *Squadrone volante*: Signorotto. Alexander's toothlessness: Habel, 7, citing Venetian ambassador. Two pasquinades against Alexander: Habel, 8 and 9. Alexander's coffin and skull: Mormando, 2011, 402n22; Pallavicino, 1839–40, 1:267; Habel, 327n22. Alexander's wooden model of Rome: Neri, 676 (diary entry for April 27, 1667). For all portions of Alexander's diary relevant to Bernini: Morello. First diary reference to Alexander's tomb: Morello, 322 (Nov. 9, 1655). Bernini's tomb for Alexander: Domenico, 154 and 166. Bernini's fever of 1655–56 and "His Holiness, who loves" (in *avviso* of Oct. 2, 1655): Mormando 2011, 247n11. Bernini's will of 1655: Martinelli, 1996, 271. "Make sure Pietro's designs": Morello, 322. Papal debt under Alexander: Magnuson, 2:131; interest rate lowering: Rietbergen, 1983, 140. Bernini as *architetto della Camera apostolica*: Domenico, 95. "The sun had not yet set": Domenico, 95, 99. Three papal diary entries (Jan. 22, Mar. 22, May 24, 1656) referring to Bernini and water supply: Morello, 322.

3. Diary entry (May 21, 1660) regarding food poisoning: Morello, 329. Colonnade project: Domenico, 99–101. Bernini's salary as *architetto*: Rietbergen, 1983, 126; his remuneration for Colonnade project: del Pesco, 54; also 40 and 56.

"Nearly half of the annual revenue": Rietbergen, 1983, 155 (154 for the numerical figure); and Carboni, 151–52, 171. Conditions in Rome for ordinary folk at the time of Alexander: Krautheimer, 126–30. "In order to assist the poor": del Pesco, 42. Job creation estimates: Rietbergen, 1983, 149. "It does not seem proper" and "In view of his merit": del Pesco, 43 and 63–64. Pope Alexander's handwritten additions to the Colonnade defense memorandum (dated ca. 1662) clearly identify the author as Bernini's son, Mons. Pietro Filippo, bearing numerous corrections by Sforza Pallavicino; they inevitably incorporate many of Bernini's own direct observations, if not extensive verbatim dictation. "For, since the Church of St. Peter": del Pesco, 65. See del Pesco, 43–45, for the text of yet another anonymous memorandum, dated to shortly after Aug. 1656, also defending the portico expenditures, which, as it says, would "keep employed so great a number of poor artists, who amidst the present calamities, cannot find work."

4. Excerpted and discussed by Krautheimer, 126–30.

5. "Is it not a shame": Rodén, 182. Raggi on Flavio Chigi's scandalous lifestyle: Neri, 663–64. Spada's criticisms of Bernini's Colonnade design: del Pesco, 49–53 and 71. *Sopra doglianʒe fatte*: see chap. 3. Spada's discovery of errors in Bernini's accounting: del Pesco, 69 and 78; Rietbergen, 1983, 146; Borsi, 2000, 349–50 (doc. of Feb. 1661 attributed to Spada). Nov. 30, 1680, *avviso* referring to audit of Bernini's accounts: Rossi/*Avvisi*, 19 (1941): 491. May 25, 1680, *avviso* about financial discrepancies: Rossi/*Avvisi*, 19 (1941): 393. "What is most needed": Pizzati, quoted by Krautheimer, 129.

6. Chair of St. Peter commission: Domenico, 109–10. Martinelli's doubts about its authenticity: D'Onofrio, 1969, XXVII–XXXVI (complete text of Martinelli's treatise on the *Cathedra*); and Mormando, 2011, 369n3. Drawing of the Baldacchino in the Morgan Library: *Petros eni*, cat. II.25. Scala Regia project: Domenico, 101–2; Mormando, 2011, 358–59n23. "This had been the most daring": Domenico, 101.

7. Porta del Popolo: Domenico, 108. Bernini's work on *Manica lunga* and Quirinal Palace, including the Gallery: Mormando, 2011, 366n31. *Virgin and the Child* in Paris: Wittkower, 1981, cat. 53. Texts of Bernini's two consultations on the Milan Cathedral facade: Fagiolo dell'Arco, 2002, 185–91. Savoy residence at Mirafiori: Mormando, 2011, 381n8. Bernini's portraits of Alexander VII: Mormando, 2011, 367n34. Commemorative papal medals: *Regista*, cat. 173, 191. Crucifixes and candlesticks for St. Peter's: Wittkower, 1981, cat. 274; *Regista*, cat. 79–80; Morello et al., cat. 21 and 22. Bernini's ephemera: Fagiolo dell'Arco, 1997.

8. "The Cavaliere replied": Chantelou, June 25, f.63, e.40; July 30, f.98, e.91; and Sept. 7, f.167, e.180. Christina's conversion to Catholicism and arrival in Rome: D'Onofrio, 1976, 11–106, the most complete, detailed account, upon which my description in large part depends. Christina as "Queen of Amazons":

D'Onofrio, 1976, 26, citing a Roman courtier, the "Anonimo Vaticano." "Pope
Alexander has had no other thought": Gigli, 750. Cost of Christina's journey:
D'Onofrio, 1976, 20. "By many persons it was reported": Gigli, 751. "In short,
in creating her": D'Onofrio, 1976, 26, again quoting the "Anonimo Vaticano."
Christina's eyes, "full of fire": the Duc de Guise, quoted by Hibbert, 191–92,
whence also details of her wig and makeup. "As if already having imagined":
Domenico, 103. Other examples of the stock theme of the "instant recognition"
phenomenon: Mormando, 2011, 354n36.

9. "Whoever does not esteem": Domenico, 103. "I have so much esteem":
Montanari, 1998, 405. "Bernini, who was at that moment": Domenico, 104. Date
of Christina's visit to Bernini's home: Mormando, 2011, 361–62n7. Bernini's praise
of Christina as art connoisseur: Chantelou, Aug. 13, f.118, e.118–19. Christina's
presence at Pietro Filippo's theatrical production: Montanari, 1998, 406–7.
Bernini's refurbishment of the Torre dei Venti: D'Onofrio, 1976, 26, 28, 34;
Montanari, 1998, 333. "All manner of evil is disseminated": D'Onofrio, 1976, 28.
Papal gift-coach to Christina: Fagiolo dell'Arco, 1997, 377 and 378; Montanari,
1998, 335. "If you see anything defective": Montanari, 1998, 333, citing Galeazzo
Gualdo Priorato.

Christina's tour by Bernini of papal art collection: Mormando, 2011, 361n4. Ber-
nini's mirror for Christina: Mormando, 2011, 420n22 (citing Lilian Zirpolo's theory
of the mirror's allegorical meaning). Christina's execution of Monaldesco: Buckley,
230–43. Alexander's tomb intended "to rehabilitate the severely damaged posthu-
mous reputation of one of [Bernini's] closest friends": Bernstock, 171. Costanza
Bonarelli as Charity on Urban VIII's tomb: Munoz; Bauer, 1976, 53. Christina's
portrait on Alexander's tomb: as far as I know, I am the first to make the suggestion.

10. Bernini works in Christina's collection: Mormando, 2011, 420n22. Gift
drawings to Christina: Chantelou, Sept. 30, f.213, e.240. "She elected to refuse":
Domenico, 167. Savior bust: see chap. 6 below. "It was a great irony": Buckley,
317. "Christina was skeptical": Stolpe, 330–31. "He believed that great lady":
Domenico, 174.

11. Donna Olimpia as obstacle to Christina's coming to Rome: D'Onofrio,
1976, 44, 48. 1656 plague in Rome: Barker; D'Onofrio, 1976, 223–58; Pallavicino,
1839–40, 2:28–36 (also published separately as *Descrizione del contagio*, 1837). Mor-
tality rate in Rome and Naples: Mormando, 2005, 5–6. "Almost all of these deaths":
Pallavicino quoted in Mormando, 2005, 6. "The better one's birth": Chantelou,
Sept. 23, f.198, e.221. Slavery in papal Rome: Bertolotti; and Maxwell, 74–87.
Slaves during Roman epidemic: D'Onofrio, 1976, 243. "After so many funerals":
Oliva, 1659, "Predica LIII: Nel secondo venerdì di Quaresima," 1:174 (s.747).

12. Domenico Bernini as plague victim and his last will: D'Onofrio, 1976, 252;
and Martinelli, 1996, 251–52. "I heard that before": D'Onofrio, 1976, 252. Plague

at Palazzo della Cancelleria, Collegio Romano, and Pamphilj home: D'Onofrio, 1976, 243, 250, and 251. Bernini's sequestration in Quirinal Palace: Barker, 244. Plague deaths of Abbatini and Donna Olimpia: Petrucci,10; and Herman, 406–8. "Domenico's baptism on the day of birth": Carletta,1. Expansion of Bernini home on Via della Mercede: Fagiolo dell'Arco, 2001, 151–52. "So true it is that buildings": Chantelou, Oct. 8, f.237 e.270.

13. Jesuit complex of Sant'Andrea al Quirinale: Bailey, 38–41. Ceva commission to Borromini: Connors, 1982, 16. *David Slaying the Lion* frontispiece: *Regista*, cat. 166–68. Jesuit centenary celebration: Fagiolo dell'Arco, 1997, 316–18. Bernini's approval of Pallavicino tomb design: Montanari, 1997, 55 and 55n90. Oliva's complaint about viewers of art in churches: Oliva, "Sermone nella Domenica XV dopo la Pentecoste," in Oliva, 1670, 142–43, s. 91. "The Almighty Father appears to be": Rossi/*Avvisi*, 19 (1941): 30 (April 20, 1675). Other *avvisi* reporting immediate reactions to Gaulli's Gesù frescoes: Rossi/*Avvisi*, 19 (1941): 392 (Aug. 12, 1679) and 393 (Dec. 23, 1679 and Jan. 6, 1680). Citations of Bernini's works in Oliva's sermons: Kuhn, 230. Oliva's antitheatrical preaching: Taviani, 241–59; see also indexes to Oliva's published sermons under *commedie* and *teatri*. Oliva and Bernini's Paris trip: Domenico, 122–23; and Chantelou, June 2, f.43–44, e.10; and July 23, f.85; e.73–74. "Nobility of the [artistic] idea": Chantelou, July 30, f.98, e. 92. "In discussing spiritual matters": Domenico, 171.

14. Pallavicino's friendship with Bernini (including portrait and "Truly has very few friends"): Mormando, 2011, 308n15. "Was a man fit to become pope": Chantelou, Sept. 7, f.164, e.176. Kircher and Four Rivers Fountain: Fehrenbach, 99–139; Rowland, 2000, 89, and 2005, 154–56 (whence "sexual edge" and "universal seminal power"). Bernini's frontispiece for Zucchi: *Regista*, cat. 171. Special lens found in Cornaro Chapel and its connection to Zucchi's work: Napoleone, 181–82.

15. Bernini's piety: Domenico, 170–73. Incomplete state of Sant'Andrea chapels in 1707: Borsi, 2000, 354 (promise of funds from G. B. Pamphilj). Applause for Sant'Andrea at inauguration: Rossi/*Avvisi*, 18 (1940): 95 (Nov. 22 1670). "It was this same church": Domenico, 108–9. Domenico's entrance into Jesuit novitiate (departing most likely summer 1673): Mormando, 2011, 4–6. Bernini's retreat after wife's death: Mormando, 2011, 255n78.

16. Bernini's work at Sant'Agnese in Agone: Preimesberger. Borromini's final days: Raspe.

CHAPTER FIVE

1. Bernini's work for Louis XIV, his trip to Paris and its aftermath: Domenico, 115–53 (and all related commentary in Mormando, 2011); Baldinucci, 111–27; and Chantelou's diary. "I don't know what game it is": Mormando, 2011, 347n3.

Cardinal Antonio's delivery of the gift for Louis XIV's newborn: Wolfe, 2008, 124. "Had been made for Rome": Domenico, 71. "It took nothing less than a war": Domenico, 116. London clash-of-coaches: Roosen, 463. Corsican Guard affair and consequences: Mormando, 2011, 374–75nn4–7. Mattia's collaboration on pyramid design: Mormando, 2011, 374–75n6. "At the peace negotiations, it was secretly": Domenico, 116. Alexander's letter granting Bernini's services to Louis XIV: Domenico, 123; its correct date: Mormando, 2011, 379n25. Pallavicino's letter regarding the concession by Alexander: Mormando, 2011, 379n24, whence the quotation, "We beg you with great insistence."

2. Bernini somehow was involved in this diplomatic affair: this observation comes from Morris, 135. "Signor Cavaliere, the exceptional": Domenico, 117. Bernini's preference for cash payment: Lavin, 1998, 70, doc. 7. Jeweled portrait of Louis: BALQ, 52, 115; its counterpart is in the Collezioni Comunali d'Arte, Palazzo d'Accursio, Bologna. "He considered himself the least": Mirot, 183n4, citing Elpidio Benedetti's letter to Colbert. Bernini's explosion of anger over Colbert's criticisms: Mormando, 2011, 377n14. July 1667 cancellation of the Louvre project: Mormando, 2011, 391n6. Colbert's jealousy of Bernini: Domenico, 138 ("some jealous minister").

3. Mont Cenis Pass and premodern Alpine crossings: Hyde, 1935a; 1935b, 55–57. Premodern beliefs and fears surrounding the Alps and mountains: Nicolson, 1–4, 17–19, 59–62, 159–61; and Schama, 1995, 411–42. Practical concerns (routes, money, lodgings, etc.) of artist travelers from France to Italy: Thuillier, 324–29. "Enter into the service of so great": Domenico, 141–42. "Even if an angel were to come down": Chantelou, June 2, f.43–44, e.10. Oliva's self-interest in encouraging Bernini to go to France: Baldinucci, i.116, e.49–50. D'Aviler's capture by pirates: Verdier, 55–56.

4. Bernini's kidney pain at Siena and lodgings at Bologna: Mirot, 198–200. Initial 30,000 livres sent to Bernini and the final cost to the French treasury of his trip to Paris: Wittkower, 1961, 517. "Seized away rather than": Domenico, 124. Interpreter Barbaret: Perrault, 76n66. Departure date from Rome: Mormando, 2011, 379n1. "Would lose him completely": Domenico, 124. Bernini's praise of Giambologna's *Sabines*: Baldinucci, 1974–75, 2:553; his enthusiasm for Salimbeni: Mormando, 2011, 380n4. Bernini's reception in Florence: Montanari, 2001. "It was as if an elephant": Domenico, 125; elephants in Rome: Gigli, 191 and 747. Bernini's arrival at and reception in Lyon: Mirot, 202–3. "This is a completely extraordinary": Chantelou, prologue, f.41, e.4. Cosimo masquerading as Bernini: Domenico, 126.

5. Sources of data on Bernini's first day in Paris: Mormando, 2011, 382n15; his two residences in Paris: Mormando, 2011, 383–84n22. "The Cavaliere repeated some reflections": Chantelou, Aug. 18, f. 126, e.128.

6. "Jean-Baptiste Colbert enjoyed" and "businesslike-to-a-fault": Trout, 19 and 20. Bernini as "monster of genius": Domenico, 19. Colbert's greeting of Bernini while the artist was still in bed: Chantelou, June 3, f.44, e.11. "Unable to endure the delay": Domenico, 127; same scene in Mattia's letter: Chantelou, f.384–85 (whence the quotation, "Signor Cavaliere always knows how to give . . ."). "Although he lived among us": Mancini, 30. Chantelou on first meeting between Bernini and Louis: June 4, f.44–45, e.12–13. "He had heard on all sides": Chantelou, June 2, f.43, e.9.

7. Mutual disdain between Louis and Bernini: Zarucchi. Mattia's letter (Sept. 11) describing Louis's behavior toward Bernini: Chantelou, appendix, f.395. "The leading knights": Domenico, 129–30. Bernini's doubts that he could "adequately live up to the exalted image" and his fears about court jealousy: Domenico, 126–27 and 130. "Speak to me of nothing small": Chantelou, June 4, f.45, e.12. "He was slightly below average height": Perrault, 62. "Bernini is a man of medium height": Chantelou, June 6, f.46, e.14.

8. See Chantelou for the following: Mattia's June 26 letter regarding Louis's gracious request, appendix, f.387; clay order, June 11, f.56, e.29; Michelangelo's refusal to do portraits, Aug. 12, f.116, e.115; "In this kind of head one must bring out," July 29, f.96, e.89; "A freshly shaven appearance lasts only two or three," Sept. 11, f.174, e.189–90; Jean Warin's portrait of Louis, Oct. 8, f.238, e.273; and last-minute carving of forehead curl, July 22, f.82, e.69 and July 29, f.95, e.88. "The cutting of this curl": Wittkower, 1951, 13.

9. "And is it possible, Signor Cavaliere": Domenico, 131. Bernini's attempt to evade the Val-de-Grâce altar commission: Domenico, 131; cf. Chantelou, June 25, f.63, e.41. "Brought no ordinary consolation": Domenico, 131–32; but Chantelou, July 8, f.72, e.55, alludes to her dissatisfaction. "His evenings here were melancholy": Chantelou, July 23, f.86, e.75. Caterina's sickness: Chantelou, Sept. 14, f.180, e.197; Sept. 20, f.194, e.216; and Sept. 21, f.196, e.217. Bernini's aversion to criticizing other artists: Domenico, 31.

10. "It did not take the King long": Perrault, 62. "Because he [the king] had understood": Fraschetti, 341n1. Chantelou for the following: "Then the King said of Bernini," Sept. 3, f.153, e.164; Colbert's satisfaction at hearing of Bernini's praise, July 29, f.95, e.88–89; "Yes, this is true but"; July 15, f.77, e.62; Bernini's criticism of Paris, Aug. 2, f.102, e.98; his criticism of French painting and style, Sept. 13, f.177, e.192, and Sept. 11, f.175, e.190; Bernini on Louis's lack of education, Aug. 2, f.101, e.96, and Sept. 6, f.159, e.171; "Designed to the taste of the ladies," Aug. 23, f.136, e.141; dissemination of that remark at court, Sept. 3, f.154, e.164; and diplomatic rebuke of Bernini, Sept. 4, f.154, e.164–65.

11. "Borromini had strayed so far": Domenico, 32. "One of the most momentous": Tinniswood, 125–26. "Bernini's design of the Louvre I would have": Tinniswood, 129. Chantelou for the following: "On leaving we went," June 20, f.61,

e.38; Bernini's evening prayer and devotional reading, Oct. 7, f.234, e.267; discussion of devotional matters and sermons, Sept. 19, f.190–91, e.211–12; diarrhea and near-fainting spell, June 12, f.56, e.29; Aug. 26, f.143, e.151; inflamed tongue, Aug. 7 and 9, f.109, e.106; eyeglasses, Aug. 2, f.103, e.99 and Aug. 14, f.119, e.119; eating of the sweets, Oct. 20, f.279, e. 323; "He said that he disliked eating," Aug. 1, f.101, e.96; Mattia's letter (June 19) on kitchen guard, appendix, f.386.

12. "As soon as we were alone": Chantelou, Oct. 18, f.268–69, e.311. "It is necessary to pay": Clément, 5:253. Bernini's final unpleasant encounter with Colbert: Chantelou, Oct. 18, f.266–70, e.308–13. Interaction between Bernini and Colbert as witnessed by Perrault: Perrault, 66–67, whence all quotations. "The myth of dynastic kingship": Jeanne Morgan Zarucchi, in Perrault, 8. "The Cavaliere, who had heard me ask": Perrault, 70–71; same episode in Chantelou (and aftermath): Oct. 6, f.229–30, e.261–62, and Oct. 7, f.230, e.267. "He always answered me by saying": Perrault, 79. Bernini's tears and Louis's kind response: Chantelou, Oct. 5, f.224, e.254.

13. Chantelou letter sent to Lyon and Bernini's response: Chantelou, f.284–86, e.329–31; Domenico, 145–46. Origins of rumor about Bernini's dissatisfaction with gifts: Chantelou, Oct. 22, f.283, e.328; Nov. 8, f.289, e. 332; Nov. 30, f.290, e.333. Oliva's letter to de Lionne: Domenico, 144. "I can affirm that my labors": Domenico, 146; Alexander's knowledge of that remark: Mormando, 2011, 394n22. Cost of marble for *Louis XIV Equestrian*: Wittkower, 1961, 521, doc. 20. Louvois's 1683 letter to Bernini sons; negative response in France to the *Louis XIV Equestrian* and its subsequent recarving: Mormando, 2011, 398n8 and 399–400nn14 and 16. Genoese and Spanish kidnapping plans: Mormando, 2011, 400n15. "The equestrian statue of the king": Mormando, 2011, 399n14. "It was found to be so hateful": Perrault, 79.

CHAPTER SIX

1. "Seems to me to have become": Montanari, 2001, 123 and 129, doc. 25. "He would have it in mind": Chantelou, Oct. 20, f.279, e.323. Date of Bernini's return to Rome and first audience with pope: Mormando, 2011, 393n16 (also for Pietro Filippo Bernini's travel to Florence) and 393n17. Innocent XI's prohibition of *terzo braccio*: Pastor, 32:36. Bernini-Rospigliosi theatrical collaboration: Mormando, 2011, 402–3nn1–2. Astrological prediction reported by Venetian ambassador: Barozzi and Berchet, 329. "He owed all his reputation": Chantelou, July 23, f.86, e.75. Campanella's horoscope for Louis XIV: Mormando, 2007, 302. Orazio Morandi: Dooley (47 for Bernini's book borrowing); and Gigli, 195, 198. Several of Pietro Filippo's astrological charts can be found throughout the collection of the Bernini family papers bound together as Ms. italien 2084, Bibliothèque nationale, Paris.

2. Bernini's friendship with Azzolino and Ottoboni: Domenico, 99. Stoning of Bernini's home: Rossi/*Avvisi*, 18 (1940): 26. "House scorning": Mormando, 2011, 254n70, citing the work of Elizabeth Cohen. Rumored 60,000 scudi spent and inaccuracy of that figure: Anselmi, 38. Rospigliosi family's resentment: Rossi/ *Avvisi*, 17 (1939): 510 (Sept. 14, 1669). Bernini as "sleazy operator" and pope's "incandescent anger": Rossi/*Avvisi*, 17 (1939): 511 (Nov. 2, 1669). Unpleasant meeting between Bernini and Cardinals Rospigliosi and Barberini: Rossi/ *Avvisi*, 17 (1939): 11 (Dec. 21, 1669). Clement IX's broken heart over Candia: Domenico, 162–63. "Exquisite standard": Domenico, 162; its description: Pastor, 31:424. Duke of Beaufort's character and Colbert's attitude toward him: Murat, 172–77. Elevation of Bouillon to cardinalate: Domenico, 162. Friendship between Bouillon, Abbé de Choisy, and Duke of Orléans: Cruysse, 50–55, 65, and, for the quotation, 70. Saint-Simon on Bouillon: Saint-Simon, 4:635–42.

3. Clement's mourning over Beaufort: Roberto, 83. Bernini's firing by Clement X and "state of despair": Roberto, 331 (two *avvisi* of Aug. 23, 1670). Cost of Rainaldi's and Bernini's work on Santa Maria Maggiore tribune: Anselmi, 38. "The one who instigates popes": Roberto, 330 (Aug. 2, 1670). Report about Bernini's suicidal state, as per Christina's Sept. 10, 1667, letter: Fraschetti, 276. Equestrian portrait of Don Gasparo Altieri: Martinelli, 1959, 219. "Well, Cavalier Bernini, we do believe": Rossi/*Avvisi*, 18 (1940): 57 (Oct. 11, 1670).

4. Bernini's planned work to display "his incomparable *virtù*": Mormando, 2011, 406n21. "He had, for his personal devotion": Domenico, 170–71. Maria Maddalena de' Pazzi's curative practices: Morrison. Bernini's medal in her honor: Fagiolo dell'Arco, 1997, 470.

5. Negative reviews of the *Constantine*: Mormando, 2011, 254n71 and 363n18. "Truly out of charity": Bauer, 53. "Without reflecting upon the Civil Laws": Martinelli, 1959, 207, *avviso* dated Dec. 20, 1670. Unless otherwise indicated, all data relating to Luigi's crime and its aftermath can be found in Martinelli, 1959, still the most complete account. Cardinal Rinaldo's knowledge of the case by Dec. 13: Jarrard, 2002, 416n46. Sodomy in Baroque Rome: Baldassari; and Cavaillé, 207–10. "Regarding the aforementioned Luigi": Martinelli, 1959, 209. Jérôme Duquesnoy's crime: Wittkower and Wittkower, 175.

6. "The Queen forcefully persuaded" and "Queen of Sweden went to see": Martinelli, 1959, 210 and 211. Christina mentions her intentions of visiting the victim's godfather-cardinal in a letter to Bernini: Morris, 150. "Don't you know that the sin": Leti, 118–19. Bernini's audiences with and uncompensated work for Clement X: Martinelli, 1959, 211–13. "There are not lacking those": Bauer, 49. Caterina Bernini's relationship with San Francesco a Ripa: Beltramme (283 for dictation of her will on premises).

7. Feb. 1675 theatrical performance at Bernini's home: Martinelli, 1959, 215. Pietro Filippo's appointment to Water Congregation: Domenico, 164; sarcasm directed against that appointment: Fraschetti, 396–97 (Modena dispatch). Bernini's papal aspirations for son: Chantelou, Sept. 7, f.164, e.176. "That dragon custodian": Passeri, 242–43 ("Vita di Abbatini"). "Had been made for Rome": Domenico, 71. Bernini's exploitation of Abbatini and his other students: Passeri, 243. "Rather stern by nature": Domenico, 176.

8. *"Pittori berniniani"*: Mormando, 2011, 370n10, citing Francesco Petrucci. Bernini, Gaulli, and Oliva: Mormando, 2011, 248n14. Bernini as godfather to Gaulli's child: Fagiolo dell'Arco, 2001, 254. For "godparenthood as an instrument of social alliance" in Italy: Alfani. "Some Florentine by the name of Bacicci" and "not much esteemed young painter": Rossi/*Avvisi*, 19 (1941): 30. "All of them concluded": Rossi/*Avvisi*, 19 (1941): 392. "But what else could she do" and "As far as the painting in itself": Rossi/*Avvisi*, 19 (1941): 393. "Brought derision to Cavalier Bernini": Rossi/*Avvisi*, 18 (1940): 237–38. Bernini's July 1672 illness: Clément 5:332n1. Caterina Bernini's death certificate: Fagiolo dell'Arco, 2001, 363. Bernini's retreat after his wife's death: see Chap. 2n17 above. Bernini's Aug. 1673 illness: Gould, 1982, 126. Domenico's absence from home as per annual census: Fagiolo dell'Arco, 2001, 347–49; his absence from Rome at time of father's death: BALQ, 58 ("et ab Urbe absentis").

9. Editorial history of Baldinucci's 1682 biography: Mormando, 2011, 16–21. "A certain abbé and dear friend": Mormando, 2011, 24–25. Texts of Cureau de La Chambre's "Préface pour servir" and "Éloge": Montanari, 1999. "What was reproached in him by his enemies": Montanari, 1999, 116–17. Mail delivery time between Paris and Rome: Montanari, 2001, 124, doc. 3. "I wish to make it clear": Baldinucci, i.184–85, e.110–11. La Chambre as Baldinucci's target: Mormando, 2011, 27.

10. "Success of complete perfection": Rossi/*Avvisi*, 18 (1940): 95. Bernini's satisfaction with Sant'Andrea: Domenico, 108–9. "It was a very familiar saying": Domenico, 158–59. "Bernini's Breezy Maniacs": Hare, 559. "Alexander VII once said": Mormando, 2011, 240. Bernini and the Galleria Colonna: Strunck, 185–226 (189 for his previous Colonna commissions). Bernini's plays of 1676 and 1677: Tamburini, 133–38. Bernini family ennoblement: Fraschetti, 106. Aristocratic marriages of Bernini's daughters: Domenico, 53. Dorotea's 1672 marriage: Fraschetti, 105. "My most dear and old friend": BALQ, 62–63. Bernini's domestic fountain: Fagiolo dell'Arco, 2001. Text of Bernini's recommendation for Chéron: *Regista*, cat. 13. Sale of Bernini portrait to the Medici: Petrucci, 317, whence all the details and quotations here cited. "The fact that Tacca babbled": Montanari, 2001, 117.

11. Modesty dress imposed on Bernini's *Truth*: Domenico, 167. Bernini's caricature of Innocent XI: Mormando, 2011, 410n1. Papal debt and near bankruptcy: *Enciclopedia dei Papi*, 3: 373–74. Reported secret loans to William of Orange: Monaldi and Sorti, "Innocent XI and William of Orange: Documents," 547–66. Fontana and de' Rossi dismissals: Rossi/*Avvisi*, 19 (1941): 254. "Letters and notes are full of ironic phrases": Stolpe, 320, also for Christina's admonishment. Christina/Innocent XI conflict: Buckley, 300–304; their clash over the theater: Montanari, 1998, 407. Innocent's suspension of Carnival: Pastor, 32:29–30. "The altar project would have kept": Rossi/*Avvisi*, 19 (1941): 161. "Present financial straits of this city": Rossi/*Avvisi*, 19 (1941): 349.

12. "In order to avoid scandals": Rossi/*Avvisi*, 19 (1941): 161. Further *avvisi* regarding Innocent's campaign against nudity and female immodesty: Rossi/*Avvisi*, 19 (1941): 535–37; Pastor, 32:27–29. Reni's *Madonna* cover-up: Pastor, 32:27. "Lewd paintings that are in the ground-floor": Rossi/*Avvisi*, 19 (1941): 308. Bernini's De Sylva Chapel with photographs before and after restoration: Negro. Bernini's *Savior* bust as related to Lateran hospice project: Lavin, 2000, 237–41. "Approaching the time of his death": Domenico, 167. "The idea that both religious conviction": Soussloff, 118. *Savior* bust in general, including the question of attribution: Mormando, 2011, 411–12n5.

13. Renewal of the cracks-in-the-cupola charges against Bernini: Domenico, 167–68. Paglia's career: Forte. "It would have to be during Our reign": Forte, 375. Connection between Bernini's exoneration and his stroke immediately thereafter: Marder, 2008, 434 (432 for concluding date of committee's investigation). Cartari diary entry: Lavin, 1972, 157n1.

14. Deterioration of the palace: Domenico, 169. 1680 *avviso* blaming Francesco Barberini: Rossi/*Avvisi*, 19 (1941): 492. Pope's May 1680 renovation order: Schiavo, 11n2. Baldinucci's account of the project: Baldinucci, i.155–75, e.89–108. Cancelleria project as vindication of Bernini: Morris, 222. Bernini's final illness and death: Domenico, chap. 23; Baldinucci, i.136–37; e.69–70. "Our true worth and our blessedness": Stolpe, 276. Mormando, 2011, 418n13, for sources of the following: Translation of Rospigliosi's libretto by Brian Trowell; "I supplicate all the saints" (Caterina Bernini); "Demonic temptations in the hour" (Stefano Pepe). "Anticipating that": Domenico, 173.

15. "Cardinal Azzolino honored the Cavaliere": Domenico, 174–75. Mocking of Bernini's appeal to Christina: Fraschetti, 423. Christina's faith in later years: Stolpe, 274. Bernini's doctors and medical treatment: Borsi, 2000, 34. Bernini's death, wake, and funeral: Domenico, 176–77; Mormando, 2011, 421n28. Time-reckoning in premodern Italy: Colzi. "I leave up to my aforementioned": BALQ, 60. Pietro Filippo's funeral: Antonazzi, 47n33. Free candle distribution at Roman funerals: Mormando, 2011, 421n28. "Universal was the mourning": Domenico,

176. Malicious *avvisi* following Bernini's death: Martinelli, 1959, 225–26, whence quotation "Cavalier Bernini has bequeathed."

16. "Estate adds up to six hundred thousand" and "above three hundred thousand": Lavin, 1972, 157n1. "The following day, taking advantage": Domenico, 176. Annual dowry for impoverished maiden: BALQ, 61. Texts of 1681 and 1731 Bernini household inventories: Martinelli, 1996, respectively 253–60 (254 for scant contents of Bernini's study) and 160–70; 1706 inventory: BALQ, 103–44. Mormando, 2011, 421n29 for Bernini crypt inscription and excavations; Gimignani's drawing for Bernini tomb; and St. Petersburg portrait bust.

WORKS CITED

Listed below are only those works explicitly cited in this volume. Ample bibliography and further documented information on Bernini's life, works, patrons, and collaborators can be found in Mormando, 2011.

Accetto, Torquato. 1983. *Della dissimulazione onesta*. Genoa: Costa and Nolan.

Ademollo, Alessandro. 1883. *Il carnevale di Roma nei secoli XVII e XVIII*. Rome.

Ago, Renata. 1997. "Young People in the Age of Absolutism." In *A History of Young People in the West*, vol. 1, *Ancient and Medieval Rites of Passage*, edited by Giovanni Levi and Jean-Claude Schmitt, 283–322, 377–82. Cambridge: Harvard University Press.

Åkerman, Susanna. 1991. *Queen Christina of Sweden and Her Circle*. Leiden: E. J. Brill.

Aldrete, Gregory S. 2007. *Floods of the Tiber in Ancient Rome*. Baltimore: Johns Hopkins University Press.

Alfani, Guido. 2009. *Fathers and Godfathers*. Aldershot: Ashgate.

Aloisi, Sabrina. 1998. *La cappella di Santa Barbara nel Duomo di Rieti*. Rieti: Editrice Massimo Rinaldi.

Anselmi, Alessandra. 2001. "I progetti di Bernini e Rainaldi per l'abside di Santa Maria Maggiore." *Bollettino d'arte* 86, no. 117: 27–78.

Antonazzi, Giovanni. 1979. *Il Palazzo di Propaganda*. Rome: De Luca.

Astarita, Tommaso. 2005. *Between Salt Water and Holy Water: A History of Southern Italy*. New York: Norton.

Bacchi, Andrea. 2009. "'Veramente è vivo e spira': Bernini e il ritratto," In *I marmi vivi: Bernini e la nascita del ritratto barocco*, edited by Andrea Bacchi,

Tomaso Montanari, Beatrice Paolozzi Strozzi, and Dimitrios Zikos, 21–69. Florence: Giunti.

Bailey, Gauvin A. 2003. *Between Renaissance and Baroque: Jesuit Art in Rome, 1565–1610.* Toronto: University of Toronto Press.

Baldassari, Marina. 2005. *Bande giovanili e "vizio nefando": Violenza e sessualità nella Roma barocca.* Roma: Viella.

Baldinucci, Filippo. 1948. *Vita di Gian Lorenzo Bernini.* Ed. Sergio Samek Ludovici. Milan: Edizioni del Milione.

———. 1996/2006. *The Life of Bernini.* Translated by Catherine Enggass. University Park: Pennsylvania State University Press; reprinted 2006, with a new introduction by Maarten Delbeke, Evonne Levy, and Steven F. Ostrow.

———. 1974–75. *Notizie dei professori del disegno da Cimabue in qua.* 7 vols. Edited and supplemented by Ferdinando Ranalli. Facsimile reprint of Florence 1845–47 edition with two volumes of appendixes edited by Paola Barocchi. Florence: SPES.

Barcham, William. 1993. "Some New Documents on Federico Cornaro's Two Chapels in Rome." *Burlington* 135: 821–22.

Barker, Sheila. 2006. "Art, Architecture and the Roman Plague of 1656–57." *Roma moderna e contemporanea* 14: 243–62.

Barozzi, Nicolò, and Guglielmo Berchet. 1878. *Le relazioni degli stati europei lette al Senato dagli ambasciatori veneti nel secolo decimosettimo.* Ser. 3, *Italia. Relazioni di Roma*, vol. 2. Venice.

Bauer, George C., ed. 1976. *Bernini in Perspective.* Englewood Cliffs: Prentice-Hall.

Bayer, Andrea, ed. 2008. *Art and Love in Renaissance Italy.* New Haven: Yale University Press.

Beecher, Donald. 1984. "Gianlorenzo Bernini's 'The Impresario': The Artist as the Supreme Trickster." *University of Toronto Quarterly* 53, no. 3: 236–47.

Beecher, Donald, and Massimo Ciavolella. 1985. "A Comedy by Bernini." In *Gianlorenzo Bernini: New Aspects of His Art and Thought*, edited by Irving Lavin, 63–114. University Park: Pennsylvania State University Press and College Art Association.

Beggiao, Diego. 1978. *La visita pastorale di Clemente VIII.* Rome: Pontificia Università Lateranense.

Beltramme, Marcello. 2003. "Tracce per una biografia morale dell'ultimo Bernini." *Studi romani* 51: 280–300.

Benocci, Carla. 2006. *Paolo Giordano II Orsini.* Rome: De Luca.

Bernini, Domenico. 1713. *Vita del Cavalier Gio. Lorenzo Bernino.* Rome: Rocco Bernabò. (For English translation, see Mormando, 2011.)

Bernini, Gian Lorenzo. *The Impresario: see* Beecher and Ciavolella.

Bernstock, Judith. 1988. "Bernini's Tomb of Alexander VII." *Saggi e memorie di storia dell'arte* 16: 167–90; 363–73.

Bertolotti, Antonino. 1887. "La schiavitù a Roma." *Rivista di discipline carcerarie* 17: 3–42.

Boisclair, Marie-Nicole. 1986. *Gaspard Dughet*. Paris: Arthéna.

Bonanni, Filippo. 1707–12. *Ordinum religiosorum in ecclesia militanti*. Rome.

Bonini, Filippo Maria. 1665. *L'ateista convinto dalle sole ragioni*. Venice.

Borromeo, Federico. 2010. *Sacred Painting; Museum*. Edited and translated by Kenneth S. Rothwell. Introduction and Notes by Pamela M. Jones. Cambridge: Harvard University Press.

Borsi, Franco. 1986. *Bernini*. Rome: Newton Compton Editori.

———. 2000. *Bernini architetto*. Milan: Electa.

Borsi, Franco, Cristina Acidini Luchinat, and Francesco Quinterio, eds. 1981. *Gian Lorenzo Bernini: Il testamento, la casa, la raccolta dei beni*. Florence: Alinea Editrice.

Briganti, Giuliano, ed. 1964. *Catalogo e stima dei dipinti e delle sculture di proprietà della famiglia Forti e provenienti dalla successione di Casa Giocondi erede di Gian Lorenzo Bernini, Feb. 20, 1964*. Rome: n.p.

Buckley, Veronica. 2004. *Christina, Queen of Sweden*. London: Fourth Estate.

Burbaum, Sabine. 1999. *Die Rivalität zwischen Francesco Borromini und Gianlorenzo Bernini*. Oberhausen: Athena.

Butterfield, Andrew, ed. 2002. *Bernini: The Modello for the Fountain of the Moor*. New York: Salander-O'Reilly.

Carboni, Mauro. 2009. "Public Debt, Guarantees and Local Elites in the Papal States." *Journal of European Economic History* 38: 149–74.

Cardella, Lorenzo. 1792–97. *Memorie storiche de' cardinali della Santa Romana Chiesa*. Rome.

Carletta, A. 1898. "La moglie di Bernini." *Don Chisciotte di Roma* 6, no. 319 (Nov. 20): 1–2.

Cavaillé, Jean-Pierre. 2010. "Jean-Jacques Bouchard, ou les tribulations d'un parisien à Rome (1631–1641)." In *Rome-Paris, 1640*, edited by Marc Bayard, 199–228. Rome: Académie de France à Rome; Paris: Somogy éditions d'art.

Cecchini, Domenico. n.d. *Vita del Cardinale Cecchino scritta da lui medesimo*. Strozzi Ms. Collection, Ms. W.b.132 (175), #5 [1650s], Folger Shakespeare Library, Washington, DC.

Cerasoli, Francesco. 1891. "Censimento della popolazione di Roma dall'anno 1600 al 1739." *Studi e documenti di storia e diritto* 12: 169–99.

Chantelou, Paul Fréart de. 1985. *Diary of the Cavaliere Bernini's Visit to France*. Introduction by Anthony Blunt; annotated by George C. Bauer; translated by Margery Corbett. Princeton: Princeton University Press.

—————. 2001. *Journal de voyage du Cavalier Bernin en France*. Ed. Milovan Stanić. Paris: Macula, L'insulaire.

Ciampi, Ignazio. 1878. *Innocenzo X Pamfili e la sua corte*. Roma.

Clément, Pierre, ed. 1865. *Lettres, instructions et mémoires de Colbert*. Paris.

Clementi, Filippo. 1939. *Il carnevale romano nelle cronache contemporanee*. Pt. 1. *Dalle origini al secolo XVII*. Città di Castello: Edizioni RORE–NIRUF.

Cohen, Elizabeth S., and Thomas V. Cohen. 2001. *Daily Life in Renaissance Italy*. Westport: Greenwood Press.

Cole, Michael. 2007. "Bernini Struts." In *Material Identities*, edited by Joanna Sofaer, 55–66. Oxford: Blackwell.

Coliva, Anna. 1998. "Casa Borghese: La committenza artistica del Cardinal Scipione." In *Bernini scultore: La nascita del barocco in casa Borghese*, edited by Anna Coliva and Sebastian Schütze, 389–420. Rome: De Luca.

Collins, Jeffrey. 2004. *Papacy and Politics in Eighteenth-Century Rome*. New York: Cambridge University Press.

—————. 2006. "Power and Art at Casino Borghese: Scipione, Gian Lorenzo, Maffeo." In *La imagen política*, edited by Cuauhtémoc Medina. Mexico City: Universidad Nacional Autónoma de México, Instituto de Investigaciones Estéticas.

Colzi, Roberto. 1995. "Che ora era? Raffronto tra le ore all'italiana e alla francese a Roma." *Studi romani* 43: 93–102.

Conforti, Claudia. 1999. "Roma in Modena, Modena in Roma." In *Modena 1598*, edited by Claudia Conforti et al., 55–79. Milan: Electa.

Connors, Joseph. 1982. "Bernini's S. Andrea al Quirinale: Payments and Planning." *Journal of the Society of Architectural Historians* 41: 15–37.

—————. 2000. "Francesco Borromini: La vita 1599–1667." In *Borromini e l'universo barocco*, edited by Richard Bösel and Christoph L. Frommel, 7–21. Milan: Electa.

Connors, Joseph, and Louise Rice, eds. 1990. *Specchio di Roma barocca*. Rome: Edizioni dell'Elefante.

Coville, Henry. 1914. *Étude sur Mazarin et ses démêlés avec le pape Innocent X*. Paris.

Croce, Benedetto. 2006. *Un paradiso abitato da diavoli*. Milan: Adelphi.

Cruysse, Dirk van der. 1995. *L'abbé de Choisy: Androgyne et mandarin*. Paris: Fayard.

D'Onofrio, Cesare. 1967. *Roma vista da Roma*. Rome: Edizioni Liber.

—————. 1969. *Roma nel Seicento*. Florence: Vallecchi.

—————. 1976. *Roma val bene un'abiura*. Rome: Palombi.

—————. 1986. *Le fontane di Roma*. 3rd ed. Rome: Romana Società Editrice.

Dall'Orto, Giovanni. 1997. "Il trionfo di Sodoma: Poesie erotiche inedite dei secoli XVI–XVII." *La fenice di Babilonia* 2: 37–69.

———. 2001. "Borghese, Scipione Caffarelli." In *Who's Who in Gay and Lesbian History*, edited by Robert Aldrich and Garry Wotherspoon, 60–61. London: Routledge.

De Paola, Francesco. 1984. *Il carteggio del napoletano Jacopo Antonio Marta con la corte d'Inghilterra*. Lecce: Milella.

dell'Arco, Mario. 1957. *Pasquino e le pasquinate*. Milan: Aldo Martello.

Del Panta, Antonella. 1993. "Genealogia di Gian Lorenzo Bernini." *Palladio* 6, no. 11: 111–18.

del Pesco, Daniela. 1988. *Colonnato di San Pietro*. Rome: II Università degli Studi di Roma.

Dooley, Brendan. 2002. *Morandi's Last Prophecy and the End of Renaissance Politics*. Princeton: Princeton University Press.

Dusmet Lante della Rovere, Maria. 1967. *Cronache inedite di Roma barocca*. Rome: Palombi.

Enciclopedia dei Papi. 2000. Rome: Istituto della Enciclopedia Italiana.

Evelyn, John. 1827. *Memoirs*. London.

Faber, Martin. 2005. *Scipione Borghese als Kardinalprotektor*. Mainz: Zabern.

Fagiolo dell'Arco, Maurizio. 1997. *La festa barocca*. Rome: De Luca.

———. 2001. *L'immagine al potere: Vita di Giovan Lorenzo Bernini*. Rome: Laterza.

———. 2002. *Berniniana*. Milan: Skira.

Fagiolo dell'Arco, Maurizio, and Marcello Fagiolo. 1967. *Bernini*. Rome: Bulzoni.

Feldkamp, Michael F. 1993. "Das Breve 'Zelo domus Dei.'" *Archivum historiae pontificiae* 31: 293–305.

Fehrenbach, Frank. 2008. *Compendia mundi: Gianlorenzo Berninis Fontana dei Quattro Fiumi (1648–51) und Nicola Salvis Fontana di Trevi (1732–62)*. Munich: Deutscher Kunstverlag.

Fiorani, Luigi. 1979. "Religione e povertà." *Ricerche per la storia religiosa di Roma* 3: 43–131.

———. 1980. "Le visite apostoliche del Cinque-Seicento." *Richerche per la storia religiosa di Roma* 4: 53–148.

Fornili, Carlo Cirillo. 1991. *Delinquenti e carcerati a Roma alla metà del '600*. Rome: Editrice Pontificia Università Gregoriana.

Forte, S. L. 1963. "Il domenicano Giuseppe Paglia architetto siciliano a Roma." *Archivum fratrum praedicatorum* 33: 281–409.

Forti, Augusto. 1980. "Ricordi del Bernini in casa Forti." *Strenna dei Romanisti* 41: 196–204.

Frangenberg, Thomas. 2002. "Giovanni Lotti on a Lost Work by Bernini." *Burl-ington* 144: 434–37.

Fraschetti, Stanislao. 1900. *Il Bernini*. Milan: Hoepli.

Gardiner, Eileen, ed. and trans. 1991. *Naples: An Early Guide*. New York: Italica.

Gian Lorenzo Bernini: Regista del Barocco. 1999. Ed. Maria Grazia Bernardini and Maurizio Fagiolo dell'Arco. Milan: Skira.

Gigli, Giacinto. 1994. *Diario di Roma*. Rome: Colombo.

Goethe, Johann Wolfgang von. 1970. *Italian Journey*. Translated by W. H. Auden and Elizabeth Meyer. London: Penguin.

Goulas, Nicolas. 1879–82. *Mémoires*. Paris.

Gould, Cecil. 1958. "Bernini's Bust of Mr. Baker." *Art Quarterly* 21: 167–76.

———. 1982. *Bernini in France*. Princeton: Princeton University Press.

Graziano, Frank. 2004. *Wounds of Love: The Mystical Marriage of Saint Rose of Lima*. Oxford: Oxford University Press.

Guarini, Battista. 1600. *Il segretario*. Venice.

Habel, Dorothy Metzger. 2002. *The Urban Development of Rome in the Age of Alexander VII*. Cambridge: Cambridge University Press.

Hammond, Frederick. 1994. *Music and Spectacle in Baroque Rome*. New Haven: Yale University Press.

Hare, Augustus J. C. 1890. *Walks in Rome*. 14th ed., rev. New York: Routledge.

Harper, James Gordon. 1998. "The Barberini Tapestries of the Life of Pope Urban VIII." PhD thesis, University of Pennsylvania.

Heiken, Grant, Renato Funicello, and Donatella De Rita. 2005. *The Seven Hills of Rome: A Geological Tour of the Eternal City*. Princeton: Princeton University Press.

Herman, Eleanor. 2008. *Mistress of the Vatican: The True Story of Olimpia Maidal-chini*. New York: William Morrow, Harper Collins.

Hibbard, Howard. 1965. *Bernini*. Harmondsworth: Penguin.

Hibbert, Christopher. 1985. *Rome: The Biography of a City*. Harmondsworth: Penguin.

Hill, Michael. 1998. "Cardinal Dying: Bernini's Bust of Scipione Borghese." *Australian Journal of Art* 14: 9–24.

———. 2001. "The Patronage of a Disenfranchised Nephew: Cardinal Scipione Borghese and the Restoration of San Crisogono in Rome, 1618–1628." *Journal of the Society of Architectural Historians* 60: 432–49.

Hyde, Walter Woodburn. 1935a. "The Alps in History." *Proceedings of the American Philosophical Society* 75: 431–42.

———. 1935b. *Roman Alpine Routes*. Philadelphia: American Philosophical Society.

Infelise, Mario. 2002. "Roman *avvisi*: Information and Politics in the Seven-teenth Century." In *Court and Politics in Papal Rome*, edited by Gianvittorio

Signorotto and Maria Antonietta Visceglia, 212–28. Cambridge: Cambridge University Press.

Jarrard, Alice. 2002. "Inventing in Bernini's Shop in the Late 1660s." *Burlington* 144: 396–408.

———. 2003. *Architecture as Performance in Seventeenth-Century Europe*. Cambridge: Cambridge University Press.

Jedin, Hubert. 1967. *Crisis and Closure of the Council of Trent*. London: Sheed and Ward.

———. 1975. *Geschichte des Konzils von Trient. Band IV: Dritte Tagungsperiode und Abschluss. Zweiter Halbband: Überwindung der Krise durch Morone, Schliessung und Bestätigung*. Freiburg: Herder.

Kessler, Hans-Ulrich. 2005. *Pietro Bernini*. Munich: Hirmer.

Krautheimer, Richard. 1985. *The Rome of Alexander VII*. Princeton: Princeton University Press.

Kuhn, Rudolf. 1969. "Gian Paolo Oliva und Gian Lorenzo Bernini." *Römische Quartalschrift für Christliche Altertumskunde und Kirchengeschichte* 64: 229–33.

Lansford, Tyler. 2009. *The Latin Inscriptions of Rome*. Baltimore: Johns Hopkins University Press.

Lavin, Irving. 1968a. "Five New Youthful Sculptures by Gianlorenzo Bernini." *Art Bulletin* 50: 223–48.

———. 1968b. *Bernini and the Crossing of Saint Peter's*. New York: New York University Press.

———. 1972. "Bernini's Death." *Art Bulletin* 54: 158–86.

———, ed. 1981. *Drawings by Gianlorenzo Bernini from the Museum der Bildenden Kunste Leipzig*. Princeton: Art Musuem, Princeton University.

———. 1998. *Bernini e l'immagine del principe cristiano ideale*. Modena: Panini.

———. 2000. "Bernini's Bust of the Savior and the Problem of the Homeless." *Italian Quarterly* 37, nos. 143–46: 209–51.

Leti, Gregorio. 2004. *Il puttanismo romano*. Ed. Emanuela Bufacchi. Rome: Salerno.

Liebreich, Karen. 2004. *Fallen Order: Intrigue, Heresy, and Scandal in the Rome of Galileo and Caravaggio*. New York: Grove Press.

Livi Bacci, Massimo. 2000. *The Population of Europe: A History*. Oxford: Blackwell.

Loskoutoff, Yvan. 2006. "Portait du cardinal Antoine Barberini d'après les lettres inédites du père Duneau." In *Papes, princes et savants dans l'Europe moderne*, edited by Jean-Louis Quantin and Jean-Claude Waquest, 172–90. Geneva: Droz.

Lupis, Antonio. 1686. *La valige smarrita*. Venice.

Magnuson, Torgil. 1982–1986. *Rome in the Age of Bernini*. Atlantic Highlands, NJ: Humanities Press.

Mancini, Hortense, and Marie Mancini. 2008. *Memoirs*. Edited and translated by
Sarah Nelson. Chicago: University of Chicago Press.

Marder, Tod. 1998. *Bernini and the Art of Architecture*. New York: Abbeville Press.

———. 2008. "A Finger Bath in Rosewater: Cracks in Bernini's Reputation."
In *Sankt Peter in Rom, 1506–2006*, edited by Georg Satzinger and Sebastian
Schütze, 427–34. Munich: Hirmer.

Marmi vivi: Bernini e la nascita del ritratto barocco. 2009. Ed. Andrea Bacchi,
Tomaso Montanari, Beatrice Paolozzi Strozzi, and Dimitrios Zikos. Florence:
Giunti.

Martinelli, Valentino. 1959. "Novità berniniane, 3: Le sculture per gli Altieri."
Commentari 10: 204–26.

———, ed. 1996. *L'ultimo Bernini, 1665–1680*. Rome: Edizioni Quasar.

Mascardi, Agostino. 1635. *Prose vulgari*. Venice.

Maxwell, John F. 1975. *Slavery and the Catholic Church*. London: Barry Rose.

McPhee, Sarah. 2006. "Costanza Bonarelli: Biography versus Archive." In
Bernini's Biographies: Critical Essays, edited by Maarten Delbeke, Evonne
Levy, and Steven F. Ostrow, 315–76. University Park: Pennsylvania State
University Press.

Mémoires de Monsieur le Cardinal Reynaud d'Este. 1677. Cologne.

Merz, Jörge M. 2008. *Pietro da Cortona and Roman Baroque Architecture*. New
Haven: Yale University Press.

Milton, John. 2004. *Areopagitica and Other Prose Works*. Whitefish, MT: Kes-
singer.

Mirot, Léon. 1904. "Le Bernin en France." *Mémoires de la Société de l'histoire de
Paris et de l'Ile-de-France* 31: 161–288.

Monaldi, Rita, and Francesco Sorti. 2008. *Imprimatur*. Translated from the Italian
by Peter Burnett. Edinburgh: Polygon.

Montagu, Jennifer. 1989. *Roman Baroque Sculpture*. New Haven: Yale University
Press.

Montanari, Tomaso. 1997. "Gian Lorenzo Bernini e Sforza Pallavicino." *Prospet-
tiva* 87–88: 42–68.

———. 1998. "Bernini e Cristina di Svezia." In *Gian Lorenzo Bernini e i Chigi*, ed-
ited by Alessandro Angelini, 331–425. Siena: Banca Monte dei Paschi di Siena.

———. 1999. "Pierre Cureau de La Chambre e la prima biografia di Gian
Lorenzo Bernini." *Paragone/Arte* 50, no. 24–25: 103–32.

———. 2001. "Bernini in Francia, visto da Firenze." *Franco Italica* 19–20:
105–33.

———. 2007. *Bernini pittore*. Cinisello Balsamo: Silvana Editoriale.

Morello, Giovanni. 1981. "Bernini e i lavori a S. Pietro nel 'diario' di Alessandro
VII." In *Bernini in Vaticano*, 321–40. Rome: De Luca.

Morello, Giovanni, Francesco Petrucci, and Claudio Strinati, eds. 2007. *La Passione di Cristo secondo Bernini*. Rome: Ugo Bozzi.

Mormando, Franco. 1999. "Teaching the Faithful to Fly: Mary Magdalene and Peter in Baroque Italy." In *Saints and Sinners: Caravaggio and the Baroque Image*, edited by Franco Mormando, 107–35. Chestnut Hill: McMullen Museum of Art.

———. 2005. "Response to the Plague in Early Modern Italy: What the Primary Sources, Printed and Painted, Reveal." In *Hope and Healing: Painting in Italy in a Time of Plague*, 1500–1800, edited by Gauvin Bailey et al., 1–44. Worcester: Worcester Art Museum.

———. 2007. "Pestilence, Apostasy, and Heresy in Seventeenth-Century Rome: Deciphering Michael Sweerts's *Plague in an Ancient City*." In *Piety and Plague: From Byzantium to the Baroque*, edited by Franco Mormando and Thomas Worcester, 237–312. Kirksville: Truman State University Press.

———. 2011. *Domenico Bernini: The Life of Gian Lorenzo Bernini*. Translation and Critical Edition, with Introduction and Commentary. University Park: Pennsylvania State University Press.

Morris, Kathleen M. 2005. "A Chronological and Comparative Study of Contemporary Sources on Gian Lorenzo Bernini." PhD thesis, University of Virginia.

Morrison, Molly. 2005. "Strange Miracles: A Study of the Peculiar Healings of St. Maria Maddalena de' Pazzi." *Logos: A Journal of Catholic Thought and Culture* 8, no. 1: 129–44.

Munoz, Antonio. 1954. "L'amante del Bernini sul monumento di Urbano VIII." *Strenna dei Romanisti* 15: 19–25.

Murat, Inès. 1984. *Colbert*. Charlottesville: University Press of Virginia.

Napoleone, Caterina. 1998. "Bernini e il cantiere della Cappella Cornaro." *Antologia di belle arti* 55–58: 172–86.

Negro, Angela. 2002. *Bernini e il "bel composto": La cappella de Sylva in Sant'Isidoro*. Rome: Campisano.

Neri, Achille. 1878. "Saggio della corrispondenza di Ferdinando Raggi agente della repubblica genovese a Roma." *Rivista europea* 9.5, fasc. 4: 657–95.

Nicolson, Marjorie Hope. 1959. *Mountain Gloom and Mountain Glory*. Ithaca: Cornell University Press.

Nussdorfer, Laurie. 1992. *Civic Politics in the Rome of Urban VIII*. Princeton: Princeton University Press.

Oliva, Giovanni Paolo. 1659. *Prediche dette nel Palazzo apostolico*. Vol. 1. Rome.

———. 1670. *Quaranta sermoni detti in varii luoghi sacri di Roma*. Rome.

———. 1677. *In selecta scripturae loca ethicae commentationes*. Vol. 1. Lyons.

———. 1712. *Sermoni domestici detti privatamente nelle Case Romane della Compagnia di Giesù*. Venice.

Olson, Todd P. 2002. *Poussin and France*. New Haven: Yale University Press.

Paita, Almo. 1998. *La vita quotidiana a Roma ai tempi di Gian Lorenzo Bernini*. Milan: Rizzoli.

Pallavicino, Sforza. 1837. *Descrizione del contagio*. Rome.

———. 1839–40. *Della vita di Alessandro VII: Libri cinque*. Prato.

Pascoli, Lione. 1730–36. *Vite de' pittori, scultori e l'architetti moderni*. Rome.

Passeri, Giovanni Battista. 1772. *Vite de' pittori, scultori ed architetti*. Rome.

Pastor, Ludwig von. 1937–40. *History of the Popes*. Vols. 25–32. St. Louis: Herder.

Pavone, Mario. 2004. "Un autoritratto del Bernini per Alessandro Siri." In *Per la storia dell'arte in Italia e in Europa*, edited by Mimma Pasculi Ferrara, 277–82. Rome: De Luca.

Pecchiai, Pio. 1959. *I Barberini*. Rome: Biblioteca d'arte Editrice.

Perrault, Charles. 1989. *Memoirs of My Life*. Edited and translated by Jeanne Morgan Zarucchi. Columbia: University of Missouri Press.

Perrini, Alberto. 2007. *Gian Lorenzo Bernini: La Verità discoperta dal Tempo*. Soveria Mannelli: Rubbettino.

Petros eni. Pietro è qui. 2006. Rome: Edindustria.

Petrucci, Francesco. 2006. *Bernini pittore*. Rome: Bozzi.

Piazza, Carlo Bartolomeo. 1679. *Opere pie di Roma*. Rome.

Piccolomini, Alessandro. 1575. *Della institutione morale*. Venice.

Pinto, John A. 1986. *The Trevi Fountain*. New Haven: Yale University Press.

Porter, Jeanne Chenault, ed. 2000. *Baroque Naples*. New York: Italica Press.

Preimesberger, Rudolf. 1970–72. "Bernini a S. Agnese in Agone." *Colloqui del Sodalizio tra studiosi dell'arte* 2: 44–55.

Raspe, Martin. 2001. "The Final Problem: Borromini's Failed Publication Project and His Suicide." *Annali di architettura* 13: 121–36.

Reinhardt, Volker. 1984. *Kardinal Scipione Borghese*. Tübingen: Niemeyer.

———. 1997. "Annona and Bread Supply in Rome." In *Rome, Amsterdam*, edited by Peter van Kessel and Elisja Schulte van Kessel, 209–20. Amsterdam: Amsterdam University Press.

Rendina, Claudio. 1991. *Pasquino: Statua parlante*. Rome: Newton Compton.

———. 2007. *Cardinali e cortigiane*. Rome: Newton Compton.

Rice, Louise. 1997. *The Altars and Altarpieces of New St. Peter's*. Cambridge: Cambridge University Press.

Rietbergen, Peter. 1983. "A Vision Come True: Pope Alexander VII, Gianlorenzo Bernini and the Colonnades of St. Peter's." *Mededelingen van het Nederlands Historisch Instituut te Rome* 44–45: 111–63.

———. 2006. *Power and Religion in Baroque Rome*. Leiden: Brill.

Rilke, Rainer Maria. 1939. *Duino Elegies*. Translated by James Leishman and Stephen Spender. New York: Norton.

Roberto, Sebastiano. 2004. *Gianlorenzo Bernini e Clemente IX Rospigliosi*. Rome: Gangemi.

Rodén, Marie-Louise. 2000. *Church Politics in Seventeenth-Century Rome*. Stockholm: Almqvist and Wiksell.

Roosen, William. 1980. "Early Modern Diplomatic Ceremonial." *Journal of Modern History* 52: 452–76.

Rossi, Ermete. 1936. "La fuga del Cardinale Antonio Barberini." *Archivio della Società Romana di storia patria* 59: 303–27.

Rowland, Ingrid D. 2000. *The Ecstatic Journey: Athanasius Kircher in Baroque Rome*. Chicago: University of Chicago Library.

———. 2005. "The Architecture of Love in Baroque Rome." In *Erotikon: Essays on Eros, Ancient and Modern*, edited by Shadi Bartsch and Thomas Bartscherer, 144–60. Chicago: University of Chicago Press.

Russo, M. Teresa. 1976. "Bernini e la Congregazione dell'Oratorio." *Strenna dei Romanisti* 37: 51–60.

Saint-Simon, Louis de Rouvroy, Duc de. 1947–66. *Mémoires*. Paris: Gallimard.

Santi, Bruno, ed. 1980–81. *Zibaldone baldinucciano: Scritti di Filippo Baldinucci ed altri*. Florence: SPES.

Schama, Simon. 1995. *Landscape and Memory*. New York: Knopf.

———. 2006. "Bernini: The Miracle Worker." In *The Power of Art*, 76–125. New York: Harper Collins.

Schiavo, Armando. 1964. *Il Palazzo della Cancelleria*. Rome: Staderini.

Schiavoni, Claudio. 1998. "Gli 'esposti' a Roma tra Cinquecento ed Ottocento." In *Popolazione e società a Roma*, edited by Eugenio Sonnino, 535–47. Rome: Il Calamo.

Segarra Lagunes, Maria. 2004. *Il Tevere e Roma*. Rome: Gangemi.

Sella, Domenico. 1997. *Italy in the Seventeenth Century*. London: Longman.

Selwyn, Jennifer D. 2004. *A Paradise Inhabited by Devils: The Jesuits' Civilizing Mission in Early Modern Naples*. London: Ashgate.

Sestieri, Ettore. 1970. *La Fontana dei Quattro Fiume e il suo bozzetto*. Rome: Palombi.

Signorotto, Gianvittorio. 2002. "The *squadrone volante*." In *Court and Politics in Papal Rome*, edited by Gianvittorio Signorotto and Maria Antonietta Visceglia, 177–211. Cambridge: Cambridge University Press.

Sincero racconto della vita del gran Pontefice Urbano VIII. 1890. In *Spicilegio vaticano di documenti inediti e rari estratti dagli archivi e della biblioteca della Sede Apostolica*, 1:333–75. Rome.

Snyder, Jon R. 2009. *Dissimulation and the Culture of Secrecy in Early Modern Europe*. Berkeley: University of California Press.

Sonnino, Eugenio. 1998. "Popolazioni e territori parrocchiali a Roma." In *Popolazione e società a Roma*, 93–111. Rome: Il Calamo.

————. 1999. "Roma, secolo XVII: Popolazione e famiglie nella 'città mas-
chile.'" In *La popolazione italiana nel Seicento*, 777–96. Bologna: CLUEB.

Soussloff, Catherine. 1987. "Old Age and Old-Age Style in the 'Lives' of Artists:
Gianlorenzo Bernini." *Art Journal* 46: 115–21.

Spada, Giovanni Battista. 2004. *Racconto delle cose più considerabili che sono occorse
nel governo di Roma*. Rome: Società Romana di Storia Patria.

Spear, Richard E. 2003. "Scrambling for *Scudi*: Notes on Painters' Earnings in
Early Baroque Rome." *Art Bulletin* 85: 310–20.

Stolpe, Sven. 1966. *Christina of Sweden*. New York: Macmillan.

Storey, Tessa. 2008. *Carnal Commerce in Counter-Reformation Rome*. Cambridge:
Cambridge University Press.

Strunck, Christina. 2007. *Berninis unbekanntes Meisterwerk: Die Galleria Colonna in
Rom und die Kunstpatronage des römischen Uradels*. Munich: Hirmer.

Stumpo, Enrico. 1985. *Il capitale finanziario a Roma fra Cinque e Seicento*. Milan:
Giuffrè.

Tamburini, Elena. 1999–2000. "Naturalezza d'artificio nella finzione scenica ber-
niniana." *Rassegna di architettura e urbanistica* 33, nos. 98–100: 106–47.

Taviani, Ferdinando. 1970. *La commedia dell'arte e la società barocca*. Rome: Bul-
zoni.

Testi, Fulvio. 1967. *Lettere*. Ed. Maria Luisa Doglio. Bari: Laterza.

Thuillier, Jacques. 1987. "'Il se rendit en Italie . . .': Notes sur le voyage à Rome
des artistes français au XVIIe siècle." In *"Il se rendit en Italie": Etudes of-
fertes à André Chastel*, edited by Giuliano Briganti, 321–36. Rome: Edizioni
dell'Elefante; Paris: Flammarion.

Tinniswood, Adrian. 2001. *His Invention So Fertile: A Life of Christopher Wren*.
Oxford: Oxford University Press.

Trout, Andrew. 1978. *Jean-Baptiste Colbert*. Boston: Twayne.

Uberti, Grazioso. 1630. *Contrasto musico*. Rome.

Varriano, John L. 2006. *Caravaggio: The Art of Realism*. University Park: Penn-
sylvania State University Press.

Verdier, Thierry. 2003. *Augustin-Charles d'Aviler*. Montpellier: Presses du
Languedoc.

Visconti, Pietro Ercole. 1847. *Città e famiglie nobili e celebri dello Stato Pontificio*.
Rome.

Waddy, Patricia. 1990. *Seventeenth-Century Roman Palaces*. New York: Architec-
tural History Foundation; Cambridge: MIT Press.

Weil, Mark S. 1974. "The Devotion of the Forty Hours and Roman Baroque Illu-
sions." *Journal of the Warburg and Courtauld Institutes* 37: 218–48.

Wittkower, Rudolf. 1951. *Bernini's Bust of Louis XIV*. New York: Oxford Univer-
sity Press.

————. 1961. "The Vicissitudes of a Dynastic Monument: Bernini's Equestrian Statue of Louis XIV." In *De artibus opuscula XL*, edited by Millard Meiss, 497–531. New York: New York University Press.

————. 1975. "Francesco Borromini: His Character and Life." In *Studies in the Italian Baroque*, 153–76, 289–94. Boulder: Westview Press.

————. 1981. *Bernini: The Sculptor of the Roman Baroque*. 3rd ed. London: Phaidon.

Wittkower, Rudolph, and Margot Wittkower. 1983. *Born under Saturn: The Character and Conduct of Artists*. New York: Random House.

Wolfe, Karin E. 1998. "Cardinal Antonio Barberini the Younger (1608–1671): Aspects of His Art Patronage." PhD thesis, University of London.

————. 2007. "Ten Days in the Life of a Cardinal Nephew at the Court of Pope Urban VIII: Antonio Barberini's Diary of December 30." In *I Barberini e la cultura europea del Seicento*, edited by Lorenza Mochi Onori, Sebastian Schütze, and Francesco Solinas, 253–64. Rome: De Luca.

————. 2008. "Protector and Protectorate: Cardinal Antonio Barberini's Art Diplomacy for the French Crown at the Papal Court." In *Art and Identity in Early Modern Rome*, edited by Jill Burke and Michael Bury, 113–32. Aldershot: Ashgate.

————. 2010. "Cardinal Antonio Barberini (1608–1671) and the Politics of Art in Baroque Rome." In *The Possessions of a Cardinal*, edited by Mary Hollingsworth and Carol M. Richardson, 265–93. University Park: Pennsylvania State University Press.

Zarucchi, Jeanne Morgan. 2006. "Louis XIV and Bernini: A Duel of Egos." *Source: Notes in the History of Art* 25: 32–38.

Zatti, Sergio. 2006. *The Quest for Epic: From Ariosto to Tasso*. Toronto: University of Toronto Press.

Zeri, Federico. 1982. "Bernini contro Bernini." In *Mai di traverso*, 94–97. Milan: Longanesi.

INDEX

Unless otherwise specified, all churches, palaces, and other edifices and institutions are in Rome. Page numbers in italics indicate figures or maps.

B = *Gian Lorenzo Bernini*
DB = *Domenico Bernini*